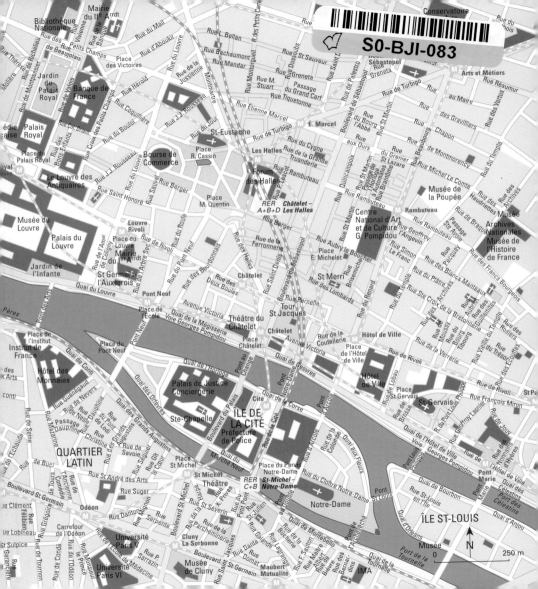

MUSÉE D'ORSAY

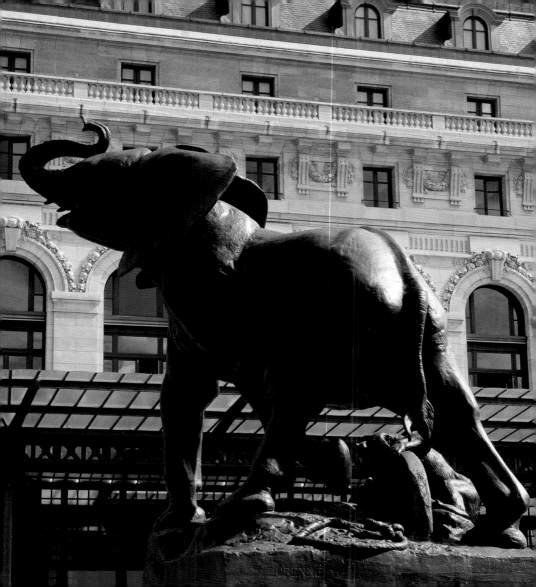

ART & ARCHITECTURE

MUSÉE D'ORSAY

Peter J. Gärtner

with contributions by
Martina Padberg
Birgit Sander
Christiane Stukenbrock

ULLMANN & KÖNEMANN

Frontispiece:
Emmanuel Fremiet, Elephant caught in Trap, 1877, museum forecourt

© 2007 Tandem Verlag GmbH
ULLMANN & KÖNEMANN is an imprint of Tandem Verlag GmbH

Art Direction: Peter Feierabend
Project Management: Ute Edda Hammer, Kerstin Ludolph
Assistant: Kerstin Dönicke
Layout: Birgit Hoffmann
Picture Research: Monika Bergmann, Nicole Klemme
Reproductions: Digiprint, Erfurt

Original title: *Kunst & Architektur. Musée d'Orsay*
ISBN: 978-3-8331-2940-7

© 2007 for this English edition:
Tandem Verlag GmbH
ULLMANN & KÖNEMANN is an imprint of Tandem Verlag GmbH

Translation from German: Mo Croasdale, Susan Ghanouni, Sandra Harper, Judith Phillips and Monique Simmer
in association with First Edition Translations Ltd
Editing: David Price in association with First Edition Translations Ltd
Typesetting: The Write Idea in association with First Edition Translations Ltd
Project Management: Béatrice Hunt and Mine Ali for First Edition Translations Ltd. Cambridge, UK
Project Coordination: Kristin Zeier and Nadja Bremse-Koob

Printed in China

ISBN: 978-3-8331-2941-4

10 9 8 7 6 5 4 3 2 1
X IX VIII VII VI V IV III II I

Table of contents

Gustave Courbet,
The Painter's Studio

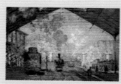

Claude Monet, *La Gare Saint-Lazare*

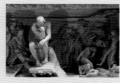

Auguste Rodin, *The Gates of Hell*

Henri Fantin-Latour, *Homage to Delacroix*

Floor plans

Upper level

Mezzanine

Ground floor

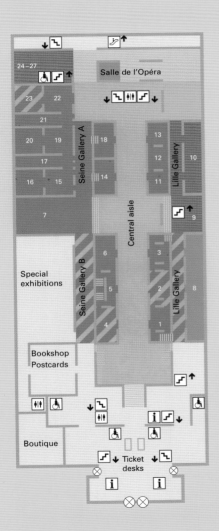

24–27

Salle de l'Opéra

23 22

21

20 19

Seine Gallery A

18

17

16 15

7

14

13

Lille Gallery

12

10

11

Central aisle

9

Special
exhibitions

Seine Gallery B

6

5

4

3

Lille Gallery

2

1

8

Bookshop
Postcards

Boutique

Ticket
desks

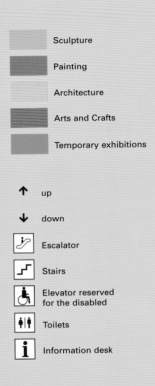

Sculpture

Painting

Architecture

Arts and Crafts

Temporary exhibitions

↑ up

↓ down

Escalator

Stairs

Elevator reserved
for the disabled

Toilets

Information desk

Ground floor

Floor Plans

Sculpture

Painting

Architecture

Arts and Crafts

Temporary exhibitions

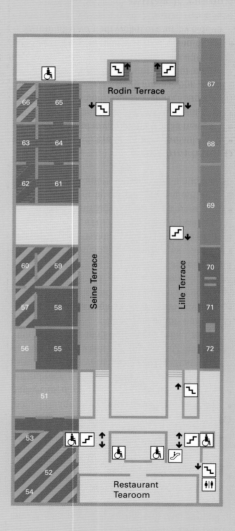

Rodin Terrace

67

66 65

63 64

68

62 61

69

60 59

Seine Terrace

Lille Terrace

70

57 58

71

56 55

72

51

53

52

54

Restaurant
Tearoom

Mezzanine

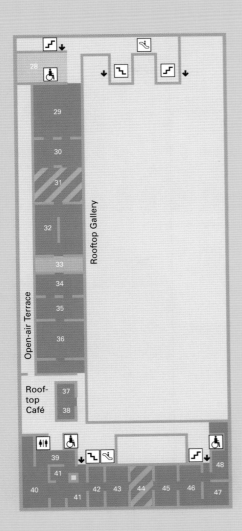

28

29

30

31

32

33

34

35

36

Rooftop Gallery

Open-air Terrace

Roof-
top
Café

37

38

39

40

41

41

42 43 44 45 46

47

48

↑ up

↓ down

Escalator

Stairs

Elevator reserved
for the disabled

Toilets

Information desk

Upper level

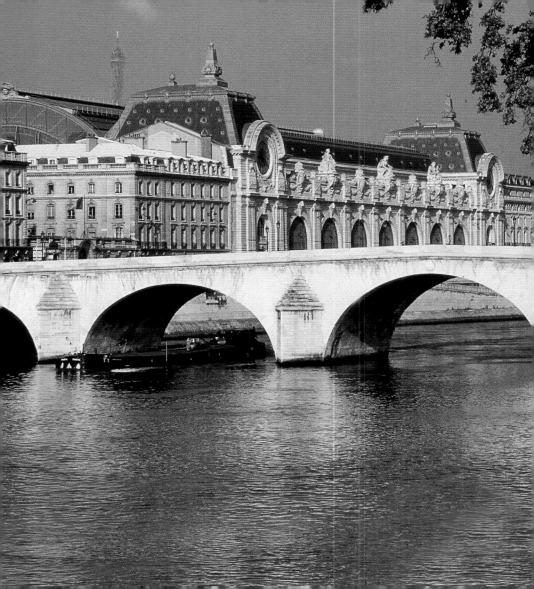

Paris railroad station provides home for 19ᵗʰ-century art

When the Gare d'Orsay was nearing completion in time for the Universal Exhibition in 1900, the painter Edouard Detaille remarked ironically: "This magnificent railroad station looks like a palace of fine arts while the Palais des Beaux Arts resembles a railroad station; I suggest that Laloux switch their functions while there's still time." Some 80 years later, this tongue-in-cheek suggestion did indeed become reality and since 1986, the Musée d'Orsay has become a showcase for French works of art produced between 1848 and 1914. Its conversion not only helped preserve a prominent 19th-century building, but at the same time provided an almost metaphorical setting for the art of this period: The railroad station – symbol of progress, mobility and the euphoria surrounding the period of industrial expansion – at the same time epitomizes the wide divergence in artistic directions around 1900. Conflicting artistic trends around this time between academicism and the avant-garde movement resulted in a wealth and variety of artistic output, which can be experienced today at first hand in the paintings, sculptures, graphics, photography, and examples of arts and crafts on display at the Musée d'Orsay.

The Musée d'Orsay on the banks of the Seine with the Pont Royal in the foreground

Victor Laloux, 1850–1937

History

The railroad station, which was originally planned for the exclusive use of railroad passengers, took the architect Victor Laloux (1850–1937) less than three years to build. Laloux's design consisted of an imposing stone façade which masked any clue as to the interior of the building, a steel and glass structure consisting of twice as much steel as the Eiffel Tower (12,000 tons) and almost

42,000 sq yds (35,000 sq m) of glass. A hotel was added on, which adjoined the station along the rue de Bellechasse and the rue de Lille. The architect insisted on planning every detail of the hotel's luxurious décor himself, commissioning officially recognized academic painters and sculptors for this purpose. The exterior façade overlooking the Seine was embellished with two enormous clocks and three monumental sculptures representing the cities of Bordeaux, Toulouse, and Nantes. Laloux clad the interior of the station with Rosetta-type stone slabs, echoing the architectural form of a classical basilica. His intention was to create a building which would not only serve as a "factory for travelers" but would also give visitors a representative first impression of Paris. The result was apparently so impressive that even the architects of the Grand Central Station in New York and Union Station in Washington, USA, were inspired by the Gare d'Orsay. Laloux's eclectic return to historical architectural forms was very much in tune with 19th-century ideas, but, at the same time, prevented such a building being fully appreciated by adherents of 20th-century functionalism.

Conversion into a museum

The introduction of new technical regulations meant that rail services had to be discontinued in 1939; the illustrious hotel, however, remained. The poet Ivan Goll spent his last years here after the end of World War II. In her memoirs, his wife gave a descriptive account of what life was like in the hotel with a railroad station in the middle of it, so to speak. In the 1960s, the building complex served as a backdrop for

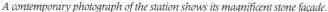
A contemporary photograph of the station shows its magnificent stone façade.

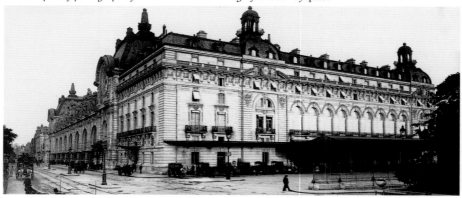

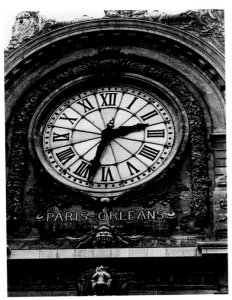

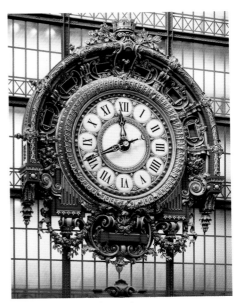

The huge clock in the Seine-facing façade

The great clock in the station concourse

the Orson Welles film of Franz Kafka's *The Trial* (1962); the theater group of Jean-Louis Barrault also had its home here for several years. Talk of demolishing the building led to the suggestion that a gigantic new hotel be built on the site of the old station. However, in 1978 the Gare d'Orsay was classified as a historic building and was thus preserved as a masterpiece of Parisian 19th-century steel architecture. Only a few years earlier, in 1973, it had proved impossible – despite a bitter struggle – to save Victor Baltard's Les Halles food market from demolition. Transforming the railway station into a museum dovetailed perfectly with 19th-century thinking: Gustave Courbet himself had thought of "turning the main railroad stations into new churches for art." Railroad stations, or "cathedrals of the modern age" as they were termed, were equally popular with the Impressionists, particularly Claude Monet, as subjects for their paintings. In the case of the Gare d'Orsay, neighboring buildings were also contributing factors: On the opposite bank of the Seine, the Louvre, the Grand Palais, and the Orangerie together form a unique museum ensemble.

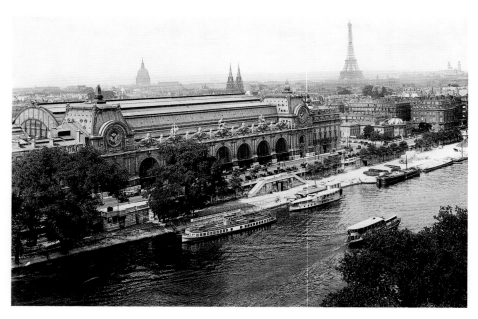

View of the museum from the Seine

Conversion work got under way in 1979. ACT Architecture's trio of architects (Rennaud Bardon, Pierre Lolboc, and Jean-Paul Philippon), who were selected to carry out the structural work, exposed the original vaulted ceiling in the main concourse and, in so doing, restored a sense of vastness to the place. Exhibition rooms were incorporated either side of the central aisle, which today serves as an avenue of sculptures. Although these obscure the arches to a large extent, they do, however, lend a museum-like atmosphere to this huge hall.

Gae Aulenti, an Italian architect, was commissioned to carry out the interior design and decoration. Her choice of using light stone gives the interior architecture an overall sense of unity and creates a light and airy atmosphere. The terraces and arcades that divide the interior horizontally into three levels enable the visitor to plan his tour according to his individual requirements. Building work was completed seven years later in 1986: The Gare d'Orsay's transformation into the Musée d'Orsay was complete.

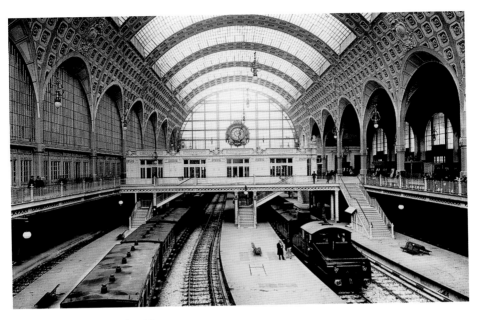

The train station around 1900

Presentation

When it came to choosing which works of art were to be housed in the museum, 1848 and 1914 were taken as the two cut-off dates marking the beginning of the Second Republic and the outbreak of the First World War. Even if these political dates do not equate with decisive turning points in the arts, this demarcation nevertheless spans the main art forms of this period.

With an exhibition area of just over 19,000 sq yds (16,000 sq m) – half the dis-

play area of the Louvre – the Musée d'Orsay exhibits 19th-century painting, sculpture, photography, and architecture and thus bridges the gap between the Louvre and the Georges Pompidou/Beaubourg Center. Since several artistic currents were running parallel to one another or even overlapping in the 20th century, the latter date should be seen as a variable boundary. Consequently, works of early Fauvism can be found on display but not works of Cubism, as these are exhibited at the Pompidou/Beaubourg Center. On the other

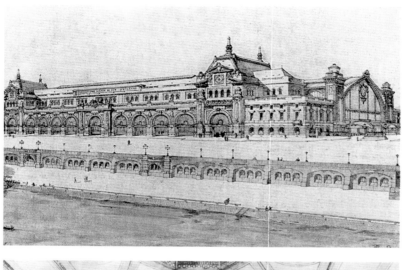

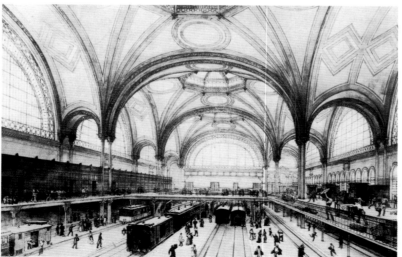

hand, some of the Musée d'Orsay's main attractions include the later works by Monet and Renoir, for example, even though these were not produced until the third decade of the 20th century.

What is particularly interesting is the overall concept of the Musée d'Orsay as a museum, where not only is academic art exhibited alongside the avant-garde but where art history can also be experienced as a contemporaneous juxtaposition of various styles. The paintings are arranged chronologically and monographically, however, enabling the visitor to distinguish the exhibits according to their date of origin and to which artistic style they belong.

The station's conversion into a museum 1979–1986

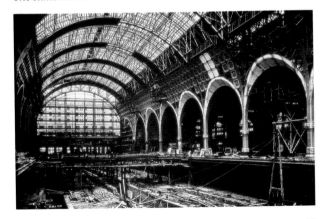

Contemporary engraving of the Quai d'Orsay railway station

Rival draft sketch for the Gare d'Orsay by Emile Bénard

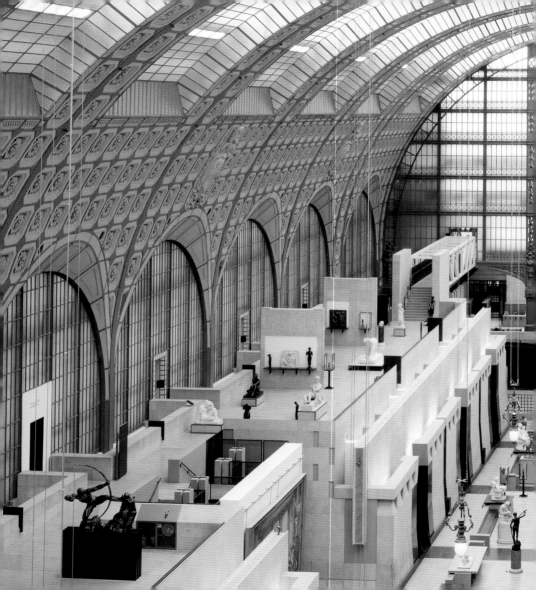

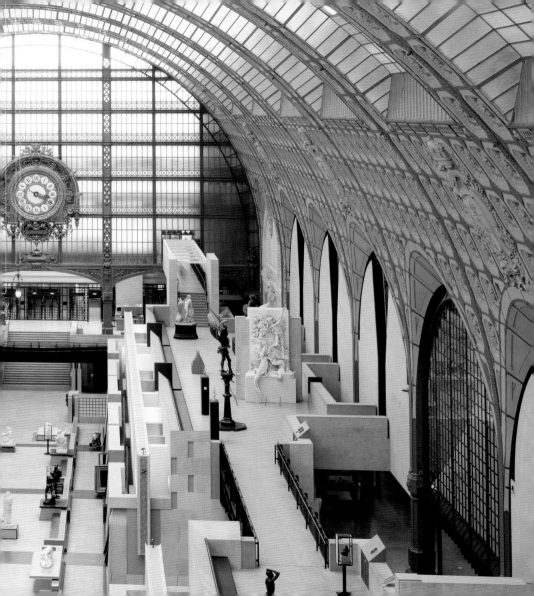

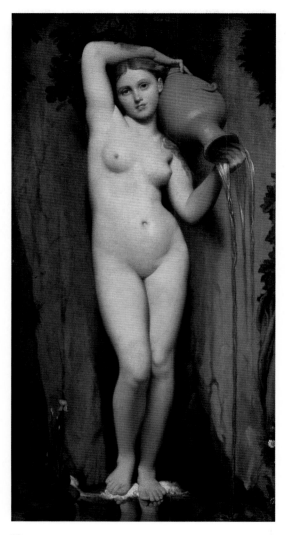

The Musée d'Orsay's collection

The ground floor exhibits focus mainly on Second Empire art, introduced by an avenue of sculptures dating from between 1850 and 1875. Here works by Ingres, Delacroix, and Moreau are displayed as well as early Impressionist works from the period prior to 1870. Completing the collection are historical paintings and portraits from the 1850–1880 period and works of the Barbizon school.

The second part of the tour continues with displays of Impressionist and neo-Impressionist works, consisting of unique collections of paintings by Monet, Degas, van Gogh, Cézanne, and Gauguin. The middle level contains examples of the official and later discredited Salon paintings from between 1880 and 1900. Parallel to this are the monumental sculptures of the Third Republic, which demonstrate the enthusiasm evident at that time for monuments and for elaborate Baroque-style façades. A substantial section of the middle

Jean-Auguste-Dominique Ingres,
The Spring, 1856, Oil on canvas,
163 x 80 cm, Ground floor, Room 1

Preceding double page:
View along the central aisle

terrace, however, is dedicated to the groundbreaking sculptures of Auguste Rodin. Displayed in front of a backdrop of academic sculpture, they highlight just how modern Rodin's artistic ventures were in his day. The works of Aristide Maillol, France's second greatest sculptor, bring us into the 20th century. The painting section of the tour ends with examples of Naturalism and Symbolism.

The museum houses a rich assortment of arts and crafts and architectural exhibits, documenting their development from historicism to Art Nouveau around the turn of the twentieth century to the beginning of modern design prior to the First World War. French arts and crafts from the Second Empire are to be found on the ground floor. Furniture, glass, ceramics and metal sculptures in the style of historicism reveal the sumptuous splendor and decorative styles favored under Napoleon III (1808–1873). At the far end of the main hall are models of prominent buildings of this period, for

Many a new discovery awaits the visitor to the Musée d'Orsay: Only 20 years separate Ingres' allegorical painting of classical antiquity *The Spring* and Cézanne's expressively formulated *Three Bathers*. The classical idealized figure in its contrapposto pose, intended as a symbol of life and fertility, is juxtaposed with Cézanne's unpolished portrayal of women. Their heavy, archaic bodies suggest a newly experienced existential sense of unity between mankind and nature. A traditional subject thus receives a fresh interpretation – Cézanne's picture is widely considered to be a forerunner of modern painting.

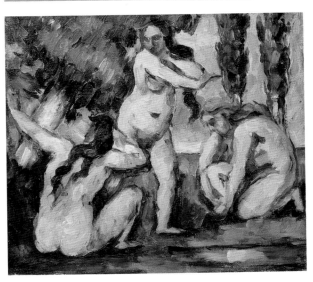

Paul Cézanne, Three Bathers, ca. 1875–1877,
Oil on canvas, 22 x 19 cm, Upper level, Room 36

example, the Paris Opera House. In addition, the visitor can acquaint himself, with the aid of an exhibition of draft drawings

Alfred Chauchard's collection includes important works of the Barbizon school

Frank Lloyd Wright. The severely geometric Viennese Art Nouveau movement is represented with works by Otto Wagner, Josef Hoffmann, and Koloman Moser.

There is a wideranging exhibition of French and Belgian Art Nouveau on the middle level. Items of furniture are arranged in delightful room settings. Along with glassware, ceramics, jewelry, and metal sculptures, they create an all-round impression of the floral abstract aesthetics of Art Nouveau. Well-known figures in the field of applied art, including artists such as Hector Guimard, Emile Gallé, Henry van de Velde, René Lalique, and Jean Carriès, are also well represented.

Endowments

The Musée d'Orsay collection not only documents artistic developments during the second half of the 19th century but at the same time highlights the tremendous importance of private patronage during this period. Were it not for the purchases and gifts of private benefactors, the museum would have been deprived of many of its masterpieces, since the only art the State was interested in purchasing in the 19th century was official Salon art. Only 10 percent of the Musée d'Orsay's Impressionist works come from the former Musée du Jeu de Paume, that is to say, were owned by the State. It was predominantly dedicated private benefactors who were among the first to discover modern painting. They began collecting it and

and architectural plans, with the architectural style and diversity of Eugène Hausmann (1809–1891).

Smaller series of rooms, leading to the upper floor, are dedicated to international arts and crafts. Here, there are special displays illustrating the Arts and Crafts Movement surrounding William Morris, one of the pioneers of modernism, as well as the Glasgow school of Art Nouveau led by Charles Rennie Mackintosh, and the Chicago school of Louis H. Sullivan and

frequently bequeathed it on their death to the French government. Since private collections are generally exhibited in separate rooms in the Musée d'Orsay, it is easy to discover the personal interests and individual tastes of these benefactors. The museum owes some of its most important paintings by Millet, Corot, and the Barbizon school, for example, to Alfred Chauchard (1822–1909), art collector and founder of the department store adjoining the Louvre. His first major purchase in 1890 was Millet's *Angelus* (cf p. 76), which had already been sold to the USA. Etienne Moreau-Nélaton (1859– 1927), one of the leading art historians of his time, donated 100 paintings to the Louvre in 1906. These included important early Impressionist works which have since been transferred to the Musée d'Orsay, the most important of which is surely Edouard Manet's *Déjeuner sur l'Herbe*. Bequests by Antonin Personnaz (1854–1936), Gustave Caillebotte (1848– 1894), and Isaac de Camondo (1851–1911) also added to the museum's wealth of important Impressionist masterpieces. Outstanding works by post-Impressionists, in particular Vincent van Gogh and Paul Cézanne, were gifted to the State by Dr. Gachet. Finally, mention must be made of Max and Rosy Kaganovitch, who acquired a collection of paintings with the sole intention of ultimately handing it over to the State. The 20 major paintings in this important collection document the development of French painting from Impressionism to Fauvism.

Paul Gachet, doctor and confidant to many artists, was very close to Vincent van Gogh

The Musée d'Orsay remains a continual source of interest. Thanks to its architectural history and the building's modern structure, it occupies a special place among Paris's museums. The tour enables the visitor to compare the major themes and artistic techniques which dominated this period of (art) history, and to make discoveries of his own. MP

 Musée d'Orsay Statistics

From Railroad Station to Museum

1900 Opening of the station concourse for the Universal Exhibition

1939 Discontinuation of rail services

1977 Thanks to an initiative by President Giscard d'Estaing, the Government decides to convert the station into a museum.

1979 ACT Architecture is commissioned to carry out the conversion work.

1986 Opening of the museum

Collection

- The collection offers a cross section of 19th-century and early 20th-century art, covering painting, sculpture, graphics, architecture, arts and crafts, furniture, and photography.
- The collection's main focus is on French painting between 1848 and 1914.
- Number of exhibits: more than 4,000
- Exhibition area: just over 19,000 sq yds (16,000 sq m)

Acquisition policy

- In order to keep adding to its valuable collection, the museum's main aim is to acquire further major paintings and sculptures from the 1848–1914 period.
- Individual works are supplemented by any sketches and studies that it has been possible to purchase on the subject. These document the various stages of artistic production from the initial idea to the completed work.
- The museum also collects selected items from the field of decorative arts and arts and crafts which help establish the cultural-historical framework of the collection.

Exhibitions

- Each year, the rooms of the former railroad station are host to three major exhibitions. These are organized either as a means of reviewing the life's work of outstanding artists or to display a collection on loan from a foreign museum.
- Staff at the Musée d'Orsay arrange numerous exhibitions in the Grand Palais.
- The museum's collection is supplemented by an extremely varied program of cultural events.

Music and film

- Concerts of chamber music in the museum's auditorium evoke the spirit of the age in which the exhibited artists lived and worked.
- Concerts are held in the museum restaurant, the former Station Restaurant.
- The museum's educational program includes concerts with accompanying talks which are designed to help the listener to a better understanding of the music.
- Silent films with musical accompaniment create an authentic atmosphere of the early days of film, from the early stages of cinematography to the invention of the sound film in the 1920s.

Guided tours

- The Museum offers visitors the opportunity to take part either individually or as part of a group in themed guided tours. These describe the collection, outline the various artistic directions, and present the life and work of selected artists (guided tours in English and French, € 6,50, + admission fee).
- Audio-guides are available in six languages to enable visitors to follow their own itinerary.

Number of visitors

- From its inauguration in December 1986 up until December 2005, more than 51 million people have visited the Musée d'Orsay.
- Admitting an average of 2,239,050 visitors a year, the museum is one of the main cultural and tourist attractions in Paris.

Opening times

- Open daily except Mondays
- Closed on December 25, January 1, and May 1
- Opening hours:
 Tuesday, Wednesday, Friday, Saturday, and Sunday:
 9.30am to 6pm
 Thursday 9.30am to 9.45pm
 Last admission at 5pm, Thursday at 9pm

Main entrance

1, rue de la Légion-d'Honneur – 75007 Paris

Public transport

Metro: Solférino (Line 12)
RER: Line C, Musée d'Orsay
Bus: 24, 63, 68, 69, 73, 83, 84, 94
Boat: Batobus

Admission prices

- € 7,50, reduced price € 5,50 (Sunday and from 4.15pm, Thursday from 8pm)
- Carte Blanche season ticket (allows one year's unlimited admission to the museum and free admission to numerous events): € 42, couples € 70
- Carte MuséO for 18 to 25 year-olds: € 18
- Reduced price for 18 to 25 year-olds and large families
- Entry free of charge for visitors under 18 years of age, art students, disabled people, and the unemployed
- Free entry for all on the first Sunday of the month

Postal address

Musée d'Orsay
62, rue de Lille – 75343 Paris Cedex 07

Internet Bookings

www.fnac.com
www.ticketnet.fr

Information

Musée d'Orsay telephone information:
+33-1-40 49 48 14
Visitors' Service:
+33-1-40 49 49 78 or 33-1-40 49 48 00
Group reservations (obligatory):
+33-1-53 63 04 50
Carte Blanche telephone information:
+33-1-40 49 47 28

Internet:
www.musee-orsay.fr

The information about the positioning of the pictures could include certain changes

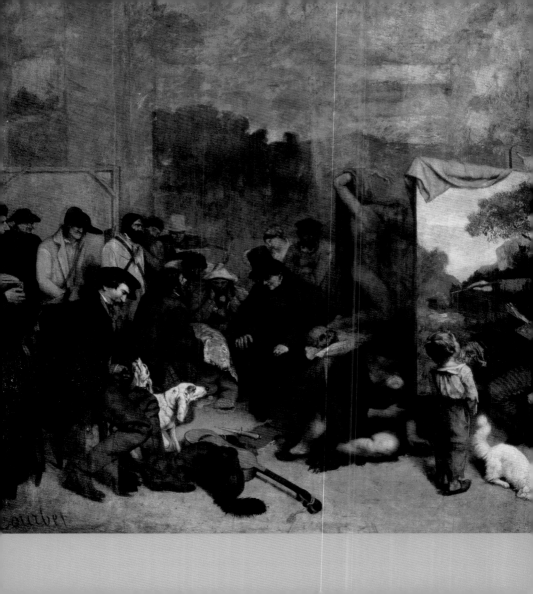

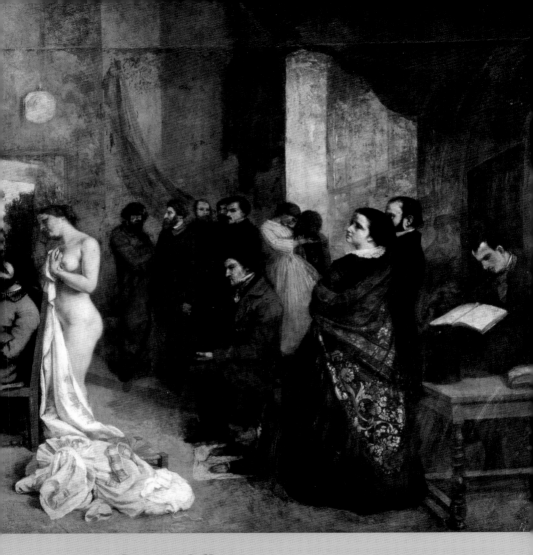

Ground floor

Ground floor 1

Other works:

1 Thomas Couture, *Romans of the Decadence*, Central aisle, p. 46

2 Camille Corot, *Morning (Dance of the Nymphs)*, Room 6, p. 78

3 1 Gustave Courbet, *The Burial at Ornans*, Room 7, p. 86

4 Alexandre Cabanel, *The Birth of Venus*, Room 3, p. 116

Preceding double page:
Gustave Courbet, The Painter's Studio, Ground floor, Room 7

Special displays

Bookshop Postcards

Boutique

Seine Gallery A

Central aisle

Lille Gallery

Ticket desks

7 6 5 4 9 3 2 8 1

Gustave Courbet, *The Painter's Studio*, p. 90

Jean-Baptiste Carpeaux, *Ugolino and His Sons*, p. 40

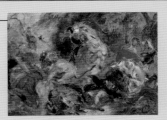

Eugène Delacroix, *The Lion Hunt*, p. 62

Jean-François Millet, *The Angelus*, p. 76

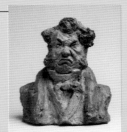

Honoré Daumier, *Laurent Cunin*, p. 72

Jean-Auguste-Dominique Ingres, *The Spring*, p. 22

Sculpture

Painting

Architecture

Arts and crafts

Temporary exhibitions

Ground floor 2

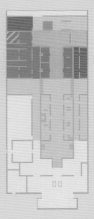

Charles Rennie Mackintosh,
Bureau, p. 166

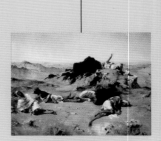

Eugène Fromentin,
The Land of Thirst, p. 145

Claude Monet, *Women in
the Garden*, p. 128

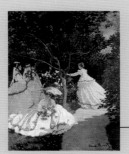

Henri Fantin-Latour,
The Table Corner, p. 139

Other works

1 Edgar Degas,
 Self-Portrait, Room 13, p. 104

2 Edouard Manet, *The Fife-
 Player*, Room 14, p. 114

3 Claude Monet, *Déjeuner sur
 l'Herbe*, Room 18, p. 126

Jean-Baptiste Carpeaux,
The Dance, p. 44

Model of the Opera House, p. 160

24–27

23 22

Salle de l'Opéra

21

20 19 18 13

17 12 10

16 15 14 11

Seine Gallery B

Central aisle

Lille Gallery

Gustave Moreau,
Orpheus, p. 102

Edouard Manet,
Olympia, p. 116

Pierre Puvis de Chavannes,
The Poor Fisherman, p. 101

Sculpture from Rude to Carpeaux

François Rude (1784–1855),
Napoleon Awakening to Immortality, 1845/1847
Plaster, 215 x 195 x 96 cm

This work not only reflects the great veneration felt for Napoleon, who had died in 1821 on the island of St. Helena, but also illustrates the way major public figures were frequently glorified in the 19th century. Claude Noisot, former commandant of the Grenadier regiment on Elba and an old comrade-in-arms of the former

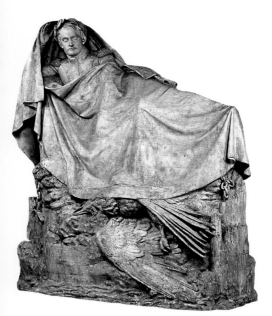

emperor, was a friend of Rude's and commissioned a bronze sculpture from him for the garden of his property in Fixin, near Dijon. It was intended to commemorate the transfer of Napoleon's body from St. Helena to the Hôtel des Invalides in Paris in 1840. Rude exhibited the first plaster model of the sculpture in his studio during the 1846 Paris Salon. It depicts the lifeless body of the emperor with an eagle by his side, symbolizing imperial power. The final version of the sculpture shows a different scene. Lying on a rock, to which he is chained like Prometheus, the awakening and rejuvenated Napoleon is seen to be lifting his shroud with his right arm and, in doing so, revealing his shoulders and his head, crowned with laurels after the manner of the Roman emperors.

An island, the sea, a mountain, or desert were commonly used in 19th-century art as settings for the portrayal and glorification of important figures. Accordingly, Rude chose as a backdrop for *Napoleon Awakening to Immortality* a rock surrounded by sea, perhaps a reference to his exile on St. Helena. His heroic sculpture differs from earlier works by other artists in one essential aspect, however. He refrained from adding decorative accessories, such as clouds or angels, and avoided any suggestion of religious symbolism which was still popular at that time in sculptures commemmorating the dead.

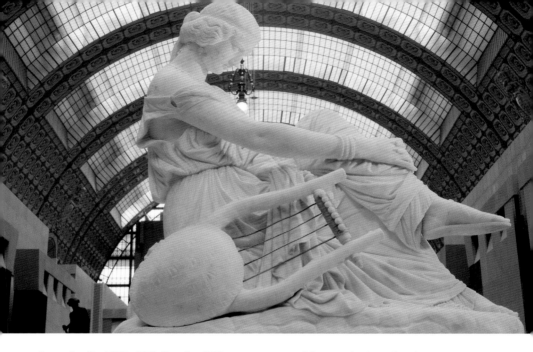

James Pradier (1790–1852), Sappho, 1852
Marble, 118 x 70 x 120 cm

James Pradier achieved his greatest success during the reign of the "Citizen King" Louis-Philippe (1830–1848); during this period he rose in popularity to become one of the most celebrated sculptors of the Bourgeois era.

The artist spent some years in Rome (1813–1819), time which he used primarily to copy the works of classical antiquity that survive there. These models became the basis for his later creative work and earned his work the title of "antique revenue" (antiquity revisited).

His marble sculpture *Sappho* shows the Greek poetess (active around 600 B.C.) as a contemplative figure, sitting with her head bowed, her left leg crossed over her right, and her hands clasped over her left knee. Her tortoiseshell lyre is set aside next to her. She is so deeply wrapped up in thought that she is completely unaware that the right shoulder of her robe has slipped down onto her arm. The sculpture demonstrates James Pradier's masterly skill in working with marble.

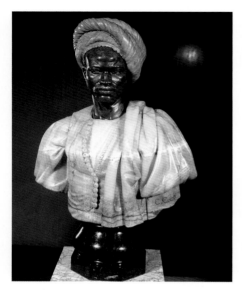

his models using an appropriately colored marble (or, as in the case of *Negro of the Sudan*, bronze) and contrasts this with lighter-colored clothing.

Cordier came across his models during his travels to Algeria and Egypt, among other places. The acclaim with which his work was received was due, in part, to the vogue for Orientalism and passion for the exotic which gripped France in the 19th century.

Eugène Guillaume (1822–1905),
Cenotaph of the Gracchi, 1848/1853
Bronze, 85 x 90 x 60 cm

Guillaume, who was a pupil of Pradier, left for Italy in 1845 after being awarded the Académie Française's Prix de Rome. While there, he spent the period from

Charles Cordier (1827–1905), Negro of the Sudan, 1857
Bronze and onyx, porphyry plinth
96 x 66 x 36 cm

Cordier was probably the greatest exponent of polychrome sculpture in the 19th century. He used various materials, such as colored marble and onyx, which he embellished with decorative details. This only applied to the accessories and clothes of his sculptures, however, as the flesh tones were always monochrome, as in the case of the *Negro of the Sudan*.

The figures are distinctly naturalistic in appearance, particularly in instances where the artist depicts the dark skin of

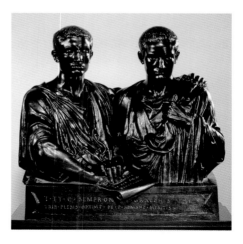

1847 to 1848 working on the model for a bust of the two Gracchi attired in classical costume and with their hair arranged in a classical style. In 1853, three years after returning to Paris, he presented it to the Salon. The work quickly made his reputation and laid the foundation for a brilliant career, during which Guillaume made his name first and foremost as a bust sculptor.

Pierre-Jules Cavelier (1814–1894), Cornelia, Mother of the Gracchi, 1861
Marble, 171 x 121 x 127 cm

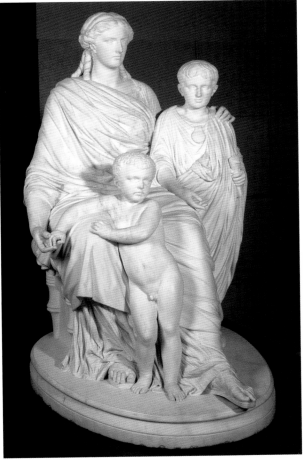

Cavelier was one of the most sought after sculptors of his day. His almost lifesize group of figures depicting a mother who is seated, with her two children standing beside her, is illustrative of official sculpture during the Second Empire, which viewed classical antiquity as its ideal. The general look of the figures, the head of the elder son, and the clothes which the group are wearing demonstrate the extent to which this work is indebted to the cult of antiquity. Contemporary critics also commended the great attention to detail and the harmonious style of the sculptor's work.

Alexandre Falguière (1831–1900),
The Winner of the Cockfight, 1864
Bronze, 174 x 100 x 82 cm

Falguière sent this statue to the Paris Salon of 1864 from Rome, where he was staying after becoming the 1859 winner of the Prix de Rome. It made his reputation as a sculptor. The subject is the same as that in the painting by Gérôme (cf p. 50), namely a cockfight. Falguière condensed the subject of his sculpture into just a human figure and an animal.

His victory in a cockfight prompts a naked young boy, proudly carrying his cockerel on his arm, to jump in the air with delight. This element of physical movement illustrates Falguière's fondness for expansive gestures. The outstretched limbs form a diagonal across the vertical line formed by the upright, slightly twisted body; a second diagonal is formed by the bent arm and the foot on the ground. The graceful and natural sense of movement is due to the fact that Falguière shaped the model from clay and did not model it from a solid block.

Antonin Mercié (1845–1916), David, 1872
Bronze, 184 x 76.8 x 83.2 cm

Mercié introduced the plaster model of his lifesize *David* to the Salon of 1872, the first to be held since the Franco-Prussian War, where it was well received. The success of Mercié's *David* – smaller reproductions of which were extremely popular in France

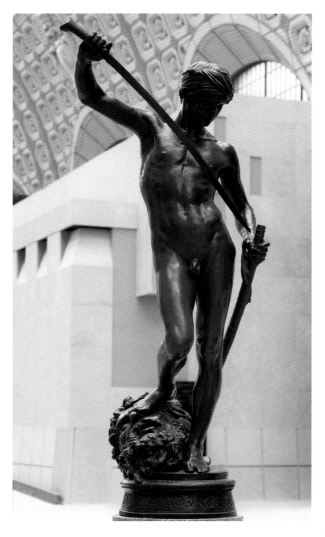

right up until the end of the century – is perhaps best understood if viewed in conjunction with the lost war and the particular atmosphere prevailing at the first postwar Salon. For a country, still smarting from the ignominy of defeat, this lifesize figure of a victorious underdog became a figure to relate to. If only France had been able to wrest victory for itself, as little David did over Goliath!

Even critics of the day pointed out how much the David sculpture owed to the early Florentine Renaissance. The total nudity and the young hero's foot resting on Goliath's head echo Donatello's *David* (around 1444/1446). David's turban, as well as his sword and the decoration around the plinth, reflect the Orientalist trend that was extremely popular in France at this time.

Expression of Despair –
The "Ugolino" theme in the hands of Carpeaux and Rodin

One of the most terrible tales related by Dante Alighieri (1265–1321) in his *Divine Comedy* tells of the loss of human dignity in the face of death. Count Ugolino della Gherardesca, tyrant of Pisa in the 13th century, is imprisoned, along with his children and grandchildren, by his enemy, Archbishop Ubaldini, and condemned to starve to death in the dungeons.

The condemned man is filled with despair at the inevitable fate of his offspring: "When I caught sight of my own features in their four faces, I gnawed my hands with the pain of it, and my children, thinking I did this out of hunger rose up, crying: 'Oh father! Our pain would be less if you ate of our flesh instead.'" Ugolino – driven almost to madness by hunger – does in fact, according to the story, eat the flesh of his own children before he dies.

Jean-Baptiste Carpeaux (1827–1875) began work on his version of Ugolino while he was at the Villa Medici in Rome in 1858 on a scholarship from the Academy of France. Whilst there, he came into contact with the classical "Laocoon" group, a highly naturalistic marble group now in the Vatican City, besides also being heavily influenced by the works of Michelangelo whom he greatly admired. It took Carpeaux three years to complete the plaster model for his "Ugolino." The bronze sculpture was commissioned by the French government in 1862 to stand in the Tuileries gardens in central Paris. It can now be seen in the Musée d'Orsay.

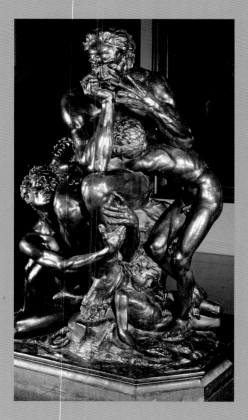

Jean-Baptiste Carpeaux,
Ugolino and His Sons, 1862, Bronze
194 x 148 x 119 cm, Ground floor, Central aisle

Carpeaux chose a pyramid-shaped construction for his sculpture, which closely mirrored Dante's original text, depicting a despairing Ugolino, surrounded by his horrified, exhausted, and dying children and grandchildren. His expressively grimacing face, the intensity of his attitude and the near-madness in his eyes create a very real and almost tangible sense of this tragic hero's isolation and raging anger despite the physical proximity of his family. The natural treatment of the figures, the finely modeled surface treatment, and the contrasting portrayals of old and young physiognomies imbue this group of figures with a shocking sense of realism.

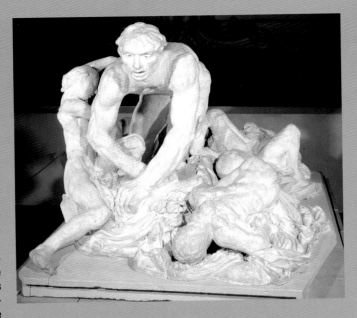

Auguste Rodin, Ugolino, 1882, Plaster, 139.2 x 173 x 278.6 cm
Rodin terrace

Exactly 20 years later, the same subject was tackled by Auguste Rodin (1840–1917). His version of the sculpture and interpretation of the subject were quite different, however. His emaciated Ugolino is seen to be crawling helplessly over the outstretched bodies of his children. Exhaustion is written all over his face and he seems the very embodiment of animalistic behavior. Heroism and human dignity have long since fallen by the wayside and all that matters now is the existential struggle for mere survival. Rodin's plaster model depicts the figures in imprecise outlines, in a way that fitted his particular sculptural style of creating a sense of movement in his work. Even though the younger artist does not appear to have been directly influenced by Carpeaux's work and arrived independently at an alternative interpretation of the same subject, it is evident that Rodin nevertheless borrowed a variation of the seated Ugolino for what has become one of his most well-known sculptures.

MP

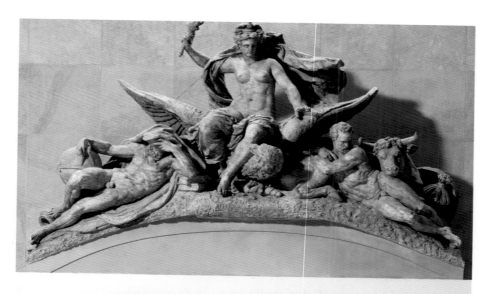

**Jean-Baptiste Carpeaux (1827–1875),
Imperial France Protecting Agriculture and
Science, 1866**
Plaster, 268 x 427 x 162 cm

In 1863, Carpeaux was commissioned to design a sculptural decoration for the southern façade of the Pavillon de Flore – part of the newly rebuilt Louvre. The resulting plaster model depicts the per-

sonification of France, seated on the back of the imperial eagle, holding a torch aloft in her right hand. Sheltering to the right and left under the bird's mighty wings are two male figures, representing agriculture and science. These are each endowed with symbolic attributes: the figure symbolizing agriculture and characterized by a bull is depicted in a state of relaxation, whereas science, seen with its globe

and compasses, is portrayed as being deep in thought.

The flanking male figures are free variations of Michelangelo's four recumbent personifications of night and day, dusk and dawn, which were created by the artist between 1524 and 1534 to adorn the Medici tombs in Florence (the church of San Lorenzo).

Jean-Baptiste Carpeaux,
The Prince Imperial and his Dog, 1865
Marble, 140.2 x 65.4 x 61.5 cm

Carpeaux was commissioned by Emperor Napoleon III to create a lifesize sculpture of the nine-year-old prince. A considerably smaller plaster version likewise portrays the boy, wearing contemporary clothing, with his favorite dog, Nero, by his side. In executing this work, Carpeaux avoided any indication of the boy's imperial background and rank in favor of the simple, childlike naturalness that is radiated by this image of a boy and his dog.

The faithful dog gives a sense of animation to the portrait. The way it is twisting its own body around that of the prince acts as a counterbalance to the vertical line of the upright figure of the boy. At the same time, it also lends stability to the whole piece – providing a support in the traditional style of classical marble statues, in which this function is often performed by a tree stump.

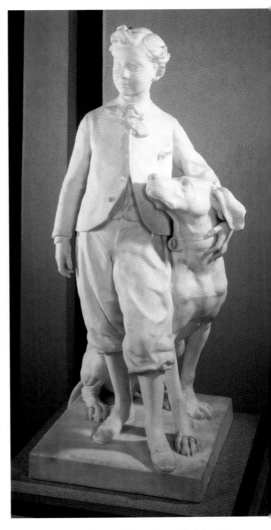

Jean-Baptiste Carpeaux, The Dance, 1869
Stone, 420 x 298 x 145 cm

The architect Charles Garnier (1825–1875), who was a friend of Carpeaux, was commissioned in 1861 with the building of the new Paris Opera House: The foundation stone was laid in 1862, but it was 1875 before the building was finally completed. Four allegorical scenes, relating to the different forms of art performed at the Opera House, were to adorn the main façade – one on each side of the two portals. The sculptors were instructed not to include more than three figures in their work. Carpeaux, who was commissioned with

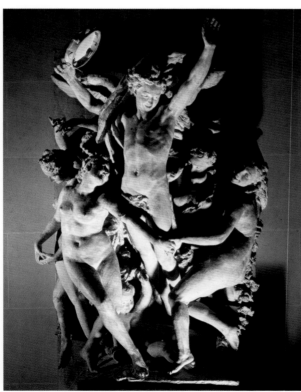

The Dance in 1865, decided to ignore this brief, however, and created a ring of six naked maidens dancing uninhibitedly around a winged male spirit, who is beating a tambourine. Inevitably, the dimensions of this ensemble were greater than Garnier's plan had foreseen. When the almost 17-foot-high stone sculpture was unveiled to the left of the right portal in 1869, it became the subject of a scandal. The dancers were considered indecent, possibly even drunk, and were therefore unsuitable for the decoration of an Opera House. In 1964, the sculpture, which had been badly damaged by pollution, was removed and brought into the museum. Since that date, a copy has occupied its original place in the Opera House's façade.

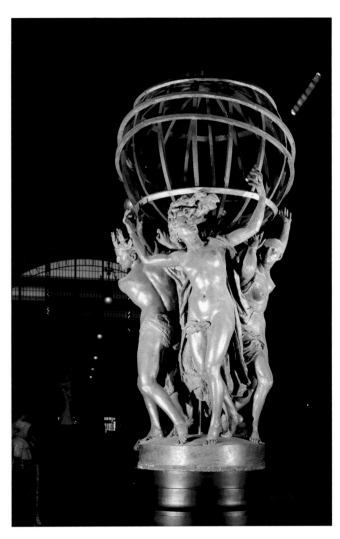

**Jean-Baptiste Carpeaux,
The Four Continents,
1867/1872**
Plaster, 280 x 177 x 145 cm

This plaster model of *The Four Continents* was Carpeaux's third major decorative commission.

The female figures, who are grouped in a circle, are holding aloft the celestial sphere. Carpeaux worked on this commission from 1867 to 1870. He presented the model to the Salon in 1872 and two years later the finished sculpture was unveiled.

The continent of Africa is portrayed by a black woman, with a band of iron around one foot as a symbol of slavery.

The figure representing America is identifiable only by her Indian headdress.

Carpeaux used a male Chinese model to represent Asia, and later transposed the head onto a female body.

Political allegory on a large scale

"Couture's work is a failed attempt to create 'great art' outside academic norms…It is solely on account of his 'good intentions' and because of the importance of his popular studio that he deserves a place in the history of French Art." Despite this harsh verdict in Kindler's Lexicon of Painting on one of the last of France's great history painters, Couture's *The Romans of the Decadence* is indeed a painting of special sig-nificance both because of its history and because of its place in the collection of the Musée d'Orsay.

Couture's work was so gigantic in size (approx. 15 ft x 25 ft) that it must have always been intended for display in a public room. It was first presented to the Salon in 1847, where it was widely acclaimed. Appearing as it did right in the middle of a highly explosive, pre-

Thomas Couture, The Romans of the Decadence (with details), 1847,
Oil on canvas, 472 x 772 cm, Ground floor, Central aisle

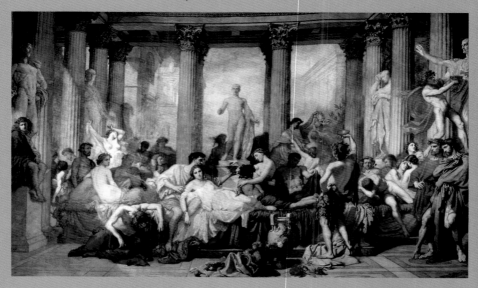

Revolutionary political situation, any intuitive observer looking at the painting would see that it was intended as a critical mirror of civilization. Under cover of the trappings of a classical setting, his painting was nothing less than an attempt at an analysis of the times. As Couture expressly pointed out in the Salon's catalog of works, he had been inspired by a text attributed to the Roman orator and satirist Decimus Inius Juvenal, who lived in Rome from about 60 to 140 A.D. and whose verses have substantially influenced our modern concept of satire. The short passage from his sixth satire reads: "We are suffering today from the dangerous consequences of a long peace; a dissoluteness, more destructive than weapons, has gained the upper hand and is wreaking revenge on a world in chains."

Decadence, a lack of discipline and ambition – in short, the loss of values and norms which help make society strong and enable it to function – these are the main themes of this enormous painting which comprises over 30 figures positioned around a large hall enclosed by Corinthian pillars in a setting straight out of classical antiquity. Beneath the marble statues of past, and presumably more illustrious, periods of the Roman Empire, an orgy can be seen in progress with its hallmarks of drunkenness and licentious sexuality. Even today, this still encapsulates our image of a decadent, declining Rome. Without the harsh tasks and sacrifices demanded by war, this new breed of slave-owning Romans no longer have any shared commitments or sense of stability to hold them together: Chaos is everywhere and they are physically destroying themselves

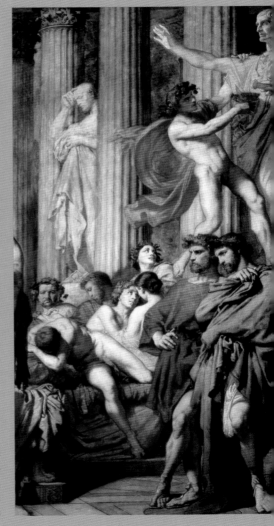

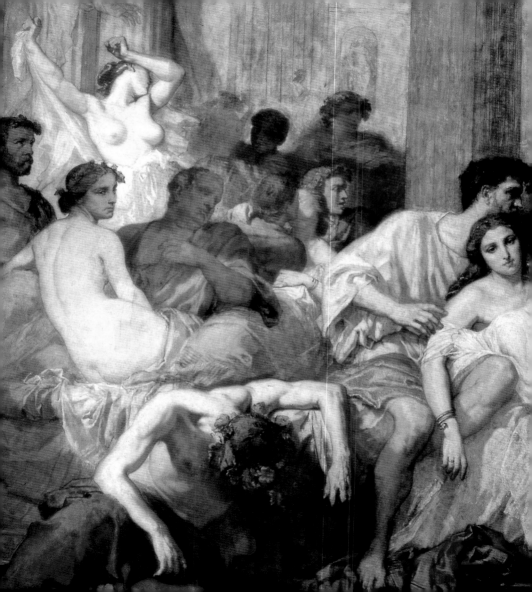

through drunkenness. Since all they can think of is their own lustful desires, there no longer exists a society rooted in the common good.

Obviously, anyone looking at the painting could scarcely fail to see the parallel with the prevailing conditions of that time and the sociopolitical situation. France's internal decline under the so-called "Citizen King", Louis-Philippe, was clearly evident throughout the country during the year preceding the outbreak of Revolution in 1848. On top of this, the beginnings of industrialization, the resulting emergence of a proletariat, and the increasing sense of insecurity on the part of the ruling bourgeoisie were all factors which dramatically aggravated the situation. The State had long since forfeited its authority. With this backdrop, Couture's gigantic canvas must have been seen as a political allegory.

Art history has a long tradition of dressing up sensitive issues in historical trappings. The painter David, for example, had made a brilliant career in the 18th century developing a new symbolism for his political history paintings. Couture, however, both in composition and painting technique, resorted to an eclectic combination of two masters of 16th-century Italian

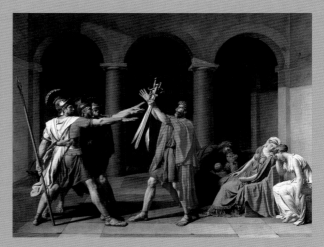

Jacques Louis David, The Oath of the Horatii, 1784
Oil on canvas, 330 x 425 cm, Musée du Louvre, Paris

painting, Raphael and Veronese, whose contrasting artistic styles Couture married in his own painting. In view of the rising success of modernism, this lack of innovation with respect to contemporary forms of expression was a criticism levied for some time not just against Couture, but against 19th-century Salon painting in general.

Perhaps it is precisely by viewing Thomas Couture's works in conjunction with the avant-garde that we gain fresh and surprising insight into the fact that the present-day interest in this artist is not solely due to his role as the teacher of Edouard Manet or Anselm Feuerbach., but also because his historical painting tells us a great deal about this period (of art history), which was indeed in decline. MP

Thomas Couture, The Romans of the Decadence (Detail)

Painting from Gérôme to Meissonier

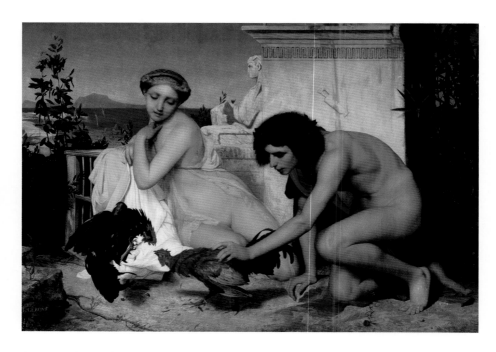

Jean-Léon Gérôme (1824–1904),
Young Greeks at a Cockfight, 1846
Oil on canvas, 143 x 204 cm

Gérôme was a painter who specialized in Greek themes. This picture, set under a Mediterranean sky with a view of the sea in the background, shows a girl and a boy, both naked, in the traditional style of classical painting. The two of them are watch-ing a cockfight in a secluded spot. The boy, who is kneeling in front of the marble plinth of a tomb, is actively interfering in the fight by pushing one of the cockerels forward. The semi-recumbent girl is more reserved and is watching the scene from the background. The obvious parallels between the animals and the human fig-ures, the advancing and retreating com-mon to both species, make it abundantly

clear that the cockfight in progress is intended to symbolize the interaction between the two sexes.

Although *Young Greeks at a Cockfight* was hung in an unfavorable spot in the 1847 Paris Salon, it attracted the attention of the public and art critics alike and represented a breakthrough for the 24-year-old Jean-Léon Gérôme, who enjoyed high esteem in the second half of the century. He later produced another version of the same subject; there are also a large number of copies in existence.

Jean Léon Gérôme, Greek Interior, 1848
Oil on canvas, 15.5 x 21 cm

Like the *Cockfight*, this *Interior* is another example of Gérôme emulating the neo-Grecian style of Joseph-Marie Vien (1716–1809). It was bought by no lesser person than Prince Napoléon himself. The figure of the youth in the earlier painting may well have been inspired by a classical relief from the Theater of Dionysus in Athens. This interior, however, is thought to have been copied from the back of a silver mirror from Herculaneum. The carefully executed sketch, which as yet lacks the smooth style of brushwork that Gérôme came to be noted for,

apparently portrays a Greek house of pleasure. Four women are grouped in the foreground, other figures are visible in the background. Toward the center of the painting, two men are approaching the prostitutes who are naked and apparently awaiting clients.

It is difficult to conceive of any greater contrast than the one evident between Gérôme's lascivious, luxuriously stretching women dating from the middle of the century and Renoir's innocent *Bathers* (cf p. 324), which appeared several decades later. These two examples perfectly illustrate the different attitudes toward sexuality and prostitution and the ways they are portrayed that were characteristic of this century. Even Cézanne, whose obsessive sexual fantasies (cf p. 300) seem far removed from the atmosphere of Gérôme's painting, copied the work from a photogravure.

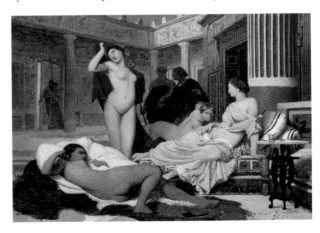

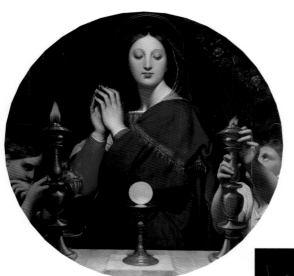

ment to Renaissance painting. The painting was strongly influenced by the great works of Raphael (1483–1520) which Ingres had seen in Italy. It was from Raphael that he borrowed the circular format and the finely detailed composition aimed at creating a sense of balance and harmony. Thus, the circle – traditionally the symbol of perfection – is reflected both in the host with its engraved Crucifixion scene as well as in the circular form of the painting.

CS

Jean-Auguste-Dominique Ingres (1780–1867), The Virgin with the Host, 1854
Oil on canvas, 113 x 113 cm

Ingres exhibited his *Virgin with the Host* at the 1855 Universal Exhibition in Paris along with 67 other paintings, consisting mainly of portraits, nudes, and scenes from mythology. This devotional picture, of slightly different subject matter, demonstrates Ingres' desire to preserve and revive the traditions of Christian art, which had begun to lose its former importance during the course of the 19th century.

The *Virgin with the Host* is not only a profession of the painter's faith in the Catholic religion but also underlines his commit-

Léon Benouville (1821-1859),
The Dying St. Francis of Assisi Being Brought to
Santa Maria degli Angeli, 1853
Oil on canvas, 93 x 240 cm

The subject of this large-scale painting is a dying St. Francis (1181–1226), being carried back to the church of Santa Maria degli Angeli at the end of September 1226 by Franciscan monks. As they near the hospital of San Salvatore, the dying monk orders his companions to stop, raising himself up on his stretcher to bless Assisi, the town of his birth, shortly to become the place of his burial. The town is depicted in the background. The painting, which was first exhibited in the Salon in 1853, was acclaimed by contemporary art critics on account of the quality of quiet piety and beauty which radiated from it. Benouville was consequently awarded a first class medal. After being exhibited for a second time in the 1855 Salon with the same degree of success, it was bought by the State. The painting belongs to the genre of works depicting religious events which were immensely popular as subject matter in the 19th century, not only with French Salon artists but also among the Pre-Raphaelites in England. CS

Scandals, in fighting and intrigues – the "Salon" and the "Refusés"

If a collector in 19th-century Paris planned to buy a painting, he would look very carefully at the reverse of the canvas and the frame on which it was stretched. If he discovered a large "R" there, he would most likely decide against its purchase. For this "R" signified that the painting had been "refused," in other words, had been rejected by the annual Salon exhibition and was correspondingly less valuable. This naturally had a direct effect on the price of a painting and an artist's standing. It was not for nothing that Honoré Daumier likened the procedure of an artist collecting his rejected works to a "funeral procession." Emile Zola, in his novel *L'Oeuvre* (1886), describes how an artist, whose works had been consistently rejected by the jury, actually committed suicide. Such a state of dependency for one's livelihood arose from the Salon's monopoly over the Paris art world. It was only here that an artist had the opportunity to attract potential clients, make contact with picture dealers and win the esteem of the art critics.

These annual public Salons were supposed to provide a means of taking into account the changed conditions affecting an artist's output. For centuries, they had executed their work

Caricature by Honoré Daumier depicting an artist collecting his rejected works as a "funeral procession"

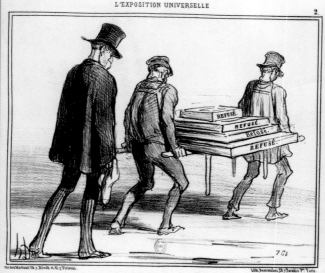

Contemporary photograph of the 1865 Salon showing the tradition of hanging paintings together

under firm contract to the court, nobility, or the Church. As a result of the far-reaching social changes wrought by the French Revolution, however, they were now working for an anonymous public, comprising a large cross-section of classes. Contemporary tastes became an important criterion on the road to fame. Successful Salon painters enjoyed great popularity in the 19th century; they were the stars of their age, on a par, perhaps, with present-day sports or movie stars. Criticism followed quickly on the heels of this experiment in artistic democracy. The main complaint was that quality had suffered as a result of the artists' pandering to the tastes of the masses. Jean-Auguste-Dominique Ingres, a highly esteemed painter, recoiled from

the Salon in disgust and wrote: "The Salon asphyxiates and contaminates the feeling for greatness and beauty. ...(It) is really nothing more than a marketplace for paintings, a bazaar filled to the brim with countless items, where art is pushed aside by commerce."

The Salon, which was originally conceived in the 17th century as an exclusive exhibition held under the auspices of the Royal Academy of Painting and Sculpture, instituted by the king of France, was opened up after 1789 to all artists and all social groups. In practice, however, the absolute authority of the renowned Académie des Beaux-Arts remained unbroken, since the jury continued to be comprised mainly of Academy members.

By admitting "ordinary folk" on certain admission-free days, the Salon assumed an educational role. The jury's selection had long since ceased to be based entirely on artistic, stylistic, or formal criteria but was always a political decision. It was hardly surprising, therefore, that they were mainly historical subjects of an exemplary nature, idealized portrayals of bourgeois families or rural peasant life, that were favored. Thanks to this conservative view of art, any new trends were effectively excluded.

Eventually, in 1863, this culminated in almost half the works submitted to the Salon being rejected on the grounds of these rigid principles. The result was that the artists affected finally gave vent to their long suppressed feelings of discontent. For years, they had suffered at the hands of intrigues and secret deals between members of the jury and, even after being successfully admitted, had frequently had to compete for the best places in the exhibition hall by means of bribes. After all, the paintings were arranged in tightly packed tiers ranging from eye-level up to the ceiling and a painter would only have the opportunity to be noticed if his painting were hung in a good spot, not against the light or in a dark corner. As the voices of protest became increasingly vociferous, the emperor of France, Napoléon III, intervened personally and instituted the so-called

Hippolyte Flandrin, Napoléon III, Emperor of France, around 1860/61, Oil on canvas, 22 x 19 cm, Musée National du Château, Versailles

Catalogue of works at the 1863 Salon des Refusés

CATALOGUE

DES OUVRAGES

DE

PEINTURE, SCULPTURE, GRAVURE

LITHOGRAPHIE ET ARCHITECTURE

REFUSÉS PAR LE JURY DE 1863

Et exposés, par décision de S. M. l'Empereur,

AU SALON ANNEXE

— PALAIS DES CHAMPS-ÉLYSÉES —

LE 15 MAI 1863

Prix : 75 cent.

PARIS

LES BEAUX-ARTS, REVUE DE L'ART ANCIEN ET MODERNE

RUE TARANNE, 19

1863

Salon des Refusés, an exhibition of the paintings rejected by the jury. This exhibition, which opened its doors on May 15, 1863, drew huge crowds of visitors. Up to 4000 people thronged the exhibition halls in the Palais de l'Industrie at the weekends. It was mainly scorn and ridicule, however, that greeted the works by Manet, Pissarro, and Cézanne, among others. "Hardly have they stepped across the threshold," wrote the English art pundit P. G. Hamerton, "when even the staidest of visitors bursts out laughing." The exhibition thus unintentionally became a substantiation of the jury's original selection.

Despite such disappointments, the Salon des Refusés paved the way in the long term for an alternative art scene, free of official control. It was a good 20 years later that the generation of younger artists, who were still being consistently rejected, banded together under the leadership of Seurat and Signac to form a "Society of Indepen-dent Artists" and organized a regular jury-free Salon des Indépendants. This had the effect of creating – as a follow-on from the mainly private exhibitions by the Impressionists – a real alternative to the Salon, which had lost its position of near-absolute authority and fallen more and more into public discredit by the end of the century. The Salon des Indépendants became an example for the so-called secession groups which were established around the turn of the twentieth century all over Europe. These consisted of associations of artists who were opposed to the way the academic art world was run and sought a different means of presenting their work to the public. As a result of this development, the art market split in different directions and became privatized, and this pattern continued throughout the 20th century. MP

Henri Gervex,
A Painting Jury, 1885,
Oil on canvas, 299 x 419 cm,
Middle level, room 52

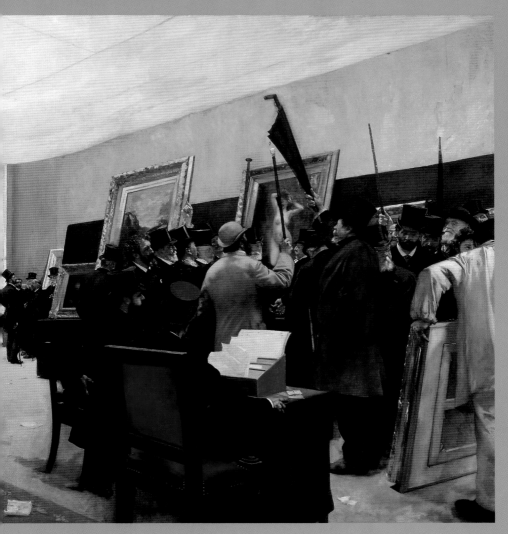

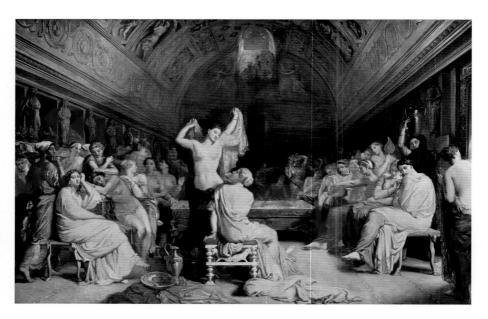

Théodore Chassériau (1819–1856),
The Tepidarium (with detail), 1853
Oil on canvas, 171 x 258 cm

Nineteenth-century artists found all sorts of opportunities for depicting female nudity. It was not uncommon for them to delve far back into the past to find subjects to fit their nude paintings. This was a means of legitimizing naked and semi-naked women and of simultaneously impressing the viewer with their in-depth knowledge of history.

Since the excavation of Pompeii and other classical sites in the mid-18th cen-tury, people believed that they had a better idea of what life was like in classical antiq-uity. In 1840 and 1841, Chassériau had vis-ited Rome and the Bay of Naples and incorporated his impressions of antiquity into this painting of a Pompeiian baths. He therefore added the subtitle: "Room in which Pompeiian women gather after attending the baths in order to dry off and relax." The scene in the tunnel-vaulted interior, which has a single window in the ceiling, permitting a view of blue sky, is full of erotic tension. A semi-naked woman stretches luxuriously without any inhibi-tion in the foreground of the picture.

Her physical charisma is so strong that a woman sitting in front of her cannot resist the temptation to reach out and touch her immaculate body. Chassériau paints female nudity with an eye toward the male visitor to the Salon. The women sitting nearest the front look invitingly, if not challengingly, out of the painting. The expression on their faces reveals that they are conscious of male scrutiny of an activity normally conducted in private.

In his work, Chassériau, who was a pupil of Ingres, succeeds in combining the latter's linear style with a lively, graduated sense of color. This is even more the case after his sojourn in Algeria (1846). Chassériau was also considerably influenced by Delacroix, celebrated for his paintings of Morocco, whose deliberately indistinct outlines, are echoed in this painting in the glow around the coal fire, for example.

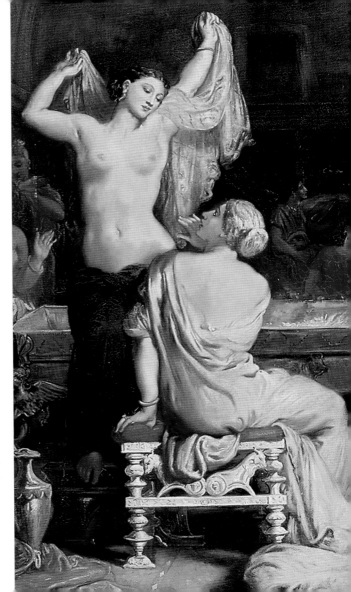

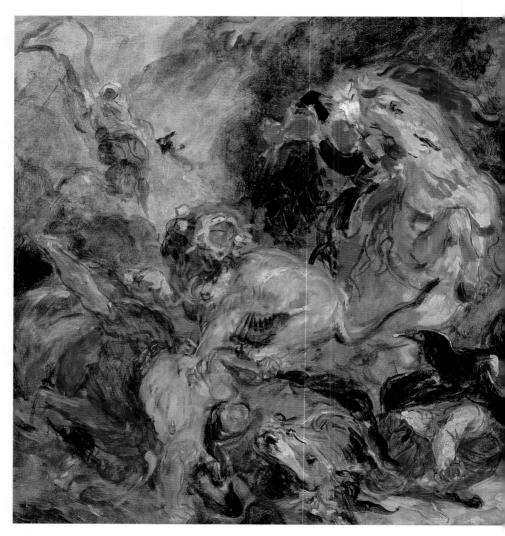

Eugène Delacroix (1798–1863), The Lion Hunt, 1854
Oil on canvas, 86 x 115 cm

Some of the highlights in the work of France's most important Romanticist include his extremely vital and colorful portrayals of animal fights. In 1832, the painter Eugène Delacroix undertook an extended trip to North Africa, which inspired him to tackle numerous subjects of the so-called Oriental genre. The painter even chose the colorful and exciting world of the Orient as a backdrop to scenes of animals fighting, such as this lion hunt. He returned from his travels not only full of fresh ideas, but also with ideas for a new and vivid palette.

This large oil sketch of *The Lion Hunt* paved the way for a painting of the same title that was exhibited in Paris at the 1855 Universal Exhibition, only to be destroyed by fire in 1870.

The sketch with its glowing colors, applied with Delacroix's distinctive broken brushwork across the canvas, is captivating. The element of free expression increases the dramatic effect. The shapes of the lions, human figures, and horses emerge only gradually from the terrible chaos of swirling colors and shapes. They form a triangle, the apex of which is the rearing horse and its rider, who has slipped to one side. To the right and left are the fighting lions, while the foreground consists of foreshortened images of fallen horses and riders desperate to get out of harm's way.

The sketch illustrates Delacroix's penchant for the violent and demonic. This is also evident in his monumental paintings and graphic sketches.

Eugène Delacroix,
Arab Stallions Fighting in a Stable, 1860
Oil on canvas, 64.5 x 81 cm

Fighting is likewise the subject of this smaller painting *Arab Stallions Fighting in a Stable*: The two horses rearing up show animal forces clashing and mingling. Two of the stablemen who sleep with them i n the stable are attempting to intervene while the third remains on his blanket. The human figures and animals together form a triangle, clearly symbolizing the motif of taking courage and rising up in protest.

This powerful study was intended by Delacroix as a preliminary drawing for a painting. During the course of the century, his delightful oil sketches became accepted as works of art in their own right on account of their vibrant brushwork and the impulsive application of color.

Alfred Stevens (1823–1906),
What is known as Vagrancy, 1855
Oil on canvas, 132 x 162 cm

Stevens' painting depicts a pitiful scene in a wintry, bleak townscape. A despondent young woman and her two children are being led away by three armed soldiers on charges of vagrancy. Witnessing the arrest are an elegantly dressed, unashamedly curious woman and a workman, who simply turns away in embarrassment. One of the two leading soldiers orders the inquisitive woman to be on her way.

Two posters have been pasted onto the snow-topped wall which blocks off the rear of the scene in which a few bare trees are visible. The words Bal (Ball) and Terrain à Vendre (Land for Sale) are just discernible. These allude to pleasures and property, a world of affluence that is unknown to the homeless woman and her children – and likely to remain so.

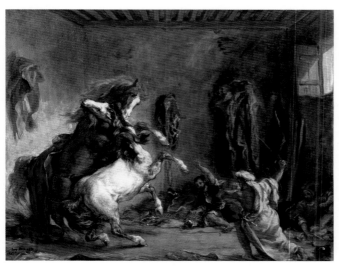

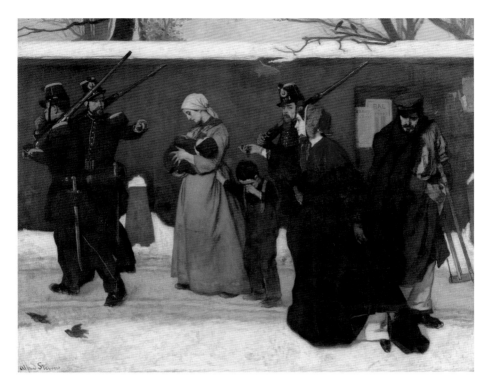

When Napoléon III saw this painting at the 1855 Universal Exhibition in Paris, he was shocked – not so much at the misery of the vagrants as at the role of the soldiers. He ordered that henceforth vagrants were only be taken to prison in closed carriages. No longer would they be paraded through the streets by the military in full public view. In the 1860s, Stevens began to enjoy great success as a painter in elegant society and began to distance himself more and more from potentially controversial socio-critical subjects of this nature.

Ernest Meissonier (1815–1891),
The Campaign in France 1814, 1864
Oil on wood, 51.5 x 76.5 cm

Meissonier's contributions to historical painting, either portraying specific events from the Bible or mythology or illustrating historical events, are usually small and modest in size.

With an attention to detail worthy of a miniaturist, Meissonier depicts Napoleon's French campaign on this wooden plaque. In 1814, the final year of his rule, Napoleon led his soldiers into defeat. The marching column has clearly branched into two. In the foreground, the mounted leaders are riding past the spectator. Napoleon himself, at once heroic and solemn, is in the lead, followed by Marshals Ney and Berthier as well as General Drouot. In the background to the right are the common foot soldiers. The snow-covered ground is churned up, the sky leaden.

Meissonier, whose pictures were greatly admired and won substantial prizes, exhibited his 1864 painting in the Salon. In 1866, it was purchased by Gustave Delahante for 85,000 francs; in 1890, Alfred Chauchard paid 850,000 francs for the work, which he later bequeathed to the museum.

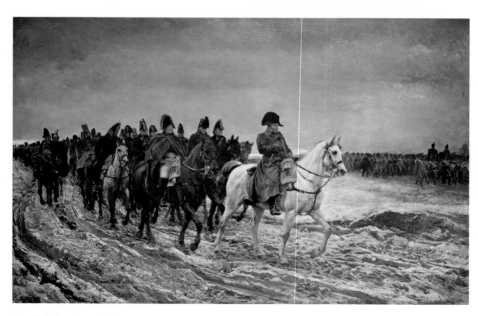

Alexandre Antigna (1817–1878),
The Lightning, 1848
Oil on canvas, 220 x 170.5 cm

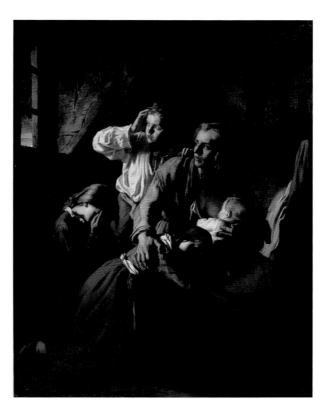

Whereas history painters preferred the past as a setting for their subjects of damnation and expulsion, Antigna tended to concentrate more on his immediate surroundings. The 19th century, therefore, produced history paintings side by side with pictures reflecting the realities of the day.

The large-scale painting *The Lightning* was exhibited in the first Salon of the Second Republic in 1848.

A young family has gathered in a garret while a storm rages outside. The father is absent from the family group. The mother is at the center of the small group, dramatically illuminated in front of a dark background. Both worried and protective at the same time, she has her hands round two of her children. She is holding the youngest to her breast. Of the other two, one has bowed her head in fear and has buried her face in her hands. The other has laid one hand on her mother's shoulder and is shielding her face with the other while she, like her mother, risks a glance outside. Antigna's painting of a poor family, perhaps rendered fatherless by circumstances, is not without ulterior political undertones. The battle cry of the barricade fighters in June 1848 "Du pain ou la mort" (Bread or death) reflected the very radical nature of the hungry population's demand for food.

Honoré Daumier

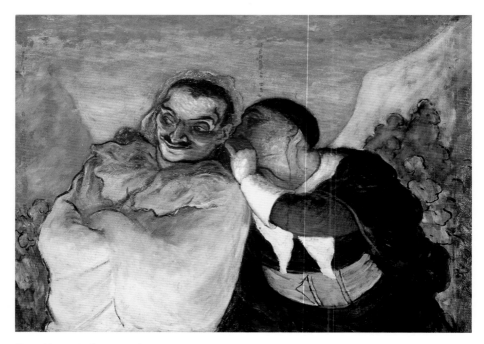

Honoré Daumier (1808–1879),
Crispin and Scapin, ca. 1858/1860
Oil on canvas, 60.5 x 82 cm

Daumier – in complete contrast to his friends of the Barbizon school – is a painter of human figures, rather than landscapes. Ordinary people interest him, but it is to the theater that he is especially attracted: *Theater Sketches* (1853), *Dramatic Sketches*

(1856), *Comedians of Society* (1858) and *Sketches – Completed at the Theater* (1864) are the titles of different series of sketches. In this picture, it is the costumes, but, more importantly, the artificial lighting from below, that make it clear that the scene depicted here is taking place on stage. Scapin is whispering something to Crispin. The latter's face mirrors attentiveness, curiosity, and a somewhat malicious sense

of satisfaction. The accuracy with which Daumier captures the expressions of the two characters is a measure of the greatness of his art.

The construction of the picture also mirrors what is taking place. The background scenery forms a V-shaped cleft toward the center behind the two figures. The arm positions of the two men mimic this while their bodies lean inwards in the opposite direction. The two of them are inclined toward each other, ear and mouth pressed close together, thus forming a triangle, the base of which is formed by the lower frame of the picture.

something important should be lost – such as the spontaneity or directness of the attack – nor did he want to lose that instant of expression that gives such vitality to his caricatures of people and makes them so transparent. It was for artistic reasons, therefore, that he refrained from finishing off the hands and created an imprecise background, the varied treatment of which serves to further emphasize the differences between the two characters that are so vividly portrayed.

Honoré Daumier,
Scene from a Comedy, 1858/1862
Oil on wood, 32.5 x 24.5 cm

This painting is also known as *The Intriguer* or *Scene Reminiscent of Molière*. There is some justification for this reference to the writer. Molière (real name Jean Baptiste Poquelin, 1622–1673), like Daumier, created a Comédie humaine, a human comedy, in which he holds a mirror up to his contemporaries. The intriguer has crossed his arms over his chest and thrown back his head in an attitude of self-satisfaction. A beam of light catches his prominent chin. The person by his side – a dignitary to judge from his dress – is obviously a victim of one of his schemes. His harshly lit face is furrowed with dismay and he is anxiously wringing his hands together. Daumier was concerned lest, by giving his work too perfect a finish,

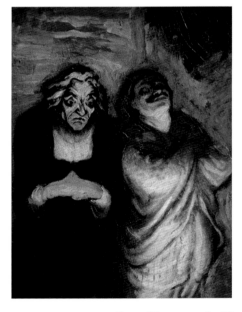

Light and shade – mothers portrayed in art

Daumier's painting of *The Washerwoman* depicts one of the countless nameless women in Paris during the Second Empire who used to spend day after day washing laundry in the Seine and not returning home until dusk. Pissarro's picture, on the other hand, portrays a rural idyll. There is nothing arduous about this mother's chores. While hanging out the washing, she is still able to watch her daughter who is sitting happily on the grass. The two of them are bathed in warm sunlight. The mood in Daumier's painting meanwhile is quite different: Although the child is carrying a toy spade in her hand, she almost seems to be using it to help her climb the steep steps. The little girl's mother is casting solicitous glances at her. The fact that she already has to accompany her mother in

Honoré Daumier, The Washerwoman, ca. 1863,
Oil on wood, 49 x 33.5 cm,
Ground floor, Room 4

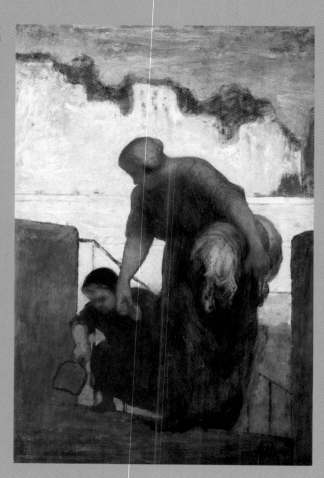

her labors suggests that she is likely to suffer the same fate. In Daumier's picture, the fading light of the setting sun falls on the row of houses on the far bank of the Seine, while the mother and her child make their way home through a dark and gloomy world. In Pissarro's painting, however, the whole scene is bathed in light, the figures are depicted in a sunny paradise. Daumier imbues his figures with an almost allegorical character. Pissarro, with his scientifically exact analysis of color, depicts his subject using small brush strokes. The colors in the painting are suggested by reflections of color: dabs of color in the white washing as well as in the shade on the ground reflect the bluish violet color of the woman's clothing. Complementary colors of yellow-orange and blue in the mother's and daughter's hair or green and red in the grass and shrubs create a color effect that is rich in nuances.

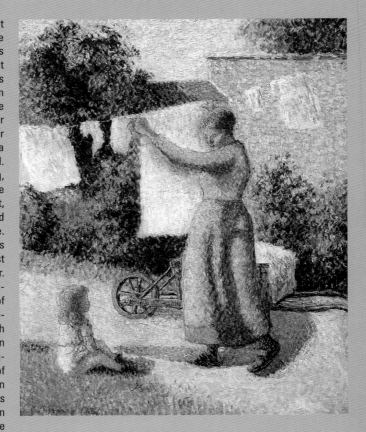

Camille Pissarro, Woman Hanging out Washing, 1887, Oil on canvas, 41 x 32.5 cm, Depository

Pissarro, the only painter to have had work shown at all eight of the Impressionist exhibitions, was justified in claiming: "My life and Impressionism are one and the same."

Daumier's terracotta busts – political physiognomics

With his series of Parliamentarians, begun in 1831, Daumier, who was already known for his paintings and cartoons, at one stroke demonstrated his talents as a sculptor. This should not come as such a surprise if one recalls the sculptural quality of his drawings and lithographs and how sculptural undertones are likewise evident in his paintings, for example his Republic (1848). Thirty-six of his busts of public figures, depicting parliamentarians like Jean-Auguste Chevandier de Valdrome (1781–1878), politicians such as Laurent Cunin, (1778–1859), or journalists like Charles Philipon (1800–1862), have survived.

Honoré Daumier, Laurent Cunin, Politician or the Angry Man, 1832/1835, oil-glazed clay, 15.3 x 13.8 x 10.1 cm, Ground floor, room 4

Honoré Daumier, Jean-Auguste Chevandier de Valdrome, Parliamentarian or the Fool, 1832/1835, oil-glazed clay, 19 x 14.9 x 13 cm, Ground floor, room 4

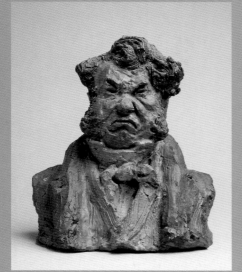

Originally, there were certainly more of them. They illustrate Daumier's favorite saying: Il faut être de son temps (You have to be of your time).

The 6–8 in (15–20 cm) high busts of unfired clay have an unpolished surface, finished with an oil glazing. The rough surface treatment anticipates the work of Auguste Rodin (1840–1917). It must be remembered, however, that the finished product, with its oil-glazing, was intended as a caricature. The busts illustrate the balancing act between a true-to-life portrait and a suggestive exaggeration: The quiff in competition with the prominent nose, the gruffness of the face, emphasized by the side-whiskers and hairstyle, as well as the pointed nose sticking out of the circular face. Since the artist is reputed never to have worked from a model, these heads must have been done from memory. These terracotta busts were not used by Daumier, but by the staff on the *La Caricature* magazine, as models for their cartoons. It was for this reason that they were kept with the publisher and not with the artist who made them.

Honoré Daumier, Charles Philipon, Journalist or Toothless Laughter, 1832/1835, oil-glazed clay, 16.4 x 13 x 10.6 cm, Ground floor Room 4

The Barbizon School

Théodore Rousseau (1812–1867),
An Avenue in the Forest of l'Isle-Adam, 1849
Oil on canvas, 101 x 82 cm

It was thanks to the painters of the Barbizon school that landscape and "plein-air" painting (the practice of painting in the open air) began to grow in popularity in French art. In 1836, Rousseau left Paris and became the first painter to settle in Barbizon, a small village on the outskirts of the Forest of Fontainebleau. Others, including Narcisse Diaz de la Peña and Millet, soon followed suit. These artists' escape to the countryside was a conscious decision. They were deliberately turning their backs on the frenzy of the big city and industrial development. At the same time, they remained within easy reach of Paris, the center of artistic recognition.

Rousseau's landscape depicts an idyllic scene in the forest of l'Isle-Adam. The eye travels upward from the undergrowth in the foreground to a clearing, bathed in a radiant sunlight. The tranquil scene in the center of the picture is framed by dense foliage and untamed nature. A country girl is sitting in the clearing with her cattle. The proportions of the figures vis-à-vis nature are distinctly smaller; Rousseau's main theme is the all-encompassing oneness with nature.

Jules Dupré (1811–1889),
The Sluice Gate, ca. 1855/1860
Oil on canvas, 51 x 69 cm

The painting of *The Sluice Gate*, which earlier research dated around 1846 but is now known to be somewhat later, is typical of the Barbizon school of painting with its portrayal of rural idylls. What is characteristic of Dupré is his use of relatively dark colors: While a band of gray cloud dominates the upper part of the picture, shades of dark green and brown are the prevailing colors of the landscape. They also determine the expanse of water in the foreground with its ducks and reflections of tree trunks and wooden posts. To the left of center, a tiny figure of a man wearing a white hat is visible. It blends harmoniously with the thick growth of bushes and trees. Dupré's strong, dense network of small brush strokes reflects the influence of Théodore Rousseau.

CS

The shepherdess is wearing the heavy clogs and traditional cape typical of her station. Her world is untouched by anything that might bring farmers or shepherds into contact with technology, with the evils of the Machine Age or any sort of mechanization. When Millet discovered that shepherds were wearing modern military coats instead of their traditional capes, he had a cape sent from Normandy for a painting of shepherds he was currently working on. This little anecdote illustrates his concept of the world and his approach to art. His works preserve on canvas a world that was already in a state of flux.

Jean-François Millet,
The Angelus, 1857/1859
Oil on canvas, 55.5 x 66 cm

Jean-François Millet (1814–1875),
Woman Knitting, 1858–1860
Oil on wood, 39 x 29.5 cm

Millet's shepherdesses are often encountered needlework. This young woman is sitting on the ground some distance from her flock with one foot crossed over the other and her crook by her side while she does some knitting. The canopy of foliage above her is a symbol of nature's role as protector.

The horizon in Millet's *Angelus* is fairly high up the picture, as it was in *The Gleaners* (cf p. 84). This is supposed to emphasize the peasants' oneness with the soil, which, here too, takes up nearly three-quarters of the painting.

In the foreground, resembling a photographic close-up, is a peasant couple with their heads bent in prayer. Grouped around the couple are a pitchfork, a basket containing potatoes, and a barrow: in other

words, their working tools and the food they have helped produce. Far away on the distant horizon is a church tower. Despite the distance, it is the sound of the evening church bells reaching them across the fields that prompts the couple to pray. The life of these people is characterized by arduous labor in the fields and a deep sense of religiousness. They appear to accept their lot unquestioningly, a factor which lends a gentle and unobtrusive intensity to the painting.

Millet's peasant couple are lit by light from the evening sky, which symbolically sets a stark outline about their heads and imbues the praying couple with a timeless, almost allegorical significance. He inspired Van Gogh, among others.

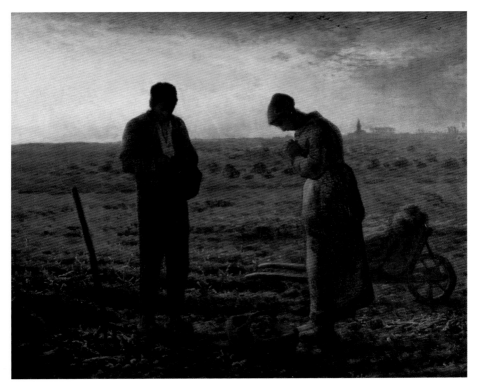

**Camille Corot (1796–1875),
Morning (Dance of the
Nymphs), 1850**
Oil on canvas, 98 x 131 cm

Throughout his long life, Corot frequently returned to the theme of landscapes in a mythological setting. In his painting *Dance of the Nymphs,* the nymphs have gathered for a morning dance in a sheltered clearing. The edges of the clearing lie in deep shade and it is backed by the dense foliage of high trees. The scene is bathed in a silvery green light. This creates an otherworldly atmosphere and at the same time underlines the importance of the gathering, which critic Emile Zola described poetically as the unity between the human figures and nature, the marriage between the "magical foliage," the "smiling, dewy morning sunrise," and the "transparent figures" of the nymphs. The pale sky, with its wisps of cloud, merges with the trees' branches and leaves, the edges of which dissolve into the light. The figures

echo the vegetation. The special morning atmosphere has a unifying effect on all the figures. Various outstretched arms or the posture of a nymph leaning forward as she hurries by echo the shape of a branch or a tree trunk, making the nymphs seem more like living plants. Camille Corot's forest idylls reveal the secret secluded corners of nature to the observer.

Once, when Corot was working from nature in the Forest of Fontainebleau together with Jules Dupré and had drawn another such ring of dancing nymphs, he told his astonished colleague, who was unable to see any such thing in nature: "So what – I can see them at any rate!" This painting, which was acquired by the State in 1851, is the only work by Corot to be officially exhibited during his lifetime in 1854. It is typical of the paintings he was producing during this period of his life. Later on, he turned to portraits and studies of women.

Camille Corot, The Mill at
Saint-Nicolas-les-Arraz (with detail), 1874
Oil on canvas, 65.5 x 81 cm

In addition to all his landscapes with a mythological theme, Corot also created a large number of pure landscapes in which the essential elements are light and shade. These works gained Corot the approval of the Impressionists, who showed their respect and affection by calling him "Père Corot." In the background, beyond the tree-lined path running parallel to the front edge of the picture, is a mill. The path does not lead up to the mill in its picturesque setting, however, as there is no link between the foreground and background; the painter is only concerned with the visual effect. The luminous quality of the house and the treatment of the water in the stream are very much Impressionist in style. Corot's style of painting is dis-

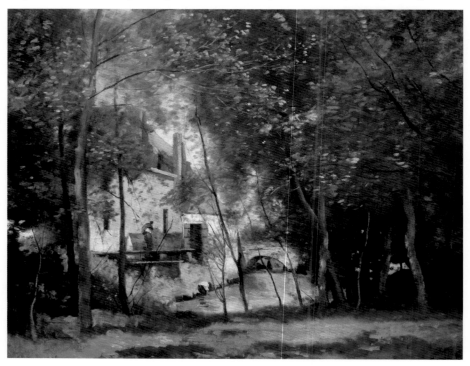

other words, mind and matter are derived from the same basic element). To them, light is the all-important principle governing everything.

Camille Corot,
The Artist's Studio, ca. 1865/1870
Oil on canvas, 56 x 46 cm (overleaf)

With the exception of a few early paintings, Corot did not begin painting human figures until later in life. The public did not get to see these works, however, until their discovery during the sale of his estate after his death. These works, which are paintings exclusively of women, seem to have a touch of despondency, of gentle melancholy, about them.

This particular small-scale study by Corot contains numerous allusions to the world of philosophy, music, and the fine arts, marking it out as a modern allegory of the arts. A young girl, lost in thought, is sitting on a chair in the artist's studio. Her right arm is resting on the back of the chair, her head resting on her hand. Her left hand is around the neck of a mandolin resting on her lap. The observer is made to feel like an intruder, not just by the mood of the painting, but also by the girl's introspective attitude and the position of the chair. Next to the girl is an easel holding a landscape painting. Despite its proximity to her, however, her attention does not seem to be on the picture for she is staring into space. Behind the girl, is an empty chair – was the artist sitting there up until a few moments ago?

tinctly freer in this work than in his *Dance of the Nymphs*. The reflections of the sun on the path, for instance, are created simply by single brush strokes. Despite these similarities, however, there is one essential difference that distinguishes it from Impressionist painting. The area at the rear of the picture, in other words, the water and the rearmost wall of the building, are depicted in a different light, a different temperature even, from the area in the foreground. Corot's landscape reflects a dualistic view of the world, which sees nearness and distance as two separate principles. The Impressionists, on the other hand, have a monistic approach to art (in

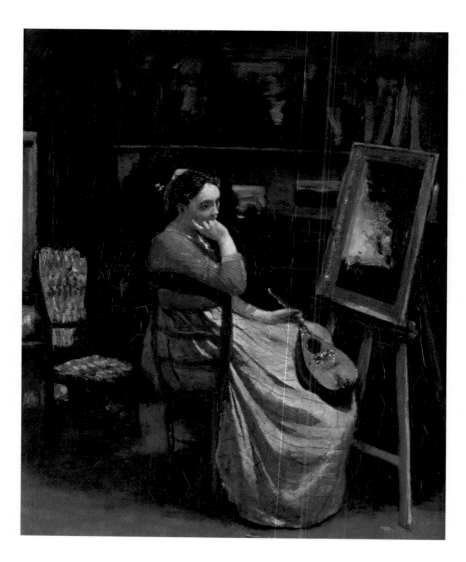

Camille Corot,
Young Woman in a Pink Dress, 1860/1865
Oil on wood, 45 x 32 cm

In contrast to the painting opposite, this work is devoid of all background scenery or any props laden with symbolism. It is also much smaller in size. It portrays the three-quarter figure of a young woman who is almost completely turned toward the observer. Her head is slightly inclined to one side, the hand of her outstretched right arm is resting on a table, and her other hand rests on her hip, the arm bent at the elbow.

The painting techniques which Corot employs here, the soft brush strokes often only hinting at something, conjure up an impression of dreamy serenity and youthful melancholy. Only the face, shoulders, and arms of the young woman are defined by light and shade. Not even the deep folds in her dress are strongly worked. The pearly gray color of the background, which is enlivened solely by the brush strokes, also seems to shimmer through into the dress, which is delicately colored with a very light application of pink.

Her musing face is accentuated by color highlights and formal touches. For instance, her décolletage is emphasized by the white lacy edge of the neckline of her dress. She is also wearing brightly-colored twists of material in her hair and a black choker with a precious stone or medallion around her neck.

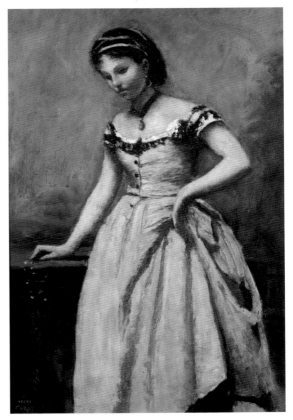

**Jean-François Millet
(1814–1875),
The Gleaners, 1857**
Oil on canvas, 83.5 x 111 cm

Millet only just managed to complete *The Gleaners* in time for the 1857 Salon. In this work, the artist paints a remarkable picture of peasant life. The women he portrays are among the poorest in society. They are gathering from the field the pitiful remnants of the crop left behind by the harvesters. Meanwhile, on the brightly lit horizon, the rich harvest is being carted away, under the eagle eye of the landowner who is watching the work on horseback from a distance.

The horizon line is high up in this picture. The three women are depicted at such close quarters that they occupy most of the foreground. Their size reflects the dignity with which they are going about their monotonous work. The women bending right over, whose positions are identical except for a variation in the angle of their left arms, form a counterbalance to the woman who is bent over her sheaf.

This oneness with the land, which is reflected in their postures, is also evident in the muted colors of their clothing. The picture's strong, dark tones are only relieved by the pink of the sky. Millet's monumentalization of peasant figures marks the entry of this genre into the Barbizon School's style of landscape painting. His picture is a powerful portrayal of the back-breaking labor associated with peasant life but it is executed in reverential tones without resorting to unvarnished realism. The mood of the picture, dominated by shades of brown and gray, is sentimental. Thanks to its monumentality, Millet's figures stand out from the landscape and do not merge into it.

The theme of human toil, whether on the land or in the city, was picked up again later in the 19th century – for instance in Daumier's *Washerwoman* (cf p. 70), Caillebotte's *The Floor Scrapers* (cf p. 202), and Degas' *Women Ironing* (cf p. 216).

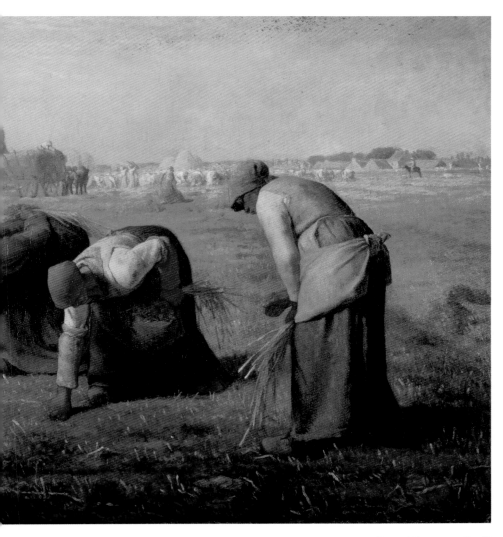

The Provinces take Paris by storm

A massive canvas caused a major outcry at the 1851 Salon: Gustave Courbet unveiled his huge painting, measuring almost 23 feet wide by nearly 10 feet high (7 m x 3 m), showing a burial attended by some 40 or so mourners. "*The Burial at Ornans* occupies an entire wall of the main Salon, imbuing a modest funeral ceremony with the dimensions of a historical scene that has been recorded in the annals of mankind," wrote Théophile Gautier, thus voicing the main criticism – namely, the perceived discrepancy between pretension and subject, between the content and the scale of its portrayal in Courbet's painting. A scene of historical significance, a decisive battle, a "classical" or religious allegory – it would have been justifiable to depict any of these on such a huge scale, but surely not the burial of a citizen of Ornans?

Courbet, however, dissociates himself from historical painting, this increasingly obsolete genre of painting. He wrote in the 1860s: "I regard the artists of a preceding century as being completely incapable of portraying things from a past… century, in other words, of painting the past…. Historical painting is a contemporary skill." Consequently, Courbet's painting can be seen as a programmatical picture, which clearly took into account the modern approach he demanded of historical painting.

The canvas depicts a burial held in 1848 at the new cemetery in Ornans, a small town near Courbet's home town of Besançon in Franche-Comté. The deceased was a distant relative of the painter, and the majority of the mourners are identifiable as friends and members of Courbet's family. The gradation in the size of the figures,

Gustave Courbet, The Burial at Ornans (with details),

which is out of perspective, is reminiscent of the Dutch 17th-century group portraits and illustrates the value Courbet places on giving a portrait-like quality to his painting. Consequently, each face has been captured by him in all its physiognomic individuality. The occasionally coarse and ugly features of some of these small-town residents was another thing which provoked the disapproval of visitors to the Paris Salon. Even more unfortunate than the realism of its portrayal was the style in which the scene was painted. Thanks to the mourners' black garb and the dirty brownish-green tone of the landscape and sky, it created an overall impression of bleakness. The painting directly communicates the bareness, desolation, and simplicity of provincial life and was regarded almost as an impertinence by the educated, artistically

849/50, Oil on canvas, 315 x 668 cm, Ground floor, room 7

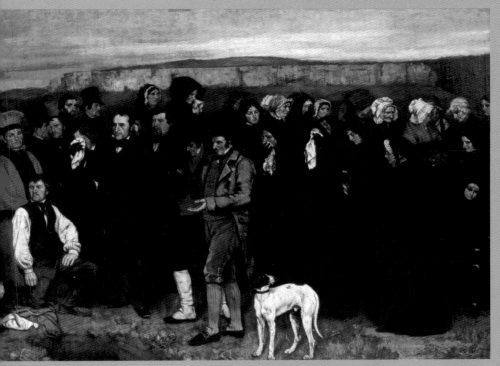

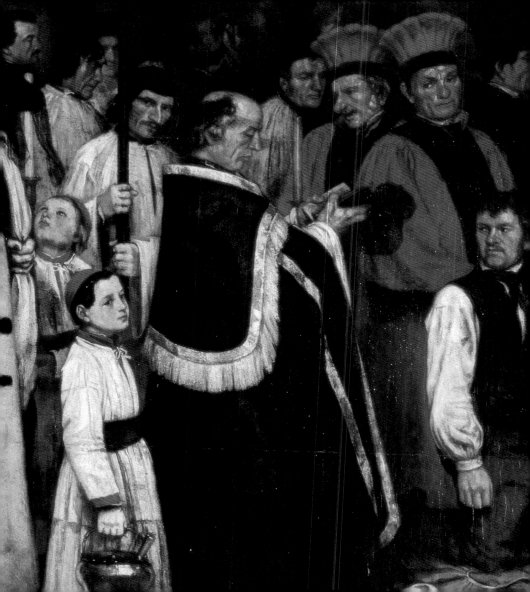

sophisticated Parisian with his refined perception of the senses. Such a painting, which so powerfully depicts the reality of provincial life, also called into question the legitimacy of Paris's pretensions as a leader of art: The Salon at least seemed to be bowled over by the ugly country bumpkins, however dirtily and unattractively depicted they might be.

Monumentalizing the banal; looking gray reality straight in the face; the individual worth of insignificant people – there are many aspects to this painting

which Courbet conceived with a specific purpose in mind. This "picture of contemporary history" has also been interpreted in various quarters as being a political allegory: Are the two men standing to the right of the open grave in the foreground and wearing Jacobin-style clothing implying that it is the Republic that is being buried here? Is the black garb of the mourners to be interpreted as a symbol of the principle of equality for all citizens as expounded by the Revolution and to which the peasant population is now also laying claim? Does this mean that it is socialist class awareness that is the actual subject of this seemingly apolitical painting? Even if we must leave the

answers to these vexed questions open to further debate by students of Courbet, it is clear that he must be viewed as a politically motivated and artistically innovative painter, whose concept of realism within art and – above all – whose paintings gave a whole new lease of life to the genre of historical painting.

MP

Gustave Courbet, The Burial at Ornans (details)

Gustave Courbet

Gustave Courbet (1819–1877), The Painter's Studio (with details), 1855
Oil on canvas, 361 x 598 cm

Gustave Courbet exhibited the studio painting along with *The Burial at Ornans* and 38 other works in 1855 in a privately erected pavilion of his own which had the word *Réalisme* emblazoned across the entrance. He had organized this exhibition next door to the Universal Exhibition building by way of protest against the official art establishment. Courbet, who gave his work the full title of *The Painter's Studio – a Real Allegory summing up Seven Years of my Artistic and Moral Life*, wrote in a letter to his writer friend, Jules Champfleury, in the autumn of 1854: "The painting is divided into two halves: I am in the center of the painting; on the right are all those who give [me] support, in other words, friends, colleagues, and art lovers; while on the left is the other world, the world of everyday life, the populace, misery, wealth, poverty, the exploiters and the exploited, the people who live on death." Thus he elevated this monumental painting of an actual painter's studio scene into an allegory of his own artistic life.

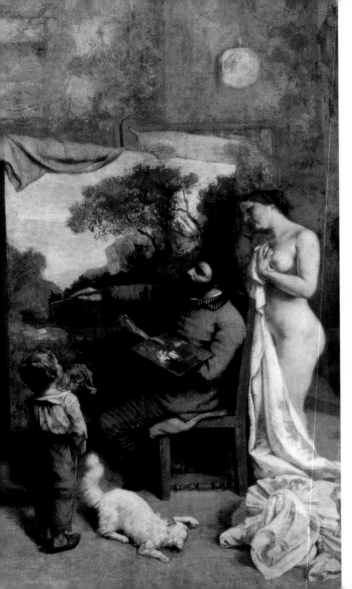

Gustave Courbet
(Details from: The Painter's Studio)

The composition of the painting conforms with the traditional structure of a medieval triptych: In the central section of a large studio, the background of which remains peculiarly indistinct, sits Courbet himself at work on a landscape. He is flanked on one side by a nude female model who is attempting to cover her nakedness with nothing more than one corner of a sheet lying in a heap on the floor, and, on the other, by a small boy and his dog. This grouping is intended as a jibe at the conservative art critics of the day – it is not, after all, these mighty experts who are deep in contemplation of the painting on the easel but a naked woman and a simple boy. What is more, it is not even a historical painting – as one might have expected of a picture this size – but a large landscape that the artist is working on.

As in *Burial at Ornans*, this is Courbet's way of

rebelling against the Academies' express guidelines on the hierarchical order of genre. He is making it quite clear that he prefers depicting nature and real life to the traditional historical style of painting.

The figures on the right of the picture – with the exception of the fashionable couple in the foreground and the two lovers in the background – are fairly easy to identify. From left to right they are the musician, Alphonse Promayet; Courbet's patron, Alfred Bruyas; the socialist and philosopher, Pierre-Joseph Proudhon; his boyhood friend, Urbain Cuénot; and Max Buchon, a nephew of Courbet. The writer, Champfleury who is portrayed seated, as is the poet Charles Baudelaire, who is engrossed in a book.

By including all these people who are important influences in his life, Courbet broadens this calculated self-portrait of himself at the easel into a portrayal of friendship. The figures on the left appear at first to be anonymous representatives of society: The huntsman, front left, represents a privileged social class; the crouching woman with a baby at her breast symbolizes the wretchedness of the proletariat. Commerce and bourgeoisie appear to come face to face in the center of the picture, while on the left we see representatives of two religions, a Catholic priest and a Jew. Rural peasant life is personified by a reaper and two hunters, urban life by a laborer. These figures could, however, just as easily be public figures: The hunter, for example, bears a strong resemblance to Napoléon III. Gustave Courbet's large painting remains one of the greatest puzzles of the 19th century.

CS

**Gustave Courbet,
The Stormy Sea (The Wave), 1869/70**
Oil on canvas, 117 x 160.5 cm

Courbet exhibited this landscape at the 1870 Salon at the same time as *The Cliffs at Etretat*. The two canvases of roughly the same size had been painted in Normandy the previous summer and depict two of nature's spectacles: a storm, and the calm that follows once it has subsided.

The Stormy Sea shows a narrow, wedge-shaped stretch of shore, on which two boats are beached. The water element dominates the sea; the colors are thickly applied with a knife, imbuing the foam, for example, with an almost tangible reality. Paint is no longer merely a means of depicting an object, but virtually becomes it. The wave comes to life in the paint. The upper half of the picture is taken up by the dramatic, turbulent sky.

The clouds are arranged in two sections using traditional painting techniques. A thin application of color forms areas of light and shade, creating the illusion of three-dimensionality.

**Gustave Courbet,
The Cliffs of Etretat after the Storm, 1869/70**
Oil on canvas, 133 x 162 cm

In *The Cliffs at Etretat*, the water and land are differently proportioned. The sea has retreated and the land occupies a greater portion of the picture. This time, Courbet's subject is the famous landmark of Etretat, the so-called Porte d'Aval, which also inspired Claude Monet, who was a frequent visitor to the Normandy coast in the 1860s.

The fishing boats are safely moored on the beach. The sailboat on the horizon, which was also visible out at sea in The Stormy Sea, has apparently survived the storm. The sky, like the sea, is calm again. The banks of cloud have dispersed and blue sky is breaking through again. Sunlight is falling on the beach, bringing with it the sun's warmth. On the shore, the washerwomen are resuming their work.

The picture is dominated from left to right by the immense solidity of the

cliffs. Gustave Courbet's characteristic treatment of the cliffs is derived from impressions gained during his youth and childhood. The karst landscape of his native Jura was very often the inspiration for his paintings.

In contrast to the paintings of Claude Monet's in the 1880s, which reduce the recognizable monumental cliffs into reflections of colored light, Courbet is always successful in bringing alive the elements of nature, the bizarrely shaped cliffs, the sea, and the sky in a very realistic manner.

In the eye of the beholder

Since 1995, the Musée d'Orsay has had in its possession a painting by Gustave Courbet (1819–1877), which, despite its relatively small size, has disturbed, attracted, and captivated the observer. What is surprising, perhaps even shocking, is the highly charged effect produced

Halil Serif, first owner of The Origin of the World by Courbet

by combining a maximum exposure of an extremely intimate region with the complete anonymity of a faceless torso.

Painted in 1866, reputedly for Halil Serif, a Turkish diplomat living in Paris, the picture existed for almost 130 years unseen, virtually hidden away and reserved solely for the eyes of its owner. Halil Serif, who eventually rose to become his country's foreign minister, and later minister of justice, was living in Paris at that time as a private citizen, fostering contacts with liberal political and cultural circles and presiding over a luxurious salon. The gossip columnists of his day described him as "a prince out of an Oriental fairy tale…, whose extravagant generosity, admiration of women, and passion for gambling reflect his Turkish origins, but whose intellect, intelligence, love of the theater and the arts are quickly turning him into a true Parisian." Halil Serif's response to the underlying racism implied in these words was to acquire an art collection which, rather piquantly, included a large number of Oriental paintings. The most famous of the 100 or so works, which Serif very quickly accumulated, was Ingres' *Turkish Bath* (1862), which portrays, through a key-hole perspective, a Westerner's notion of Oriental eroticism in circular format. From Gustave Courbet's extensive assortment of erotic nudes, Serif acquired not only the large canvas entitled *The Sleep* (1866), but also this small intimate study. He never exhibited it in

Gustave Courbet, The Origin of the World, 1866, Oil on canvas, 46 x 55 cm, Ground floor, room 7

public and it was not until Serif's treasures were auctioned following his bankruptcy in 1868 that it came to light. After this, the trail of *The Origin of the World* was lost for a time until it was sold in 1913 via the famous Bernheim-Jeune Gallery to the Hungarian painter, Baron Ferencz Hatvany, in Budapest. In the meantime, the offending picture had long since been concealed from

public view behind an inoffensive landscape, also by Courbet, entitled *The Castle of Blonay* (1874–1877). The outer panel had to be unlocked and removed before yielding up its secret to its lawful owner.

After the upheavals of the Second World War, when the painting apparently fell first into the hands of the German Wehrmacht and was later

Jean Auguste Dominique Ingres, The Turkish Bath, 1862, Oil on canvas, d. 108 cm, Musée du Louvre, Paris

seized by the Red Army, Hatvany finally managed to track it down and return it to Paris in 1947. He sold it eight years later for one and a half million francs to Jacques Lacan, a well-known French writer and psychoanalyst who immediately had it concealed again. This time it was hidden behind a calligraphic-style painting by the Surrealist, André Masson. This revealed a rough outline of the actual subject which would only have been recognizable to someone

who knew the painting. Lacan, following in the footsteps of Sigmund Freud, analyzed the meaning of paintings and studied the categories of the imaginary and the symbolic through his contact with the Surrealists. He, too, kept the picture under lock and key at his country house. For many years, not even an illustration of the painting existed, nor was it shown at the exhibition of Courbet's life's work in 1977 – doubts even began to circulate about its existence. It was not until Lacan's heirs sold it to the French government to pay off inheritance taxes that it joined the collection at the Musée d'Orsay where there was no further need for it to be handled so discreetly. It suggests the observer, in his perusal of the picture, symbolically taking possession of the female body, an approach that remained typical of the late 19th and the 20th century. Modern medicine, the development of photography and, not least, the psychoanalysis of sexual complexes all combined to make the hidden sex an object of study, thus exposing it and turning it into common property. The dramatic detail of Courbet's painting alludes to the parting of the (female) body and the penetration of its innermost regions. The anatomical directness of this picture and the way this intimate region is exposed to public view are an unfailing source of interest to the viewer and ensure that the painting remains at the center of controversial debate. It gives rise to innumerable questions about the boundaries of liberality, the purpose of art, and the tyranny of the intimate, which are testimony to the continuing importance of this painting to the development of art in western civilization.

MP

André Masson, Outer panel for The Origin of the World, 1955, Oil on wood, 46 x 55 cm, Private collection, Paris

Naked Woman with Dog, 1861/1862
Oil on canvas, 65 x 81 cm

It is the brazenness of Courbet's painting that people find most fascinating. It depicts a voluptuous naked woman, who is playing in an unmistakable manner with a little dog and is just on the point of kissing it on the mouth.

At second glance, the scene appears to be a parody. On the one hand, it is reminiscent of the historical paintings depicting mythological encounters between beautiful mortals and Zeus in animal form: Leda and the swan, Europa and the bull, Ganymede and the eagle, etc. On the other hand, Courbet is also following a typical French traditional style of painting, the popular Rococo subject of a girl engaged in play with a dog. Any association with this epoch, however, was to be avoided at all costs. It almost seems as if Courbet was trying to test just how far he could go with his artistic realism. His model's hair is dishevelled and she is on the plump side, rather than conforming with the accepted image of ideal beauty. The whole effect is heightened by the girl's curling of her big toe and the grubbiness of the sole of her left foot, which is presented to the viewer.

The immaculate nudes of Salon painting, the countless Venus paintings, in which two elderly women(!) are seen making fun of in one of Daumier's caricatures, are skillfully transformed by Courbet into a painting of earthly sensuality. His revamping of stultified concepts, however, provoked a spate of malicious comments and countless caricatures. His figures were reviled as being particularly grubby and coarse representatives of the peasant class. Courbet was one of the most caricatured and therefore best-known artists of his time and he was to have a lasting influence on French art.

Puvis de Chavannes and Moreau

**Pierre Puvis de Chavannes
(1824–1898),
The Poor Fisherman, 1881**
Oil on canvas, 155 x 192.5 cm

The Poor Fisherman is the most renowned of all of Puvis' paintings. The fisherman's hair and posture, and, above all, the way his hands are clasped together as he stands in the bow of his boat cannot help but recall the *Ecce Homo* genre of paintings. Like Jesus Christ with his crown of thorns, whom Pilate held up as an example to the people, the fisherman appears to be a fellow sufferer. His two children seem to blend in with their barren surroundings; while the older girl is picking flowers, the younger child is lying back asleep. They seem oblivious to the cares of their father in the foreground who is desperate for a catch.

All three figures are painted in flat colors with clear contours. Their bodies seem almost frozen in position so as not to disturb the stillness enveloping their melancholy world. Significantly, the fisherman and his family cast no shadows – in contrast to the boat, which, thanks to its reflection, can be seen twofold. The background is decoratively executed, and the sweeping expanse of water gives a feel of monumentality to the picture. The painting's colors are predominantly pale, light tones. Puvis, the Symbolist, derived his inspiration for the subdued colors in his paintings from the fresco painting of early Italian Renaissance, which he discovered during his travels.

Symbolism, which appeared in French art and literature in the 1880s, was a protest against Realism and Impressionism. The artists were at pains to express their thoughts by means of symbolic pictures, frequently accompanied by mythical or religious, as well as decadent or erotic, overtones.

Gustave Moreau (1826–1898),
Orpheus (with detail), 1865
Oil on wood, 154 x 99.5 cm

In addition to painters like Manet, Courbet, and Degas, whose works depicted modern life, there were other 19th-century painters who continued to find inspiration in the Bible or mythology. Among these was Gustave Moreau, a passionate collector of rarities, who was known mainly for his opulent historical paintings. In his tranquil, contemplative portrayal of the Orpheus theme, produced in 1865, however, this predilection is only apparent in the Oriental style of the young woman's dress, which is encrusted with rosettes, palmettes, and pearls. The two tortoises in the front right-hand corner of the

painting are possibly an allusion to the mythical origins of Orpheus' lyre, which is supposed to have been fashioned from a tortoise shell. In the catalogue for the 1866 Salon, the theme of the painting, which may not have been immediately clear to the observer, is described by Moreau himself as follows: "A young girl is reverently holding up Orpheus' head and lyre which have been washed up onto the shores of Thrace by the waters of the Hebrus." In other words, Moreau is portraying the tragic end of the Orpheus myth, setting it in a morbid landscape amid fantastical rock formations. According to this myth, which provided the inspiration for many other paintings from Bellini to Corinthia, Orpheus, the famous singer, was able to bewitch the very trees, rocks, and wild animals themselves with the power of his singing. When his young wife, Euridyce, dies after being bitten by a venomous snake, Orpheus persuades Hades to let him bring her back from the Underworld; however, when he turns around to look at her, after being expressly forbidden to do so, she is lost to him forever. Furthermore, Orpheus meets his own death by refusing to pay homage to Dionysus, whereupon he is torn to pieces by maenads, the female followers of the god.

CS

Early Degas

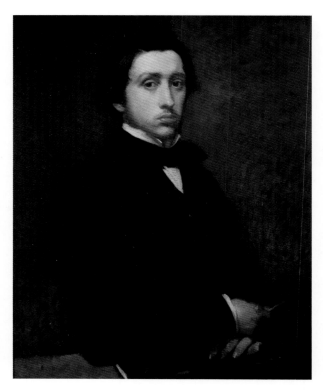

Edgar Degas (1834–1917), Self-portrait, ca. 1855
Oil on paper, 81 x 64.5 cm

His *Self-portrait* shows the 21-year-old painter as a reserved and even aloof observer. An overall sense of restraint permeates the painting. The colors are sombre and the figure is barely distinguishable from the dark background. Not a single detail of his conventional costume gives anything away, and even the resting hands are devoid of any meaningful gesture. Only the drawing crayon and portfolio of drawings make any reference to the young man's interest in art.

This painting has frequently been likened to an early self-portrait by Ingres, aged 24, whom Degas greatly admired. It is this fact, perhaps, that throws light on Degas' intentions: This up-and-coming young artist was hoping to follow in the footsteps of his role model. Not long afterwards, however, Degas was to distance himself from the norms of the Academy which Ingres so vehemently upheld, later allying himself to the Impressionist movement from its very beginning.

Degas, as a young man, was very ambitious in some of his early works, tackling both portraiture and even historical painting.

Edgar Degas,
At the Races, in Front of the Stands, ca. 1869
Oil on paper, 46 x 61 cm

Many of Degas' drawings and studies of movement after 1860 are inspired by race-course scenes. His paintings of horse races – a favorite pursuit of the Paris bourgeoisie – reflect how much he was influenced by the works of famous painters such as Théodore Géricault (1791–1824) and Ernest Meissonier. He was similarly influenced by Japanese woodblock prints. The asymmetry of this composition – with a single rider to the left and a group of riders to the right – derives from Oriental art. A further source of inspiration was photography, of which Degas made much use in his art, in particular the series of photographic studies by Eadweard Muybridge (1830-1904) showing animals in successive stages of motion.

Edgar Degas,
The Bellelli Family, 1858/1860
Oil on canvas, 200 x 250 cm

In 1858, during a visit to Florence, Degas decided to paint a group portrait of his aunt's family. He devoted a great deal of time and effort to this large painting with which he hoped to impress the Salon. When it was exhibited in 1867, however, it did not meet with the hoped-for acclaim. Despite this, the work occupies a key position among Degas' early works on account of its psychological insight. The individual figures recall portraits by Holbein or Van Dyck. Its position in the Musée d'Orsay collection, just off the central aisle, reflects its importance in relation to Degas' output as a whole.

The stance and characterization of the figures reflect the family's circumstances. After the 1848 uprising, Gennaro Bellelli was forced to leave Naples with his family and go into exile, eventually ending up in Florence. Unable to work and facing financial worries, the publicist became increasingly gloomy and withdrawn, which alienated him from his wife and family. While the mother's arm is placed protectively around the shoulder of one of her daughters, her sister is seated on a chair between her parents – uneasy and defiantly trying to escape from the evident tension of the situation.

While the group around Laura, the mother, is painted in the traditionally formal manner of portraiture, the portrayal of Gennaro in his casual pose represents an abrupt break with this classical tradition. Is he looking on disapprovingly as his family models for the painter? The classical stance of the figures on the left contrasts with the realistic situation depicted on the right.

It may possibly have been a lithograph by the celebrated caricaturist Honoré Daumier in 1837 that provided Degas with his inspiration for this work. The armchair is a dominant feature in both works, as is the telling gap between the husband and wife. If so, then Degas, who was an admirer of Daumier, has managed to elevate an ephemeral newspaper caricature into an ambitious painting. Degas continued to draw inspiration for some of his later works from prints, especially Japanese woodblock printing.

Early Manet

Edouard Manet (1832–1883),
Lola de Valence, 1862
Oil on canvas, 123 x 92 cm

Edouard Manet was without doubt one of the most ambivalent artists working in the 19th century. Despite his strong links with the Impressionists, he did not take part in any of their exhibitions. Manet craved official recognition in the Salon and thus remained committed to the institutional opportunities it offered.

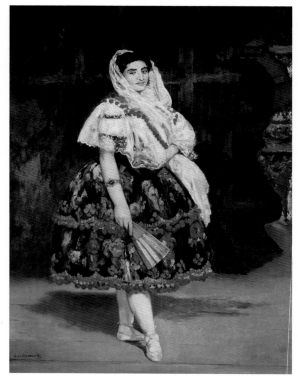

Lola de Valence was a dancer in the Flor de Sevilla dance company, which performed in Paris in 1862. Manet's painting of the dancer demonstrates his interest in the craze for all things Spanish which had gripped Paris at that time. (A few years prior to this, for example, the famous Galerie espagnole had been instituted in the Louvre under Louis-Philippe.)

The red and green flowers and tassels on Lola de Valence's heavy dancer's dress provide a sumptuous contrast with its black background. Draped over her head and shoulders is a white, lacy shawl. Lola de Valence is half-turning to face the observer. The balletic position of the dancer's feet and arms reflect this movement. The stage flats behind her were painted later over what had originally been a neutral background.

Edouard Manet,
Emile Zola, 1868
Oil on canvas, 146 x 114 cm

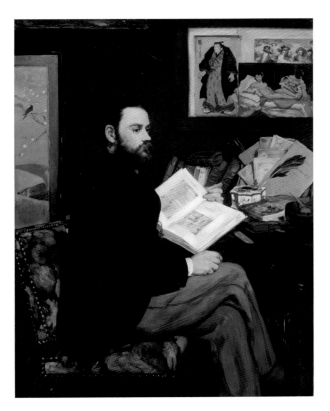

Manet's portrait of Zola is a tour de force, more "a kind of still life than the expression of a human being," as the artist Odilon Redon observed.

Zola is sitting at his desk with an open book in front of him. The quill pen directs our attention to his pamphlet on Manet; the title on the book is also the artist's signature. On the wall above the desk is a lithograph by Nanteuil after Velázquez's *Drinkers*. These objects, which supposedly reflect Zola's interests, are actually an indication of Manet's great admiration for the Spanish painter. The Japanese print on the left by Utagawa Kuniyaki II shows *The Wrestler Onaruto Nadaemon of Awa Province*. Like the screen on the far left of the picture, it illustrates the impact that Japanese art was having on modern Western artists of that time. Within this structure of vertical, horizontal, and diagonal lines, Manet creates a scene that symbolizes not only the interests of Zola, the poet and art critic, but also those of the painter himself. The lack of a traditional sense of perspective is a less obvious reference to the art of the East.

In defence of modernism – Emile Zola, art critic

"A work of art is a piece of nature, seen through a powerful temperament" – this was the simple formula which encapsulated Zola's concept of art, fashioned primarily through his personal contacts with the Impressionists as well as his own literary work. Emile Zola (1840–1902), one of France's most important 19th-century writers, was first introduced to modern painting by his old schoolfriend Paul Cézanne, who took him to the Salon des Refusés in 1863. As well as admir-

Emile Zola, around 1902

ing works by Pissarro, Jongkind, Whistler, and Cézanne himself, which were on display there, Zola was most impressed by Edouard Manet and his now famous painting entitled *Le Déjeuner sur l'Herbe* (1863). Soon afterwards, he visited the studios of Camille Pissarro and other artists of this circle and, in the course of many discussions, gained a strong insight into contemporary art theory. Furthermore, he learned at first hand of the difficulties these artists faced in making a living and getting their works accepted in the art world. From that time on, he lent his support, both as an art critic and sometimes even as a patron, to the Impressionists. In January 1866, after the failure of his latest novel, he accepted a job as literary critic for the *L'Evénement* (The Event) newspaper and asked to be entrusted with the job of reporting on that year's Salon.

In the 19th century, art criticism became increasingly important as a means of communication between artists and the public. In view of the excessive number of art works applying for acceptance in the Salons and the social significance of these exhibitions, it satisfied the visitors' need for information and guidance. Nearly all French newspapers and magazines, even the popular press geared to a mass public, published reviews of the exhibitions, usually in the form of a series. These were obviously of decisive importance to the artists on account of the wide readership involved. A negative review

could be devastating, whereas a euphoric one could mean a major breakthrough. Consequently, a public forum began to develop where the rivalries between the conservative supporters of traditional Academy art and the committed defenders of the modern avant-garde could be battled out.

Zola made his position quite clear in this debate even before the doors of the 1866 Salon had opened. His first two articles were a direct attack on the Jury and its methods. Zola criticized the way the Academy protected its own members, the preferential treatment given to its colleagues and their pupils and the selection of works within the narrow constraints of academic art. Concluding his pre-Salon article, Zola called for a new Salon des Refusés, which would enable the public "to judge the judges as well as the judged in a like manner." Afterwards, he visited Manet in his studio, viewed the painting that the jury had rejected and devoted an entire article to him, even though he was not represented at all at the Salon. He concluded with the provocative prediction: "Manet is destined for a place in the Louvre, just like Courbet and any other artist who possesses an original and strong temperament." Soon afterwards, *L'Evénement* found itself in dire straits, receiving mountains of

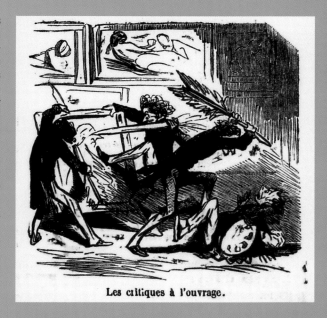

Les critiques à l'ouvrage.

The caricature by Cham from the satirical magazine Le Charivari of July 3, 1853, shows the critics at work

protest letters and letters from people canceling their subscriptions. The consequences were obvious: financial considerations forced the paper to terminate Zola's contract. Only two of his articles were published, discussing the Realists surrounding Courbet, the Barbizon school, and, particularly, Pissarro. These expressed his view that in future it would no longer be the subject of a painting, its informative, or moralizing content, that would be significant, but the individual way that a painter viewed the world around him and how he cap-

tured this insight in his painting. In so saying, Zola was expressing one of the key concepts of Impressionist art.

Surprisingly, none of his articles ever mentions his long-standing friend, Paul Cézanne, with whom he had an increasingly difficult relationship. While Zola was enjoying his greatest success as a writer in the 1870s and was able to buy a small property in Médan on the banks of the Seine, which he furnished almost like a museum with valuable works of art, Cézanne continued to live in dire financial straits, with the additional encumbrance and responsibility of a wife and child. It was not just these differences in their social station that led to a rift but, more importantly, Zola's disappointment in his

Émile Zola at his desk in his study in the rue des Bruxelles, Paris, ca. 1895

friend's artistic development. His long years of failure and the hostility that Cézanne had encountered undermined Zola's belief in his creative ability. In the end, he deposited the numerous paintings given him by his friend in a storeroom in his house, believing that he should hide these works from the eyes of the critics. Zola was still convinced that Cézanne was a genius, but that so far he had not managed to produce a work of genius. All this culminated in his novel *L'Oeuvre*, published in 1886, in which the main character is an artist who, torn between his ambitious dreams and realization of the inadequacies of his artistic work, commits suicide. Cézanne recognized himself in this character, as did many other artists of the Impressionist circle. It was this condemnation of their work, this condescending sympathy on the part of a former comrade, who had meanwhile surrounded himself with the comforts of bourgeois life, that this group of painters found so hurtful and that led to a complete rift. In 1898, when Zola spoke out publicly in support of Captain Dreyfus, who had been sentenced to lifelong deportation to Devil's Island for alleged treason, and demanded a retrial, he incurred massive criticism on the part of militarists and anti-Semites. Only very few of his artist friends remained who were prepared to support him throughout this difficult situation.

MP

Zola's trial in February 1898 for criticizing French military justice provoked a scandal

Edouard Manet,
The Fife-Player, 1866
Oil on canvas, 161 x 97 cm

This painting shows the figure of a young fife-player of the Imperial Guard depicted against an almost monochrome background. He stands out in sharp distinction against the grey background thanks to his uniform: Black shoes with white spats, red trousers with black stripes down the sides of the legs, the black jacket with its gold buttons, and the white sash and the cap. There is the merest suggestion of shadows around the boy's feet, giving a hint of three-dimensionality.

The painting was denounced by the art critics, who criticized its sharp contrasts and likened it to a playing card. Emile Zola, however, saw it in a completely different light. He wrote enthusiastically: "I don't believe it is possible to achieve such a dramatic effect by any simpler means."

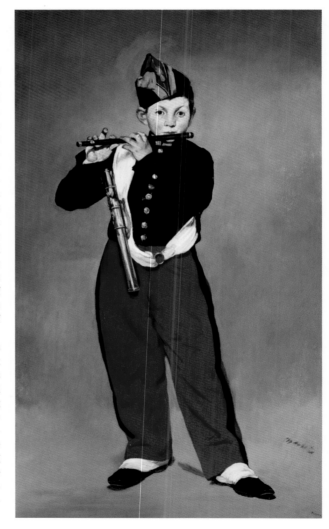

Edouard Manet, Still Life of Peonies and Shears, 1864
Oil on canvas, 31 x 46.5 cm

This small study is charming proof of Manet's expert skill in painting still lifes. Although the two full blooms of the Chinese peony are the focus of attention, they are not positioned at the exact center of the picture. Similarly, lying next to the flowers are the shears, which are cut off by the left-hand edge of the picture frame, thus helping to decentralize the composition even further and making it appear as if the frame of the picture has been chosen by the artist at random.

Set against the dark background, the blooms, painted in broad, strong brush strokes in a range of muted and tinted whites, stand out in all their splendor. Only the top edge of the table, on which the blooms are lying, is visible on the right-hand side. Behind it is the "absolute black," as Paul Valéry called it, of which Manet was extremely fond. Providing a stark background contrast, it serves to emphasize the delicate beauty of the peonies, so characteristic of Manet's still lifes.

A classical goddess and her modern sister

Alexandre Cabanel, The Birth of Venus, 1863, Oil on canvas, 130 x 225 cm, Ground floor, room 3

Edouard Manet's *Olympia* created a storm in Parisian art circles when it was exhibited at the 1865 Salon – as had *Le Déjeuner sur l'Herbe* two years previously. In order to understand what so enraged the public, it has to be compared with Alexandre Cabanel's *Birth of Venus*. While Cabanel's painting epitomizes the official taste in art during the Second Empire – significantly, it was no lesser person than Napoléon III who purchased this much acclaimed picture from the 1863 Salon – Manet broke with convention

altogether, producing a work which gave fresh impetus to contemporary painting.

The subject of both paintings is Venus at rest, a theme that has been repeated many times since the Renaissance. Cabanel was inspired by Raphael's *Triumph of Galatea* (ca. 1512); Manet, on the other hand, based his work on Titian's *Venus of Urbino* (1538), which he had copied in 1853 during a visit to Italy, and on Goya's *Naked Maya* (ca. 1800). Although both artists were influenced by famous Old Masters,

their portrayals of female nudes were nevertheless very different. Cabanel's newborn Venus, depicted in shades of pale pink and blue, is lying stretched out on the rolling waves of the sea. This goddess, portrayed with sanitized eroticism, was the epitome of idealized naked female beauty at that time. It was no surprise, therefore, that Manet's self-confident *Olympia* provoked a public outcry. For the young woman, who is staring unwaveringly at the spectator, is not a goddess of love, but a courtesan, who has not yet made up her mind whether or not to receive her client, whose arrival is heralded by the impressive gift of flowers brought in by her black maid. Furthermore, the painting is flooded with a strong frontal light, which made it seem even more offensive to onlookers of the time. Manet's *Olympia* threw down the gauntlet to hypocritical Parisian society, which accepted the portrayal of a naked woman as long as it was wrapped in a mantle of mythology but was not disposed to see reality portrayed in painting.

CS

Edouard Manet, Olympia, 1863, Oil on canvas, 130.5 x 190 cm, Ground floor, room 14

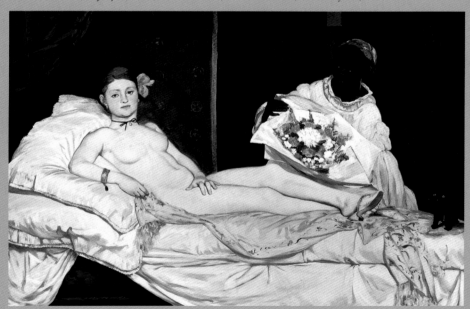

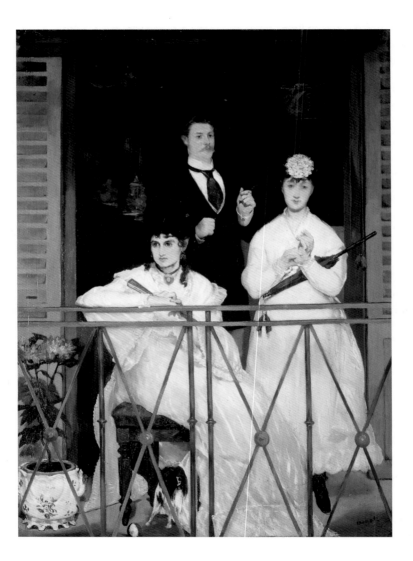

Edouard Manet, The Balcony (with detail), 1868/69

Oil on canvas, 170 x 124.5 cm

The woman seated in the foreground of the painting is Berthe Morisot, standing next to her are Fanny Claus, a friend of the Manets, and the landscape artist Antoine Guillemet. The child to be seen in the background, carrying a coffee service, is the shadowy form of Léon Léonhoff. It is in *The Balcony* that Berthe Morisot, who was a pupil of Manet and who later became his sister-in-law, appears for the first time in his paintings.

The group portrait is an illustrative example of Manet's art. It demonstrates both the influence of older art on his work – it echoes the theme of Goya's painting *The Majas on a Balcony* (1806–1810), for example – and at the same time, the modernity of his painting. The detachment of the figures from one another and their lack of communication are the first indications that this is Manet's depiction of modern life. Each of the figures is facing as well as looking in a different direction. Even their hands are held close to their bodies, if not actually clasped together as in the case of the women in the foreground. The sharp lines of the balcony and the aggressive ironwork further emphasize the indifference of

these figures to one another. The sense of self-absorption is so strong that it inspired the Surrealist painter René Magritte (1950) to create a paraphrase of it, depicting a collection of coffins, rather than people, on a balcony.

The second indication that the painting represents modern life is the expression on their faces, typical of many of Edouard Manet's figures. Paul Valéry, the poet, described it as "the presence of absence." Dark, open eyes, with only an occasional highlight, stare into empty space with a fixity of expression that is devoid of any visible emotion. This same expression can be seen, once one knows to look for it, in many of Manet's other paintings – for example in *Olympia*, the portrait of *Emile Zola,* and *The Fife-Player*.

Bazille and early Renoir

Frédéric Bazille (1841–1870),
The Pink Dress, 1864
Oil on canvas, 147 x 110 cm

The picture was painted at Méric, the old family estate near Montpellier. The artist spent his summers here in the company of his relatives after spending most of the winter months in Paris.

Thérèse des Hours, a cousin of the painter, is seated on a low wall, gazing out over the village of Castelnau-le-Lez bathed in evening sunshine. The painting can be dated from a letter written by Bazille's father on December 16, 1864. It is Bazille's first attempt at painting a figure in an outdoor setting. Since the figure is portrayed from behind, the view of the landscape assumes an equal importance with the painting's foreground. The composition and his precise balance of color are designed to make the spectator's glance flit back and forth between the figure and the landscape, so that the proximity of the figure and the distance of the village beyond complement one another. Combining the two depths of vision in this way was a new departure in contemporary painting at a time when the Academy's rigid approach to distinguishing between historical painting, portraiture, genre, landscape, and still-life was beginning to lose its hold.

CS

Frédéric Bazille,
The Family Reunion, 1867
Oil on canvas, 152 x 230 cm

Like his friend Monet, Frédéric Bazille devoted a great deal of his time during the 1860s to painting figures in outdoor surroundings. Painters were constantly calling on their friends and relatives to act as models. Bazille's group portrait in 1867 depicts eleven members of his family on the terrace of the house in Méric, assembled in the shade of a spreading chestnut tree. From left to right are Frédéric Bazille himself, his uncle Eugène des Hours, his parents, and his cousin Pauline with her husband Emile Teulon. Seated in front of them are Madame des Hours and her daughter Thérèse, whom he painted three years earlier in *The Pink Dress*. On the right of the picture are Marc Bazille, Frédéric's brother and his wife Suzanne, together with their cousin Camille des Hours. Exhibited in the 1868 Salon under the title *Family X…*, *The Family Reunion* marked Bazille as one of the pioneers of Impressionism. He was killed in action during the Franco-Prussian war.

CS

Renoir and Bazille met in November 1862 in the studio of Charles Gleyre, where they attended drawing classes along with Claude Monet and Alfred Sisley. The four pupils quickly became friends and left Gleyre in the spring of 1863 in order to devote themselves entirely to open-air painting.

Bazille worked first with Monet in Chailly on the outskirts of the Forest of Fontainebleau. In 1865, the friends shared a studio in Paris and, once again, spent the summer in Chailly.

Monet's work on *Le Déjeuner sur l'Herbe* was interrupted when he injured his leg in an accident and was confined to bed. Bazille painted him in this condition. The picture, entitled *The Improvised Ambulance*,

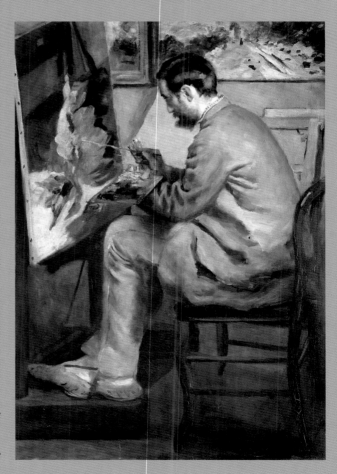

Auguste Renoir, Frédéric Bazille at his Easel, 1867, Oil on canvas, 105 x 75.5 cm, Ground floor, room 18

today hangs in room 18 on the ground floor of the Musée d'Orsay.

The next summer, Bazille moved into a studio in the rue Visconti in Paris that he now shared with Auguste Renoir. Toward the end of 1867, Bazille painted his friend in a nonchalant attitude with his feet up on the seat of his chair, looking over to the left with a serious, penetrating gaze. The painting, which was executed in rapidly applied brush strokes, remained in Renoir's possession for the rest of his life.

Renoir reciprocated by painting a picture of his friend in their studio: Bazille is at his easel, leaning forward slightly with his feet crossed, working on a still life of dead birds. On the wall behind him is a winter landscape by Claude Monet with a view of Honfleur. The predominant colors in the picture are gray and beige, and the only flash of color is the red stripe on Bazille's shoe.

Within a few years, Renoir was to abandon these subdued, pale tones and his colors would become more vivid.

Despite their differences, one important factor links these paintings by young avant-garde painters: They depict what appears to be a random moment in everyday life and avoid any semblance of a posed composition. This spontaneous representation of reality, rather than a more naturalistic approach to subject matter, became one of the basic artistic principles of Impressionism.

CS

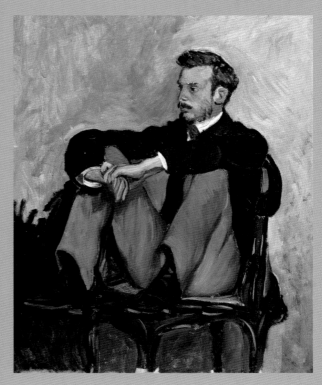

Frédéric Bazille, Portrait of Auguste Renoir, 1867
Oil on canvas, 122 x 107 cm, Ground floor, room 18

Auguste Renoir (1841–1919),
Barges on the Seine, 1869
Oil on canvas, 47 x 64 cm

Although Auguste Renoir's artistic career revolved primarily around painting human figures, every now and again he turned his attention to landscapes. The painting *Barges on the Seine* (1869) looks down from an elevated position on the left bank of the Seine onto a wide bend of the river where a line of barges, appearing to move very slowly, stretches off into the distance. This picture is one of Renoir's first landscapes painted in the Impressionist style. His characteristic use of muted blue, green, and gray tones can be seen especially in the clouds where they are applied with superb skill in thick pastose splashes. Only the long line of black barges stands out in contrast. It is no coincidence that Renoir incorporated them into his Seine landscape as an allusion to technology's encroachment on nature and urban life, since this was a theme much favored by the Impressionists. Urged on by his painter friends Monet, Sisley, and Bazille, Renoir increasingly turned his attention to painting in the open-air from 1863 onwards.

During the years that followed, the painters often worked together on the same subject in the Forest of Fontainebleau or along the Seine. The aim of their studies amid nature was to fix sense impressions onto canvas. Renoir's *Barges on the Seine*, for example, was painted on a summer day with sunshine, clouds, and wind; this type of weather meant that the light conditions could change from one moment to another. Consequently, the artist had to paint using small, rapid brush strokes. This method of painting, characteristic of the newly emerging style of Impressionism, no longer raises any eyebrows but it must have seemed revolutionary to the public of that period.

CS

Early Monet

The Cart, Road under Snow, Honfleur, ca. 1867
Oil on canvas, 65 x 92.5 cm

Monet's fascination with impressions gleaned from nature is the hallmark of his art. He was influenced by the forces of nature: The variations in light – in his painting of *The Cart*, it is still illuminating the horizon while growing steadily weaker along the road – and the changes in the seasons and times of day. The scene shown in the painting is a winter landscape, a less than spectacular window on nature in a season when atmospheric conditions are especially fleeting and fragile, and when even the tiniest variations in the light can alter the scene significantly from one moment to another. It was precisely this transience of atmosphere that fascinated Monet and the other Impressionist painters and that they sought to capture in their canvases.

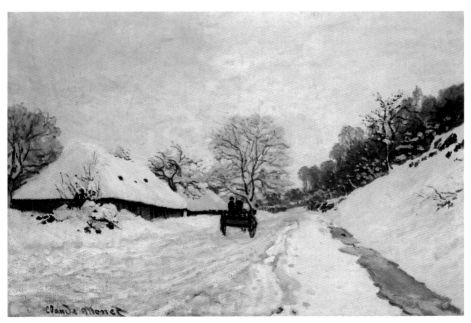

A summer picnic

The early works of Monet, who more than anyone is the quintessential Impressionist, seem, surprisingly, to have focused on paintings of the human figure, the most important of these being the immense composition entitled *Le Déjeuner sur l'Herbe*, one of the most important unfinished works in art history.

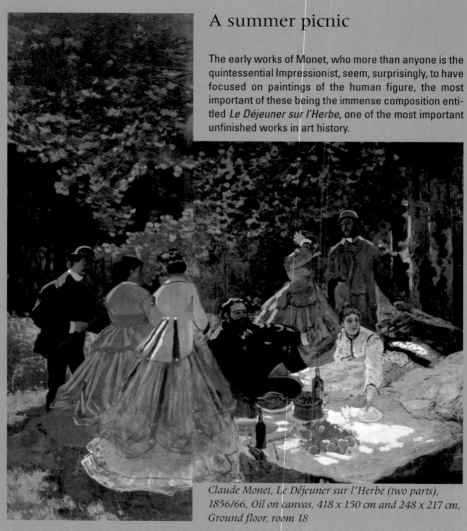

Claude Monet, Le Déjeuner sur l'Herbe (two parts), 1856/66, Oil on canvas, 418 x 150 cm and 248 x 217 cm, Ground floor, room 18

Encouraged by some success in the 1865 Salon and spurred on by Manet's *Le Déjeuner sur l'Herbe* (cf p. 180), which had appeared two years earlier, Monet began work on a huge canvas measuring approximately 15 ft by 20 ft (4.5 m x 6 m). He worked on it in his studio with the aid of individual studies which had been done in the open. In 1866, he abandoned this ambitious work and left the painting unfinished. The monumental group portrait would not have been completed in time for the opening of the Salon.

Having been forced to leave the canvas with a creditor as security, he was not able to redeem it until 1884. In the meantime, the painting had unfortunately been damaged. Consequently, Monet cut the composition up into three sections; only the left-hand and middle sections have been preserved. A study carried out in September 1865, which is currently housed in the Pushkin Museum, Moscow, gives an impression of the full-scale painting which contained no fewer than 12 life-size figures.

Claude Monet, Le Déjeuner sur l'Herbe (Study), 1865, Oil on canvas, 130 x 181 cm, Pushkin Museum, Moscow

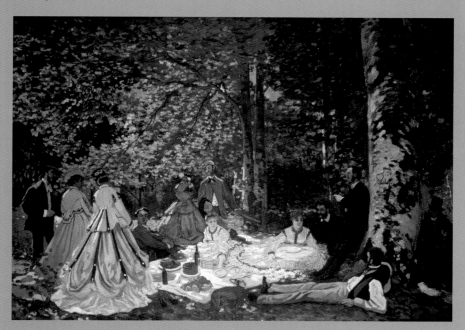

It probably belongs to the Lecadre family, for it was their garden which served Monet as the background for a portrait of Jeanne-Marguerite Lecadre, which was also completed in 1866 and is now housed in the Hermitage Museum in St. Petersburg.

CS

Claude Monet,
Women in the Garden, 1866/67
Oil on canvas, 255 x 205 cm

All three of the female figures in the left half of the painting are modeled on Camille Don-cieux, who would later become Monet's wife. When this large canvas was rejected by the Salon, Monet exhibited it in 1867 at the Salon des Refusés. It had been rejected on the grounds of its mundane subject matter and its style of painting, notably the strong contrasts between light and shade in the picture as well as its luminous colors. The rejection of *Women in the Garden* was a blow to Monet, but his friends came to his rescue. Frédéric Bazille bought the painting in monthly instalments of 50 francs, giving the painter a regular income; following his premature death in 1870, it passed into Manet's pos-session until Monet bought it back from him in 1876.

Claude Monet, Garden in Bloom in Sainte-Adresse, ca. 1866
Oil on canvas, 65 x 54 cm

Monet painted the *Garden in Bloom* in the summer of either 1866 or 1867 while he was in Sainte-Adresse, a village near Le Havre where he had spent his youth. The painting, with its captivatingly strong and luminously bright colors, reveals the small, but deliberately chosen corner of a garden.

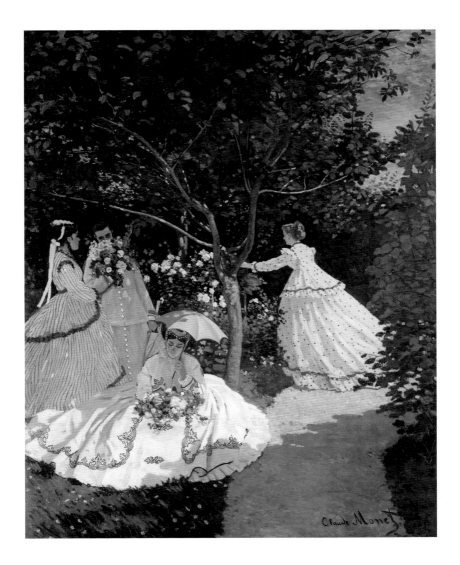

Claude Monet

Portraits of ladies of the Second Empire

In 1867, a wealthy friend and patron Louis-Joachim Gaudibert, a shipowner, commissioned Monet to do three portraits. Two were to be of Gaudibert himself and the third one of his wife.

This full-length portrait of Madame Gaudibert illustrates just how easily Monet was able to turn his hand to official portraiture. The woman's elegant posture lives up to the idealized concept of formal portraiture existing at that time. By including a detail like the woman adjusting her glove, which was intended to introduce an element of movement into the statuesque pose, Monet is adhering to the traditional style of portrait painting of the day. *The Lady with the Glove* by Carolus-Duran (1838–1917) illustrates this very clearly. What was unusual, and no doubt shocking, was the fact that the subject of Monet's portrait had averted her head.

The colors used by Monet are muted, even if – by Academy standards – they are still

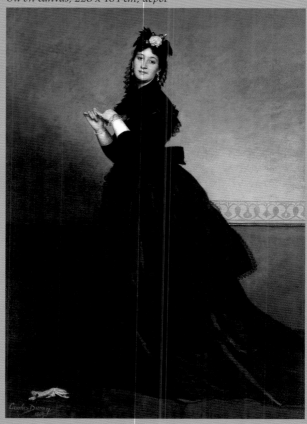

Charles Carolus-Duran, The Lady with the Glove, 1869, Oil on canvas, 228 x 164 cm, depot

much too bright. Carolus-Duran's painting of his wife Pauline, dressed in unrelieved black, is much more limited in its range of colors, with almost no variation in tone. Monet also exercised restraint with regard to his brushwork, but does give a hint at how far the painter might go. The sumptuous dress is not painted in detail but is suggested in broad brush strokes. The flower-patterned carpet and the drapes in the background are somewhat sketchily portrayed. The bold treatment of the still life of flowers on the table is reminiscent of open-air paintings. In contrast to this, *The Lady with the Glove* reflects the sober tones of the wall and floor, relieved solely by the geometrical decorative frieze.

Claude Monet, Madame Louis Joachim Gaudibert, 1868, Oil on canvas, 217 x 138.5 cm, Ground floor, Seine Gallery B

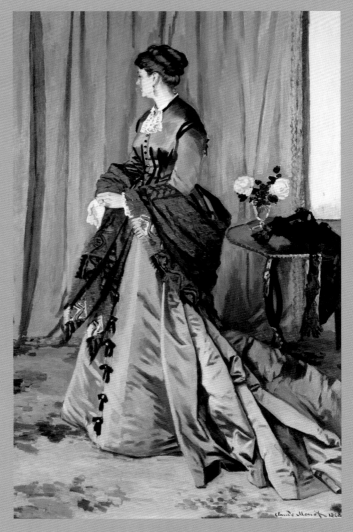

Alternative ways of reaching the public –
the first group exhibition by the Impressionists

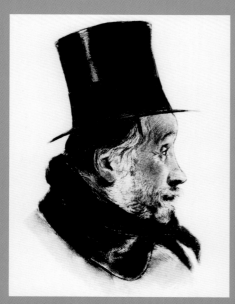

Edgar Degas argued in favor of a loose association of artists exhibiting as an independent group

As far back as the 1860s, Camille Pissarro and his artist friends, in an attempt to overcome personal and artistic isolation, had already discussed the possibility of setting up an association to help them in their struggle to gain recognition and make a living. The economic crisis that overtook France in 1873 put paid to even the modest sales made by Impressionist artists, and this meant that the artists had to take a much more active personal role in selling their work, since gallery owners were no longer in a position to buy paintings at their own risk.

The founding document of the "Societé Anonyme des Artistes (Peintres, Sculptures et Graveurs)" bears the signatures of eleven artists, including Claude Monet, Auguste Renoir, Edgar Degas, Berthe Morisot, and of course, Camille Pissarro, who, from the outset, was the driving force within the group. The members did not always see eye to eye with regard to the association's objectives and aims: Whereas Pissarro favored an association of artists organized along the lines of a cooperative and had, accordingly, brought along the statute of the bakers' cooperative of Pointoise as a blueprint for their own statute, Degas was more concerned lest there was the least suspicion of the group having a political slant and, consequently, favored a loose association of exhibitors. What they all had in common, however, was a very critical opinion of the Salon and the selection criteria of its jury. Most of them, after all, had had their works repeatedly rejected and some of them had decided not to bother submitting any more paintings to the official Salon. Nevertheless, a few of the members were at pains to avoid creating the impression of being a group

The studio of Félix Nadar on the boulevard des Capucines

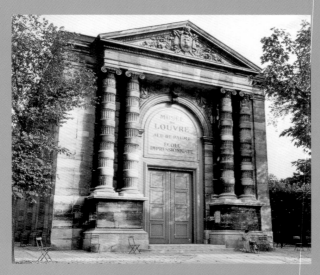

The Musée du Jeu de Paume in Paris housed the famous collection of Impressionist paintings up until 1986

of rejects, since they still secretly hoped for official recognition by the Salon. An annual subscription of 60 francs entitled the members to exhibit two works each at an exhibition organized by the group itself. Where each painting was hung was decided – in the interests of fairness – by drawing lots. There were no other hard and fast rules regarding either subject matter or style.

It did not take long for rooms to be found for the first exhibition: Nadar, a well-known Parisian photographer, arranged for his former studio on the boulevard des Capucines to be used for the event. It consisted of several rooms on the second floor which, thanks to its prime

location on one of the main boulevards in Nouveau Paris, was ideally placed for attracting custom. The next step was to find more artists to take part in the exhibition and therefore share the costs of it. This, too, highlighted more differences within the group than common ground: While Pissarro invited Cézanne, who was regarded as savage and unrestrained in his painting, to take part (the latter's *A Modern Olympia* (cf p. 334) had already provoked a scandal), Degas, on the other hand, favored the mainstream Salon artists, thinking that they would help to project a somewhat less revolutionary image. He managed to persuade the successful Italian artist, Giuseppe de Nittis, as well as Stanislas Lépine, a pupil of Corot, to take part; Lépine's rather muted landscapes had long since found favor in official art circles. Altogether 30 artists agreed to participate, exhibiting a total of 165 paintings – in other words, far more than allowed for in the Statute. These included a number of painters whose style was not Impressionist, but who joined the group as a result of personal connections with individual members. The overall impression was one of diversity and the exhibition was far from being an exclusively Impressionist occasion.

Nevertheless, the paintings by Monet, Pissarro, Degas, and the other members who

formed the nucleus of the group attracted the most attention and were more thoroughly reviewed in the press than those by Salon artists. As far as many of them were concerned, their participation in this exhibition was just a one-off. In 1876, a total of only 18 artists got together for the second group exhibition.

On April 15, 1874, two weeks prior to the opening of the official Salon, the exhibition was ready and opened daily from 10am to 6pm and from 8pm to 10pm. Admission cost one franc; the hastily produced catalog was on sale for 50 centimes. Attendance was very satisfactory: On the first day, there were about 200 visitors, and by the time the exhibition ended on May 15, an average of 100 visitors per day had been recorded. Altogether 50 generally favorable articles and reviews had been published in the press. The small number of damning and caustic reviews, published in *Le Charivari* and elsewhere , only served to arouse further interest in the exhibition and possibly led to some people coming along to the boulevard des Capucines purely out of a desire for sensationalism or personal amusement.

In the wake of this public discussion, a label was attached to this new style of painting, one that has stuck to this day. The story has it that Renoir's brother Edmond, whose job it was to edit and produce the catalog, became so annoyed not only at the excessive number of paintings submitted by Monet but also at the unimaginativeness of their titles (*Entrance to the Village*, *Way Out of the Village*, *Morning in the Village*) that he asked the artist to change them. Monet responded by looking at one of his paintings depicting a view of Le Havre harbor,

saying "Why don't you just call it 'Impression'?" And that is what happened – and the critics who, then as now, endeavored to catalog and classify new art forms, seized upon the new term gratefully. Jules Castagnary, who was a strong supporter of the group of artists surrounding Pissarro, was one of the first to use the term "Impressionists" in his article on the exhibition, which appeared in *Le Siècle* of April 29. He commented that it was not the landscape itself that they were portraying, but the impres-

Catalog from the first Impressionists' exhibition, 1874

SOCIÉTÉ ANONYME
DES ARTISTES PEINTRES, SCULPTEURS, GRAVEURS, ETC.

PREMIÈRE

EXPOSITION
1874
35, *Boulevard des Capucines, 35*

CATALOGUE

Prix : 50 centimes

L'Exposition est ouverte du 15 avril au 15 mai 1874,
de 10 heures du matin à 6 h. du soir et de 8 h. à 10 heures du soir.
PRIX D'ENTRÉE : 1 FRANC

PARIS
IMPRIMERIE ALCAN-LÉVY
61, RUE DE LAFAYETTE
1874

Claude Monet. '72

sions evoked by that landscape. The special significance of what the individual artist actually sees, experienced in one fleeting instant, remains one of the hallmarks of Impressionist painting, despite all subsequent attempts to classify it within the framework of art history. What it also involves is a spontaneous, rapid, almost sketchy painting technique, causing a blurring of the outlines, possibly even dissolving the subject of the painting.

When it was over, the artists discovered that the ticket money and the disappointing number of sales had failed to cover the costs of rent, décor, posters, catalog, insurance, etc. Frustrated at the lack of financial success, the association immediately disbanded. The founding members dispersed all over the place. Cézanne made his way to Aix-en-Provence, Sisley accepted an invitation to England, Pissarro returned to Pontoise, which he was forced to leave again just a few weeks later with his large family because of his huge debts. "I have suffered unspeakably," he wrote to a friend a few years later, "and I am still suffering dreadfully even now…and yet I wouldn't hesitate to tread the same path again if I had my time over again." It was Pissarro, who, by dint of his own personal efforts, organized altogether eight group exhibitions up to 1886. Though smaller in size, these exhibitions were more discriminating in their selection process and provided an excellent insight into artistic developments leading to Pointillism and neo-Impressionism.

MP

Claude Monet, Impression,
Sunrise, 1872,
Oil on canvas, 49.5 x 65 cm,
Musée Marmottan, Paris

Henri Fantin-Latour

Henri Fantin-Latour (1836–1904),
The Studio in Batignolles, 1870
Oil on canvas, 204 x 273.5 cm

There are many precedents for this type of group portrait, especially in 17th-century Dutch painting (e.g. Frans Hals). Furthermore, romanticism turned genius and friendship into a veritable cult, one that produced numerous paintings depicting visions of fellowship. Fantin paved the way for this painting with an oil sketch (1869) and a pastel drawing (1870). It brings together various associates of Monet. Behind the artist, who is working at his easel, is Otto Scholderer of Germany.

Seated in the chair is Zacharie Astruc, whose portrait Manet is currently working on. Astruc, the "fantastic poet," as Fantin described him, had urged Manet to visit Spain (1865), an experience which proved to have an immense influence on his art. Behind him is Bazille, "a very promising talent." Also visible in the right-hand background are: Renoir, a painter "who will make a name for himself," Zola, "Manet's greatest champion in the press," Edmond Maître, and Monet, himself, who was probably added at a later date. Fantin does not include himself in the picture on this occasion. What is even more surprising is that Camille Pissarro, an extremely important member of the "group," is missing from the scene.

The Studio in Batignolles was exhibited in the 1870 Salon where it was awarded a medal. In ways like this, these passionate young artists, whose works of art would inevitably cause a stir and who were not initially admitted to the official annual exhibition, managed to gain entry to the Salon.

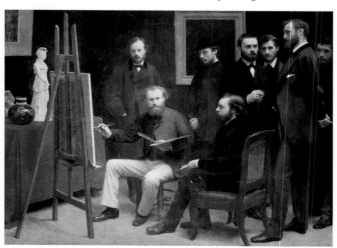

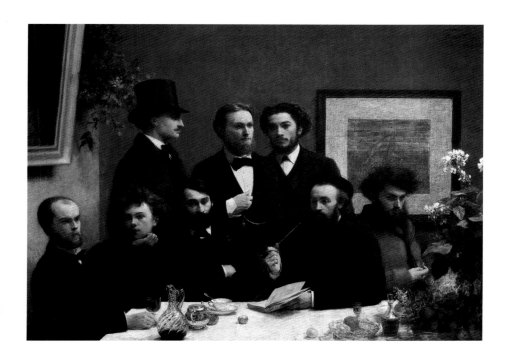

Henri Fantin-Latour, Table Corner, 1872
Oil on canvas, 160 x 225 cm

This group picture brought together several writers, namely Paul Verlaine, Arthur, Rimbaud, Elzéar Bonnier, Léon Valade, Emile Blémont, Jean Aicard, Ernest d'Hervilly, and Camille Pelletan. Originally, Fantin was planning a companion piece to his *Hommage à Delacroix*, which was to feature Baudelaire, the influential writer, at its center. This plan gradually receded in favor of a rather informal grouping of literary figures around a table.

This late group portrait became famous because of its authentic portrayal of Verlaine and Rimbaud, who are sitting on the left-hand side of the table in the foreground. The portrait of Arthur Rimbaud (1854–1891), who died very prematurely, is particularly lifelike and accurate. His head, with its shock of unruly hair, is propped up on his hand, as he gazes off into the distance, lost in thought.

Seascapes and beach landscapes

Eugène Boudin (1824–1898),
The Beach at Trouville, 1864
Oil on wood, 26 x 48 cm

Seascapes and beach scenes have long been popular subjects among painters. Eugène Boudin is no exception. He discovered the Normandy seaside resort of Trouville in 1863, and from then on the beach there became one of his favorite subjects.

The sense of immediacy in *The Beach at Tronville* is so strong that it seems to capture a single ephemeral moment in time. Summer guests have gathered on the beach, where they are sitting in a tight group looking out over the English Channel and enjoying the wind and the weather. They have made themselves comfortable on chairs and erected a small tent. The sky takes up a large part of the picture and is fairly uniform in color, whereas the figures liven up the foreground with splashes of color.

Boudin submitted this painting as a sketch to the Salon in the same year he painted it, where, despite its small size, it achieved great success.

In 1858, Boudin met Monet and became the young man's first drawing master. As Monet still recalled in 1900: "In his infinite kindness, Boudin undertook my instruction. My eyes were slowly opened and I finally understood nature; at the same time, I learned to love it." Monet could have found no better teacher than Boudin, an unsophisticated painter with no formal training, who seemed to know what lay

ahead when he said: "Everything painted directly on the spot always has a strength, a freshness, a vividness of touch that one doesn't find in the studio." Corot called Boudin "the master of the sea." He also painted the beach and harbor at Honfleur.

Eugène Boudin, The Jetty at Deauville, 1869
Oil on wood, 23.5 x 32.5 cm

In this picture, Boudin's preference for free, loose brushwork can be seen even more plainly. In contrast to *The Beach at Trouville*, the people on the beach do not form a largely homogeneous group. Everything is dispersed, ephemeral: The flags are merely dabs of color in the clouds, the dog just a patch of color on the beach. In view of the fact that Boudin used to record the date, time, and wind direction on individual works, it is quite apparent that he was not only the teacher but also the forerunner of Monet.

Claude Monet (1840–1926),
Hôtel des Roches Noires in Trouville, 1870
Oil on canvas, 81 x 58.5 cm

A year after Boudin's Deauville painting, Monet painted the hotel in Trouville. A famous seaside resort on the Normandy

coast, Trouville was one of the most popular holiday destinations for Parisian society at around this time. Thanks to his rapid, expressive brushwork, the clouds appear foreshortened and the flags are fluttering as if in tatters in the wind. Even the figures, like the man raising his hat on the left, are sketchily captured with just a few brush strokes.

The elegant building is one of the plush, new holiday hotels on the Normandy coast, an area with which the painter had been familiar since childhood. Between the imposing façade and the promenade is an arresting interplay of light and shade. Monet's art is characterized by his free and expressive style of painting. With superb skill, he transfers the liberties he takes onto canvas. The fact that it did not meet with public approval was partly to do with the picture's size. It was twice as large as Boudin's "sketch" and, for that reason alone, gave the impression of being an elaborate work – in the eyes of the Salon jurors, however, it was no such thing.

Orientalism

Gustave Guillaumet (1840–1887),
The Desert, 1867
Oil on canvas, 110 x 200 cm

For many artists, portraying a landscape, especially the desert, represented a considerable challenge. A desert landscape could not offer much in the way of unusual subjects or any diversity of scenery. The essential thing was to reproduce the endless expanse and monotony and to capture its distinctive atmosphere in paint.

Gustave Guillaumet exhibited this very impressive desert study at the 1868 Salon. He was already renowned for his Oriental subjects and motifs and had seen real deserts on his trips to North Africa and the Middle East.

In this painting the horizon is low. There is an impression of seemingly unending depth and breadth. The sky and desert are bathed in the glaring light of the sun, the sand seems to glow, and the air is shimmering with heat. Far away on the horizon, a caravan is passing in front of the scorching sun. In the foreground, however, as if warning of how deadly the desert environment can be to man and animal alike, lies the skeleton of a dead camel, which has perished in the parching heat.

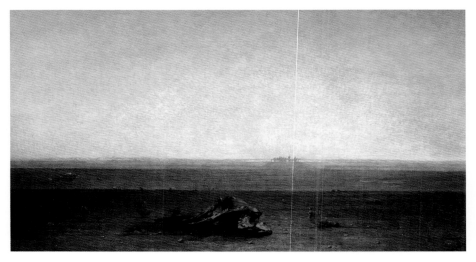

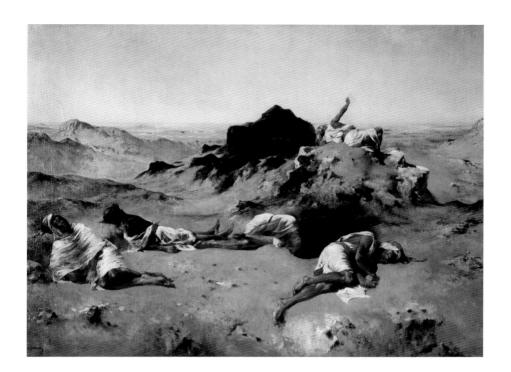

Eugène Fromentin (1820–1876),
The Land of Thirst, ca. 1869
Oil on canvas, 103 x 143 cm

Eugène Fromentin was known as a painter and a writer. He can be seen as the idea of Orientalism personified. This prolific figure borrowed the title for his desert picture from his books of memoirs *A Summer in the Sahara,* written in 1857. Fromentin based his memoirs on his travels through Algeria.

The picture shows a barren desert landscape in which we see a scattering of people, all approaching death. The sun is at its zenith, the shadows are short. While the figures in the foreground are lying weak and spent on the ground or huddled on their sides, the prone figure which is to be seen on the elevated mound in the background is stretching out one arm. This desperate gesture expresses the cruel suffering and final agony of his death throes.

**Alexandre Gabriel Decamps
(1803–1860),
Turkish Merchant Smoking
in his Shop, 1844**
Oil on canvas, 36 x 28 cm

Alexandre-Gabriel Decamps was one of the most important exponents of Oriental painting of his day. This picture of a shopkeeper represents a typical example of one of the main themes of this genre: A picturesque view of everyday life at the bazaar. A raised awning permits the spectator a glimpse into the dark recesses of the smoking shopkeeper's stall. The light falling on him creates a charming effect.

**Henri Regnault (1843–1871),
Arbitrary Execution under the Moorish
Kings of Granada, 1870**
Oil on canvas, 302 x 146 cm

This painting of a cold-blooded execution illustrates the interest in the sort of real and imagined despotic actions with which many artists associated exotic foreign lands.
On the steps leading to a courtyard which has obviously been inspired by the Alhambra in Granada, stands an impassive executioner, at whose feet lies his victim: His head has been severed from his body with a sword and blood is running heavily down the stone steps.

"…we are now Orientalists" (Victor Hugo, 1829) – Oriental trends and Oriental studies

Galerie des Tapis d'Orient

The discovery and adoption of the Orient, perceived as an exotic and mysterious region, steeped in history, and the antithesis of Western culture, reached a peak in the 19th century as a result of numerous expeditions and journeys undertaken by literary figures and artists. The Ottoman Empire had for many centuries posed a serious threat to Christian countries: the Turks had, after all, got as far as Vienna in 1683. Cultural encounters had been limited almost exclusively to the existence of individual collectors' items in royal treasure chambers and to the *Thousand And One Nights* collection of fairy tales, published in French for the first time in 1717. Now, however, the political climate and the politics governing relations

Parisians purchasing Oriental carpets at the Bon Marché department store

Interior decoration illustrates the contemporary taste for the Oriental

with one another were changing. The Orient, more a place in people's imaginations than a clearly defined geographical area, was becoming an object of research while providing a fertile ground for Western imagination.

So much interest in collecting all things Oriental could only be sustained, however, by an expansionist French foreign policy; in 1798, Napoleon Bonaparte undertook an ambitious Egyptian military campaign against the Turks who had ruled there for over 250 years. From the outset, the operation was beset by failure. On August 1, 1798, Admiral Nelson destroyed the French fleet of 400 ships and even the initial occupation of the country eventually had to be abandoned because of a succession of partisan uprisings, outbreaks of disease, and other epidemics.

Jules Cayron,
Portrait of Count Boniface de
Castellane in costume, 1912,
Oil on canvas, 39.3 x 22 cm,
Musée Carnavalet, Paris

Harem women making music in an Oriental interior

years 1810 and 1812 and intended as a gift for Joséphine, Napoleon's divorced wife.

Running parallel to the attempt to gain military supremacy over the country was the growing interest in numerous state-funded, scientific explorations of Egypt, the results of which were published between 1808 and 1824 in a 24-volume edition entitled *Description de l'Egypte*. The scale of this publication alone shows that it was a work of encyclopaedic character. Innumerable illustrations of Oriental art and cultural monuments were published for the first time and served many artists of the day as a compendium which could supply them with subject material and decorative patterns.

This was followed by a spate of privately organized trips, which were joined by literary figures and artists. Gustave Flaubert, Guy de Maupassant, the Goncourt brothers, Théophile Gautier, as well as painters such as Eugène Delacroix, Gustave Guillaumet, and Eugène Fromentin were among the most prominent figures taking part in these trips to the Orient, which, following the annexation of Algeria, frequently had Northwest Africa as their destination. For Henri Matisse, too, this encounter with Islamic culture in Algeria in 1906 and Morocco in 1911 was to be the source of very important artistic inspiration, as can be observed in his paintings.

Back home, however, Napoleon allowed himself to be fêted as the conqueror of Egypt, triggering off a spate of veritable Egyptomania, the evidence of which can still be seen today in many architectural drawings, interior designs and handicrafts stemming from the 19th century. J.F.C. Swebach-Defontaines, for example, created an extravagant piece of porcelain that had an Egyptian theme, which was produced by the imperial porcelain manufacturers of Sèvres between the

The many travel reports and memoirs do not just detail the actual impressions, however, but also give insight into the authors' own prejudices. Admiration for the early advanced civilizations is mixed with a disparaging attitude toward the Islamic culture of the day, which was regarded as uncivilized and not even independent. The writings of François René de Chateaubriand (1768–1848) and Alphonse de Lamartine (1790–1869) are typical examples of the attempts to endorse and legitimize such preconceptions of the Orient.

Gérard de Nerval (1805–1855), in his *Voyage en Orient*, published in 1852, was the first writer to be concerned with authenticity. The result was deeply disillusioning: "Kingdom by kingdom, province by province, I have lost the best half of the universe and soon I will no longer know where my dreams will find a refuge," wrote Nerval to his friend, painter and writer Théophile Gautier.

These imagined Oriental fantasies, which often resembled a wonderful, sensual fairy tale, apparently had no basis in reality within a society that was becoming increasingly colonialized.There were many ways to overcome this gulf between reality and fiction.

When Gautier eventually visited Egypt himself several years later, he refused to stay in anything other than first-class hotels and saw the land and its people through the eyes of a tourist, purely as an atmospheric, romantic, and artistically stimulating backdrop. There were others, however, who tried to assimilate themselves completely, either by donning Oriental costume during their travels, like Nerval, or even converting to Islam. Problems appear to have arisen in dealing with the exotic culture, the strange customs, and the apparently unpredictable mentality of the people. The biography of Isabelle Eberhardt (1877–1904) tells the story of an eccentric writer who, dressed in Tunisian men's clothing, lived in North Africa among the native population and was consequently robbed of her own culture and regarded with distrust by bureaucracy. Suffering from a sense of isolation and from nervous depression, she can be regarded as a particularly extreme, yet nevertheless typical example

The front cover of Volume I of the Description de l'Egypte, 1808, Egyptian Museum and Papyrus Collection of the Berlin State Museum

Gustave Courbet, The Sleep, 1866, Oil on canvas, 135 x 200 cm, Musée du Petit Palais, Paris

of the consequences of trying yet failing to marry two opposing cultures.

The attitude toward acquiring Oriental subjects in painting remained ambivalent. In principle, any paintings *à la turque* were greatly in demand in the 19th century and very salable, thus tempting a large number of painters to specialize in this subject. Where to start, however, was something of a difficult question: Since Islam forbids the depiction of humans or animals in pictorial form, there were no Islamic examples available to support European fantasies about the Orient. Artists therefore projected their own ideas about unbri-

dled passion onto a variety of popular hunting scenes as well as portraying lascivious concubines, thinking themselves unobserved, luxuriously stretching their limbs with an erotic lack of inhibition in their harems.

In the 1870s, Oriental painting found itself overtaken by the general trend towards realism. A trip to the Orient was now deemed indispensable if buildings, costumes, faces, and landscapes were to be portrayed with any accuracy. Painters like Gustave Guillaumet (1840–1887) and Jean-Léon Gérôme (1824–1904) assembled individual subjects in countless sketches which would later

form the basis of paintings to be completed in their Paris studios. Eugène Delacroix's sketches, completed in 1832, following his visit to Morocco, represent a highpoint in his early artistic career. Objectivity was, however, hard to come by in many instances.

European collectors still sought and preferred exotic themes that would lend atmosphere to their own surroundings. The ability to understand all things foreign as well as the foreigner himself from the standpoint of one's own circumstances remained an unfulfilled promise, however.

MP

Eugène Delacroix, Illustrations from the Album of North Africa and Spain, 1832, watercolor, 19 x 12 cm each page, Musée du Louvre, Paris

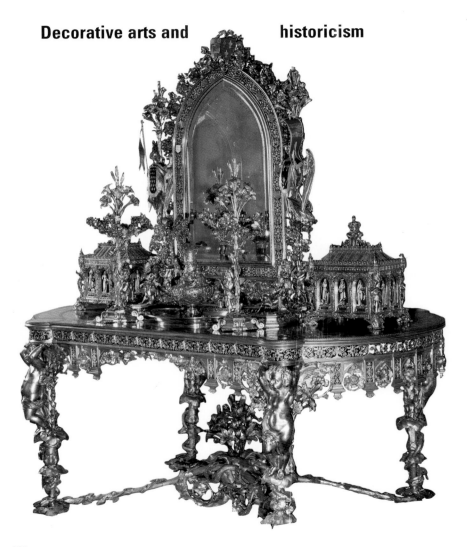

François-Désiré Froment-Meurice (1802–1855), Dressing table with toilet articles (with detail), 1847–1851
Silver and bronze, partially gilded, engraved iron, enamel, gemstones, glass, Height 210 cm

The dressing table was designed to commemorate the marriage of Louise Marie Thérèse, granddaughter of the French king, Charles X, to the future duke of Parma. The lavishness and perfection of its design elicited great admiration at the 1851 Great Exhibition in London. The work was the fruit of collaboration between Froment-Meurice, the jeweler, who ran a busy, well-known workshop in Paris and was considered one of the Romantic movement's leading exponents of his craft, an architect, two sculptors, a technical designer, and an ornamentalist. With its mixture of styles borrowed from a variety of periods, including Gothic, Baroque, and Rococo, together with the sumptuous splendor of its ornamentation, this piece of furniture is a typical example of Second Empire decorative art. It includes some unusual features which hark back to earlier styles, for example, the jewelry box of inlaid enamel which is reminiscent of a Gothic reliquary. BS

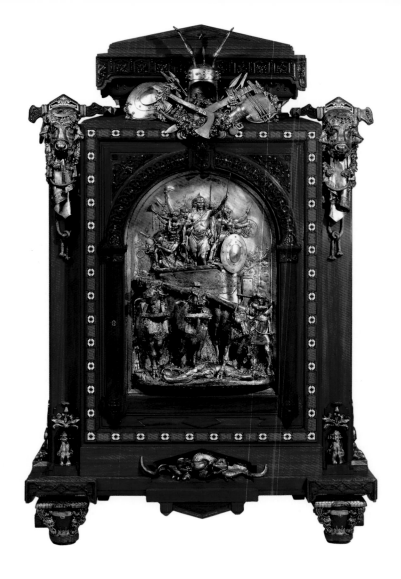

Charles-Guillaume Diehl (1811–ca. 1885),
Emmanuel Fremiet (1824–1910),
Medal cabinet, ca. 1867
Cedarwood, walnut, ebony, ivory on oak, silver-plated bronze, and copper, 238 x 151 x 60 cm

Charles-Jean Avisseau (1796–1861),
Design: Octave Guillaume de Rochebrune
(1824–1900), Goblet and Bowl, 1855
Faience: Goblet: Height 34.5 cm;
Bowl: Diameter 51.5 cm

One of the most original contributions to the 1867 Exhibition in Paris was this medal cabinet designed by cabinetmaker Charles-Guillaume Diehl. Unlike many other items of furniture at that time, it did not imitate any particular historical style, but makes reference to several. The silver-plated sculptural work by the sculptor Emanuel Fremiet is the dominant feature of the cabinet. In keeping with nationalist principles, it depicts King Merwechs defeating his adversary from Attila's hordes near Châlons-sur-Marne, a subject that the artist borrowed from early French history.

BS

The response of ceramists like Charles-Jean Avisseau to the influences of industrial mass production was to produce high-quality ceramics by hand. Design and techniques were based on famous ceramics of the past. The imaginatively sculptured decoration on this brightly colored goblet standing in a bowl depicting all kinds of creatures, such as salamanders, snakes, and snails, as well as foliage, fruits, and masks, is a free imitation of the work by Bernard Palissy, a 16th-century Parisian enamelist and theoretician, which was decorated with moulded plants and animals.

BS

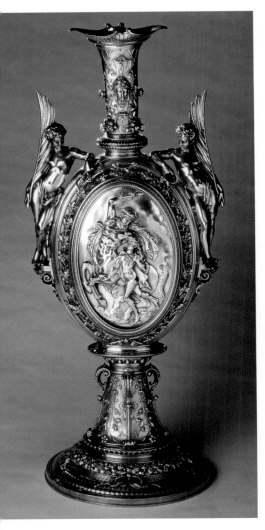

Christofle & Co., Mathurin Moreau (1821–1912),
Aigiste Madroux (d. 1870),
Vase, ca. 1867
Silver, partially gilded, 75 x 26 x 13 cm

The Christofle firm, which is still in business today, enjoyed huge success in the mid-19th century as France's leading manufacturer of electroplated silver items. As well as a wide range of silver-plated tableware and cutlery for the mass market, it also produced some remarkable individual pieces in solid silver. An example of this is the vase, designed from an idea by the sculptor Moreau and the ornamentalist Madroux. It is a Napoléon III hunting trophy with a mythical subject. Young Achilles is being instructed by his wise teacher, the centaur Chiron, in the art of sprinting.

BS

Félix Bracquemond (1833–1914),
Eugène Rousseau (1827–1891),
manufactured by Creil and Montereau,
Table centerpiece, designed 1866
Faience, printed decoration, painted in color,
15 x 62.2 x 42.2 cm

This dinner service, consisting of over 200 pieces, which the Parisian designer, glass and ceramics dealer Rousseau successfully exhibited first in 1867 and at every world exhibition thereafter until 1878, illustrates the remarkable influence of Japanese woodcut printing on contemporary decorative arts. Decorated by Félix Bracquemond, or with the help of his etching plates

at least, they show animals and plants in Japanese style distributed seemingly at random over a light background. The style of the porcelain crockery echoes traditional French faience. BS

Eugène Rousseau,
Appert Frères glassworks, Vase,
designed 1875–1878
Glass, overlays, engraved, painted, enameled, and gilded, 25.8 x 23 x 5.5 cm

Eugène Rousseau, who originally ordered this faience service from Bracquemond, himself produced decorative glassware in cooperation with the Appert Frères glassworks in Batignolles near Paris. Their shape and decorations were inspired by the Oriental vogue of the time. Like the animals on Bracquemond's service, this simple vase is decorated with a delicate, colorful fish. The application of droplets of

pale blue glass trickling down from the upper edge of the vase gave this design, of which there are several variations, the name *modèle à larmes* (teardrop style).

BS

Architectural models

The Musée d'Orsay houses a collection of models, drawings, photographs, and plaster sculptures of one of the most important buildings of the Second Empire, the Paris Opera House, designed by Charles Garnier (1825–1898), a young architect who emerged as the eventual winner of a contest in 1860 to select a designer for the building. Construction work began in 1862 on what was then the biggest opera house in the world; it was not inaugurated, however, until 1875 during the Third Republic.

The scale model representing the entire Opéra quarter illustrates just how much this elaborate building stood out from its surroundings among Baron Haussmann's straight avenues and regular façades: Garnier preferred opulent neo-

Lengthways cross section of the Paris Opera House, made 1982–1986, by L'Atelier, Rome, under the direction of Richard Peduzzi, Ground floor, Salle de l'Opéra

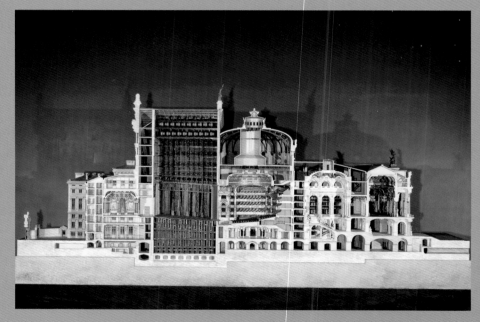

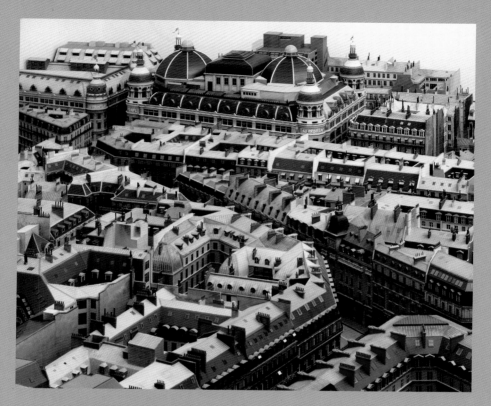

Model of the Paris Opéra quarter in 1914 with the two domes of the Printemps department store, by Rémy Munier and Eric de Leusse, Ground floor, Salle de l'Opéra

Baroque curves to the austerity of straight lines, ornamental exuberance to simplicity. The Opera House's exterior reflects its inner structure which is displayed in a lengthways cross section of the building. Garnier created a magnificent ambience to greet the public's entrance to the building, with a vestibule, foyer, loggia, and three-story stairway with its five flights of stairs. Beneath the copper dome at the heart of the building is the auditorium in red and gold. The building also incorporated a section reserved for the artists and administrative offices. BS

International arts and crafts

Philip Webb (1831–1915), made by Morris and Company, Sideboard, ca. 1880
Mahogany, varnished in black; embossed colored leather, partially gilded. 204 x 202 x 63 cm

Philip Webb, architect and designer, collaborated closely with William Morris designing furniture, textiles, metal sculptures, and glassware. His furniture was intended

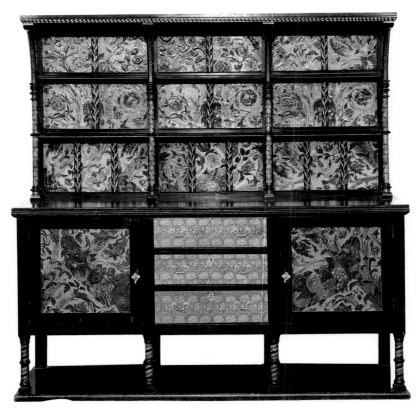

to be uncompromisingly honest, heavy in form and solidly made and did not attempt to hide but, on the contrary, stressed, how it was made. Despite his preference for the practical, Webb did, however, like effective decoration. He contrasted the heavy sideboard's simplicity and geometrical severity, for instance, with doors and back panel of colored leather decorated with almost Baroque-style tendrils of foliage, flowers, and fruits in a manner typical of the Arts and Crafts movement. BS

William Morris (1834–1896),
William Frend De Morgan (1839–1917),
Tiled panel (Detail), 1876/77
Faience, 163 x 90 cm

The central figure in English efforts to bring about a revival of arts and crafts was the designer William Morris. He was also active in politics as a leading socialist. Morris was opposed to art being regarded as the privilege of the elite and eschewed industrial mass production, striving for a return to high-quality craftsmanship. With his gift for drawing patterns and his sensitivity toward natural forms, he developed floral designs which his firm converted into wallpaper, textiles, or – with the help of ceramist William Frend De Morgan – transferred them onto earthenware panels. Morris' decor was inspired by historical patterns and Oriental models. Their individuality and vivacity distinguished them from other purely historical ornamentation of the day.
 BS

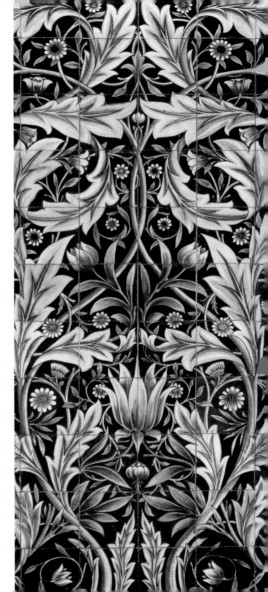

Christopher Dresser (1834–1904), made by J.W. Hukin & J.T. Heath, Bracher & Sydenham, Soup tureen, patent 1880
Silver-plate, ebony handles.
21 x 31 x 23 cm

Unlike Morris and his circle, the English designer and theoretician Christopher Dresser, an ardent admirer of Japanese art, placed himself in the service of industry. He produced designs for industrially manufactured household objects, including silver-plated metal items. This tureen, with its simplicistic beauty and its geometrical lines, is a forerunner of 20th-century functional design. BS

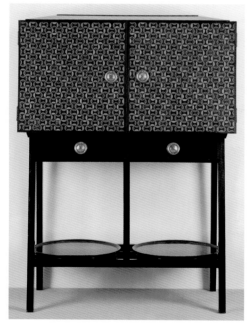

Ernest William Gimson (1864–1919), Manufactured by Kenton and Company, Cupboard, 1891
Ebony, marquetry work consisting of various exotic woods, metal fittings,
139.7 x 101 x 45.3 cm

Ernest W. Gimson, architect, designer, and prominent member of the English Arts and Crafts movement, went to great lengths to ensure that full justice was done to the materials used and that the quality of craftsmanship was of the best. His furniture has clear, elegant lines. He frequently incorporated the wood's natural grain into the design or used precious woods to decorate his most exclusive items, like this cupboard, with elaborate marquetry. BS

Kolomann Moser (1868–1918), Manufactured by Wiener Werkstätte, Music cabinet, ca. 1904
Oak, treated with white lead, varnished in black, silver-plated metal, glass, 199 x 200 x 65cm

The furniture produced by the Wiener Werkstätte reflected the extravagant tastes of wealthy art lovers. This music cabinet, designed by Koloman Moser, comes from the salon of the Wittgensteins, a well-known Viennese family of art lovers, who also had close links with the famous composers of their time, including Johannes Brahms and Richard Strauss, as well as Gustav Mahler. The severe, clean lines of this cabinet are typical of the geometric style of Viennese Art Nouveau. The protruding gilded edge with its delicate wavy pattern puts one in mind of musical waves vibrating across the piece, lightens the appearance of the piece, and relieves its austerity.

The whiteness of the lead helps to bring out the natural grain of the varnished oak. Narrow, silver-plated metal plates on the doors, depicting the Muses, enliven the cabinet and emphasize its exclusive aesthetic beauty.

One of the leading exponents of geometric design, clear form, and a minimum of symbolic elements, was the Scottish architect and designer, Charles Rennie Mackintosh (1868–1928). His furniture is a deliberate alternative to the sometimes excessively opulent French style of Art Nouveau. BS

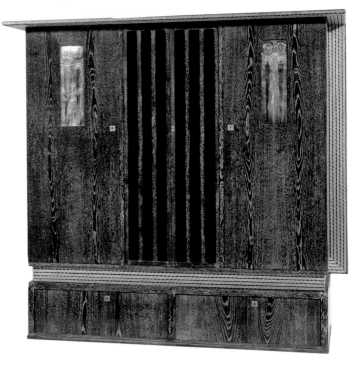

Charles Rennie Mackintosh (1868–1928), Manufactured by Alex Martin, Desk, ca. 1904
Wood varnished in white, colored glass, leaded, 121.9 x 81.3 x 41.9 cm

This desk, with its austere elegance, white lacquered finish and stylized, slightly asymmetrical flower on the inside rear panel of the writing section, was part of a bedroom suite and is typical of the furniture designed by Glasgow architect Charles Rennie Mackintosh. Geometric shapes, narrow proportions, an emphasis on the vertical, as well as fine, abstract floral decorative ornamentation are very characteristic of his style. Mackintosh's furniture is very different in style from the robust pieces of the English Arts and Crafts movement and from the elaborate curves of French Art Nouveau. Mackintosh found little recognition in his native Scotland or England; on the Continent, however, his work was perceived as novel and refreshing and had a strong influence on Viennese Art Nouveau.

BS

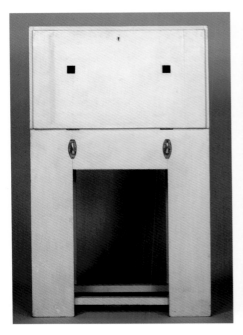
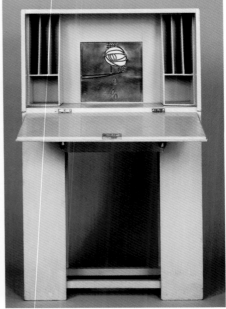

**Frank Lloyd Wright
(1867–1959), Linden
Glass Company,
Chicago, Glass window,
ca. 1908**
Clear and colored glass,
zinc trim,
112 x 104 cm

The avant-garde of American architecture and interior design in the early 20th century is represented by the Chicago architect Louis Henry Sullivan and his pupil, Frank Lloyd Wright.

Wright's architectural designs were individual works of art in their own right. The aesthetic beauty of his famous series of "prairie houses," characterized by long low buildings, and a breaking-away from traditional house design, was rooted in Japanese architecture. Wright also used unmasked materials such as natural wood, tiles, and stone. Rooms and levels ran freely into one another. Open wall elements of glass formed a connection between inside and outside, between architecture and nature. Wright's designs for this window, for instance, with its carefully designed metal border, favored strong tectonic right angles, and gained him a reputation as the most influential American architect of the modern age, a pioneer of abstract geometrical forms. BS

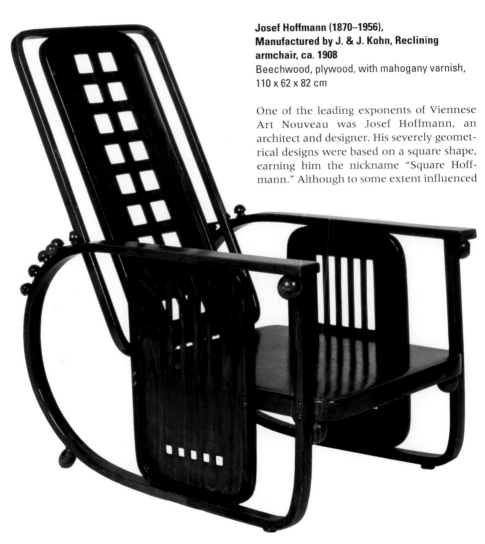

Josef Hoffmann (1870–1956), Manufactured by J. & J. Kohn, Reclining armchair, ca. 1908
Beechwood, plywood, with mahogany varnish, 110 x 62 x 82 cm

One of the leading exponents of Viennese Art Nouveau was Josef Hoffmann, an architect and designer. His severely geometrical designs were based on a square shape, earning him the nickname "Square Hoffmann." Although to some extent influenced

by Mackintosh, his pleasing designs for utilitarian objects owed more to practical and functional considerations. This armchair with its reclining backrest was produced from Hoffmann's design by the firm of Kohn. This comfortable piece of furniture exudes a timeless elegance and simplicity of style that meet all the demands of modern styling and design.

BS

Koloman Moser (1868–1918),
Manufactured by Wiener Werkstätte,
Inkpot and stand, 1903/04
Silver, glass; Inkpot: 6.7 x 9.2 x 5.5 cm,
Tray: 1.5 x 22.7 x 15.4 cm

The Wiener Werkstätte was founded in 1903, producing hand-finished examples of aesthetically beautiful arts and crafts –

such as furniture, glass, textiles, ceramics, bookbindings, leatherware, and metalware. It was headed by Josef Hoffmann and Koloman Moser. After being trained at the Academy in painting and drawing, Moser attended Vienna's School of Arts and Crafts and, like many artists of his generation, dedicated himself almost entirely to this field. Their declared aim was to fill life with art.

This silver inkpot with its stand is an example of the sort of perforated metal items produced by the Wiener Werkstätte from designs created by Josef Hoffmann. Koloman Moser's creations were similarly square in design. This approach of applying a uniform concept to all utilitarian objects intended for everyday use was the main principle running through this whole branch of art.

BS

Thonet Brothers, Chairs model no 56 and no 4, patent 1885 and 1849, manufactured after 1922 and 1881–1890
Bent beech, caning,
81.5 x 36.8 x 43 cm and 93.5 x 42 x 52 cm

Michael Thonet (1796–1871), a German furniture-maker who settled in Vienna in the 1840s, developed new methods for making modern suites of furniture. He developed a procedure for bending wood which resulted in simplifying production and as well as lowering costs, increasing durability, and lightweight design. His chairs, which were designed for cafés and hotels and were produced in their millions around the turn of the 20th century, consist of just a few basic elements. The rear legs and backrest are molded from a single piece. The front legs are attached to the seat which is made from a wooden ring with caning.

Thonet was able to create timeless furniture for a mass market, the aesthetic appearance of which resulted directly from the way it was manufactured. Among the exhibits on display from the Musée d'Orsay's rich collection are examples of bentwood furniture produced by Thonet and competing firms, such as the Kohl firm, based on designs by Hoffmann, Wagner, and Loos. BS

**Koloman Moser, Paradise
(detail of an angel),
Glass design for the church
of St. Leopold am Steinhof,
Vienna, 1904**
Distemper on paper,
415 x 774 cm

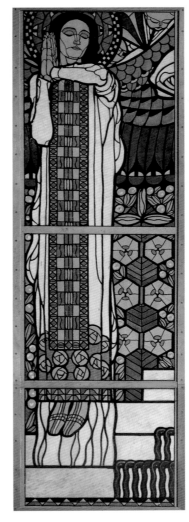

The church of St. Leopold at the Steinhof sanatorium in the Baumgartner Höhe region of Vienna was built by architect Otto Wagner between 1904 and 1907. The church consists of a monumental central building in the form of a cross with cubical side sections, a central cupola, and two bell towers. The building represents the pinnacle of ecclesiastical architecture at this time and conforms completely with the style of Viennese Art Nouveau.

The huge glass panels designed for the church by Koloman Moser blend perfectly with the overall style of the building. The light that is admitted by these panels produces a special white and gold luminosity in the nave. The side windows include motifs of saintly figures, symbolizing the Works of Mercy.

Moser's semicircular window positioned over the entrance porch, the design for which is kept at the Musée d'Orsay, portrays God the Father on his heavenly throne flanked by two angels, at whose feet the figures of Adam and Eve are seen to be kneeling.

The window's structure is strictly symmetrical. The monumental shapes are two-dimensionally stylized, and the background area is decorated with a variety of geometrical, abstract ornamentation. The colors of the stained glass panels are predominantly dull shades of blue or brown.

The majestic figures, the hieratic figure of God, the still and contemplative angels produce an overall effect of solemn stateliness which is entirely in keeping with the spirit of the architect's sacred building.

BS

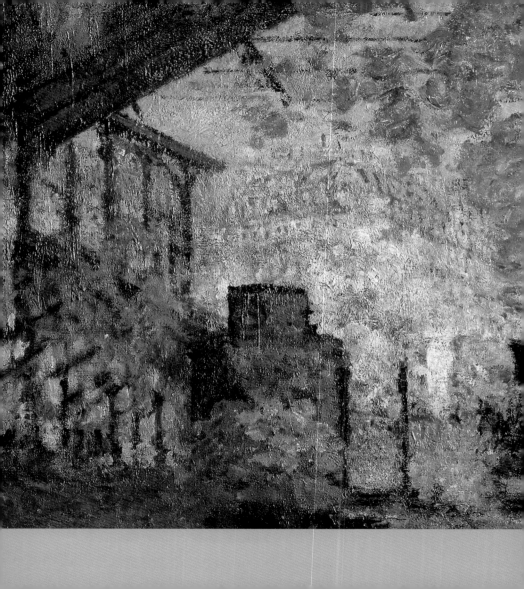

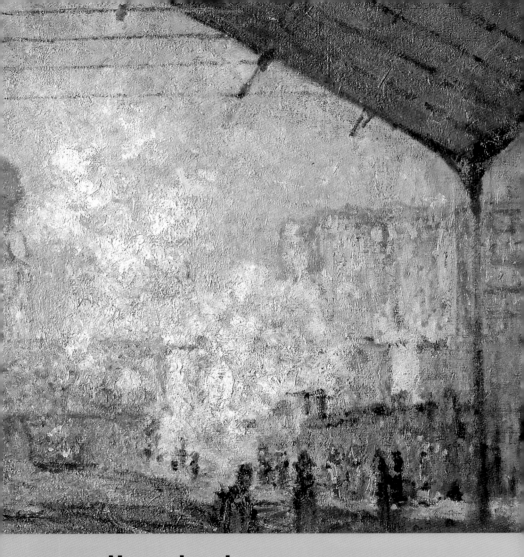

Upper level

Upper level 1

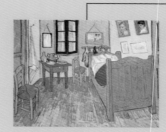

Vincent van Gogh,
Van Gogh's Room in Arles, p. 280

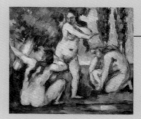

Paul Cézanne,
Three Women Bathers, p. 23

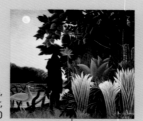

Henri Rousseau,
The Snake Charmer,
p. 340

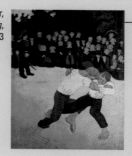

Claude Monet, *Waterlily Pool*,
p. 320

Paul Sérusier,
Breton Wrestling,
p. 343

Other works:

Previous double page:
Claude Monet, La Gare Saint-Lazare, upper level, room 32

Open-air terrace

35

36

Upper level gallery

Upper
level
café

37

38

39

41

40

41

42

43

44

45

46

47

48

Sculpture

Painting

Architecture

Arts and crafts

Temporary
exhibitions

Henri de Toulouse-
Lautrec, *Jane Avril
Dancing*, p. 375

Paul Gauguin, *Women of Tahiti*,
p. 358

Georges Seurat, *The Circus*,
p. 364

Upper level 2

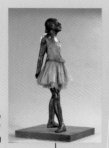

Edgar Degas, *Little Fourteen-year-old Dancer*, p. 220

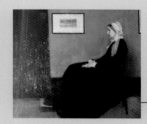

James Abbott McNeill Whistler, *The Artist's Mother*, p. 192

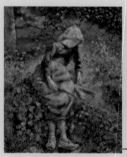

Camille Pissarro, *Young Girl with a Walking Stick*, p. 233

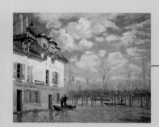

Alfred Sisley, *Flooding at Port-Marly*, p. 234

Claude Monet, *Rouen Cathedral*, p. 266

Other works:

1 Honoré Daumier, *The Republic*, room 29, p. 178

2 Claude Monet, *A Field of Poppies*, room 29, p. 184

3 Gustave Caillebotte, *Planing the Floor*, room 30, p. 202

4 Claude Monet, *La Gare Saint-Lazare*, room 32, p. 260

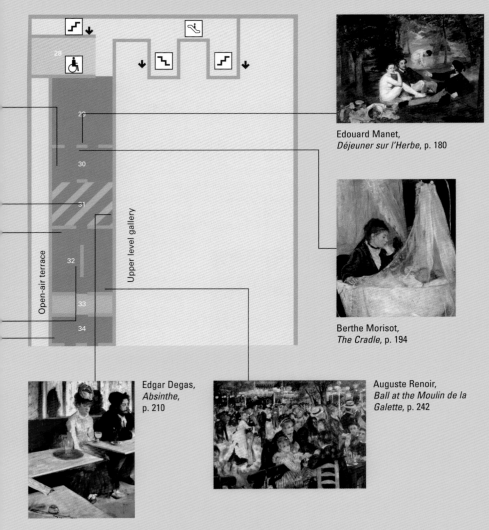

Edouard Manet,
Déjeuner sur l'Herbe, p. 180

Berthe Morisot,
The Cradle, p. 194

Edgar Degas,
Absinthe,
p. 210

Auguste Renoir,
*Ball at the Moulin de la
Galette*, p. 242

28

29

30

31

32

33

34

Open-air terrace

Upper level gallery

The Moreau-Nélaton Collection

Honoré Daumier (1808–1879),
The Republic (with detail), 1848
Oil on canvas, 73 x 60 cm

Daumier's contemporary, often waspish caricatures, which were published in the daily newspapers, brought him fame during his lifetime. However, his day-to-day work prevented him from devoting more effort to painting, which he always envisaged as the ultimate goal for his artistic creativity. Daumier's paintings, in total around 250 of them – an almost negligible number compared with the thousands of drawings and lithographs – were initially familiar only to a small circle of friends. It was not until the major exhibition of 1878, arranged by Durand-Ruel a year before Daumier's death, that he obtained public recognition as a painter.

The subject matter of Daumier's early pictures is mythological, religious, or allegorical. His painting *The Republic* – a reference to the Christian concept of *caritas* (love) – is a personification of the French Republic, in the form of a mother, nourishing and teaching her children. She is seated on a cuboid throne of stone, against an almost monochromatic, midnight-blue background. With one hand she is grasping the tricolor, while holding one of her children with the other. In the foreground, the third child is reading.

The sculptural effect produced by the ample, naked bodies and the dramatic lighting lend baroque pathos to the work. It might have been inspired by Rubens, and looks more like the work of Delacroix than of Daumier. At the same time, however, it is typical of Daumier that he was able to achieve such an impressively monumental effect in a small-scale format.

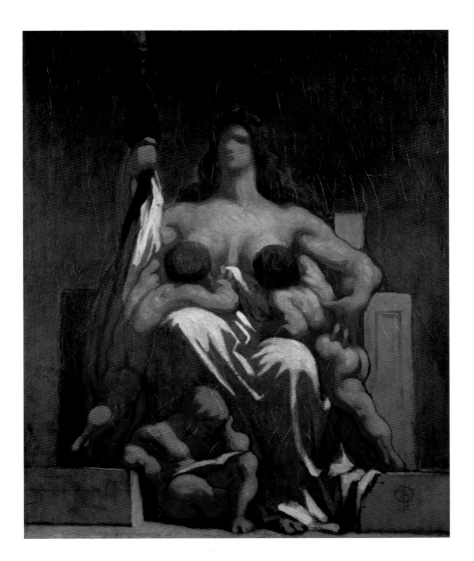

Historical painting and modernity

To create pictures of modern life, instead of continuing to paint stale old mythological and historical subjects – this, in a nutshell, was the fundamental challenge to contemporary artists posed by the art critic Charles Baudelaire. To this he added a second maxim: although the subject matter of the pictures was to be drawn from the present, the means of portrayal were nevertheless to remain timeless, and therefore in a certain sense "classical." Modern painting attempted to combine contemporary subject matter on one hand with the entire arsenal of historical forms of artistic expression on the other.

Manet became the prototype of the "modern painter," according to Baudelaire's definition. The painting that caused a scandal, which was exhibited in 1863 in the Salon des Refusés, is not of a picnic in an urban forest, as the French title suggests. Instead, it highlights the prostitution that was widespread in the Bois de Boulogne, which was common knowledge in Paris, but which was a taboo subject and certainly not suitable for a painting. Two gentlemen in bourgeois attire, deep in conversation, are sitting with a naked young woman, who fixes the onlooker with a self-assured stare. In the background, a female bather is standing knee-deep in a small pool. On second glance, one is irritated by the odd arrangement of the posed group, apparently placed on the forest stage almost in the manner of a collage. It becomes clear that the picture is not a scene observed by the artist, but has instead been deliberately staged. There are also precedents for it in the history of art.

Experts make frequent references to the famous *Concert Champêtre* (ca. 1510), previously attributed to Giorgione – however, as a result of recent research, also frequently attributed to the young Titian – which Manet would have been able to study in the Louvre at will. A friend of the artist reported that a copy of this

Edouard Manet, Le Déjeuner sur l'Herbe, 1863, oil on canvas, 208 x 264 cm, upper level, room 29

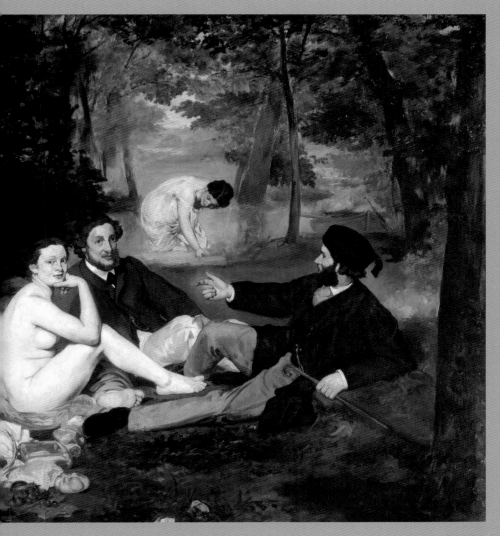

Italian Renaissance painting, which depicts two clothed men and two naked women with nature as the backdrop, even hung in Manet's studio.

However, the two paintings have practically nothing in common: Manet adopted neither the motif of the musicians, to be construed as symbolizing harmony, nor the goatherd with his flock, which extends the subject matter of the picture and turns it into a bucolic genre scene. As regards the composition of the painting and the positioning of the models, Manet was reproducing in detail a copper engraving by Marcantonio Raimondi, executed ca. 1515/16 from a drawing by Raphael. It depicts the figures of two river gods and a nymph in attendance at the Judgement of Paris. Manet used these mythological figures as templates, on which he then superimposed his urban characters.

As a result, the subject chosen from the stock of traditional historical themes was completely reinterpreted and secularized, or, viewed from another angle, the secular theme was structured in the form of a historical quotation; the categories of painting that had previously been fundamental to artistic thinking, and according to which pictures were judged, were thus broken down. This re-evaluation of existing categories and hierarchies, of which the public at that time had an intuitive understanding, was received in 1863 by apparently continuous gales

Marcantonio Raimondi (from Raffael), The Judgement of Paris (Detail), ca. 1515/16, copper engraving, 29.8 x 44.2 cm, British Museum, London

Giorgione, Concert Champêtre, ca. 1510, oil on canvas, 110 x 138 cm, Musée du Louvre, Paris

of laughter. As Zola reported, "The exhibition was separated from the other one (the official Salon) only by a turnstile. One entered as if entering the Chamber of Horrors at Madame Tussaud's in London. One expected to succumb to fits of laughter, and indeed one did laugh, right from the start. Manet's Déjeuner, hanging in the last room, made the walls shake." During his creative life, Manet was particularly hurt by this disparaging attitude, since he did not see himself as a revolutionary or a social outsider, but was at pains to achieve official recognition. Nevertheless, he continued to pursue Baudelaire's ideas rationally, and created in his work an urban panorama formulated in a truly classical style.

MP

Claude Monet (1840–1926),
A Field of Poppies, 1873
Oil on canvas, 50 x 65 cm

Monet showed this small picture at the first group exhibition held by the Impressionists in 1874. The picture is clear evidence of the Impressionists' preoccupation with the then very modern themes of leisure and relaxation. Two women, accompanied by their children, are walking through the tall grass in a field full of poppies. It is easy to see from their fashionable hats and the parasols they are carrying that these are not peasant girls, but young ladies from the city who have come to take a restful walk in the country.

The two couples consisting of woman and child, mark the ends of an invisible diagonal line that conveys an impression of the countryside stretching away into the distance. In this landscape, man and nature are united in a harmonious, colorful whole. A *Field of Poppies* has become one of Monet's best-loved paintings.

**Edouard Manet
(1832–1883),
Blonde Woman with
Bared Breasts, ca. 1878**
Oil on canvas,
62.5 x 52 cm

This relatively large portrait shows how closely Manet's style of painting was able to approach the art of the Impressionists, even in his paintings of nudes. Although the contours of the woman's body are seen as clearly defined, and the almost monochromatic bacground appears almost uniform in its execution, the signs of a direct, very personal brushstroke technique are nevertheless equally apparent. This can be seen in the flower on the hat, or in the wisps of clothing around the shoulder, upper arm, and breast. The charm of this painting derives from the contrasting nature of the techniques used. The effect is that of a fleeting sketch – and yet no detail is missing.

However, the painting also demonstrates how little interest Edouard Manet had as an artist in the classical, and traditional representation of the nude, in which nakedness was usually legitimized by means of symbolic or allegorical meanings. The young woman resembles neither a nymph nor a Venus, but looks quite simply like a young model who has bared her breasts in order to be painted.

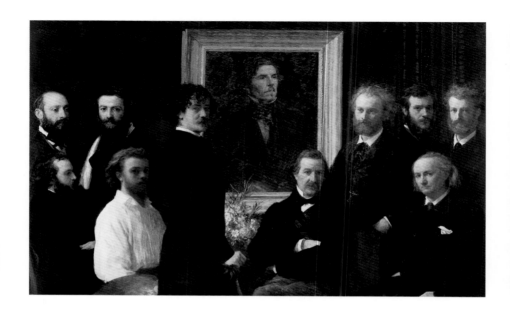

Henri Fantin-Latour (1836–1904),
Homage to Delacroix, 1864
Oil on canvas, 160 x 250 cm

The *Homage to Delacroix* is the first in a series of pictures that Fantin-Latour painted of friends, which, along with his delicate still lifes of flowers, was to bring him fame. It was painted one year after the death of Delacroix. The latter appears as a portrait in the center of the picture, honored by a bouquet of flowers placed in front of it. Fantin-Latour painted the portrait from a photograph that had been published ten years previously. The ten painters and critics who have gathered to pay their respects to Delacroix are, from left to right: Louis Cordier, the critic Edmond Duranty, Alphonse Legros, the artist himself (the only figure appearing in his shirt-sleeves, palette in hand), followed by Whistler, Champfleury, Edouard Manet, Félix Bracquemond, the poet Charles Baudelaire, and Albert de Balleroy.

There are many precedents for the group portrait genre, especially in 17th-century Dutch painting (Frans Hals, for example); as far as the 19th-century artist was concerned, it helped him establish his own traditional credentials.

Alfred Sisley (1839–1899),
Footbridge at Argenteuil, 1872
Oil on canvas, 39 x 60 cm

During his creative period, Sisley, to an even greater extent than Pissarro, was almost exclusively a painter of landscapes. The majority of his works focused on the small villages in the vicinity of Paris, such as Marly, Louveciennes, Voisins, Sèvres, and Moret-sur-Loing, as a result of which he became known as the Impressionist who painted the Ile-de-France.

In the *Footbridge at Argenteuil* we can already see one of his favorite motifs: water.

But the resemblance to several of the sensitive landscapes of Camille Corot, whom Sisley much admired, is still visible. The structure is somewhat conventional – with the diagonal of the footbridge leading the eye into the picture – and the colors are subdued. In addition, the forms of the objects are drawn with the brush, as can be seen for example in the figure of the man with the walking stick. Sisley was not the only artist to have painted the bridges at Argenteuil, which was one of the most important centers of Impressionist painting. Claude Monet and Camille Pissarro also returned to this motif repeatedly over the years.

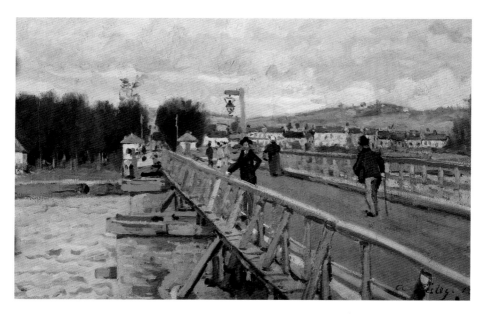

Charles Baudelaire – discoverer of modernity

Charles Baudelaire (1821–1867), a tragic, enigmatic personality, has become the stereotypical modern hero, a product of the epoch that he himself defined and described. His life seems to have been characterized by perpetual failure. His privileged start in life, his artistic ability, and his potential for development were only marginally utilized. Baudelaire's "spleen," a total inertia that sometimes overwhelmed him like an attack of influenza, hindered and paralyzed his productivity. Volumes of poetry, a novella, critical accounts of the Salons, essays, and correspondence were nevertheless produced – but no *roman à clef*, and no plays. He could not summon up the sustained effort or day-to-day application necessary to produce a major work. At the time of his death – he died aged 46 years – he was practically unknown; on the Parisian literary scene he was regarded at best as a brilliant eccentric, who had perpetual difficulties finding a publisher. Perversely, his work was much more warmly received after his death. His poetry appealed to an entire generation, which identified with it. The Impressionist painters' attraction to subjects taken from modern life, the countless depictions of scenes in cafés, pastoral picnics, horse races, people strolling on the boulevards, the prostitutes and socially excluded, had all been addressed – indeed practically laid down as a requirement – in Baudelaire's theoretical writings on art.

Baudelaire lived his life as a bohemian and an

Charles Baudelaire, ca. 1854, photographed by Félix Nadar

eccentric. When he inherited a fortune at the age of 21 following the premature death of his father, he moved into palatial apartments in Paris and spent it in record time. Two years later his mother was once more obliged to bale him out; he was declared incapable of managing his own affairs and had to exchange his luxury accommodation for a garret room, which he shared with his lover, Jeanne Duval. He was

involved in a problematic relationship with her lasting many years, characterized by mutual dependencies, quarrels, illnesses, episodes of addiction, and separations. Both were dependent on drugs and infected with syphilis. In 1845, Baudelaire attempted suicide. "I am killing myself, because I cannot go on living, because the effort of going to sleep and the effort of waking up have become intolerable for me," he wrote in his valedictory note. Obliged to face up to life again, he returned to his earliest plans and began working as a writer. The first works he published were criticisms of the Salons, for which there was a large and interested readership at that time, and a corresponding demand on the part of the publishers. Confronted with the countless heroes of antiquity and with the half-clothed mythological figures in the paintings at the Salons of 1845 and 1846, Baudelaire called the aims and possibilities of contemporary art into question. Under the title "On the heroism of modern life," the 24-year-old writer ventured a revolutionary prognosis: "The true painter," he wrote, "will be the painter who takes the epic side of contemporary life, and who by means of his colors or

his drawing teaches us to understand how great and how poetic we are in our neckties and our patent leather boots." Instead of the historical picture, with its glorified borrowings from the past and its claims to be morally improving, the task and challenge facing painters was the picture depicting the present. Baudelaire was, simultaneously, questioning artistic form.

In an era of enormous upheavals, quantum leaps in technology and industry, and new forms of social structure, Baudelaire suggested that art should find new forms of expression too: it was a matter of developing different perspectives and techniques, capable of formally

Edouard Manet, Portrait of Jeanne Duval, 1862, oil on canvas, 90 x 113 cm, Szépmüvészeti Múzeum, Budapest

LES

FLEURS DU MAL

PAR

CHARLES BAUDELAIRE

On dit qu'il faut couler les exécrables choses
Dans le puits de l'oubli et au sépulchre encloses,
Et que par les escrits le mal ressucité
Infectera les mœurs de la postérité ;
Mais le vice n'a point pour mère la science,
Et la vertu n'est pas fille de l'ignorance.

(THÉODORE AGRIPPA D'AUBIGNÉ, *Les Tragiques*, liv. II)

PARIS

POULET-MALASSIS ET DE-BROISE

LIBRAIRES-ÉDITEURS

4, rue de Buci.

1857

*Frontispiece to the first edition of Baudelaire's Les Fleurs
du Mal, 1857*

respect after an interval of ten years. Baudelaire entitled a chapter of a text written in 1863 "La modernité," thus inventing the concept that characterized this epoch more than any other. The word "modernus" was not new, but had been used since antiquity to describe whatever was new, current, or very fashionable at any particular time, to distinguish it from the old or unfashionable. Baudelaire's nominalization of the adjective was, however, not just a grammatical quirk, but an interpretation of the present, the main identifying feature of which is obviously the constant replacement of what was new yesterday with what is new today. Developing this idea further, we see that the only thing that is permanent is change – impermanence, perpetual renewal. As a logical consequence, therefore, it is impossible for tangible values, or a timeless aesthetic consensus to continue to exist; instead, man and society around him must continually reinvent themselves. In many respects our understanding today of the modern and the avant-garde is marked by Baudelaire's analysis.

For Baudelaire the poet, the slowly formulated concept of the modern was accompanied by the search for an adequate literary language. His most famous collection of poems, which was published in 1857 under the title *Les Fleurs du Mal* (The Flowers of Evil), and which the imperial censors considered offensive

capturing the features that were symptomatic of that particular era. Impressionism, by virtue of its sketchy painting technique, its fast and spontaneous accessing of subject matter without preliminary drawings and compositional studies, finally met Baudelaire's demands in this

because of its blasphemous tendencies, juxtaposes ancient myths with observations of Parisian daily life, the elevated with the banal, the fantastic with social realism. For Baudelaire, both the past and the present became raw material, set pieces, or quotations. He did not, therefore, work on a great literary panorama, such as Emile Zola and Honoré de Balzac attempted to achieve with an extremely precise, objective, even scientific approach, but recognized that it was the fragment, the isolated detail, that can in fact provide information about modern urban reality in all its variety and its hectic pace. He wrote poems – partly under the influence of hallucinogenic drugs – which, by virtue of their impenetrability, were still influencing authors in the subsequent Surrealist movement 50 years later.

As a writer, Baudelaire had an almost unprecedented belief in the untrammeled development of artistic individuality and originality. "In the realms of poetry and art … every flower is spontaneous, individual," he wrote. "An artist can call only upon himself. He promises the future nothing, except his work. He is answerable only to himself. He is his own king, priest, and God." The description of the working and living conditions of modern artists could hardly be clearer or more prophetic. The social isolation, the sense of existential completeness, the unqualified belief in their own actions, without institutionalized support – such was the path that generations of young painters, writers, and musicians in the 20th century were to tread. Baudelaire, the magician among poets, was one of their forefathers.

MP

Manuscript page from Baudelaire's poem "Les Yeux de Berthe"

James Abbott McNeill Whistler

**James Abbott McNeill Whistler (1834–1903),
Arrangement in Gray and Black no 1:
Portrait of the Artist's Mother, 1871**
Oil on canvas, 144 x 162 cm

James Abbott McNeill Whistler painted his famous *Portrait of the Artist's Mother* in the summer of 1871 in London, and exhibited it only one year later at the Royal Academy. The painting shown in the Paris Salon in 1883 was bought by the French nation in 1891. Whistler was extremely familiar with avant-garde trends in both these metropolitan art centers. Born in Massachusetts, in the United States of America, his family initially moved to Russia. From 1859 he lived in London, and during his first stay in Paris, from 1855 to 1859, he struck up friendships with Courbet, Fantin-Latour, and other young artists. Nevertheless, his painting remained remarkably self-contained and independent, strong evidence of which is provided by the portrait of 67-year-old Anna Mathilda Whistler. The artist wrote as follows about this painting: "It is interesting for me, because it is a portrait of my mother; but can, or should, the public be interested in the person portrayed? The value of the picture must be determined exclusively by the quality of its construction." Whistler showed his mother in profile, seated on a chair, incorporating her formally within a rigid system of verticals and horizontals provided by the floorboards, curtain, chair-back, footstool, and pictures on the wall. The woman, dressed in black and wearing a white bonnet, stands out clearly against the gray wall; form and color are therefore subordinate to the overall design of the picture, which has been thought through in a strictly disciplined fashion.

The *Portrait of the Artist's Mother* stands at the beginning of Whistler's successful career as a portrait painter, and already contains all the characteristics of his subsequent works. Most of his portraits are typified by a restraint that is intended to achieve harmony, and this was in tune with neither the English nor French contemporary taste. In producing his simple paintings, Whistler turned to the Calvinist-influenced 17th-century interior painters, with whose work he had become familiar in the summer of 1863 in the northern Netherlands, and also in museums in London and Paris. Dutch art of the "Golden Age" was of equal significance for Whistler as that of the Far East, especially Japan, where he had found his ready-made ideal of formal harmony.

CS

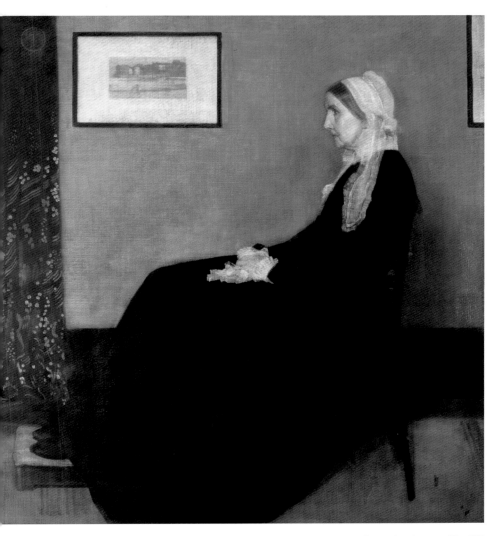

Berthe Morisot and Mary Cassatt

Berthe Morisot (1841–1895),
The Cradle, ca. 1872
Oil on canvas, 56 x 46 cm

A decidedly feminine element is introduced into the art of the Impressionists in the works of the artists Berthe Morisot and Mary Cassatt. Subject matter taken from the sheltered lives of prosperous women and children interested their male colleagues far less frequently.

The Cradle was shown in 1874 at the first Impressionist exhibition. Berthe Morisot – as the only female artist in the exhibition – was represented by eight additional works. The subjects of the painting are her sister Edma and the latter's daughter Blanche, born in 1871. An atmosphere of intimacy emanates from the picture, which depicts the intensity of the bond between mother and child. Seated by the cradle, the mother watches over the sleeping newborn child, who lies with her right hand resting on her head. The delicate features of the baby, whose face is turned toward us, can be seen only indistinctly through the drapes. Contrasting with this is the profile of Edma, on which a warm light is falling, and which Berthe Morisot has painted with considerable economy and restraint, but at the same time with appropriate definition.

Impressionist painting in the 1870s attempted to capture a moment in a constantly changing world. By contrast, Morisot's picture conveys an impression of time standing still. But the artist's sister is holding the drapes around the cradle between the fingers of her right hand. At any moment, Morisot seems to be saying, she might move it, lift the baby, and change the scene.

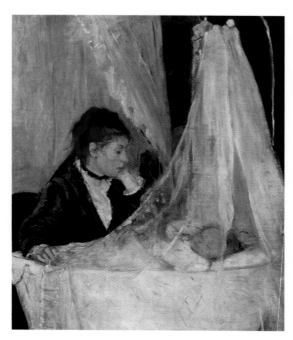

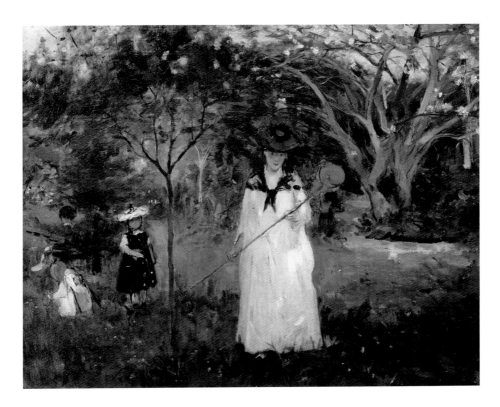

Berthe Morisot, Looking for Butterflies, 1874
Oil on canvas, 46 x 56 cm

As in *The Cradle*, we again see Edma and Blanche in this painting. This time they are pictured with Jeanne, Blanche's elder sister in a garden full of rich green color. A delicate, young tree is growing in the foreground, while in the background a stout old one is visible. Artistic forms have been relaxed to capture nature and people on equal terms. Thus, no features are visible on Jeanne's countenance, and it is hard to decide whether the light-colored flecks scattered among the natural greenery are butterflies or flowers. It captures the visual impact of the scene and is thus a typical Impressionist work.

Berthe Morisot, Young Woman in Ballgown, 1879
Oil on canvas, 71 x 54 cm

It is easy to imagine how Mary Cassatt's young *Woman with Needlework* might look, if she were to put on a ballgown and lift her head to gaze curiously, and yet still rather shyly, at the world. Morisot's picture illustrates just such a moment. Suddenly, the background to the pictures acquires equal significance. The dense vegetation shuts out the external world and protects the young woman's youthful beauty and innocence. The luminous flowers symbolize her life as it may be in the future. The neckline of her dress, its picturesque opulence suggestive of a bouquet of flowers, supports such an interpretation of the picture.

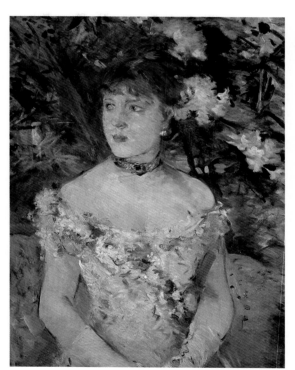

Mary Cassatt (1845–1926), Woman with Needlework, ca. 1880/1882
Oil on canvas, 92 x 63 cm

Mary Cassatt's artistic interest focused on the human form. This was something she shared with her painter colleague Edgar Degas, by whom she was most influenced. The *Woman with Needlework* is a typical work by Cassatt. Central to the painting is a young woman from a good, protective family. She is presented in a three-quarter-length pose in the open, sitting in the soft light of a shaded corner of the garden.

The painting comes alive by virtue of the calculated tension between the delicate draftsmanship with which the face and hands are rendered in the center of the painting, and the simplification of the pale blue dress.

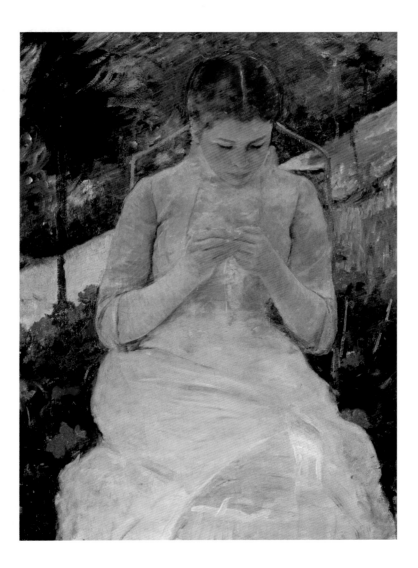

On women painters and other oddities – women painters in Paris

"And I can see nothing … nothing other than painting. If I were to become a great painter, it would be fate compensating me, I would have the right to possess feelings and opinions (of my own). I would really be something." These were the words written in 1878 by the 19-year-old Russian, Marie Bashkirtseff, in her diary, which documents the period that the artist, who died prematurely, spent studying at the Académie Julian in Paris. The artistic center in the French capital was the only place in 19th-century Europe offering women reasonably acceptable educational opportunities, and thus Paris became a melting pot for an international community of female students. Although they were also denied access here to the official Académie des Beaux-Arts until 1897, many private academies ran so-called ladies' classes offering art lessons to women. The quality of the teaching was nevertheless very variable, and depended on the commitment of the individual teacher. Frequently there was no entrance examination, in order that the great demand for educational opportunities for women could be met with maximum profit, nor was there any critical discussion of the pupils' efforts, with the result that the entire sphere of women's study was overshadowed by a certain dilettantism. In addition, a crucial aspect of the training of an artist – the study of the nude – was usually completely absent. Although accurate knowledge of human anatomy was an essential prerequisite for historical painting, women were only allowed to draw plaster casts or clothed models. As a consequence, women painters were consigned to the so-called minor categories of portraiture, still life, animal paintings, or genre scenes.

Despite these limitations and restrictions, a whole series of female artists achieved public recognition in the 19th century, succeeding in securing for themselves a

Marie Bashkirtseff (1859–1884), with model in the studio

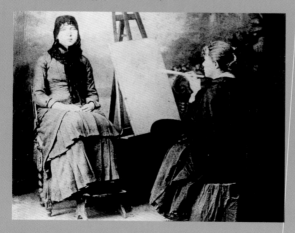

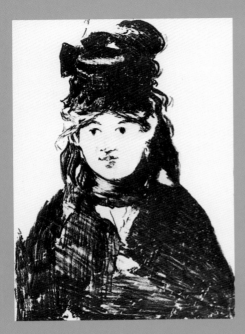

Rosa Bonheur (1822–1899), one of the most successful female painters of her times

Berthe Morisot (1841–1895), a lithograph by her brother-in-law Edouard Manet, from a portrait dated 1871

place in the art world and in the documented history of art. One such was Rosa Bonheur (1822–1899), who, despite her apparently conservative career as a painter of animals, was a particularly independent and confident artist. In the 1840s and 1850s she enjoyed overwhelming success in the Salons and at court with her large-scale animal paintings, which were partly interpreted as political allegories. Usually clad in men's attire when traveling to the slaughter-houses or livestock markets where she made numerous sketches, and as a lesbian who lived with her partner, she even developed a rational alternative to the traditional role model assigned to women in her private life. In 1849, Rosa Bonheur opened a private school of draftsmanship for girls, which was supported by the Emperor, but throughout her lifetime she continued to press for the Ecole des Beaux-Arts to be opened to women.

A generation later, alongside Marie Bracquemond and Eva Gonzalès, two female artists whose high-quality works are still central to Impressionist painting regularly exhibited their

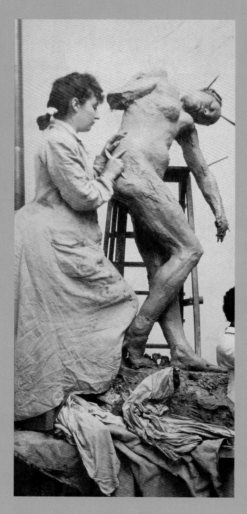

Camille Claudel (1864–1943) at work

work in the group exhibitions: Mary Cassatt (1845–1926) and Berthe Morisot (1841–1895). While Cassatt, an American who had been a pupil of the famous Salon painter Jean-Léon Gérôme and who lived in Paris permanently from 1874, had gained access to the Impressionist circle through her contact with Edgar Degas, the turning point for Morisot was her meeting with Edouard Manet, whose brother Eugène she married in 1877. Initially, under the influence of Corot and Daubigny, Morisot had worked in the open air using muted, earthy colors, but now lightened her palette and began using a freer brushwork technique. *The Cradle,* shown at the first group exhibition in 1874, is a major work already displaying maturity and at the same time an illuminating example of Morisot's typical subject matter. The private domestic scene, and in particular the intimate relationship between mother and child, repeatedly attracted her attention, reflecting the kind of life led by women in affluent bourgeois society. In this, she shows an affinity with Mary Cassatt, who, having had some success in the Salons with several very conventional portraits, found innovative forms of expression, especially in pastels, and likewise turned for her subject matter to the daily lives of women living in carefree, happy, and yet constrained circumstances. Mary Cassatt, who had already exhibited work in the USA pavilion at the 1878 Great Exhibition, and whose work was exhibited exclusively on several occasions from 1881 onwards by the respected gallery owner Durand-Ruel, also became active as a patron and as a contact between her painter friends and the American art world.

The very small number of women who were active in the male-dominated world of sculpture included Camille Claudel (1864–1943), whose sculptural work was overshadowed by that of Auguste Rodin for far too long. For a period of nearly ten years, Claudel was Rodin's preferred model, his pupil, his studio assistant, and ultimately his most important colleague and his lover. Working alongside him, she produced a body of work in her own, sympathetic style, which should be regarded not just as subject to Rodin's influence, but also as having exerted a far greater influence on his creative efforts than has previously been supposed. However, this artistic and erotic partnership was not characterized by mutual inspiration alone: competitiveness, envy, and jealousy were even stronger factors. Despite exhibiting her work regularly and being favorably received by the critics, Camille Claudel, by contrast with Rodin, never succeeded in obtaining her own public commission, and thus never gained recognition as an artist in her own right. For the most part, therefore, she created small-scale sculptures and models, which were seldom converted into large marble or bronze sculptures because of the enormous financial outlay required. After phases of stagnation, she felt exploited, persecuted, and plagiarized by Rodin. In 1893 she moved back to her studio in the boulevard d'Italie and began a dramatic slide into destitution and decadence, to which her mother and her brother, the famous writer Paul Claudel, finally responded in 1913 by committing her to an asylum. She died there 30 years later, languishing in isolation and almost completely forgotten.

Self-confidence in their dealings, expecta-

tions of subordination, gradual accommodation, or furious rebellion – female artists had many approaches to life and work as a reaction to the restrictions and obstacles imposed on them by society. The artistic breakthrough came mostly when they were able to circumvent the female roles traditionally assigned to them, when they succeeded in escaping from domesticity and were able to participate in the male-dominated art world. The French capital and the fast-moving private art market offered new opportunities, even to women.

Even a small studio offered many female artists their first measure of freedom

Gustave Caillebotte

Gustave Caillebotte (1848–1894),
Planing the Floor, 1875
Oil on canvas, 102 x 146.5 cm

Caillebotte was a collector as well as a painter. The considerable fortune that he inherited in 1874 was invested in the paintings of his artist friends Cézanne, Degas, Manet, Monet, Pissarro, Renoir, and Sisley. After his death in 1894, this collection was bequeathed to the French nation. Caillebotte forged friendships with the Impressionist painters by virtue of his art. At the second Impressionist exhibition in 1876, in addition to several traditionally executed paintings, he showed his famous *Planing the Floor*, which caused a considerable stir. Three men, naked from the waist up, are kneeling on the floor of an empty room flooded with sunlight, planing the floorboards. The onlooker observes the scene from above, with the result that the workers appear below the horizon line. By using this device in his composition, the painter probably intended to emphasize the low social status of the men. The portrayal of urban work, rather than agricultural work such as in Millet's *Corn Gleaners* (see page 84), is as typical of Caillebotte as the extraordinary aesthetic with which he depicts strong physical exertion. Because of this, and because of the unconventional form of the composition, *Planing the Floor* is still ranked today as a masterpiece.

CS

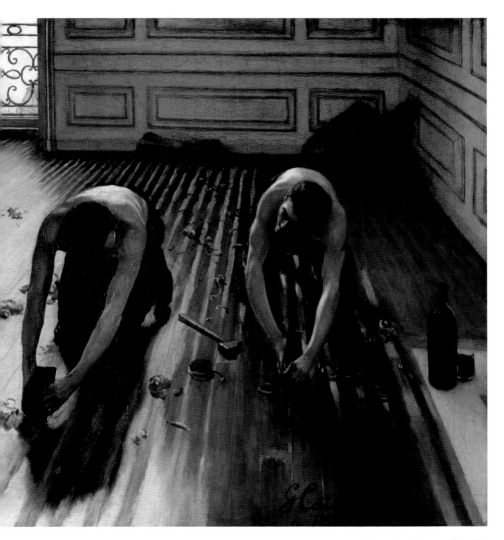

Edgar Degas

Edgar Degas (1834–1917),
Orchestra of the Opéra, ca. 1869
Oil on canvas, 56.5 x 46 cm

Edgar Degas had probably made the acquaintance of the bassoonist Désiré Dilhau by the mid-1860s. When the latter asked the artist to paint his portrait, Degas

initially intended to paint him alone, but then the idea occurred to him to paint the unusual view of the *Orchestra of the Opéra*. The orchestra is not authentic and the position of the instruments is arbitrary. The musicians include members of the orchestra, such as the cellist Louis-Marie Pilet, and in addition friends of both the painter and the musician.

The picture uses many of the techniques that are typical of Degas. The fragmentary scene is boldly chosen. The musicians filling the central space are enclosed by the front edge of the orchestra pit and the apron of the stage. Degas uses a formal detail – the back of the chair on the right – to create a link with the background, in the shape of the coffered paneling of the box. The heads and feet of the dancers are cut off, and they appear only as pink and blue tutus. Emmanuel Chabrier, the only composer known to be a friend of Degas, peers out from the small box in the top left-hand corner of the picture. The scroll-shaped neck of the double bass

rises up out of the orchestra pit toward the brightly lit stage and stands out as a dark shape against the light background.

For Degas, this group portrait signified a breakthrough in terms of his own personal subject matter, the world of the Paris Opéra. Thanks to his friends, the artist was not only able to attend performances, but also rehearsals and even lessons. Thus Degas was able to climb out of the orchestra pit and enter the world of ballet dancers that was to prove so important for his art.

Edgar Degas, Lorenzo Pagans and Auguste de Gas, ca. 1869
Oil on canvas, 54.5 x 40 cm

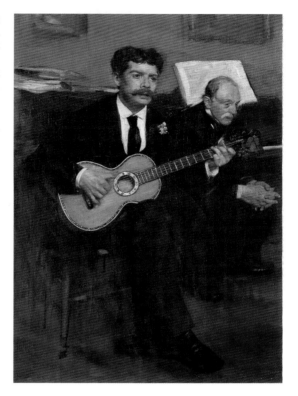

In around 1865, Degas became friendly with Edouard Manet, and made contact and struck up friendships with the circle of late-Impressionist painters. From that point onward, he turned increasingly to the portrayal of modern life in his painting, and the world of the Opéra entered his work.

Degas came from a musical family and inherited his love of music from his father, through whom his first friendships with musicians were formed. This painting shows the artist's father, seated in front of an open grand piano, his head thrown into relief in a very distinctive manner against a background of sheet music. In the foreground, Lorenzo Pagans, guitarist and tenor at the Opéra, is sitting playing his instrument. The involvement of both men in the music lends the small-scale picture intense warmth. As a mark of his esteem of the musicians depicted, perhaps also as a personal memento, this picture hung in Degas' bedroom.

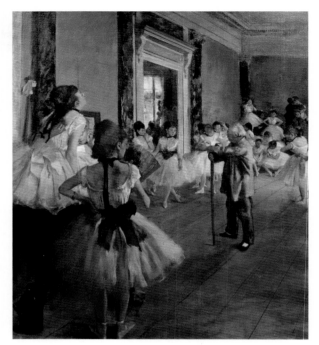

Dance Class at the Opéra was Degas' first masterpiece from the world of dance, the theme of his most prolific sequence of pictures. During the years in which Degas chronicled its progress, French ballet suffered a decline. The great era of Romantic ballet, from the late 1820s to the late 1860s, was at an end, and the next golden age would only come at the beginning of the 20th century with the advent of the Ballet Russe.

Degas' *Dance Class at the Opéra* harks back to past greatness, for in the center, surrounded by his pupils, stands the dancing teacher Jules Perrot, formerly a star performer in the Paris Opéra, who had also achieved fame as a dancer-

Edgar Degas,
Dance Class at the Opéra (with detail),
ca. 1873/1876
Oil on canvas, 85 x 75 cm

In around 1874, Degas was preoccupied with six major series of motifs, to which he was to devote himself with varying degrees of intensity: horse racing, women washing or ironing, café-concert singers, milliners, ballet dancers, and women at their toilet.

choreographer, and *maître de ballet* in London and St. Petersburg. By showing the young dancers standing at a respectful distance from Perrot, Degas succeeds in emphasizing the form of Perrot in the middle of the large room.

Degas often chose rehearsal and teaching situations for his pictures of the ballet, performances less frequently. By means of these glimpses behind the scenes, the painter provides us with an intimate insight into the fascinating world of ballet.

Narrative details – such as the watering can in the bottom left-hand corner of the picture, the dancer at the piano scratching her back, the transparent fan of the dancer in the foreground, and the stage mother in the background, putting a consoling arm around her daughter – are not arbitrarily chosen, but carefully calculated compositional elements. He prepared these by means of numerous drawn studies. Even the action of the girl scratching her back, which amuses the onlooker because it is so mundane, was first captured by Degas in a study. The German painter Max Liebermann, a contemporary of Degas, enthused at the time about the Frenchman's talent for structuring paintings. In addition to the "impression of a fleeting moment in time" captured in the pictures, Liebermann remarked admiringly: "He knows how to compose a picture in such a way that it does not appear to have been composed at all."

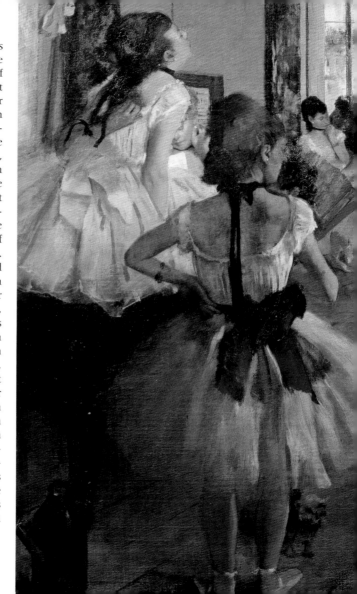

Edgar Degas, Blue Dancers, ca. 1886/1890
Oil on canvas, 85 x 75.5 cm

In the years after 1890, Degas frequently picked out three or four dancers from a group. In these compositions he showed less interest in the relationships and tensions between figures and the surrounding space than in so many of his previous pictures, focusing instead on the movements of the arms and torso in particular. The dance studio, the barre, the mirror, in other words everything identifying the location, have all disappeared. The faces of the dancers are unrecognizable. Form and outline, the flow of lines and internal drawing, the relationship between figure and background, are apparently all that is

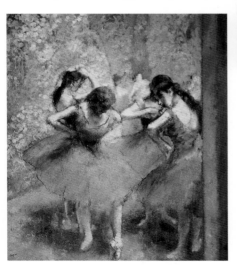

important for the painter. The four dancers almost melt into one. Degas painted their poses as a sequence of movements in space, seen in slow motion. The replication of the figures is accompanied by an intensification of color.

From the numerous pictures of ballet dancers which only the Musée d'Orsay can offer, we can see why for us today the name of Degas has become almost synonymous with the ballet. For years Degas attended rehearsals, and returned over and over again to this theme.

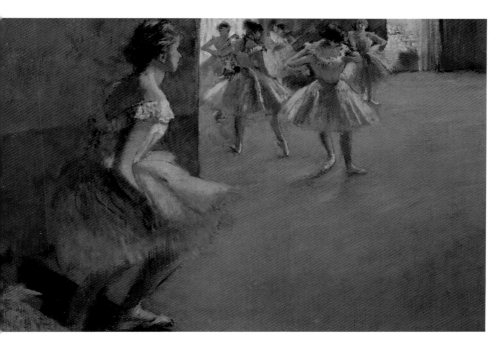

Edgar Degas, Dancers Climbing the Stairs, ca. 1886/1890
Oil on canvas, 39 x 89.5 cm

Degas' paintings of the ballet, with their eccentric viewpoints and bold intersections, have an enormously modern feeling. He was fascinated by the way dancers moved. This scene, with its simple foreground, is typical of Degas. A few dancers are hurrying up the stairs to the dance floor to join others in the lesson. The edge of the picture cuts drastically into the two figures on the left of the staircase; the turning movement of the figure nearest the front introduces a counter-movement laden with tension into the picture. The other dancers are gathered in the background. The blank surfaces of the floor and the wall contrast with the taut arrangement of figures in the rectangle of the picture and their varying size. Degas' mastery as an artist is shown in the original spatial arrangement. He composed "not in space, but with space," as the German painter Max Liebermann had already observed.

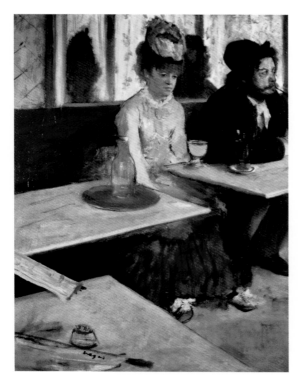

Edgar Degas, Absinthe, ca. 1876
Oil on canvas, 92 x 68 cm

After a visit to Degas' studio, the novelist Edmond de Goncourt wrote in 1874: "He is currently the man best able to portray contemporary life, to capture its essence." The characters and the location of this painting are known. They are the painter and engraver Marcellin Desboutin and the actress Ellen Andrée, pictured in the Café Nouvelle Athènes on the Place Pigalle. This café had just succeeded the previously frequented Café Guerbois as the favorite meeting place for Edouard Manet and his circle.

The faces of both visitors to the café are placed by Degas in the top right-hand corner of the picture, while most of the remaining surface of the painting is taken up by largely empty tables. *Absinthe* is therefore a decentralized composition, in which filled and empty spaces contrast with one another. In addition, the perspective alternates: we see the tables from above, but the man and woman from below.

The juxtaposition of the two people, together with the intense black shadows of their heads in the background, emphasizes the prevailing sense of dislocation. The two figures, sitting in silence with their glasses in front of them, ignoring one another, are in general terms a metaphor for modern man: indifferent, perhaps even desensitized, and for whom the café is no longer a place where experience has heightened intensity. He is alone, even when he is in company, and he knows it: the light in the eyes has been extinguished. The use of cold blue and gray emphasizes the sombre mood.

Edgar Degas,
Madame Jeantaud in Front of the Mirror,
ca. 1875
Oil on canvas, 70 x 84 cm

In the 1870s, the Jeantauds were among Degas' close circle of friends. The portrait shows Madame Jeantaud in front of a mirror, an artistic device that not only opens up the pictorial space, but also allows two aspects of the subject to be shown. What we see directly is the profile of Madame Jeantaud that is turned away from us. She is evidently about to go out, and is casting a final glance over her apparel; her face appears in the mirror in three-quarter profile.

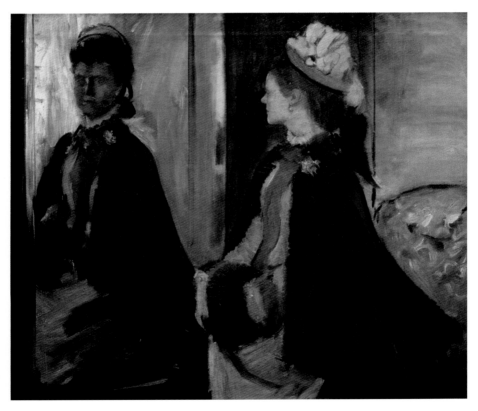

The bohemian life –
the café as a meeting place for artists

"…They began a heated discussion over their drinks. They were comparing open-air painting with working in the studio. They talked at great length about how the jury at the Salon was tied to the past, and how it might be possible to be accepted by the Salon without first having to imitate the imitators. One of them suggested blowing up the Beaux-Arts building while a general meeting of the Academy was in progress. Another was of the opinion that they would have to burn down the Louvre. Cézanne had the idea of giving the members of the Academy five acres of land in Algeria, and forcing them into an honorable early retirement. There was a great deal of laughter."…This fictional scene, described by Irving Stone in his novel *Depths of Glory* (1985), is set in the Café Guerbois, where Claude Monet, Camille Pissarro, Frédéric Bazille, and Paul Cézanne met regularly in the evenings, and accurately captures the rebellious mood and also the ironic, mocking tone that was prevalent among the young artists of the Impressionist generation. The shared perception of being excluded from the official art world, and the wrangling with the Academy and the Salon, which were the authoritative but totally fossilized institutions providing artistic training and careers in art, united them in a group seeking its own guidelines and artistic goals, as well as new places where they could exhibit their work in public. The cafés and brasseries thus provided a forum for nocturnal discussion, permitting an exchange of opinions between painters, writers, and journalists of the type that was so painfully lacking within the

Edouard Manet, In the Café (Café Guerbois), 1869, pen-and-ink drawing, 26.2 x 33.3 cm, Staatliche Museen, Berlin

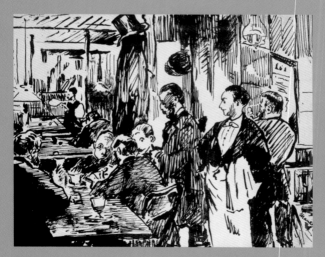

*Edouard Manet, George Moore in the Café Nouvelle Athènes, ca. 1879, oil sketch,
65 x 81 cm, Metropolitan Museum of Art, New York*

highly traditional Académie des Beaux-Arts. During the course of a single evening, questions relating to art theory or practical questions about the craft of painting might lead to heated debates, polarizations, the formation of cliques, disagreements, and insulting behavior. "Nothing was more interesting than these battles of words," recalled Monet later. "They sharpened our intellect, filled us with enthusiasm, which lasted for weeks, until an idea finally took shape. We left the café with our will strengthened, our heads clearer, and our spirits lifted." Manet, to whom Zola, despite acknowledging his modesty and good nature, also ascribed a quick and very scornful tongue, sometimes became involved in particularly heated disputes

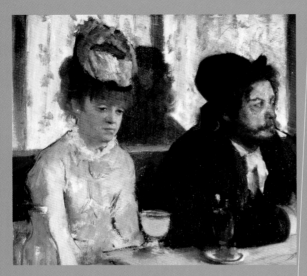

Edgar Degas, Absinthe (detail), ca. 1876, oil on canvas, 92 x 68 cm, upper level, room 31

gance. The young Claude Monet, who arrived in Paris in 1859 from the provincial town of Le Havre, had his first experience there of an artistic milieu that provided him with inspiration and challenge. The pupils of the then very popular and famous Charles Gleyre, who ran a large studio, gathered in the evenings in the Café Fleurus, which was decorated with wall paintings by Camille Corot. Until 1866, Edouard Manet and his friends favored the Café de Bade in the center of Paris, but then moved to the aforementioned Café Guerbois in the rue des Batignolles (now the avenue de Clichy). Here Manet became the intellectual focus of the "Batignolles" group, to which Renoir, Degas, Pissarro, Sisley, and many other, now less well-known, painters belonged. It also included art critics such as Théodore Duret and Théophile Silvestre, and literary figures such as Emile Zola and Charles Baudelaire. Félix Nadar, who worked as a photographer and caricaturist, and who made his studio available to the Impressionists in 1874 for their first exhibition, also made the acquaintance of the young artists there.

— simply because his ideas on painting were completely different from those of the much younger Impressionists. An angry rift developed between him and Degas that resulted in the return of paintings each had given the other as gifts. One of these arguments, this time with the writer Edmond Duranty, a radical champion of realism and modernity in art, turned into a duel, in which Zola was obliged to act as second to his friend Manet. (No one was seriously hurt.)

Who was to meet whom, and where, was planned in advance. The spartan Brasserie des Martyrs and the Andler cellar were regular haunts for the group of "Realists" led by Gustave Courbet, who eschewed all luxury and ele-

In 1877, the Impressionists again transferred their allegiance, this time to the Café Nouvelle Athènes on the place Pigalle, which had served as the meeting place for the intellectual opposition during the era of Napoléon III. A picture of a dead rat was provocatively painted on the

ceiling, and the interior of the café, which the Irish writer George Moore once referred to as the real and superior Académie des Beaux-Arts, is hung with several paintings by Degas and Manet. This idea of the café as a school, a practical educational establishment, is undoubtedly justified. Ultimately, young artists found their role models here, painters discovered their models, art dealers and gallery owners negotiated sale prices and terms for exhibitions. Thus a tradition was established in the 19th century that was adopted repeatedly, even stage-managed, by new generations in different locations and in other parts of the city. In this way the bohemian milieu forged for itself a very unique, alternative image, which was immensely attractive to candidates for membership because of the very nature of its unspoken "entrance requirements." Any tourist in Paris can still sense this for himself when he enters one of these countless street cafés.

MP

In the 1870s, the Café Nouvelle Athènes, also known as the Café des Intransigeants, became a meeting place for the Impressionists

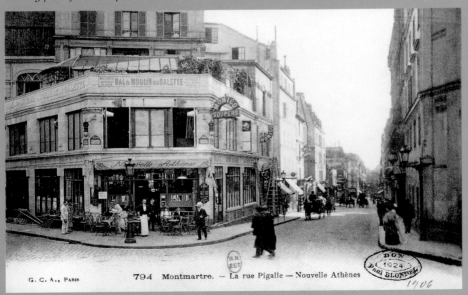

G. C. A., Paris 794 Montmartre. — La rue Pigalle — Nouvelle Athènes

Edgar Degas,
Laundresses Ironing (with detail), 1884/1886
Oil on canvas, 76 x 81 cm

19th century extended the scope of women's labor, which was reflected in the creative work of Degas from 1869. In his

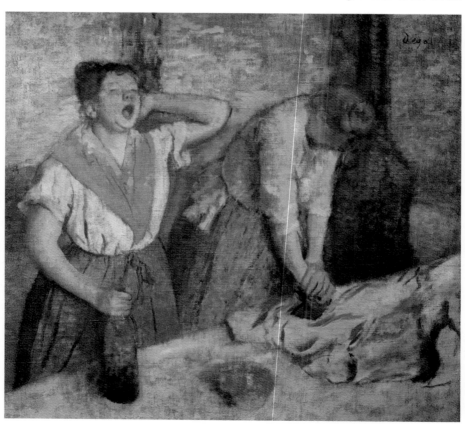

This painting is among Degas' most famous pictures of women washing and ironing. The urbanization that took place in the treatment of this theme, the artist made increasingly sparing use of descriptive details, concentrating more and more on

isolated actions and contrasting movements: for example, the totally exhausted woman pictured alongside the woman who is working hard at her ironing.

The working conditions of these women were miserable, the wages low, the working hours long, and the workplace often a cold, damp, underground cellar. Their situation was associated with occasional prostitution and problems with alcohol – the yawning ironer is clutching the neck of an almost empty bottle of red wine. Naturalist literature, for example Zola's novel *L'Assommoir* (subtitled *Gervaise: The Natural and Social Life of a Peasant under the Second Empire*) deals with this in greater detail and more directly than the picture by Degas. The latter approached the world of work with the detachment of the artist, as is shown by the composition and the structure of the painting. This is determined by verticals and diagonals. The thin application of paint, which only just covers the canvas in places, gives the oil painting a pastel-like appearance and a delicacy, which seem very difficult to reconcile with the subject matter. But there is also a detail that is worth noting: The hearty yawning is

not intended to convey the immediacy of a fleeting moment. In the *Café-Concert Singer* (1878), the singer wearing gloves is shown with her mouth wide open. In her case, however, it is not a yawn: she is mastering a stage pose she has struck, the black-gloved hand lifted to her face. Therefore, what at first glance appears as a moment snatched from life, is in fact due to a calculated artistic device. "Nothing must appear accidental in art, not even movement," was Degas' maxim.

Degas the sculptor

Edgar Degas, Horse, bending its head to run forward, 1865/1881
Bronze, 18.6 x 9.5 x 28.1 cm

After the death of Degas in 1917, around 150 half-disintegrated small wax and clay sculptures were found in his studio. These were free-standing figures, scarcely eighteen inches high, representing racehorses, women bathing, and ballet dancers in particular. It only proved possible to restore 73 of them, which were subsequently cast in bronze in limited editions of 22 at most. The *Horse, bending its head to run forward* is one of a total of twelve surviving sculptures of horses, in which the animals, two of which are carrying jockeys on their backs, are captured in action, showing different movements. These animal sculptures, which are difficult to categorize in relation to Degas' other work, have recently been dated as having been produced in the 1880s. CS

**Edgar Degas, Dancer (Large Arabesque),
1882/1895**
Bronze, 40.5 x 56.2 x 31 cm

Degas turned to sculpture mainly as a result of his steadily deteriorating eyesight toward the end of his life. Sculpture gave him the opportunity to give three-dimensional form to the movements and complex balance of the dancers, still vivid in his memory, which he had long studied and previously captured in many paintings. With their precarious equilibrium between sweeping movement and finely balanced static poses, Degas' *Dancers* are daringly executed, despite their modest size. The artist himself was more than willing to acknowledge this. He once told Georges Jeanniot, "You can have no idea what this has cost me in terms of research and bad temper; it is the balance, above all, that is so hard to achieve."

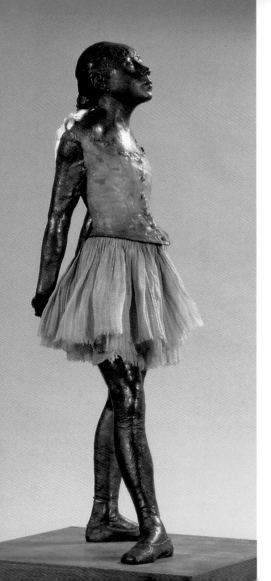

Edgar Degas, Little Fourteen-year-old Dancer, 1880/1881
Bronze with patina and textiles,
98 x 35.2 x 24.5 cm
(excluding plinth)

The three-foot-high statue of the fourteen-year-old dancer Marie van Goethem, a pupil at the Ecole de Danse de l'Opéra, was a bone of contention. Degas made numerous sketches in preparation for this sculpture, drawing his model from different angles – from the rear, from the side, from the front – for the most part with the feet and arms in a memorable stance: the spine straight, the shoulders pulled back, the right foot forward to provide stability, and the arms behind the back with the hands touching. The little dancer holds her head tilted backwards.

Degas gave his polychrome wax figure artificial hair and silk ribbons, a corsage, and a tutu, as well as stockings and ballet slippers. He showed his work in a specially made glass case. The critics were horrified. There was talk of a "flower of premature corruption" and "animal shamelessness," indeed it was said that "the depraved face of this young girl, barely on the brink of adulthood, a flower from the gutter, is unforgettable." Degas' crass realism was no less horrific to his contemporaries than his disregard for the current ideal of beauty. (In 1996 a bronze cast of the sculpture was sold at auction for 10.8 million dollars.)

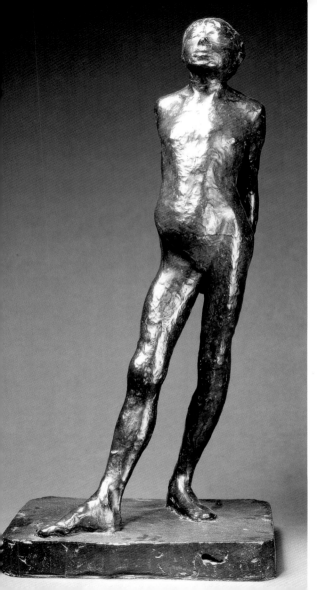

Edgar Degas, Nude study for the Little Fourteen-year-old Dancer, 1879/1880
Bronze, 73.5 x 34.9 x 31 cm

The *Little Fourteen-year-old Dancer* is encountered twice in the Musée d'Orsay. In this incarnation, she stands before us unclothed. The original, together with the originals of many other surviving sculptures by the artist, is in the Paul Mellon collection in Upperville, Virginia. There was never any doubt that this nude study model, the original version of which was in red wax, together with a series of drawings, was produced in preparation for the clothed *Little Fourteen-year-old Dancer* shown to the public in 1881. The posture of the young girl is identical in both versions: the only differences are in the size of the two statues – the nude is smaller than the final version by about a quarter – and in the less-detailed execution of the unclothed variant. In the study, the girl seems even younger and more boyish than in the final version.

CS

Edgar Degas, The Tub, 1886/1889
Bronze, 22.5 x 43.8 x 45.8 cm

Degas' potential as a sculptor is exemplified by *The Tub*. With this work of art, the artist realized an innovative form of representation: a sculpture intended to be viewed from above. The vitality of a young woman, lying in the bathtub with her legs crossed, as comfortable as if she were sitting in an armchair, is only revealed to the onlooker when viewed from this angle.

It is possible that Degas intended *The Tub* to be placed directly on the floor, without a plinth. This would have further increased the realism of his sculpture, for in the wax original the flesh-colored figure of the woman lay in a lead bowl, surrounded with water made milky with plaster and holding a real bath sponge in her hand.

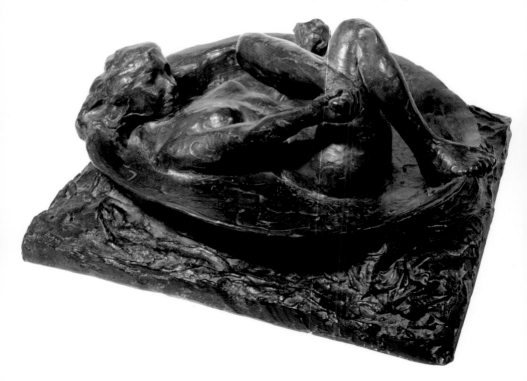

Edouard Manet

**Edouard Manet
(1832–1883), Stéphane
Mallarmé (with detail),
1876**
Oil on canvas,
27.5 x 36 cm

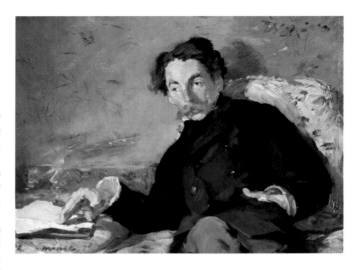

Antonin Proust gave the poet Mallarmé the following description: "… he had large eyes, his straight nose was clearly defined above the stiff moustache, the lips beneath forming a thin line. His prominent forehead jutted out from underneath his thick hair. His beard, trimmed to a point, stood out against the background of the dark necktie he wore slung around his neck … his carefully chosen words followed one after the other, the intonation very correct, and were accompanied by expansive movements of his hands." Manet's miniature portrait of Mallarmé, pictured sitting quite relaxed in his armchair, testifies not only to the accuracy of the writer's words, but also to the friendly relationship that existed between the painter and his subject.

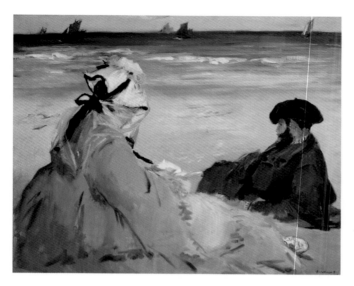

worn by his brother-in-law and the light-colored attire of his wife. Their faces are rendered with a few commanding brush strokes. The effect of both figures is extraordinarily monumental; they seem to fill the majority of the pictorial space, in contrast with Boudin's beach scenes from Trouville or Deauville (see pp. 140 and 142). Even the horizon recedes to the top edge of the picture.

Edouard Manet, On the Beach, 1873
Oil on canvas, 59.5 x 73 cm

Edouard Manet, Asparagus, 1880
Oil on canvas, 16.5 x 21.5 cm

Manet painted this beach scene in 1873, during an extended stay in Berck-sur-Mer. It shows the decisive momentum his painting had acquired due to the influence of the Impressionists: Although Manet had turned to open-air painting, he did so as a portrait painter. The two figures on the beach are his wife Suzanne, who is reading, and her brother Eugène, the husband of Berthe Morisot, who is lost in his own thoughts. The couple are viewed from the side, one behind the other, so the figures appear to be of different size. Manet gives a brief account of the dark-colored clothing

This modestly sized picture – scarcely more than six inches high and not much wider – shows a single stick of asparagus. The painting is one of a series of small still lifes from the final creative years of the painter, featuring subjects that attracted little attention – a single lemon, for example, was the subject of another. Despite this, in a very special way they testify to the virtuosity of the painter as a colorist. Manet presents the noble vegetable against a background that offers hardly any color contrast. It is only by virtue of the abundant nuances of the coloring that the stick of asparagus is

transformed into a delicacy of peculiarly sensual charm.

A story on the origin of this picture shows Manet to be an artist with a sense of humor. Charles Ephrussi had acquired a painting of a whole bunch of asparagus from Manet for 800 francs. When Ephrussi paid 1000 francs instead of the agreed sum, Manet sent the single stick of asparagus shown here, adding the message, "A stick was missing from your bunch."

The painting was of tiny dimensions completed in a very short space of time, with the signature "M" for Manet in the top right-hand corner swiftly inserted as a deliberate gesture. This is – as the anecdote makes clear – nothing more than a detail of a still-life painting. No doubt it was mainly due to the circumstance detailed above that the artist was able to exercise his artistic talent in such a free and fun, light-hearted manner.

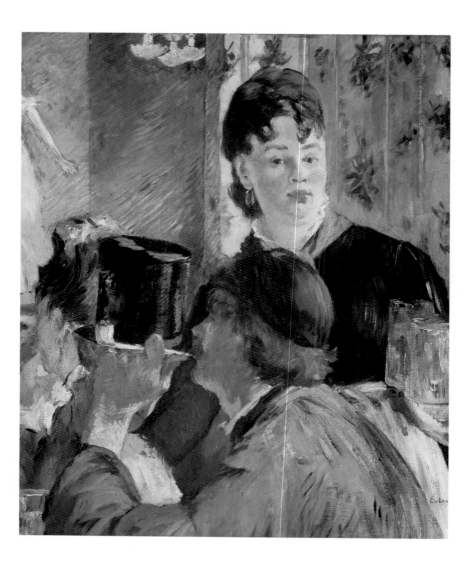

Edouard Manet, The Waitress, 1878/79
Oil on canvas, 77.5 x 65 cm

Cafés had existed in Paris since the end of the 17th century, but their numbers had increased by several thousand during the reign of the Emperor Napoléon III, owing to the construction of the wide boulevards and the rising growth of a leisured population that was in need of relaxation and diversion. The *café-concerts*, which were large coffee houses with a changing program of entertainment, were especially popular with Parisians.

In *The Waitress*, Manet shows an apparently fleetingly captured moment, reminiscent of a snapshot, in one of these *café-concerts*, where it seems many customers are gathered. The onlooker, however, sees just a few figures superimposed upon one another, some of which are obscured by others or cut off by the edges of the picture. The figure of whom we can see the most is that of the busy young waitress, who is gazing out from the painting in the direction of the onlooker. She has just served the beer that has been set down in the bottom left-hand corner of the picture to the man smoking a pipe, who is seated in the foreground, and the shadowy figure whose profile is hidden. In her left hand she is still holding two more glasses for other customers, which are indicated by means of a few unusually free brush strokes. The smoker is taking no notice of the waitress; his attention is focused on a singer who has just come on stage, of whose figure we can

see just enough at the edge of the picture to give a comprehensible meaning to the sequence of events. A popular anecdote, however, suggests that the man was amorously involved with the waitress, having accompanied her to Manet's studio in order to forestall any improper advances from the painter – artists were, of course, considered to be untrustworthy.

The face of the waitress is the only aspect of the painting executed in any great detail; the remaining figures, including a man with a top-hat and a woman whose hair is piled high on her head, as well as the decor of the coffee house, are painted with nervously applied brush strokes, reflecting the transience of the moment that has been captured. This does not mean, however, that the composition was not well thought out prior to its execution. During the 1870s, Manet had prepared a large number of drawings and sketches in the bars and cafés of Paris, the subjects of which he was to use later for some of his oil paintings. Another painting, executed at the same time, showing the same figures that appear in *The Waitress* in Paris, can be seen in the *Corner of a Café-Concert* in the National Gallery in London. Recent research suggests that the painting is a fragment, representing about a third of an originally much larger coffee house scene. This large painting was later cut up: the third on the left-hand side is now in the Oskar Reinhart "Am Römerholz" collection in Winterthur, Switzerland, while the central section seems to have disappeared without trace. CS

An Impressionistic triad

These three works by Sisley, Pissarro, and Monet are displayed by the Musée d'Orsay as a triad. The idea for such an arrangement came from the former owner, Ernest May, an early patron of the Impressionists. The suggestion was that the three paintings should be assembled as a triptych. The pictures are of approximately the same size and were painted at around the same time. In addition, they are by artists who, together with other like-minded artists, exhibited their works publicly in 1874 at the Première Exposition de la Société Anonyme des Artistes-Peintres, Sculpteurs et Graveurs (first exhibition of the anonymous society of painters, sculptors, and engravers), in order to enter the annals of art history as Impressionists.

Hung directly alongside one another, they reveal similarities and differences. The light, or

Alfred Sisley, The Ile Saint-Denis, ca. 1872, oil on canvas, 50.5 x 65 cm, upper level, room 32

Camille Pissarro, Entrance to oil on canvas, 46 x 55.5 cm

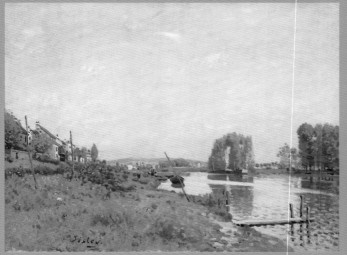

rather the atmospheric mood produced by light in a landscape, is the common theme of all three paintings. The artists worked with similar media in order to give form to these perceptions. The outline, as used to define the form of an object, is avoided. The material quality is dissolved; nature becomes merely an illusion. The colors of the spectrum define the color palette; black, for example, is hardly ever used. The similarity of approach of artists with such different personalities is still astonishing today. One could almost forget that the Impressionists were a highly heterogeneous group. Taking Sisley, Pissarro, and Monet as examples, we also find differences that cannot be overlooked. In his search for the picturesque moment, Pissarro usually turned to the land. The village street and the road into a village, flanked by trees and disappearing into the distance, are his favorite motifs. Monet, and perhaps to an even greater extent Sisley, were drawn to water: both artists were fascinated by the fleeting reflections produced by light on its moving surface. Unlike Pissarro, they frequently compose their pictures with the vanishing point offset from the center, often corresponding to the direction in which the water is flowing, but intensifying the onlooker's sense of exclusion.

Village of Voisins, 1872,

Claude Monet, Sailboats at Argenteuil, ca. 1872, oil on canvas, 49 x 65 cm

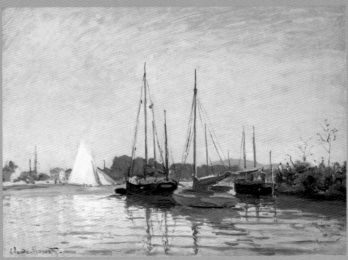

Camille Pissarro

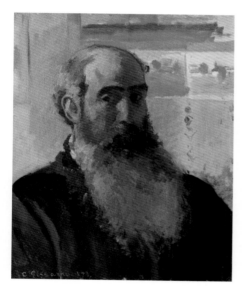

**Camille Pissarro (1830–1903),
Self-portrait, 1873**
Oil on canvas, 56 x 46.5 cm

stands out against the light background, bringing the figure into the foreground. Pissarro's deliberately simple self-portrait shows a man who did not like to draw much attention to himself. Despite this, it exudes a certain charisma. One thinks involuntarily of a prophet, or a venerable patriarch – and indeed Pissarro was a paternal friend and an important artistic role model for many young painters around this time.

Ten years later, in a letter to his son Lucien, a painter and graphic artist living in London, Pissarro drew a portrait of himself in words: "People do not like me until they have known me for a while – people who like me must have a soft spot for me. For the casual passer-by, a fleeting glance is not enough – he sees only the surface, and because he does not have enough time, he walks straight past!"

**Camille Pissarro, Red Roofs,
a Wintry Impression, 1877**
Oil on canvas,
54.4 x 65.5 cm

This self-portrait is the only one from the artist's mature period. The artist is shown half-length against a backdrop of patterned wallpaper hung with other pictures, details of which are scarcely discernible. Three fourths of the face are in light shadow. The dark eyes stand out, as do the brows and the dark part of the beard around the mouth. In a similar fashion, the clothing

This picture was first shown in 1877 at the third Impressionist exhibition in Paris. It is a work that is typical of Camille Pissarro. In his many representations of rural life, which he continued to paint throughout his career, with fields, harvests, orchards, and vegetable gardens, he was at pains to

portray light and landscape in unified harmony. In this painting it is not just the houses in the village at the bottom of the hill that are steeped in the warm reddish glimmer of the evening light: instead the entire landscape is defined by the red and reddish-brown tones in a manner characteristic of the artist and found in many of his other paintings.

Pissarro always worked out his compositions very carefully. Evidence of this can be seen in the painting *Red Roofs*, especially in the almost sculptural quality of the bare fruit trees in the foreground, the slender trunks of which throw long shadows into the wintry garden, allowing the onlooker a view of the houses in the hamlet in a most delightful way. CS

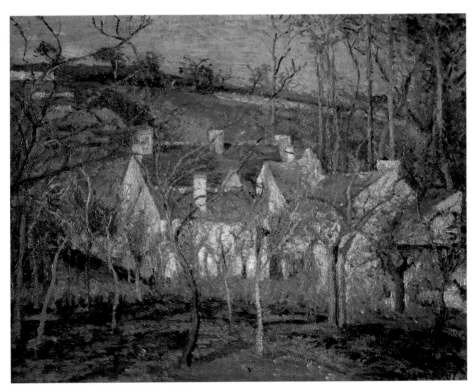

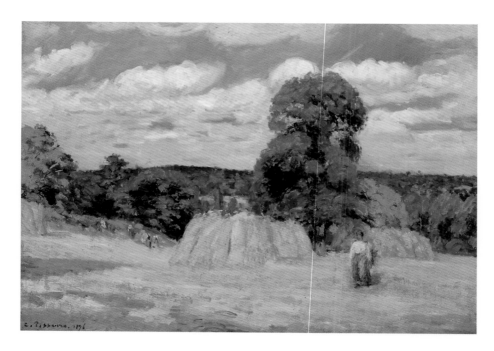

Camille Pissarro, Harvest at Montfoucault, 1876
Oil on canvas, 65 x 92.5 cm

Pissarro's landscapes include the people who live and work there; unlike his Impressionist friends Monet and Renoir, these are not city people who travel to the country to relax on the weekend, but peasant farmers and their wives, herdsmen, and shepherdesses. Yet, unlike Millet, Pissarro does not monumentalize his agricultural laborers. They are not posed, and they themselves form an integral part of the landscape. For Pissarro, there was no longer a hierarchy according to which figures were more important than landscape. He approached both human forms and landscapes in the same way: With a broad brush stroke, which clearly reveals how the painter reacted to the fleeting impression offered to him by nature. In the figure of the woman who can be seen in the foreground on the right, Pissarro extracts the quintessential from this artistic approach, uniting in her form the field, the trees, the sky, and the clouds by means of color.

Young Girl with a Walking Stick
(Peasant Girl Seated), 1881
Oil on canvas, 81 x 64.5 cm

For Pissarro – as well as for Renoir or Monet – the period around 1880 marked a caesura. After almost a decade, these Impressionists took stock of what they had achieved so far, and considered their own positions in a new way.

Young Girl with a Walking Stick is one of the first compositions in which the painter places the figure centrally. It is also one of a series of paintings that show peasant women resting. From the point of view of content, the subject of Pissarro's picture was silent contemplation. If one looks at the artistic technique, a change in the characteristic brushwork of the painter is evident. The canvas is covered with a multitude of increasingly minute dots of color. This development heralded what is generally

referred to as Pissarro's neo-Impressionist phase. The painter worked in this style from 1886 to 1890, encouraged by Seurat, the founder and theoretician of neo-Impressionism, whom he had met through Signac in 1885.

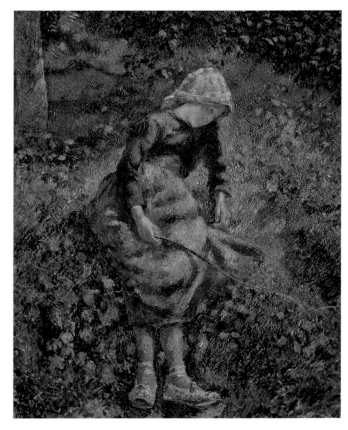

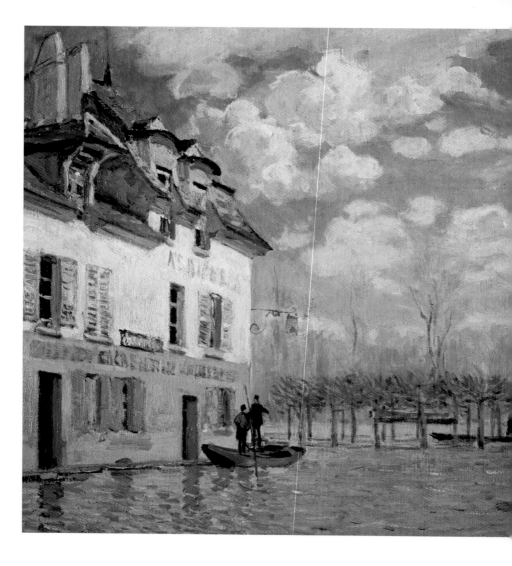

Alfred Sisley

Alfred Sisley (1839–1899),
Flooding at Port-Marly, 1876
Oil on canvas, 50.5 x 61 cm

Working from a boat during a catastrophic flood in the spring of 1876, Alfred Sisley painted the corner of a wine merchant's house in the small town of Port-Marly on the banks of the Seine. The event was also recorded by a number of lithographs in the contemporary press. In this painting, which is one of a group of six works, the Impressionist artist succeeded in depicting the interplay of water, sky, and light in masterly fashion. The disturbed surface of the water, in which are reflected the trees, the house, and the two men standing in the boat and on a hastily erected footbridge, is reproduced in the same fine style of painting – full of nuances – as the vast, blue, luminous sky filled with white clouds above a low horizon. Sisley told the art historian and collector Adolphe Tavernier, who himself owned one of the pictures of the flood, "The sky cannot just be a background … I emphasize this element, because I want people to understand the importance I

attach to it … When I start a picture, I always begin with the sky." And his portrayals of the sky are indeed comparable with those of the great Dutch landscape painters of the 17th century, in other words with the paintings of Jan van Goyen, Salomon van Ruysdael, or Jacob van Ruisdael. Equally influential were the works of the English painters John Constable (1776–1837) and William Turner (1775–1851), with which he had become familiar in London. Sisley, who was descended from an English family, had completed his studies in England between 1857 and 1861, and had also stayed there on several occasions in subsequent years.

Flooding at Port-Marly originally formed part of the collection of the industrialist Ernest Hoschedé, one of the first patrons of the Impressionists, whose widow Alice became the second wife of Claude Monet in 1890.

CS

Alfred Sisley, Regatta at Molesey, near Hampton Court, 1874
Oil on canvas, 66 x 91.5 cm

Only two years after the *Ile Saint-Denis* (see p. 228), Sisley painted a picture during a stay in England that conveys a totally different impression. There is no longer a motif leading the eye into the distance. Everything remains in the foreground in a picture of a very worldly phenomenon. The colors have become more luminous, and Sisley is also freer in his approach to form. His brushwork – very much in the manner of a person's handwriting – reveals the immediacy with which he transfers the experience of the moment onto the canvas. This is exemplified by the judges, dressed in white, and the flags – above all their reflections on the surface of the water. The subject of the painting is not the regatta itself, but the turbulent air that dissolves objects as it gently swirls around them. The incessant flow of light and the nuances of color that are visible on the surface of the water are the real inspiration for the picture.

Alfred Sisley,
Snow in Louveciennes, 1878
Oil on canvas, 61 x 50.5 cm

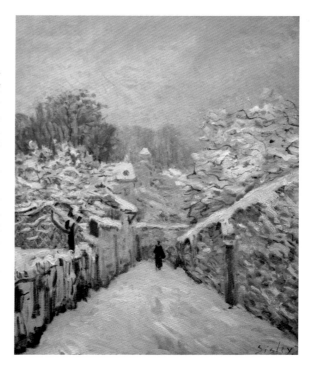

Many of Sisley's works appear to be typical examples of Impressionism, and this snow-covered landscape, which dates from his most successful period, is no exception. In his treatment of the mother-of-pearl tones of the snow, the artist truly mastered the evocation of the imponderable and the transitory. This is made all the more surprising by the fact that the depiction of the quiet snow scene is accomplished with broad brush strokes, which appear to heighten rather than diminish the suggestive effect. The air is filled with white snow flurries; snowflakes have settled on everything – the path, trees, walls, roofs, and fences. As yet, the snow remains virgin.

Snow scenes were particularly attractive to artists such as Sisley, or indeed Pissarro and Monet, because of the challenge of capturing the quality of the light and of mastering shadows. For the Impressionists, shadows were not colorless, nor were they simply dark. As Renoir said in 1910, "A shadow is neither black nor white. It always has a color. Nature knows nothing but colors." What is the color, though, of a shadow in the snow? Instead of white, the areas of shadow contain colors reflected from the objects creating the shadows, or colors determined by the atmospheric conditions. The area that is exposed to the light also affects everything that is in shadow. Blue tones predominate, like those shimmering through the covering of snow on the path. Sisley's picture is one of the most poetic renderings of the fragile and ephemeral world of snow.

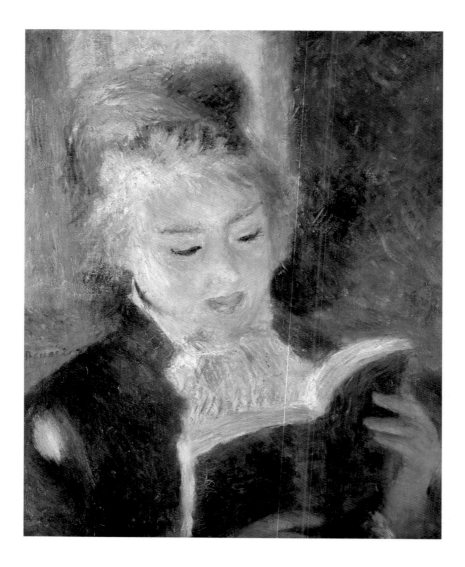

Auguste Renoir

Auguste Renoir (1841–1919),
Woman Reading, 1874
Oil on canvas, 46.5 x 38.5 cm

Renoir's *Woman Reading* was painted in the year in which the first Impressionist group exhibition was held. Renoir is the only Impressionist painter to have made use of his talent primarily in the fields of figure and portrait painting. In his portraits of women he showed a marked preference for small-scale pictures, frequently characterized by their intimacy. The subject of the *Woman Reading* is treated as a manifestation of light. The brightness of the light shining through the window behind the woman's head is reflected by the book so that it permeates her countenance, pervading it with vivid and delicate shades. Accents are provided by the black eyelashes encircling the downcast eyes and the red, sensual mouth. The face is depicted with such radiance that one might believe it to be the source of the light.

Auguste Renoir,
Study. Female Nude in the Sun, ca. 1876
Oil on canvas, 81 x 65 cm
(following page)

When the artist showed his study *Female Nude in the Sun* at the second Impressionist group exhibition in 1876, the influential critic Albert Wolff, who was dismissive of Renoir, wrote the following: "Just try to make it clear to Monsieur Renoir that a woman's bosom is not a mass of decomposing flesh, with green and purple flecks indicating its total putrefaction." Wolff's criticism fails to recognize the painter's primary artistic concern, which was to depict sunlight filtering through leaves onto a woman's body. Renoir tried to capture the soft gleam of this shimmering light on the delicate skin in his painting by supplementing the basic color of the flesh – pink – with a range of yellow, green, blue, and violet shades reflected on the skin. Despite the abundant nuances of this kaleidoscope of color, the body of the girl has a sculpted appearance, and for the most part its form shows definite contours. The backdrop of nature, which is likewise flooded with light, is by contrast much more loosely depicted; Renoir has painted it as an open, abstract form.

The beautiful young woman, a 19-year-old model called Anna, with her very feminine body and delicate features, is the perfect embodiment of Renoir's ideal of womanhood. The artist, for whom women and nature were of equal importance, remained loyal to this ideal to the end of his life. The seeds of his large painting entitled *The Bathers* (see p. 324), which was created almost half a century later, are already present in this work.

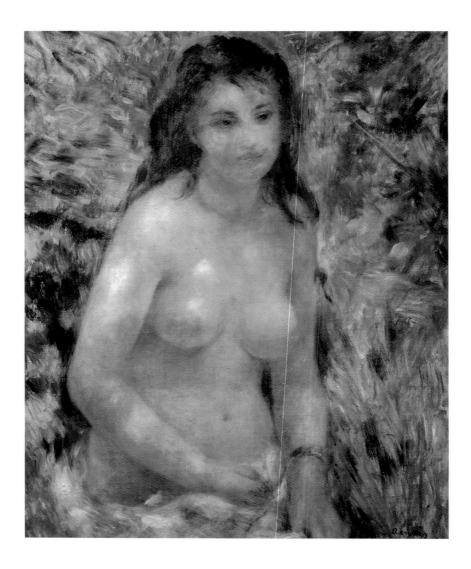

Auguste Renoir, The Swing, 1876
Oil on canvas, 92 x 73 cm

The Swing was shown in 1877 at the third Impressionist group exhibition. In it, as his contemporaries observed, Renoir was adopting the style of 18th-century French painting, the tradition of the *fêtes galantes*, and the manner of artists such as Watteau or Fragonard. At the beginning of his artistic career, Renoir had copied works by these painters in the Louvre and had earned his living by painting fans in the Rococo style. The subject of the rural *fête galante* was therefore one with which he was extremely familiar. These were open-air scenes, usually in the well-tended grounds of a large country estate, where people conversed or danced together, listened to music, or relaxed in some other way, for instance by taking a leisurely swing.

Renoir transported this scene to a garden in Montmartre. All the motifs are immersed in soft spots of color. They are in the sunlight that falls, as so often in Renoir's paintings, through the leaves and covers all the objects in shades of pale yellow and blue. Color for Renoir is a factor that links everything together: It connects what is near to what is distant, the man in the immediate foreground with the group of fig-

ures in the background, to the right. In addition, it links different surfaces, such as the rough tree trunk and the hard seat of the swing, or the foliage of the trees directly next to the soft, delicate face of the woman. The Impressionists believed color to be an essential constituent of the world, uniting everything and enabling a homogeneous visual world to flourish. As used in this painting, however, the effect was considered too daring by some critics of the day.

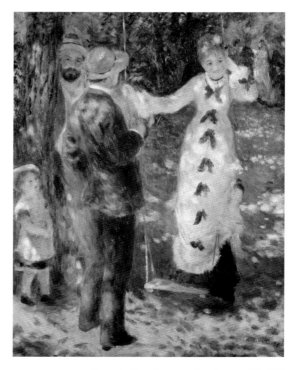

Auguste Renoir, Dance at the Moulin de la Galette (with Detail), 1876
Oil on canvas, 131 x 175 cm

This picture, which is one of Renoir's largest compositions, was also shown in

1877. It again features the cheerful attitude to life seen in *The Swing* and the Impressionist theme of figures in the open air. The assembled company are enjoying the carefree mood of a Sunday and the agreeable warmth of the sunlight filtering through the leaves. Everyone feels in harmony with the world, no one is worrying about their obligations or everyday cares.

The Moulin de la Galette was a dancing garden, cre-

ated by converting two old windmills on the hill in Montmartre, where the public could come and dance on Sundays. In 1876 Renoir had a studio very close by. His friends placed themselves at his disposal as models: In the foreground, Estelle is seated on the bench, with Franc-Lamy next to her, and the painter Norbert Goeneulle and Renoir's future biographer, Georges Rivière, have joined them at the table. Solares y Cardenas, a Spanish painter, is dancing with his girlfriend, Margot.

According to Rivière, Renoir painted the canvas directly from the scene. Although many people are visible, sometimes packed tightly together, there is no sense of overcrowding, because of the skillful arrangement of the picture. The triangular forms seen on the table are echoed by the triangle formed by the couples dancing in the middle ground of the picture. The horizontal line formed by the lamps on the left hand side is repeated in the row of sun hats on the other side.

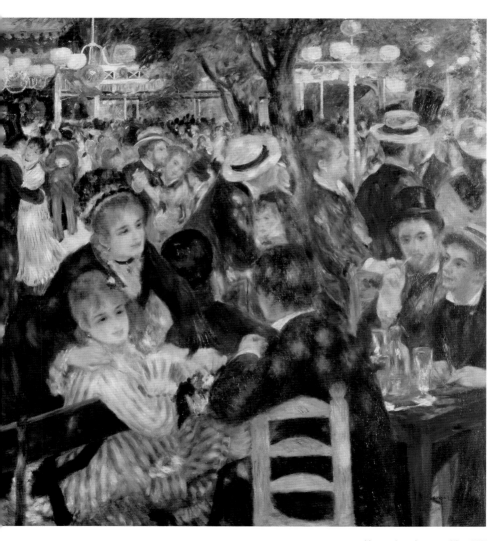

New steps

The two large dance scenes, conceived as pendants, were initially shown in April 1883 on the occasion of a Renoir exhibition in the Durand-Ruel gallery in Paris. Paul Durand-Ruel (1831–1922) bought the paintings in 1886 and kept them until after Renoir's death in 1919.

Since Paul Lhote, a friend of the artist, served as the model for the male dancer in both pictures, the different effect produced by the pictures is primarily due to the two figures of the women and the treatment of the background. The elegant young woman in *Dance in the City* is pictured with her partner in a room in which the chic decor is emphasized by the pillar and the large potted plants. The dancer is the 17-year-old Suzanne Valadon, who later became a painter herself. The model posing for *Dance in the Country*, who gazes smilingly out at the onlooker, is Aline Charigot, swaying in the arms of Paul Lhote under a chestnut tree. Renoir met Aline, who was 18 years his junior and whom he was to marry in 1890, when he engaged her as a model in 1880.

These two paintings were created during a period in which Renoir started to

*Auguste Renoir, Dance in the City, 1883
Oil on canvas, 180 x 90 cm,
upper level, room 34*

distance himself from impressionistic painting in the search for new stylistic media and subject matter. The painter himself told the art dealer Ambroise Vollard some years later: "In around 1883, there was a watershed in my work. I had come to the end of the road as far as Impressionism was concerned, and recognized that I could neither paint nor draw. In a word, I was in a cul-de-sac!" While traveling in Algeria in 1881 and 1882, he discovered the light of the Mediterranean, the bright colors and the vibrant hustle and bustle of the country; in 1881, in Italy, he was enthralled by the painting of the Renaissance and the works of classical antiquity. Spurred on by these new stimuli, he turned in 1883 to drawing and linear representation, as can be clearly seen in *Dance in the City* and *Dance in the Country*. Although the colors are still bright and full of contrast, as in earlier paintings, the composition of the pictures is simpler. By contrast with older works from Renoir's Impressionist phase, the brushwork is no longer fleeting and spontaneous, but is gentle and restrained. These two paintings mark the transition to the master's final great period of creativity.

CS

Auguste Renoir, Dance in the Country, 1883
Oil on canvas, 180 x 90 cm,
upper level, room 34

Auguste Renoir and Richard Guino (1890–1973), Water (Large Laundress), 1917
Bronze, 123 x 69 x 135 cm

From 1907, the year in which Aristide Maillol painted a portrait of Renoir, the artist also began working on sculptures.

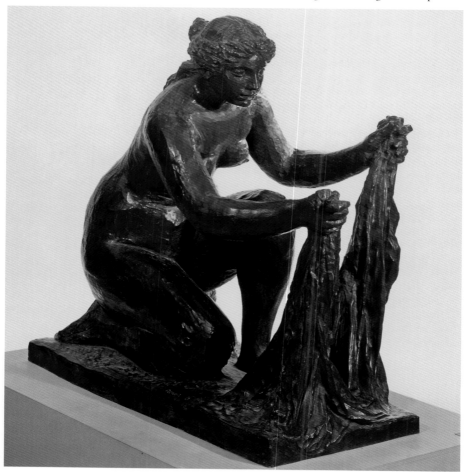

In turning to sculpture in old age, Renoir resembles Degas. The sculpture entitled *Water* or *Large Laundress*, which was created in collaboration with Richard Guino, was executed in 1917 in bronze. A woman's figure, typical of Renoir's paintings, has assumed three-dimensional form. What is unusual for the artist is the aspect of work that is suggested by the sculpture – the woman, supported with one knee on the floor, is holding the washing in both hands.

Auguste Renoir and Richard Guino, Madame Renoir, 1916
Polychrome plaster, 82.4 x 53 x 34.5 cm

This bust is of Renoir's young wife, Aline Charigot. The couple married in 1890. Her face is framed by a wide revers collar and a hat with a downturned brim, decorated with two full-blown roses. The subject died in 1915, and Renoir had one of these busts erected on her grave in Essoyes, her birthplace in the Champagne area.

Claude Monet

with the swimming baths to the right. Individual motifs, in particular the two bridges of the town, recur again and again in the paintings of Monet and of his friends. In addition to the bridge shown here, there was also a railroad bridge, which repeatedly cast its spell over the artist.

Claude Monet (1840–1926),
Argenteuil Basin, ca. 1872
Oil on canvas, 60 x 80.5 cm

Claude Monet,
The Bridge at Argenteuil, 1874
Oil on canvas, 60.5 x 80 cm

Monet settled in Argenteuil in 1871, after his return from a trip to England. Apart from minor interruptions, he stayed here until 1878. He was followed to Argenteuil by Renoir, Sisley, Pissarro – who at that time was living in nearby Pontoise – and Manet.

Monet's picture of the harbor shows the tree-lined promenade along the bank in soft summer light. The road bridge over the Seine, with one of its tollgate towers, is visible in the background; to the left in the basin is the floating boat-hire company,

The sailboats on the Seine, which Monet often painted from his floating studio, were also among his favorite motifs in Argenteuil. He had had a cabin on a boat converted into a studio, in which he said there was "just enough room to set up an easel."

Because water mirrors the visual world, it is an element that is found again and again in Monet's pictures: The boats, the embankment, the house on the opposite bank, the trees, the bridge, and the all-enveloping sky are reflected in the water.

The gliding movements of the sailboats and rowboats corresponded with the idea Monet – and the other Impressionists – had of the relationship that should exist between man and nature. Man does not harm nature, but moves in unison with it, allows himself to drift. There is also a third interpretation of Monet's painting of the bridge: The space in which the motifs are shown is close to the spectator, and is on a human scale. Impressionist landscape paintings rarely entice the spectator into the distance, but usually show a section of the natural landscape that lies within the range of the eye of the painter – and of the onlooker.

Water, wind, and sun

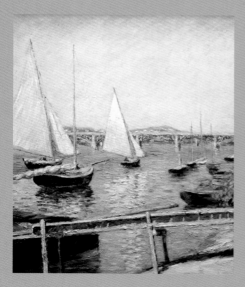

Gustave Caillebotte, Sailboats at Argenteuil, ca. 1888, oil on canvas, 65 x 55.5 cm, upper level, room 30

This work reveals the extent to which Caillebotte's art was characterized by his admiration for impressionistic painting. It shows the riverbank and the landing stage near his house in Le Petit Gennevilliers, on the opposite side of the river from Argenteuil. The old wooden bridge at Argenteuil and the pillars of the railroad bridge can be seen in the background.

The small town of Argenteuil had become famous because of painters like Monet, who lived there from 1871 to 1878. One of Monet's early works from this period, *Regatta at Argenteuil* (1872), was once in the Caillebotte collection.

Monet's picture has much in common with that of Caillebotte. At the same time, however, the juxtaposition reveals the fundamental differences between the two painters, and shows the limitations of Caillebotte as an artist. The water is the main motif in both pictures. It is the element that corresponded most closely to the Impressionists' view of the world, because it contained a multitude of visual images of the world in its countless reflections, and because at the same time it could be interpreted as being symbolic of the tendency to drift. The view shown by Monet, though, is of a space that is close to the onlooker, while Caillebotte's painting leads the eye into the distance. Caillebotte was obliged to structure the resulting depth by means of the

landing stage and the bridges. The immediacy of sensation is also stronger in the case of Monet. The latter reacted to the impression offered to him by nature with broad, short brush strokes, and in so doing he neglected the details. In the case of the Caillebotte painting, on the other hand, the impression of nature is broken up by the rational approach of the artist. Unlike Monet's, his sailboats are not resolved as purely visual phenomena, and even his bridge in the background has a more tangible material presence than that of Monet's houses.

Claude Monet, Regatta at Argenteuil, ca. 1872, oil on canvas, 60 x 100 cm, upper level, room 32

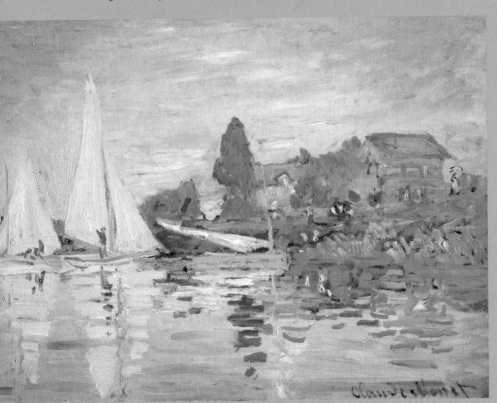

Claude Monet, Breakfast (Monet's Garden at Argenteuil), ca. 1873/1874
Oil on canvas, 160 x 201 cm

This picture, entitled *Breakfast*, shows the garden of the first house in which Monet's family lived in Argenteuil. In the foreground, shaded by trees and separated from the background by a band of light, stands a bench, a side-table, and the breakfast table.

The crockery has not been cleared away, suggesting that the parents are nearby, while the parasol on the bench and the sun hat hanging in the branches indicate the presence of Camille, Monet's wife. Oblivious to all this, Jean, the young son of Camille and Claude Monet, born in August 1867, is playing in the shade by the table. The child's nanny is in the background, and is keeping close watch over him.

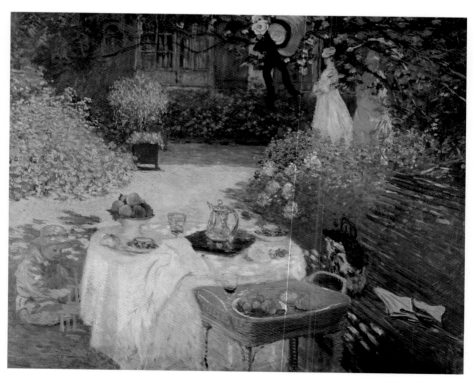

In addition, the picture conveys a sense of hospitable attentiveness that is typical of many Impressionist works. The garden, enclosed on three sides, is a symbol of a safe world, in which every day is a happy Sunday. The onlooker perceives this garden idyll in terms of a prosperous and well-tended existence. The remains of the meal on the table – the focal point of the picture – are still inviting, and there is plenty of room on the bench. Monet has fused a still life and a figure painting together with a garden landscape to create a symbolic representation of what it might be like to live in paradise.

Claude Monet, The Rue Montorgueil in Paris, (Fête on June 30, 1878), 1878
81 x 50.5 cm

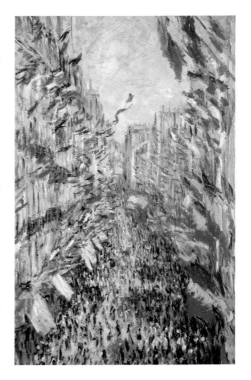

If one did not know that this painting was by Monet, it could easily be mistaken for the work of one of the Fauves. Flags were flown on June 30, 1878, to mark the opening of the Great Exhibition. On that day, a sea of flags was fluttering in the wind, and countless people filled the streets.

Monet chose a high vantage point in order to emphasize the huge gathering of people. Viewed at close quarters, the milling throng gives the illusion of an ethereal carpet of color. It is not until one is at a certain distance from the painting that the concrete aspect of the picture comes into focus, and the people on the streets become recognizable as well as the individual flags, which look as though they have been released from the façades of the houses to the left and right. The disintegration of form and the free use of color are exaggerated, in other words it is almost impossible to grasp either in purely objective terms. Dots, flecks, and dashes have taken over: blue, white, and red, they dart back and forth across the fronts of the houses, and march in black and white along the street.

The railroad station – the cathedral of the 19th century

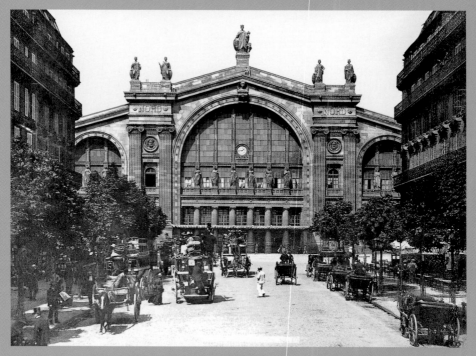

The Gare du Nord was built between 1861 and 1865 by Jakob Ignaz Hittorf.

The opening of the Musée d'Orsay in 1986 in the former Gare d'Orsay united the 19th-century art exhibited with a building that could hardly be more typical of that era. Railroads and railroad stations were symbols of the desire for progress and the industrial ambition that seized the whole of Europe in the mid-19th century, bringing lasting changes in the appearance of the cities. The first rail lines, which were opened in France in 1843, connected Paris with Rouen and

Orléans. These initially very modest advances were nevertheless associated with great expectations as regards increased mobility, flourishing trade and industry, and – as a consequence – increased social prosperity. "The zeal and the fervor with which the civilized nations build their railroads is comparable with that shown several centuries ago, when the churches were being built," wrote the imperial advisor and government economist, Michael Chevalier, in 1852. Napoléon III, a thoroughly progressive emperor, promoted and exploited this promising system which, with a great deal of noise and steam, connected town and country at a speed that was previously unheard of. In a very short time, rail lines were radiating out from Paris to destinations all over France. A correspondingly large number of railroad stations was built, and these were operated by private railroad companies. The Gare d'Orsay station was built by the Compagnie des Chemins de fer d'Orléans, which until that point had only had access to a station a very long way from the city center, the Gare d'Austerlitz.

In 1897, when the company was able to buy from the State a plot of land on the Quai d'Orsay, on which stood the remains of the walls of the old Comptroller-General's headquarters, set on fire in 1871 during the Commune uprising, the scene was set for the construction of a new station. It

Railroad stations became great places in which to experience life in the urban metropolis – mobility, anonymity, and a spirit of solidarity are strongly in evidence here.

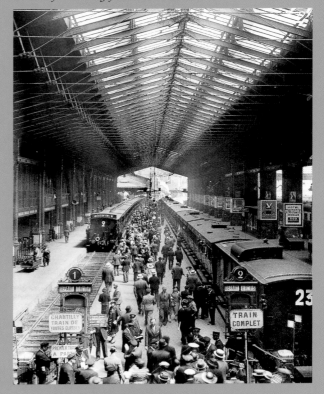

was designed and executed with the utmost speed by the architect Victor Laloux (1850–1937). The Gare d'Orsay was already operational by the time of the 1900 Great Exhibition. It served not only to provide a grandiose welcome for visitors to Paris, but also offered luxury accommodation in the integral Terminus Grand Hotel, with its 350 rooms. In 1900, the design and construction of a station was a completely new architectural undertaking, for which there was no precedent, and which had to meet very specific functional demands. From a modern perspective, the architects of that period had an astonishing ability to conceal the technical aspect behind a multitude of features borrowed from castle and cathedral architecture. The Gare du Nord, built between 1861 and 1865 by the German architect Jakob Ignaz Hittorf (1792–1867), has a monumental façade incorporating the setpiece of a triumphal arch from classical antiquity, extravagantly embellished with figures. It is adjoined by a vast hall constructed in iron and glass, flooded with light, which, by virtue of its vast and imposing dimensions, really does remind one of a cathedral building. The designs by Laloux for the exterior and interior decoration of the Gare d'Orsay were particularly complex, and made ref-

erence to forms and structures seen in various bygone eras. An elaborate coffered ceiling, monumental loggias, and decorative figures with a mythological theme were all combined to make a prestigious ensemble. From the perspective of the 20th century, which was schooled in functionalism, the Gare d'Orsay constituted a prime example of fin-de-siècle bad taste, and it was threatened with demolition for many years until a revival of historical styles brought about a change of heart and the station was turned into a museum.

The first rail lines radiated out in all directions from Paris (situation as of 1850).

The expansion of the rail network had numerous consequences: Wide swathes had to be cut through the medieval quarters, changing the urban structure. Major new routes were formed by the great boulevards, which accommodated the traffic associated with arrivals and departures. The stations thus became points of reference in a network connecting the capital to the country as a whole, achieving structural connections between its citizens for the first time. As a result, there was a broadening of horizons in terms of experience and perception. The station was a place defined entirely by the brief encounters of embarking and disembarking travelers. Nowhere else could the new experiences of anonymity and urban solidarity be more strongly felt than in the station concourse, teeming with strangers.

As symbols of progress, speed, and modernity, the railroad and the railroad station were discovered as subjects for painting by the Impressionists in the 1870s: In 1877, Claude Monet exhibited six pictures showing the Gare Saint-Lazare from different perspectives. His view of the platforms, the tracks, the engines, and the glazed station concourse manages to capture the fleeting moment, the atmosphere created by light and steam, the constant flux of men and machines. This is achieved with the aid of a vibrant pictorial surface and nervously applied brushwork, as a result of which the material aspects of the subject seem to dissolve.

A contemporary remarked that "his brush has expressed not only movement, color, and hustle and bustle, but the noises as well; it is incredible. This station is in fact filled with noise, grinding sounds, and whistles, which can be heard through the blue-gray clouds of smoke pouring forth. It is a pictorial

During the course of a single generation, a dense network of rail lines was laid, covering the whole of France (situation as of 1890).

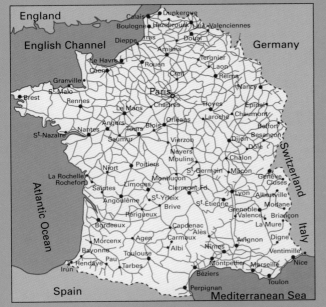

symphony." In this picture, Monet had created an artistic monument to the railroads, which were incidentally used by the painters as their main means of transport.

MP

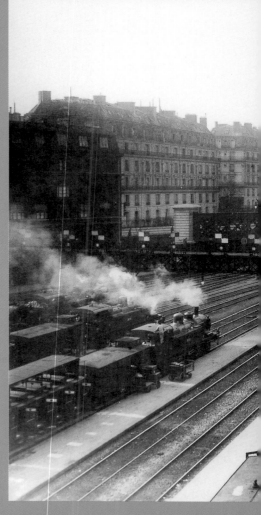

The Gare Saint-Lazare (1837–1867)

The newly built stations were located at the extremities of Haussmann's main routes.

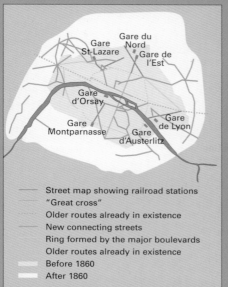

Street map showing railroad stations
"Great cross"
Older routes already in existence
New connecting streets
Ring formed by the major boulevards
Older routes already in existence
Before 1860
After 1860

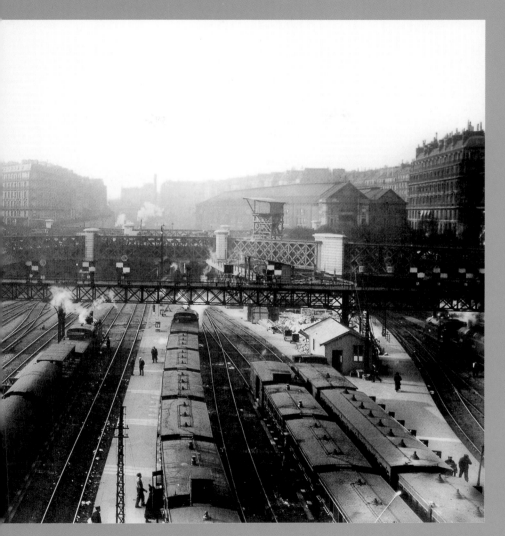

**Claude Monet,
The Gare Saint-Lazare, 1877**
Oil on canvas,
75.5 x 104 cm

At the beginning of 1877, Claude Monet moved near to the Gare Saint-Lazare, of which he was subsequently to paint twelve different views. This was the first experiment that the artist had made with the technique of serial repetition of a motif, a way of working that was to become typical of him from the late 1880s onward. When six views of the Gare Saint-Lazare were displayed at the third Impressionist exhibition in 1877, Emile Zola wrote that "Our painters are compelled to discover the poetry of railroad stations, in the same way that their fathers discovered the poetry of forests and rivers." Zola's apt remarks alluded to the fact that the newly constructed stations seemed to be an embodiment of the idea of modern, mobile, progressive living, a theme which the Impressionists had adopted in their works.

Monet captured the façade and the surroundings of the station, as well as the concourse with trains arriving at the platforms. He had obtained official permission so that he could also work inside the building. However, he only made preliminary drawings from life. The oil paintings themselves were executed in the studio, where the artist was able to work in peace and in more spacious surroundings than among the hectic comings and goings of the station.

By contrast with the usual interior views of the Gare Saint-Lazare, the painting in the Musée d'Orsay shows the gigantic iron and glass construction of the roof, with its apex placed symmetrically at the top of the picture on the vertical axis. There is a clear view of the Europe bridge and a few houses in the background, while inside the station steam, clouds, trains, and waiting passengers mingle in a shimmering, atmospheric picture in which it almost seems possible to hear sounds.

CS

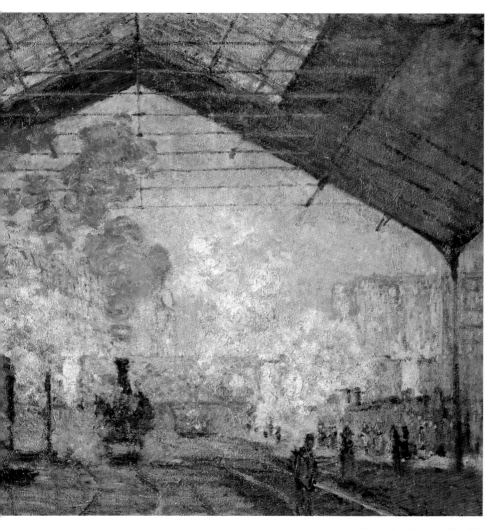

At the edge of the visible –
mountain landscapes by Monet and Hodler

Claude Monet, Mount Kolsaas in Norway, 1895, oil on canvas, 65.5 x 100 cm, upper level, room 34

In the spring of 1895, his interest having been sparked by the stories of the Norwegian painter Frits Thaulow, Monet traveled to Norway. He painted views of the fjords and the towns of Sandvik and Björnegaard, where he was staying, and at the same time he created the remarkable landscapes featuring Mount Kolsaas. The version in the Musée d'Orsay is painted in white and subdued shades of blue, gray, and violet. The colors of the sky and the landscape merge into one another, with the forested slopes of the mountain providing the only accents. Monet, who in this picture was pushing back the frontiers in terms of reproducing the visible, said in an interview with the *Dagbladet* newspaper in April 1895: "For me, the

subject matter has ceased to be of the essence. What I want to reproduce is the interaction between myself and the subject matter." Monet's late paintings, which no longer show reality in a naturalistic sense, but which increasingly adopt subjective sensations as their theme, point to the future beyond Impressionism. In the late 19th century, the feelings and states of mind of artists of widely differing stylistic persuasion – Expressionists and Symbolists, Cubists and Futurists – are captured on canvas. Thus, in the work of the Swiss Symbolist Ferdinand Hodler (1853–1918), we find a picture, comparable with those of Monet, of a snow-covered mountain landscape that is characterized by inner emotion. Here, he developed an abstract technique of linear representation, creating pictures in which the sensations felt by the artist when confronted with the powerful spectacle of nature were paramount.

Ferdinand Hodler, Schynige Platte, 1909, oil on canvas, 67 x 90.5 cm, mezzanine floor, room 60

Claude Monet, open-air study; Woman with a Parasol, turned to the right, 1886
Oil on canvas, 131 x 88 cm

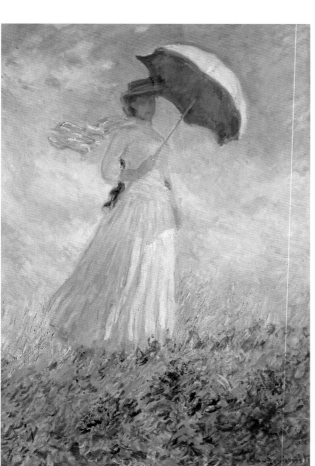

After a few pictures painted in the 1860s, Monet dispensed almost entirely with figures in his works, devoting himself to landscape painting. However, when he did include large figures in his landscape paintings, as started to happen again in the 1880s, he treated them as if they were an element in the landscape. In this painting, he was fascinated by the very low viewpoint from which the model is shown; she stands on a riverbank against a background of pale blue sky. We know that the young woman in both pictures is Suzanne Hoschedé, who had taken a walk on the Ile aux Orties on a sunny but windy day, accompanied by her younger sister Germaine, Monet's son Michel, and the painter himself. Suzanne was one of the daughters of Alice Hoschedé, who was to become Monet's second wife. They were married in 1889. His future stepdaughter Suzanne was to be for a long time one of the painter's favorite models.

Claude Monet, open-air study; Woman with a Parasol, turned to the left, 1886
Oil on canvas, 131 x 88 cm

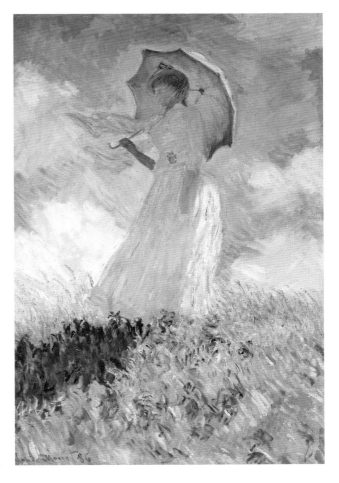

Around the mid-1880s, Monet reverted to the beginnings of his career as an artist and took up figure painting once more. In a letter to the art historian Théodore Duret, he wrote: "I am working as hard as ever, but on something new – figures in nature, and in particular my approach to them, painting them as if they were landscapes. It is an old dream that has always dogged me, and I would really like to turn it into reality at last – but it is so difficult."

What Monet meant is obvious when one is confronted by these paintings. The face is only fleetingly suggested, the figure is robbed of its individuality. Instead, the picture is characterized by natural phenomena: the brilliant sunshine, that sets nature alight and from which the woman is protecting herself with a parasol, and the wind chasing the clouds across the sky, stirring the grass, making her dress billow out and the ribbons on her bonnet flutter.

The loss of the original

The theory of impressionist painting, in essence, required the elimination of all narrative element and the increasing disappearance of material aspects, as well as an emphasis on the intrinsic value of color and application of color. The artists had been developing this since the 1870s, and had been mocked and excluded from the academic art world as a result. Their definition of the picture as a manifestation of the visual impression, and as canvas to which form is given by means of color, was largely at odds with the demands of a public accustomed to art as a means of educating and communicating values. As a painter, Claude Monet was constant-

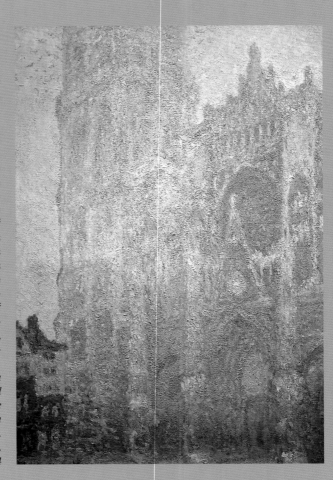

Claude Monet, Rouen Cathedral, the Façade and the St.-Romain Tower in the Morning (Harmony in White), 1893, oil on canvas, 106 x 73 cm, upper level, room 34

ly driven in his work by the process of concentrating on optical phenomena, and in doing so was continually pushing back the frontiers. When he painted a portrait of his first wife Camille on her deathbed in 1879, he was horrified to discover that, frightened as he was, he "perceived nothing but a colorful impression." The object, viewed as something of significance, was increasingly absent from his pictures, while painting became more important to him as "a powerful and at the same time sensitive communication of nature." In landscape painting, the weather conditions at a particular moment in time were now central, while atmosphere and light assumed the roles of composition: they were the motivating forces of pictorial representation.

When Monet finally began his serial compositions in the late 1880s, which initially featured haystacks, then poplars, and in the early 1890s the cathedral at Rouen, these works constituted a logical progression of his artistic interests. By constantly portraying the same subject, the variables determined by the time of day and the lighting – the chill of the early morning, the shimmering midday heat, the slow lengthening of shadows after sunset, or the reflections after a shower of rain – could be particularly strongly accentuated. Different times of day and a changing color palette were substituted for innovative subject matter. Monet included the time of day and the dominant colors in the respective titles of his paintings as a matter of course. Sometimes he worked simultaneously on two canvases, in order to be able to react immediately to changing light conditions. As a result, the subject of the picture receded further and further into the background: At first glance we can see the shape of a cathedral, but on closer inspection the cathedral architecture dissolves before our eyes into a vibrant ensemble, composed merely of a collection of brush strokes.

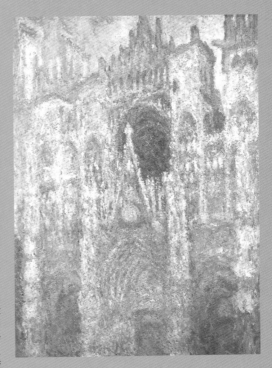

Variant: The Façade in Sunlight (Harmony in Blue), 1893, oil on canvas, 91 x 63 cm

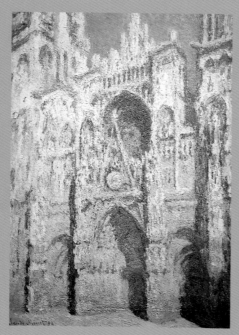

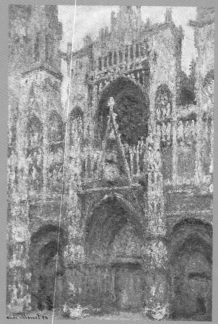

Variant: The Façade and the St.-Romain Tower in Sunlight (Harmony in Blue and Gold), 1893, oil on canvas, 107 x 73 cm

Variant: The Façade in Dull Weather (Harmony in Gray), 1892, oil on canvas, 100 x 65 cm, both on upper level, room 34

As regards traditional expectations of painting, the series by Claude Monet was an increasing source of irritation: Whereas the finished picture had previously constituted the optimal final product, resulting from numerous preliminary studies and sketches, many paintings of equal worth now revolved around a single theme. Detailed consideration of composition and design now gave way to the artist's swift, spontaneous act of painting. Taken to its logical conclusion, this implied a devaluation of concepts such as uniqueness or originality. Monet thus opened a door to developments that bore fruit well into the 20th century. Serial working became established as an artistic principle, a convincing reflection of the conditions under which art was produced in the "age of technical reproducibility."

MP

Claude Monet,
Haystacks, Late Summer in Giverny, 1891
Oil on canvas, 60.5 x 100.5 cm

Between 1890 and 1891, Claude Monet created no fewer than 25 "haystack" paintings. His aim was to demonstrate that the same objects, viewed from the same angle, change their form and colors at different times of the day and in different seasons. He explained his observations in a letter dated October 7, 1890, to Gustave Geffroy in the following words: "I am working a great deal, I have had the idea of painting a series of different effects (the haystacks), but at this time of year the sun goes down so quickly that I cannot keep up. I am making desperately slow progress, but I can tell as time goes by that I have a great deal more work to do if I am to reproduce exactly what I have in mind – the immediacy, the atmosphere of the moment, the same light pervading the entire space – and I am repelled more than ever before by the easy pictures produced at one sitting."

In May 1891, 15 paintings in the "haystacks" series were already on show in the Durand-Ruel gallery in Paris, and were sold in just three days at prices ranging from 2000 and 4000 francs. On May 9, 1891, Durand-Ruel himself bought the picture that today hangs in the Musée d'Orsay, together with six other "haystacks," for 2500 francs each. CS

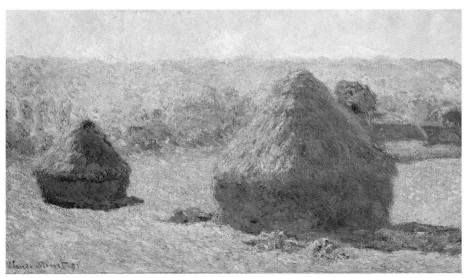

Vincent van Gogh

Vincent van Gogh (1853–1890),
A Tavern in Montmartre, 1886
Oil on canvas, 49.5 x 64.5 cm

This picture shows the tavern La Guingette, one of the typical meeting-places in the famous Parisian artists' quarter, which at that time was more like a village. However, the hustle and bustle of Sundays in Montmartre was of no interest to van Gogh. Only the seats under the pergola are occupied; in the foreground to the left, a couple, looking somewhat lost, is sitting at a table on one of the wooden benches, with the waiter standing a little apart.

The brushwork is already very free, released from its traditional task of delineating the image – in the leaves on the trees, for example, the clay-like foreground, or the waiter's apron. The colors, however, are confined to the earthy, dark tones that are reminiscent of van Gogh's early work.

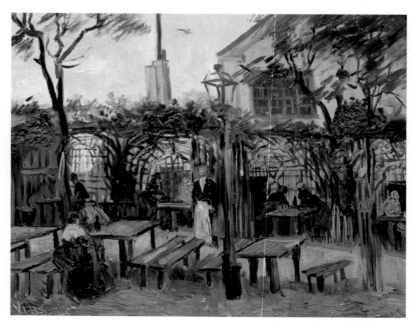

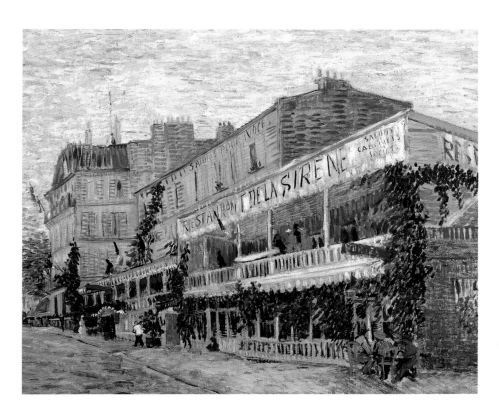

Vincent van Gogh,
The Restaurant de la Sirène in Asnières, 1887
Oil on canvas, 54.5 x 65.5 cm

This picture of an inviting restaurant in Asnières was painted only six months after *A Tavern in Montmartre*. Van Gogh's palette has lightened considerably, and his brushwork is noticeably more animated. The artist's unique facility for communicating his feelings directly by means of his brushwork is already in evidence. The light and the associated atmospheric effects have become the actual subject of the picture, very much in the spirit of the Impressionists. Although still restrained, the painting is defined in terms of color by contrasting complementary colors: Blue and orange, red and green.

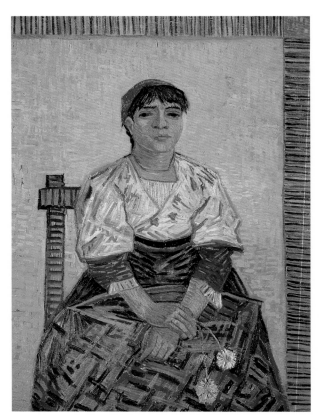

Vincent van Gogh, The Italian Woman, 1887
Oil on canvas, 81 x 60 cm

of his own work in addition to Japanese woodcuts. Van Gogh and Agostina, the Italian woman, were well acquainted and it is often suggested that they were also involved in a love affair.

The yellow and orange background, by which he produces a monochrome effect, is the result of van Gogh's study of colored Japanese woodcuts – at that time Japanese prints were held in high esteem – as is the painted frame bordering the canvas on two sides. The deliberate asymmetry of the vertical and horizontal lines of the chair echoes that of the painted border.

The artist's exploitation of the contrast between the complementary colors of red and green in this picture exemplifies the use of strong colors that is so typical of him. The two colors alternate in the stripes in the border, but the order breaks down in the head and hands: The short brush strokes begin to lead an energetic life of their own, which turns into a veritable riot in the painting of the blouse and skirt. Behind this lies van Gogh's intention to heighten the intensity of expression of his colors.

The subject of this painting is Agostina Segatori, the owner of the Tambourin café on the boulevard de Clichy. The artist often ate in this café, where he exhibited some

**Vincent van Gogh,
Eugène Boch, 1888**
Oil on canvas, 60 x 45 cm

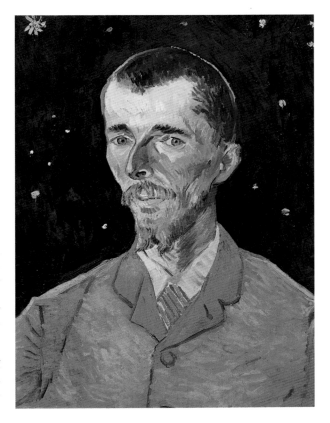

Throughout his life, van Gogh was drawn to portrait painting. All too frequently, however, he was frustrated in this ambition by the difficulty in finding models. In Arles, where he conceived the idea of a working community for progressive artists, he developed the idea of a "rogue's gallery" of characters such as the agricultural worker, the poet, and the lover. The Belgian painter Eugène Boch sat as the model for his portrait of a poet.

In a letter to his brother Theo, van Gogh wrote about the painting as follows: "Behind the head, instead of the blank wall of the shabby room, I am painting the infinite. I am making a simple background using the deepest, most penetrating blue that I can possibly create, and, as a result of this simple juxtaposition, the blond head against the deep blue background acquires a mysterious quality, like a star against a dark blue sky."

Van Gogh wanted to "express the intellectual quality of a forehead, by means of a luminous light color standing out against a dark background." Accordingly, the color contrast in this portrait is used to point to a symbolic meaning. The artist delighted in the psychologically expressive properties of color, of which this provides a very good example.

Vincent van Gogh, The Ballroom at Arles, 1888
Oil on canvas, 65 x 81 cm

This picture was painted during the time van Gogh spent with Gauguin in Arles. It shows the influence of Gauguin, but is influenced to an even greater extent by Emile Bernard. The composition of the ballroom shows great simplification of form. Strong black outlines delineate faces, hair, and clothing, reminiscent of the lead in stained-glass windows. There is a marked reversal of van Gogh's personal signature in the surface application of color. To a large extent he also dispensed with the drawing of detail. The decorative effect thus obtained seems in contradiction to the essence of van Gogh, but it does provide evidence of his efforts to achieve a unified pictorial surface.

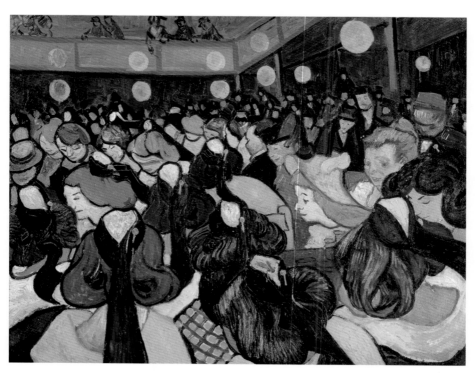

Vincent van Gogh,
Self-portrait, 1889
Oil on canvas,
65 x 45 cm

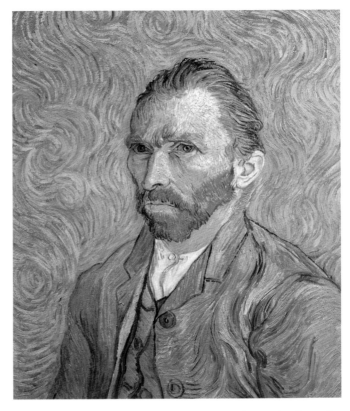

This celebrated self-portrait, painted in Saint-Rémy in August and September of 1889, is one of the last of a long series of more than 40 self-examinations. Like his famous compatriot, Rembrandt, van Gogh made repeated attempts to confront himself. As a result, he established himself at the forefront of a long tradition, in which the self-portrait became an important means of expression, and which was to extend via Edvard Munch (1863–1944) to include the German Expressionists. Van Gogh was not interested in the "photographic likeness" in portraiture, but in the "passionate expression." Accordingly, the largely monochromatic background – "the blue is a fine, southern blue," he wrote in one letter – is given movement only by the brushwork. Blue is also the color of distance: Since it recurs in the painter's jacket and waistcoat, van Gogh recedes from the onlooker. The reddish hair and beard are in contrast with the blue. By virtue of the color used – red, the color of proximity – the face is brought into the foreground. In this relationship of tension, the white shirt acts as a neutral area in terms of color. The intensity of the portrait is typical of the artist.

The long road to fame –
Vincent van Gogh and his heritage

Theo van Gogh, the brother of Vincent van Gogh, 1889/90

"With few words, Madame Theo van Gogh led us to the storeroom. All the pictures – almost all Vincent's works – stood there, unframed, turned to face the wall. On the tables were thick folders containing hundreds of drawings.

Madame van Gogh invited us to turn the pictures round and open the folders, excused herself, saying she was expecting a friend, and left us alone."

During the hours that followed on this May afternoon in 1894, the famous Art Nouveau painter and designer Henry van de Velde became increasingly fascinated by the work of the then practically unknown Vincent van Gogh, who had committed suicide three years previously.

In an attic in Bussum, in Holland, his sister-in-law, Johanna van Gogh-Bonger, was storing an inheritance that was to undergo a quite sensational increase in value in subsequent years due to her skill and commitment. The circumstances were not exactly encouraging: During his life, van Gogh only participated in three exhibitions and was granted only one individual exhibition of his work, in the Restaurant du Chalet in Paris. In 1890, the year of his death, he sold his first and only picture to the wife of an artist friend. The memorial exhibition organized by Emile Bernard and Theo van Gogh after his suicide had to be held in his brother's private apartment in Paris, since none of the galleries was interested in the work of the eccentric Dutchman.

Throughout his entire creative life, Vincent van Gogh received generous financial support from his brother Theo, who worked for a large art dealer in Paris. In return, Theo received almost all the work produced by the artist. From the very beginning, Theo had declined to regard the payments as charity; as he prophesied in a letter to his mother, written as early as 1885, "I regard the money that I give him as payment for his work, payment that he has earned. It may take a long time, but one day his work will be valuable."
In the few years until Vincent's death, about 500 paintings and 350 to 400 drawings accumulated at Theo's house. When the latter died quite unexpectedly only six months after his brother, they were inherited by Theo's young wife, Johanna van Gogh-Bonger, and were no doubt initially viewed by her as a further complication in an already difficult situation.

How was it that the entire work of the artist Vincent van Gogh nevertheless received such great acclaim posthumously? How can we explain the fact that this artist is so well known today? And, last but not least, how is it that canvases, which in those days were totally worthless, now command top prices at auction, even higher than those paid for high-quality works of Old Masters?

The first factor in this unlikely development was the commitment of the heiress. By the beginning of 1891, Johanna van Gogh-Bonger had worked long and hard to produce an inventory; she conscientiously kept accounts until her death in 1925, lent works for exhibition, and sold some to various art dealers, without ever succumbing to the temptation to flood the market with paintings by van Gogh. It was only as a result of her circumspection and care that the next generation of artists, collectors, museum curators, and art critics were able to make their collective discovery of these apparently worthless works of art.

The famous gallery owners Ambroise Vollard in Paris and Paul Cassirer in Berlin were primarily responsible for releasing the work of the Dutch painter from the dust of the attic room and putting it on public display.

After 1900, especially in Germany, important private collectors and progressive museum directors became aware of van Gogh's work

Johanna van Gogh-Bonger with her son Vincent Willem, the godchild of Vincent van Gogh, 1890

and made some initial purchases. The decisive moment came when the art historian Julius Meier-Graefe analyzed van Gogh's work in detail in his *History of the Development of Modern Art*, published in 1904, thus contributing greatly to the esteem in which van Gogh was held. During the years that followed, his painting came under fire as modernism fought to become established. The purchase in 1911 of a landscape painting by the art gallery in Bremen, for instance, provoked a quite hysterical reaction among conservative artists and critics. Almost simultaneously, as a result of the Sonderbund (special league) exhibition in 1912, featuring over 100 exhibits, van Gogh was "discovered" as one of the forefathers of modern painting and as a model for young German artists. His intensely colorful pictures and

Vincent van Gogh, Poppy Field, 1889/90, oil on canvas, 71 x 91 cm, Kunsthalle, Bremen

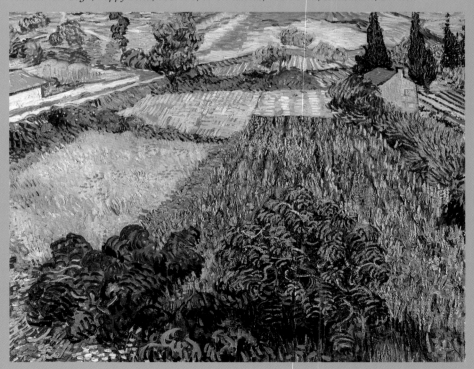

his unmistakable brushwork either shocked or enthralled the public – at any rate they left no one cold, even though they were more than 20 years old. Prices began to rise in the wake of intensifying interest in the painter by art dealers, who were now joined by the Parisian galleries of Bernheim-Jeune and Druet. An important oil painting from the artist's Arles period, bought in 1905 for about 1790 € from the Berlin-based dealer Paul Cassirer, was to command a sale price of 12,700 € seven years later. As a general rule, therefore, public collections today only possess works by van Gogh as a result of prompt purchases or generous bequests from private art-loving individuals.

The Musée d'Orsay owes its impressive collection of 22 oil paintings, which it could not afford at current prices, primarily to private collectors. An important role in this was

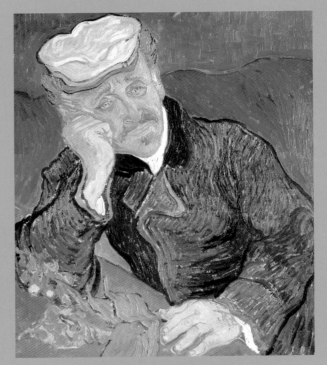

Vincent van Gogh, Dr. Paul Gachet, 1890, oil on canvas, 68 x 57 cm, upper level, room 35

played by Paul Gachet, the doctor who treated van Gogh from May 1890 onward in Auvers-sur-Oise, and in whose care he died two months later, on July 29, following a suicide attempt. In Gachet's impressive art collection, alongside works by Cézanne and Renoir, there were 26 pictures by van Gogh, eight of which were acquired directly by the French nation after the

Second World War and today belong to the Musée d'Orsay, among them *The Church at Auvers-sur-Oise* (see p. 283).

MP

279

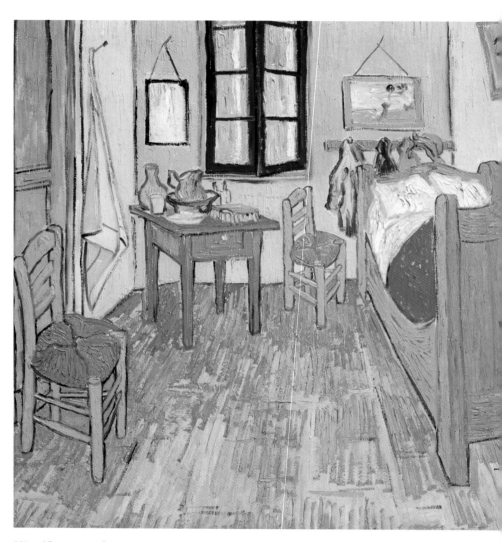

Vincent van Gogh, Van Gogh's Room in Arles, 1889
Oil on canvas,
57 x 74 cm

Van Gogh painted the second version of his *Room in Arles* during the year he spent in hospital at Saint-Rémy after his psychological breakdown in Arles. Subject to bouts of depression, he was to shoot himself the following year. The picture is one of his most famous, and is rightly considered a masterpiece. We know that the artist himself thought it one of his best works, not only because he repeated it so many times, but from things he wrote in his correspondence. When, in a letter to his brother Theo, van Gogh described the first version painted in October 1888, he referred to it as "quite simply his bedroom," and said that "color alone" was the subject of the painting. He also told his brother that he intended to give objects a "grander style" by means of "simplification."

The color characteristics of the painting are defined by the decisive use of contrasting complementary colors – red and green, yellow and purple, blue and orange – to which van Gogh added a fourth contrasting pair, namely black and white.

Van Gogh's use of perspective when portraying objects constitutes an unusual artistic innovation. The foot of the bed towers up as if viewed from beneath, whereas the onlooker looks down upon the pillows, the chairs, and the table. But even this perspective is not uniform, for the chairs and table are shown as if they are viewed from different heights. The painter has no fixed viewpoint in relation to the room; it varies from object to object as the viewer surveys the picture. A subjective experience of space is a feature of Van Gogh's composition, and, together with a use of color aiming to achieve heightened symbolism, is typical of his style, which van Gogh wanted to be seen as "grand style."

The painter himself – who is clearly identifiable by his red hair – is present in the picture, though this is not immediately apparent, gazing at the onlooker from the self-portrait that hangs on the wall above the bed.

From Naturalism to Expressionism

Two works in the Musée d'Orsay offer us an opportunity to compare the art of Millet directly with that of van Gogh.

Millet's picture shows the church in Gréville, a village on the coast of Normandy quite near the artist's birthplace. The simple rural church and adjoining buildings take up almost the entire width of this landscape-format painting; they appear firmly embedded in the earth. At the same time, the apex of the roof and the cross on top of the tower rise up into the cloudy sky. Cattle graze near the wall surrounding the churchyard, and a farmer is walking past on the path in front of it. The foreground is painted in earth tones of brown and green, while the upper half of the picture is dominated by the shimmering blue of the sky and the gray and pink of the clouds. The church, radiant in the soft light, is a place of refuge.

Van Gogh's picture, painted only 16 years later, is identical to that of Millet in terms of the motifs, but is based on a completely different artistic premise. The church in Auvers-sur-Oise has been transformed by the artist into a vision using form and color. Painted in portrait format, the church towers up before the onlooker like a fortification. The path leading to it forks in the foreground into two narrow paths passing the church on either side. On the path to the left, her back turned toward us, a peasant woman is walking into the distance. The path is bathed in light, while the church is viewed against the backdrop of a dark blue sky that merges with the blue-black of the night sky at the edges of the picture. The brushwork is restless and full of movement, and the forms of the church are distorted in the Expressionist manner.

The attitude to the subject and its treatment in terms of form and color are evidence of the fact that the content of van Gogh's picture is determined not by subdued emotion, as in Millet's more lyrical painting, but by highly intensified expression of feeling.

Jean-François Millet, The Church at Gréville, 1871/1874, oil on canvas, 60 x 73.5 cm, ground floor, room 6

Vincent van Gogh, The Church at Auvers-sur-Oise, 1890, oil on canvas, 94 x 74 cm, upper level, room 35

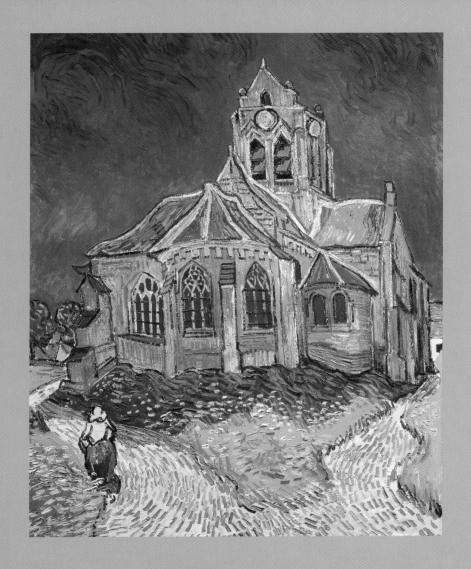

Vincent van Gogh, The Nap, 1889/90
Oil on canvas, 73 x 91 cm

While in Saint-Rémy, van Gogh transformed an engraving, a copy he had made of a drawing by Jean-François Millet, whom he much admired, into an oil painting possessing the intensity of color and immensely energetic brushwork that are typical of his final creative phase. In the midday heat, a farmer and his wife are taking a rest from their strenuous work in the fields in the shade of a haystack. The man has pulled his sunhat right down over his face, removed his heavy wooden shoes, and has put these to one side, together with the pair of sickles. The blue sky contrasts with the yellow field, and this intense color contrast is repeated in the foreground in the couple and the haystack providing the shade.

The theme of this painting, which can be seen as symbolizing work, rest, and human companionship, must have appealed directly to van Gogh. Throughout his life, he empathized with the destitute. This feeling of solidarity had led in 1879 to his dismissal as a lay preacher in the Borinage, the Belgian coal-mining district, because the overwhelming poverty there made such an impression on him that he gave away all his possessions on the spot.

Vincent van Gogh, Thatched Houses in Cordeville, Auvers-sur-Oise, 1890
Oil on canvas, 73 x 92 cm

Regardless of his beleaguered state of health, van Gogh found the small village of Auvers-sur-Oise, a spot where other painters such as Daubigny or Cézanne had lived before him, attractive from the very beginning. The day after his arrival at the house of his host, Dr. Gachet, the painter wrote to his brother Theo: "Auvers is truly very beautiful; there are still a lot of old thatched roofs here." Vincent van Gogh endows the subject of his painting with a primeval qual-

ity: The thatched houses emerge from the background of a terraced slope. It is a matter for conjecture as to whether the trees rising up on either side have adapted their form to that of the houses or vice versa. The form and color of the painting also support the interpretation that this is a place where life is closely bound up with the earth. The brickwork in the façade of the houses echoes the terracing, the color of the buildings reflects the green and ochre of the surrounding natural environment, and even the blue of the sky is picked up in the brickwork in the foreground. Yet the rural idyll is given subliminal tension by virtue of the strong wave-like movement in the lines extending from the bushes, via the flame-like trees, into the clouds.

Mademoiselle Gachet in her Garden at Auvers-sur-Oise, 1890

Oil on canvas, 46 x 55.5 cm

Van Gogh painted the elder daughter of Paul Gachet, Marguerite, in her garden. The blond young woman, looking like the ethereal figure of an angel, is standing in her white gown in the middle of a magnificent profusion of flowers in full bloom, a view that is closed in to the rear by the cypresses that van Gogh loved and painted again and again. The equation of woman with nature is given literal form in this portrait, in which the artist presents Marguerite, who is barely 20 years old, as a creature of the garden, just as though she were the most beautiful bloom in it.

Vincent van Gogh, Dr. Gachet's Garden in Auvers-sur-Oise, 1890
Oil on canvas, 73 x 52 cm

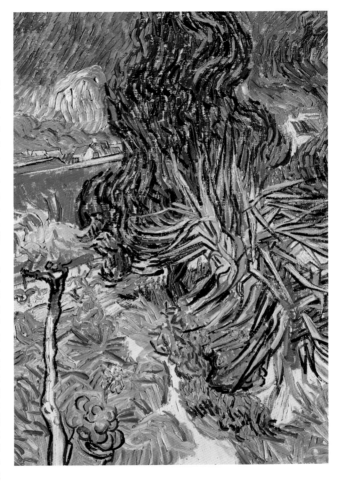

The local inhabitants of Auvers-sur-Oise referred to the house in which Dr. Gachet lived with his children, on a hill and surrounded by high walls, as "the citadel." Paul Gachet, a doctor specializing in nervous disorders, looked after the sick van Gogh during the last few weeks of his life.

It is clear from van Gogh's large-scale painting of the garden that it gave the impression of a secure environment, or even of a fortress. The garden is densely overgrown with trees and plants. Towering, dark trees enclose the plot of land, permitting only the occasional glimpse of a neighboring roof. In addition, the painter's viewpoint has been chosen in such a way that the large cypress in the background obstructs the view of the distant landscape and the sky. The house and garden of the Gachet family therefore stood apart, shut off from the outside world, as though offering a refuge.

Places of retreat –
in search of the artist's personal style

In 1855, in a pavilion in front of the Great Exhibition site, which he had built himself and which bore a sign bearing the legend "Realism," Courbet defiantly and confidently exhibited his paintings, which had been rejected by the jury of the Salon year after year. Thus began the inexorable process that was to result in the demise of the traditional artistic institutions.

View of the pool built by Claude Monet in his garden at Giverny

Claude Monet standing in front of the enormous waterlily painting in his studio at Giverny, ca. 1923

The authority of the Académie des Beaux-Arts and the Salons, which until that point had launched and endorsed every artist's career, crumbled. The young painters organized themselves, made alternative arrangements for exhibitions, found ways to market their paintings themselves with the aid of courageous gallery owners, and for the most part gained recognition, albeit belatedly, in the form of purchases made by collectors and – slowly but surely – by museums. However, the decline of the fossilized institutions and the reformed criteria for evaluating painters that were instigated by the artists themselves were only one side of the coin. At the same time, the new criteria for judging artistic quality were questioned: If craftsmanship, skillful composition, and mastering the subject matter of historical paintings were no longer the mark of an outstanding artist, how should such an artist be recognized in future? Individuality and originality, uniqueness and simplicity – these were the magic words whispered in collectors' circles that determined success or failure, and continue to do so today. In this way, a

process of individualization of artists was begun, covering the whole spectrum from the search for an individual style, a unique signature, and original subject matter, to external and internal isolation.

Claude Monet in Giverny, Paul Cézanne in Provence, Paul Gauguin in the South Seas, and

Paul Cézanne photographed by Emile Bernard in southern France

Vincent van Gogh, at first in Arles and later in Auvers-sur-Oise – these are four prominent examples of the tendency to retreat that dogged artists up to the turn of the twentieth century, in the search for their own and unmistakable style of painting.

After a marathon consisting of seven exhibitions organized by the Impressionists in Paris in the years between 1874 and 1882, most of the members of the group left the capital. After years of oppressive existential Angst, Claude Monet's growing financial resources enabled him to buy – and renovate – a house and garden at Giverny. He created a Japanese-inspired garden with a waterlily pool, exotic aquatic plants, dense shrubberies, a bridge, and picturesque weeping willows. The result was a program of expansion of the artistic act: The artist not only created the painting, but the subject matter as well. An army of gardeners helped the aging Monet create his own world, into which he withdrew completely from 1900 until his death in 1926, a world to which his cycle of large-scale paintings provide a memorial. All references to the external world, whether technical or social, disappeared from Monet's artistic universe: Railroad stations and boulevards were replaced by the paradise garden, seen as a *hortus conclusus*, or secluded terrain.

Paul Cézanne had already turned his back on Paris in 1877, after his works in the third Impressionist exhibition had met only with disapproval. "The artist whom the press and the public have attacked the most and treated the worst is Monsieur Cézanne. Every conceivable insult has been hurled at him, and his pictures have induced paroxysms of laughter that have yet to

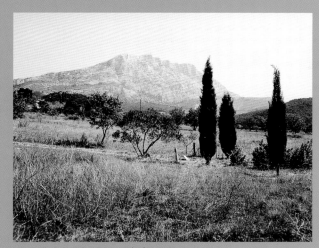

Mont Sainte-Victoire at Tholonet in Provence

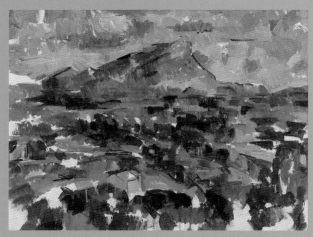

*Paul Cézanne, Mont Sainte-Victoire, ca. 1904/1906,
oil on canvas, 63.5 x 83 cm, Kunsthaus, Zürich*

cease," wrote Georges Rivière, one of the few well-disposed critics. After this slight, Cézanne, who had inherited a fortune and, unlike most of his painter friends, was therefore financially independent, returned to his native Aix-en-Provence. He stayed away from Paris for nearly 20 years, and did not show his paintings at any exhibitions. Totally cut off from the artistic scene, from colleagues, collectors, and critics, Cézanne developed a new spatial concept in his isolation in the natural environment that broke with all the rules of perspective and the Impressionists' reliance on atmospheric detail. His landscapes, which were frequently painted in the area around the Mont Sainte-Victoire, instead lay claim to autonomy and universal applicability: Constructed from form and color, they show themselves to be independent of variables such as the weather, the conditions of light, the time of day, or the season.

In Provence, Cézanne trod a new artistic path, and he trod it alone. In 1895, when the art dealer Ambroise Vollard held an exhibition in his gallery in

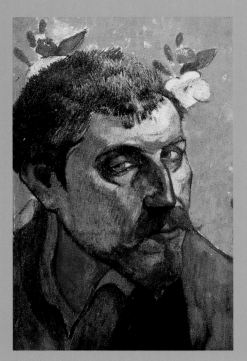

Paul Gauguin, Self-portrait "Les Misérables"
(detail), 1888, oil on canvas, 71 x 91 cm,
Vincent van Gogh Foundation/Rijksmuseum
Vincent van Gogh, Amsterdam

the rue Lafitte including about 150 works by
Cézanne, this was a revelation to the young
generation of artists led by Emile Bernard and
Maurice Denis. Cézanne's stylistic influence
continued well into the 20th century. In particu-
lar, it is scarcely possible to imagine Cubism
without the work of Cézanne.

It was not on his native territory, but in exotic
foreign parts that Paul Gauguin sought new
visual impressions and above all a new way of
living. In 1891 he traveled to Tahiti for the first
time, and found there – after earlier stays in
Brittany and an interlude in Arles – a place cor-
responding with his ideals of an existence that
was opposed to the constraints of civilization
and untouched by the effects of alienation.

However, Gauguin was disappointed to dis-
cover that French colonialism had wrought last-
ing changes in the traditions and living
conditions of the islanders, and that the par-
adise he conjured up in his paintings had actu-
ally long ceased to exist.

Nevertheless, he finally made his home in the
South Seas in 1895, and began the rational
development of his artistic ideas that made him
the protagonist of modern Primitivism. An alco-
holic, psychologically frail, a martyr to his sex-
ual obsessions, Gauguin painted pictures right
up to his death in 1903 that for the first time do
not just portray the exotic, but also attempt,
using appropriate pictorial means, to capture
formally the supposedly naive and genuine
nature of primitive peoples.

Once again it was the art dealer Ambroise
Vollard, an astute businessman and art lover,
who offered Gauguin a contract in 1896 and
acquired exclusive rights to show his paintings
in Parisian galleries.

Young women of Tahiti
standing in front of a beach hut

Gauguin's beach near
his house on Tahiti

The cycle was complete: Gauguin's longing for the primeval and for harmony between man and nature had induced him to leave Europe once and for all, yet his paintings came back to Europe to delight the public – even today – with the same fantasies of a primitive life in which civilization was anathema, a life which largely failed to materialize for Gauguin.

The final years of Vincent van Gogh's life in Arles, Saint-Rémy, and Auvers-sur-Oise were marked by his descent into ill health and ultimate death. He had left Paris in 1888, drawn by his desire for continuing personal artistic development and his hope of founding an artists' community. Although, under the influence of the countryside in the south of France, van Gogh managed to free himself from Impressionist and neo-Impressionist models while in Arles, the collaboration with Gauguin that he had yearned for ended in disaster. His self-mutilation in

Paul Gachet, Vincent van Gogh on his Deathbed, 1890, charcoal drawing, Musée du Louvre, Paris

December 1888 was the first sign of van Gogh's mental illness, which increasingly isolated the artist from his colleagues and his surroundings. In May 1889, he admitted himself to the asylum at Saint-Rémy, where he lived and worked for a year. In total seclusion both outward and

The room in which van Gogh died in Auvers

inward, Vincent van Gogh developed the expressive pictorial language that made his works unique and so illuminating for successive generations of artists. Van Gogh's final weeks, spent in Auvers-sur-Oise at the home of Dr. Gachet, were enormously productive until his attempted suicide, the consequences of which led to his death on 29 July 1890. Van Gogh was literally painting for his life; his deepest crisis perhaps produced his most overwhelming credo in the power of artistic creativity. Unlike many of his friends, he would not survive to enjoy his own success. His death in a spartan attic room brought to an end the life of an artist that would be unequaled as a symbol of the modern artist's existence. Although financially dependent upon his brother, having had little success in selling his paintings, and having received no recognition, Vincent van Gogh had produced an original body of work that was to have a fundamental influence on future artistic developments.

These four examples clearly demonstrate that modernism, with its claims regarding innovation and originality, required, or at least provoked, the isolation of the artist. This was the culmination of a development over the centuries in which artists were gradually released from the constraints of the guilds and later of the royal courts. The history of modern art is also marked by many attempts to relieve this personal and social isolation, as is evident from the many colonies, groups, and communities of artists. However, in the majority of these we see individual artists leaving the group, or even breaking it up, in order to make their own personal mark on the development of art and thus to position themselves as inventors or innovators. Luck and the dilemma of modernism as an individualist system therefore go hand in hand.

MP

Vincent van Gogh, Saint-Paul Hospital in Saint-Rémy, 1889, oil on canvas, 63 x 48 cm, in storage

Paul Cézanne

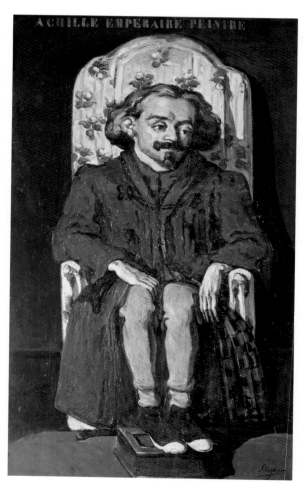

**Paul Cézanne (1839–1906),
Achille Emperaire, 1867**
Oil on canvas, 200 x 122 cm

This larger-than-life portrait depicts the Provençal painter Achille Emperaire (1829–1898), who was a friend of Paul Cézanne. He is seated in a high-backed white armchair decorated with flowers, which makes him stand out clearly from the dark background. His body is directly facing the onlooker. His huge head is in stark contrast with the delicate hands, the thin body, and the gawky, stunted legs. Emperaire's gaze is oblique.

This picture, like all the other paintings that had been submitted by Cézanne in previous years, was rejected by the Salon jury. This was in part due to the gloomy, mysterious use of color and the unnatural effect produced by the color contrasts. By the standards of the Academy, the portrait looks dirty; this is particularly noticeable with regard to the head, on which the light falls from the left. In addition, the blue morning coat is unbut-

toned above the knee, revealing the pink, withered legs, the feet clad in shoes with white points. The deformity of the subject may have been the ultimate reason for the rejection. There is a world of difference between Cézanne's portrait of his friend and Léon Bonnat's rather later painting of Jules Grévy (see p. 398), so striking that it suggests Cézanne may have practically provoked the jury to reject his painting.

Paul Cézanne, Magdalena (Pain), ca. 1869
Oil on canvas, 165 x 125.5 cm

This painting, a relatively early work, shows the penitent Mary Magdalene as she kneels before a table or altar, on which lies a skull, which is a traditional symbol of transience. The three stylized tears suspended above her are a sign of repentance and consequent forgiveness. Mary Magdalene is viewed from the front, the objects by contrast are seen from above. Using lively brush strokes and a thick application of color, Cézanne adds accents to the gloomy background: A subdued blue and pale white tones fall obliquely on the

clothing, while earthy green and brown tones, brought into relief with white, give form to the face and the skull. This painting is very much so characteristic of Cézanne's work at this time.

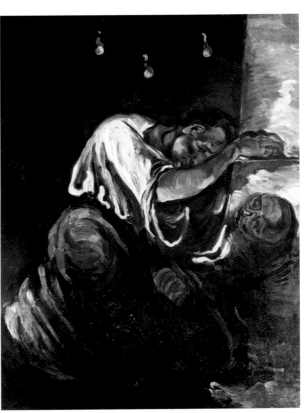

Paul Cézanne, Dahlias, ca. 1873
Oil on canvas, 73 x 54 cm

Still life was one of Cézanne's favorite genres, because the motionlessness of the objects portrayed suited the slow, dogged manner in which the painter worked. He painted still lifes throughout his life, and they include some of his most famous works.

This painting of dahlias is the first in a series of flowers in a Delft vase that Cézanne painted in the house of his friend, the collector Paul Gachet, in Auvers-sur-Oise. After embracing open-air painting in the early 1870s, the artist's color palette grew stronger.

Paul Cézanne, The Blue Vase, 1889/90
Oil on canvas, 61 x 50 cm

It is hard to imagine two paintings more different than Cézanne's *Dahlias* (1873) and *The Blue Vase* (1889/90). In the later still life there is much greater differentiation in the rendering of the pictorial space. In the background, sections of two picture frames and a wall-covering form a slight diagonal running through the picture. In front stands a table, cut off at both ends by the sides of the picture, its lower edge only slightly above the bottom edge of the painting and almost parallel to it. On the table, next to the vase containing the flowers, are a bottle, a plate, and another vessel. Three apples lie in the foreground, in line with the vase. The small number of carefully placed objects are organized in a skillful interplay of verticals, horizontals, and diagonals. The range of colors, which are applied more thinly than in *Dahlias*, reflect Cézanne's striving for equilibrium. The most intense color values are seen in the flowers, where red is juxtaposed with white, and white with green. The harmony of the picture is basically determined by the subtle range of various shades of blue, which are accompanied by contrasting orange and pale ochre, the complementary color. Around the central blue vase, which dominates the composition, the tallest flowers form a turquoise group; as if by extension the wall has a bluish sheen, and even the shadows of the objects assembled on the table are blue.

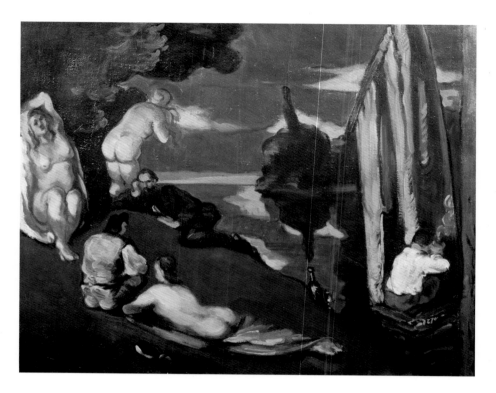

Paul Cézanne, Pastorale (Idyll), 1870
Oil on canvas, 65 x 81 cm

In his early years in Paris, in addition to a few isolated portraits and landscapes, Cézanne mainly painted serious, gloomily executed scenes of temptation, murder, and abduction. The *Pastorale* also has the characteristic features of Cézanne's early work: In unreal moonlight, three naked

women and three clothed men are on a river bank. The men give the impression of being relatively detached. While the man on the grass, below left, and the man in the boat have their backs turned to the onlooker, the bearded young man lying on the bank has Cézanne's features: The painter himself – entangled in erotic fantasies – is present in the picture. However, this is no ideal dream world that the artist

portrays, but a dark, threatening landscape, in which naked femininity shines out palely like a temptation.

The subject matter is reminiscent of pastoral scenes from the Venetian Renaissance, as painted for instance by Titian and Giorgione, but also reminds us of the works of Rubens, with which Cézanne was familiar from the Louvre. At the same time, the painting can be interpreted as the young artist's personal response to Manet's *Déjeuner sur l'herbe* (see p. 180), which scandalized the Parisian art world in 1863.

CS

picture was painted directly from nature in Auvers-sur-Oise, and can be viewed as an early example of the impressionistic phase in Cézanne's work. At the same time, however, huge differences are visible between Cézanne's open-air painting and the much lighter and more spontaneously executed paintings of his Impressionist friends. The paint is thickly applied; in places, for example the path in the foreground and the house further away in the center of the background, the artist used a spatula. On one hand the thick covering of paint reflects the abundance of impressions provided by nature, while on the other it is also evidence of Cézanne's endeavors to construct a pictorial space.

Paul Cézanne, The House of the Hanged Man, 1873
Oil on canvas, 55 x 66 cm

The artist himself ascribed great significance to this landscape painting, the title of which has lingering echoes of the subjects of his early period. It is also one of the few he signed, and he exhibited it on no fewer than three occasions during his lifetime (in 1874, 1889, and 1900). The

The "realization" of nature in paintings – the *Bathers* series

Bathers feature on more than 200 occasions in the work of Paul Cézanne – in over 20 oil paintings, some large-scale, in numerous studies and sketches, and in drawings and prints. No other subject was painted continually to such an extent over a period of almost 40 years. Historically, the motif of bathers can be traced to various literary sources. It begins with Susannah in the Old Testament, who was gaped at by a lecherous old man as she lay in the bath, moves on via the birth of Venus, emerging in antiquity from the waves on a Cyprus beach, to

Paul Cézanne, Bathers, ca. 1890/92, oil on canvas, 60 x 82 cm, upper level, room 36

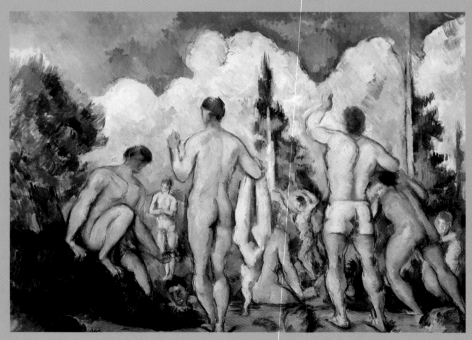

Alexandre Cabanel, The Birth of Venus (detail), 1863, oil on canvas, 130 x 225 cm, ground floor, room 3

the concept of baptism, in which bathing acquires a whole new meaning in the Christian context of physical and spiritual cleansing.

Paintings for the Parisian Salons continued to draw on these literary precedents until well into the 19th century, albeit frequently as mere justification for erotically charged offerings of idealized female nudes. Alexandre Cabanel's *Birth of Venus* which was exhibited in the 1863 Salon, encapsulates the predominantly voyeuristic view of the female body on the part of both

the artist and the onlooker. With the advent of modernism, artists increasingly began to dissect the underlying philosophy of such motifs, which were felt to be hollow and false. "Bathers," in other words pictures of naked people in natural surroundings, emerged as a genre in its own right, of which Cézanne's paintings serve as an example.

They show groups of people lying, crouching, standing, or moving about in the open air. Turned away from the onlooker, by no stretch of

the imagination displaying their nakedness, their bodies are not idealized, but appear heavy and voluminous, we can even describe them as overstretched and heavily distorted.

While Cézanne broke the anatomical rules in his portrayal of the human body, a second glance shows him also breaking away from convention as regards the composition of the landscape. Foreground and background are closely related in terms of color, and there is no spatial depth; instead there is a narrow stage, on which the figures appear like actors. By contrast with the Impressionists, Cézanne is not concerned with the authenticity of the observed moment, but with a deliberately calculated composition. He himself used the French term *réalisation*, for which "realization" is an inadequate translation, to describe the relationship between man and nature: With natural phenomena as the starting point, the artist invents a parallel picture beyond space and time, which is subject not to the criteria of observation of nature, but to the demands of an artistic structuring of nature. As a result, the landscape and the nudes merge into a quite architectural construct, over which the artist himself has total control. By this means, Cézanne opened up new opportunities with regard to form that extend far beyond the Impressionism movement.

MP

Paul Cézanne, Bathers, ca. 1890/1900, oil on canvas, 22 x 35.5 cm, upper level, room 36

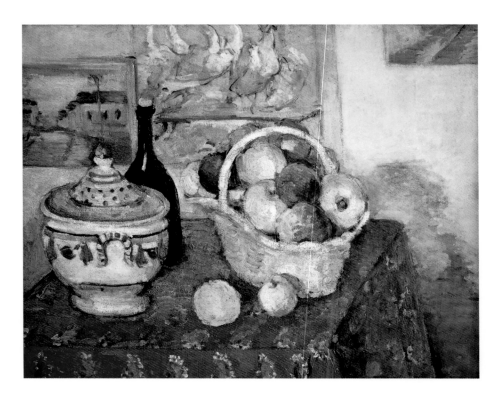

**Paul Cézanne, Still Life with Soup Tureen,
ca. 1877**
Oil on canvas, 65 x 81.5 cm

This still life, painted in Pontoise in around
1877, shows part of a landscape painting by
Pissarro in the background, which also fea-
tures as a painting within a painting in Pis-
sarro's portrait of Cézanne. The elements
of a still-life painting – a soup tureen, a
wine bottle, and a fruit basket – are con-
tained within a clear framework of verti-
cals, horizontals, and diagonals formed by
the table in the foreground and the paint-
ings in the background. Arranged one
behind the other and viewed slightly from
above, the objects are assembled on one
level. The exuberant colors used by the
artist embrace the entire spectrum from
yellow to violet.

Paul Cézanne, Apples and Oranges, ca. 1899
Oil on canvas, 74 x 93 cm

This picture is from Cézanne's later work, from the period that began around 1895. It differs fundamentally from the *Still life with Soup Tureen* painted over 20 years previously. Spatial organization, distinguishing clearly between foreground and background, has largely been dispensed with. The mediating effect of perspective is also absent, with the result that the plate of fruit and the apple in the center appear in danger of falling over. The color spectrum is markedly less broad than before. The tablecloth and furniture, which form a backdrop, are painted in tones of brown and green. The richness of color and the abundant nuances in the red, yellow, and orange tones is focused on the fruit. Cézanne links these areas of intense color with neutral zones.

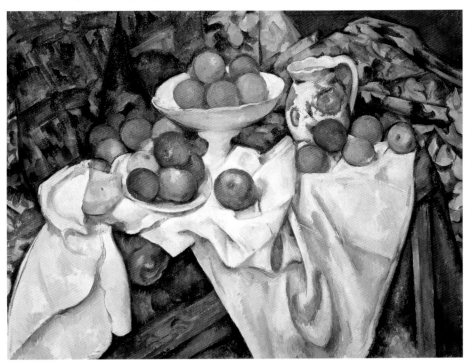

Paul Cézanne, The Bridge at Maincy, 1879/80
Oil on canvas, 58.5 x 72.5 cm

This landscape was painted during the period when Cézanne was resident in Melun (from April 1879 to March 1880). It shows the bridge over the river Almont in Maincy, near Melun.

Cézanne builds the intense green landscape using deliberately structured brush strokes. The arrangement of individual layers is in line with the objects portrayed: The arches leading to the small wooden bridge are formed with rising strokes of color, the smoothly flowing river is rendered by brush strokes parallel to the lower edge of the picture, while the forest has most layers of color. Depth in the painting is conveyed exclusively by the receding intensity of the color, with the dark areas in the

water suggesting proximity, and the lighter areas suggesting distance.

Interestingly, Cézanne combined his painting technique with a traditional artistic concept. The bank area, which is cut off at the edge of the picture, and the two tree trunks rising up in the bottom left-hand corner of the picture introduce a dimensional scale in the foreground of the picture that is perspectively clearly distinct from the bridge further to the rear.

Paul Cézanne, Woman with Coffeepot, ca. 1895
Oil on canvas, 130.5 x 96.5 cm

This painting combines the genres of portrait with still life. The ordinary woman in her plain, blue dress is viewed frontally, and the vertical axis of the painting passes through her. A vertical line appears to run from the parting in her hair, via the bridge of her nose, down to the fold in the center of her dress, emphasizing the upright bearing of the figure and giving her a dignified, solemn presence. Cézanne invests everyday objects with a presence comparable to that of the figure. The apparent fold in the center of the painting has formal parallels in the spoon in the cup and the handle of the coffeepot. Both verticals are further elongated by the shadow. The circle of the cup is echoed in the collar of the dress, and the fold in the tablecloth is repeated in the folds of the dress.

Of all the colors used, none stands out from the rest. The rust red of the tablecloth recurs in the figure and in the dress, as does the metallic blue of the coffeepot. Even the pink and white tones of the flower pattern on the wallpaper shine through underneath the blue of the dress. In this picture, Cézanne upgrades the value of objects. They no longer occupy second place, but share a common existence with the figure and are given comparable weight. The figure and the objects are placed on equal terms in front of the rectangular areas of the paneled double door; the distances between the rectangles are strikingly similar to the distances between the objects, giving the whole composition a formal unity.

The Card-Players (with detail), 1890/1895
Oil on canvas, 47.5 x 57 cm

At the beginning of the 1890s, Cézanne was to be found in Aix-en-Provence, busily working on his ambitious composition *The Card-Players*, of which several versions were painted. His models were simple peasant farmers who worked on the land at Jas de Bouffan, the Cézanne family estate. No fewer than five versions survive. The two earliest versions include five and four figures respectively, while the three subsequent versions confine themselves to two figures, seated opposite one another.

Cézanne's working approach was reductive, thus increasing the density compared with the previous versions. The background, which in the large-scale compositions containing several figures still suggests a scenic setting, is like-

wise increasingly simplified. The painting owned by the Musée d'Orsay is the final and smallest picture in the series.

The game has not yet begun; no card has yet been played. The bottle set between the two players, its verticality emphasized by a highlight, divides the scene into two almost symmetrical halves, and underlines the opposition of the two players. There is a slight asymmetry in the posture of the men, in the complementary colors shaping the trousers and jackets of the adversaries, and in the different head coverings. Whereas the figure on the left is sitting in front of a background structured only by means of color, the other is in front of the vertical lines formed by the interior fittings in the room.

Colorful pictures for the show booth

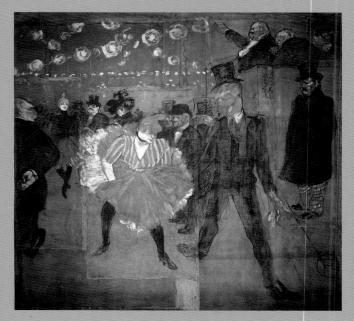

Henri de Toulouse-Lautrec, Dance at the Moulin Rouge, 1895, Oil on canvas, 298 x 316 cm, upper level, room 36

a decoration for La Goulue's show booth situated at the Foire du Trône, a fairground on what is today the place de la Nation.

The dancer's career, which had begun just ten years previously, was crowned by her very successful appearances at the Moulin Rouge, opened in 1889. With her dancing partner Valentin le Désossé (1843–1907), who was said to be "boneless," she was one of the great stars of the legendary Parisian dance hall. The posters by Toulouse-Lautrec had also made a considerable contribution to its fame. After La Goulue had grown fat and left the Moulin Rouge, she hoped to make a living by means of dance displays at markets. In 1895, Toulouse-Lautrec supported her in this project with the two large-scale pictures, executed with hurried brush strokes, which looked more like drawings than paintings, since the canvas remains visible

In the spring of 1895, Louise Weber (1866–1929), better known as La Goulue (the glutton), told Toulouse-Lautrec, "I should be delighted if you had time to paint something for me." The result was two pictures, *Dance at the Moulin Rouge* and *Moorish Dance*, which the artist painted as

in many places. The picture on the left makes reference to the glorious past of La Goulue, and shows her with Valentin le Désossé dancing the quadrille at a ball at the Moulin Rouge. *Moorish Dance*, on the other hand, shows a contemporary event. In a way that is characteristic of Toulouse-Lautrec, the onlooker is drawn into the picture, and forms part of the group of spectators with the life-size figures in the foreground, whose attention is focused on the dancing figure of La Goulue. The spectators are the old circle of friends from Montmartre, whom the painter portrayed here for the last time: Tinchant, the pianist from the Chat Noir, is seated at the grand piano on the stage, back left; in front of him stand such figures as the photographer Paul Sescau, Toulouse-Lautrec' friend Maurice Guibert, and his cousin Gabriel Tapié de Céleyran. The corpulent gentleman with the black top-hat and light-colored jacket can be identified as the writer Oscar Wilde; the woman in black wearing the large hat decorated with feathers is Jane Avril. Toulouse-Lautrec himself appears on the right next to the dancer, a small man wearing a black bowler hat. Finally, in the bottom left-hand corner we recognize the strikingly dressed Félix Fénéon, spokesman of the neo-Impressionists.

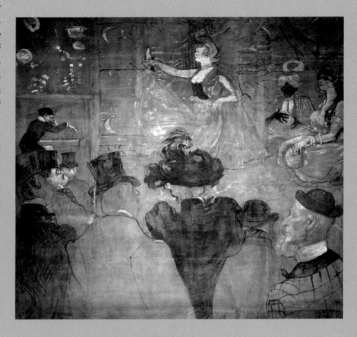

Henri de Toulouse-Lautrec, Moorish Dance, 1895, Oil on canvas, 285 x 307.5 cm, upper level, room 36

In 1926 both paintings were cut up by La Goulue, and were not restored until after their purchase by the Louvre in 1929.

CS

Degas' Pastels

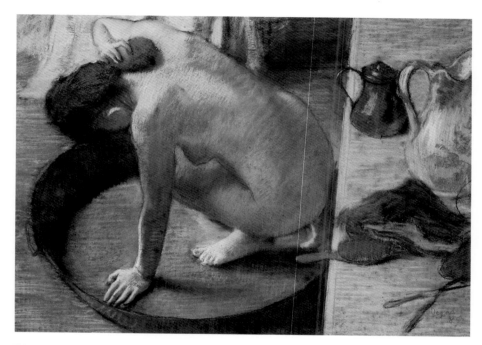

Edgar Degas (1834–1917), The Tub, 1886
Pastel, 60 x 83 cm

Complex movements and postures pro-
vided a challenge that Degas found partic-
ularly irresistible. In this pastel, a young
woman, viewed almost directly from
above, is crouching in a shallow tub. She
supports herself with one arm out-
stretched, braced on the bottom of the

bowl, while lifting a sponge to the back of
her neck with her right hand. The curved
line of her body contrasts with the vertical
line of the edge of the table to the right,
which is echoed in the line of her out-
stretched arm. In their shape and color, the
toilet articles reflect the form and coloring
of the lovely young woman. However, they
are viewed from a different angle and with-
out any foreshortening in the perspective,

resulting in great tension in the contrast between the woman, who is viewed from above, and the objects, which are viewed from the front.

The surprising structure of the picture, the table top cut off on three sides, and the different angles from which the figure and the objects are viewed, are compositional techniques that serve to provide an extremely lively impression. A work by the Japanese artist Katsushika Hokusai, which similarly shows a woman at her toilet, may have inspired the dichotomy in the composition of Degas' picture, but the earlier version, painted in 1798, lacks the virtuosity of Edgar Degas' spatial organization.

Edgar Degas, Primaballerina (Dancer on the Stage), 1878
Pastel, 58 x 42 cm

The *Primaballerina* is not executed solely in pastel. Degas made use of the possibilities of mixed media to convey the airy quality of the tutu and to juxtapose surfaces executed in the finest detail with swiftly and sketchily colored surfaces. As a result, there is tension between the foreground and background, the stage and the wings. A few particularly light-colored areas of the picture, such as the neck, waist, and leg of the dancer, are emphasized by dark accents, such as the fluttering black band around her neck and the faceless man standing in the wings. The picture typifies Degas' lifelong fascination with dances.

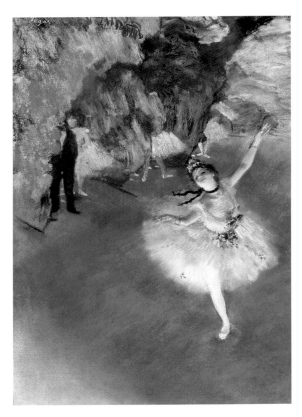

"Les Japons chez nous" – Japan comes to Paris

Ando Hiroshige, Plum Blossom in the Kameido Garden, 1857, colored woodblock print from the collection of Vincent van Gogh, 34 x 22.5 cm, Museum für Ostasiatische Kunst, Cologne

From 1867 onwards, the painters Félix Bracquemond and Henri Fantin-Latour, as well as the art critics and collectors Philippe Burty, Alphonse Hirsch, and Zacharie Astruc, met regularly at the house of Marc L. E. Solon, director of the famous imperial porcelain factory in Sèvres. They donned precious kimonos and ate from a Japanese-inspired dinner service designed by Bracquemond, decorated with birds, insects, and fish. Together they perused colored woodblock prints by Hokusai (1760–1849) and Hiroshige (1797–1858) and discussed artistic theory. However, their Société du Jinglar, named after the heavy Japanese wine served with meals, was only one of many sources of Japonisme in Paris, a phenomenon that was to become a central focus of inspiration for modern artists in the second half of the 19th century. Not always so inclined to modish mannerism, the Impressionist painters, followed with particular intensity also by the neo-Impressionists, sought a rapprochement with Japanese art, for example within the framework of the Société des Aquafortistes (Society of Etchers) founded by Bracquemond. This society included Edgar Degas, Edouard Manet, and James MacNeill Whistler among its members, and made detailed analyses of Japanese prints in the course of endeavors to rediscover the print as an art form. These were mostly the woodblock prints in the style known as ukiyo-e of the late 18th and 19th centuries, which practically flooded the Parisian market after Japan and France established trading relations in 1858. This genre of Japanese paintings and prints is

characterized by representations of everyday domestic life, public entertainments such as the theater, festivals, or fights in the ring, but also includes landscape motifs. In Japan, ukiyo-e was a bourgeois, practically even a folk art form, which because of the relatively high numbers of editions printed was collected mainly by the lower social strata and was available in every bookstore. In Paris, such works could be bought cheaply from the 1860s onwards in special East Asian stores. In the years between 1886 and 1888, even Vincent van Gogh, who was always living on the bare minimum, bought with the help of his brother Theo over 500 Japanese prints costing two to four francs each. As a result of studies at the home of Samuel Bing, one of the most prominent collectors of Japanese woodcuts, he had become a self-taught connoisseur of Japanese old masters and their schools. The van Goghs exhibited their collection for the first time in 1887 in the famous Café Tambourin in Montmartre. For van Gogh, this contact with traditional East Asian pictures opened up a world that established new aesthetic criteria. "I am in Japan," he wrote to Theo, four weeks after arriving in Arles in the spring of 1888, by which he meant that he was in an "honored land of art" and a landscape, in which he hoped to incorporate these new stimuli in his own art.

If we look for the sources of this inspiration, the roots of which lay in the art of the Far East, it becomes evident that, by contrast with Orientalism, it was not so much due to the adoption of foreign subject matter or an approach to life that was felt to be exotic. On the contrary, formal and stylistic aspects were the prime con-

Vincent van Gogh, Père Tanguy, 1887, oil on canvas, 92 x 75 cm, Musée Rodin, Paris

siderations. The writer Edmond de Goncourt (1822–1896), who claimed for himself the honor of having discovered Japanese art and was certainly an important propagandist for Japonisme, noted in his diary in April 1884, "Japonisme is nothing more and nothing less than a revolution in the outlook of European peoples; I maintain that it will bring a new sense of color, new decorative form, and even poetic imagination into the work of art … as never before."

Looking at Japanese prints did indeed encourage greater formal autonomy in particular. Artists such as Manet, Degas, and Monet, and

317

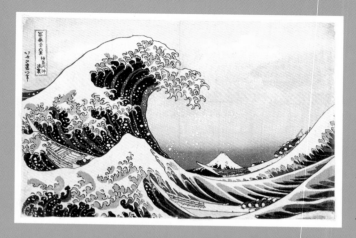

later also Cézanne, Seurat, Gauguin, van Gogh, and Toulouse-Lautrec, observed that they were faced with an artistic tradition in which illusionism was unknown. This simultaneously provided reassurance and the stimulus to regard the picture not as a virtual window, but as a surface to which form had to be given. Dispensing with scientific perspective and sculptural modeling of figures, and instead favoring organic outlines and strong, pure coloring, these Japanese prints seemed to point the way ahead. They encouraged artists to turn away from mere imitation of reality — a task that had in any case long since been assumed by photography — and offered opportunities for an interpretative view of the subject of the picture as a meaningful or aesthetic phenomenon. As a result, it was also possible to re-evaluate decorative art, which gave new direction not only to arts and crafts, but also to painting. In this sense, Japonisme

had a far-reaching effect on the international Art Nouveau movement. Paris remained the focus of European Japonisme. The exhibition of Japanese art from private collections in Paris, opened in the Galerie Georges Petit in 1883, was undoubtedly a high point. The 3000 works of art from the 9th to the 19th centuries were an impressive testament to the zeal of the collectors, and as representative examples provided insight into the development of East Asian art. Further exhibitions and numerous publications followed until about 1900. Hokusai and Hiroshige, the artists already mentioned, remained the most popular masters of ukiyo-e, but were joined by Utamaro (1753–1806), whose prints decorated Paul Gauguin's studio and about whom Samuel Bing published an article in the London arts and crafts journal, Studio, in 1895. Henri Toulouse-Lautrec, who also possessed several ukiyo-e prints and whose studio

partner, Maurice Manzi, had an outstanding collection of works by Utamaro, became known as the "Utamaro of Montmartre" because of his painting of Parisian cabaret and brothel motifs. His famous posters in particular show a deep understanding of Japanese precedents in their surface structure and exciting compositional techniques. MP

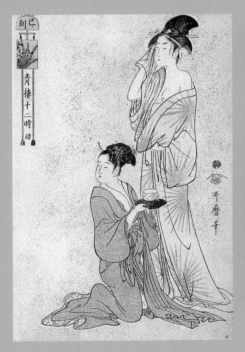

Utamaro Kitagawa, *The Hour of the Snake,* *1794, colored woodblock print, 38.8 x 24.7 cm,* *Museum für Ostasiatische Kunst, Cologne*

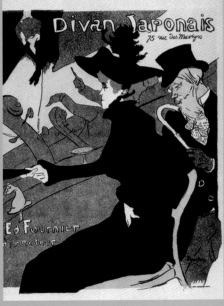

Henri de Toulouse-Lautrec, *stage poster for the* *Divan Japonais, 1892/93, 80.8 x 60.8 cm,* *Gerstenberg collection*

The Late Work of Monet and Renoir

Claude Monet (1840–1926),
The Artist's Garden at Giverny, 1900
oil on canvas, 81 x 92 cm

In 1883 Monet rented a country house in Giverny, a small town situated between Paris and Rouen. He loved the estate so much that he bought it in 1890 and lived there until his death in 1926. When Monet took over the property he discovered an orchard, which over the following years he changed into a sea of flowers. The geometrical construction of the flower beds is clearly visible in the painting *The Artist's*

Garden at Giverny. Two diagonal lines running parallel to each other form the framework of the composition. The first, at the bottom right, is formed by the small pathway between the bright purple irises, the second, in the center of the picture, by the main avenue bordered by spruce trees which leads up to the house. From Claude-Monet's later paintings it can be seen that he was constantly changing the garden; the trees appearing in this painting for instance were cut down after 1900 to admit more light.

CS

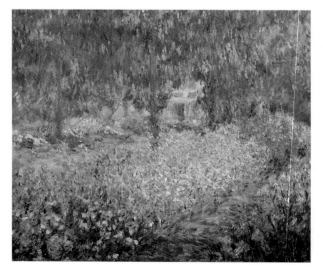

Claude Monet, Waterlily Pond (Harmony in Rose), 1900
Oil on canvas, 89.5 x 100 cm

In 1893 Monet acquired an additional piece of land situated on the south side of his property in Giverny with the intention of redesigning it as an exotic water garden with a waterlily pond. Whereas since 1887 the flower garden at the house had been one of Monet's preferred subjects, from 1895 onward he painted countless variations on the waterlily pond

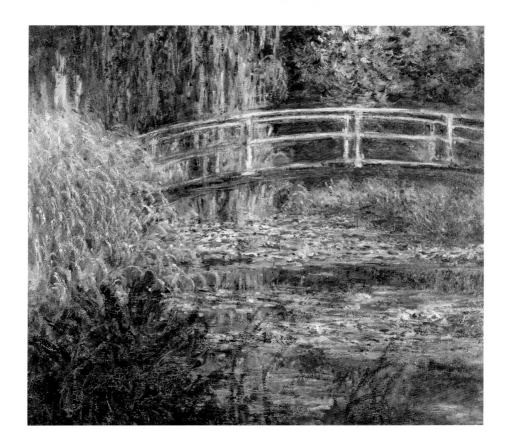

with the Japanese bridge. And in the works of 1900 in particular the view of the pond is only slightly varied as the artist had had a special structure built from which he could work. This enabled him to give the impression of standing in the water to paint. Even during his later creative years the waterlily pond at Giverny remained for Monet an important source of inspiration, since he could record the colors as they changed according to the light at different times of the day or in different seasons, something which was always of great interest to the master. CS

Claude Monet,
London, Houses of Parliament, 1904
Oil on canvas, 81 x 92 cm

During his four visits to London between 1900 and 1905, Monet also did a series of paintings of the Houses of Parliament. In these works his art attained new heights. Everything visible is resolved in the reflection of light. The subtitle of the painting, *With the Sun Shining through Fog*, is significant. Not only the sky, but also the river and even the buildings are fused together in dazzling color tones. The Houses of Parliament rise up out of the fog like a vision. It is not the building which seems to be present but rather its optical effect.

Blue Waterlilies, ca. 1916/1919
Oil on canvas, 200 x 200 cm

In Monet's late waterlily paintings the importance of the area around the pond and the Japanese bridge was progressively reduced. In the end, it was only the surface of the pond that was of any significance.

The artist wrote to his biographer Gustave Geffroy, "My work takes up all my time. I have become obsessed by this water scene with its reflections. I'm an old man and it taxes my powers but I would like to reproduce what I feel." Monet's efforts to represent his feelings resulted in his effecting momentous steps for art. The horizon, that line which provides a framework to the pictorial space of a landscape and directs the eye of the observer, was removed from his work, with the result that – disregarding the waterlilies in the center, which are still shown from above – the reflection and the actual object coincide with each other. The observer is plunged into a pictorial world of water and has lost his detachment. The eight large waterlily paintings (1917–1926), which the artist bequeathed to France as early as 1922, mark the end of Monet's work. Since 1927 they have been on

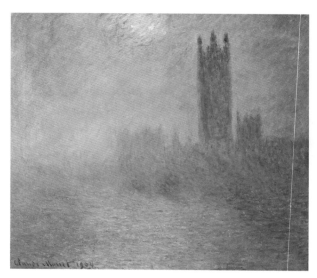

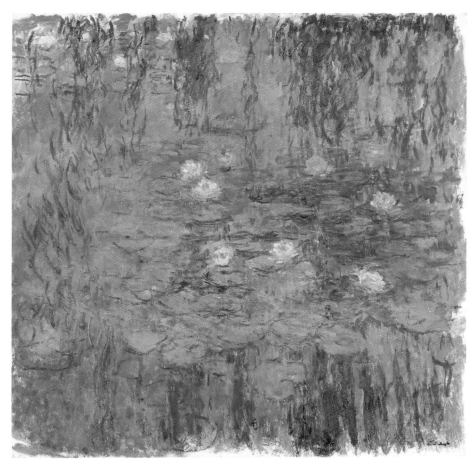

show in the oval rooms of the orangery. With these paintings, which he consciously left between objectivity and abstraction, Monet went far beyond the realms of impressionism. Indeed, in many ways, they seem to anticipate the characteristics of Abstract Impressionism and the work of Kandinsky.

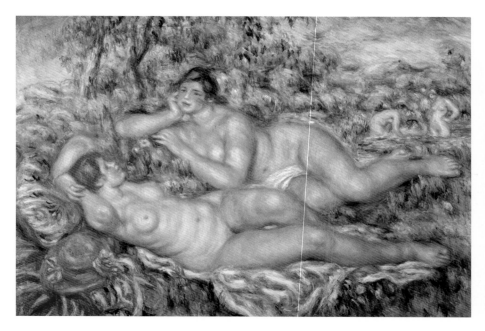

Auguste Renoir (1841–1919),
The Bathers (with detail), 1918/19
Oil on canvas, 110 x 160 cm

After 1900 Renoir mainly lived in the south
of France. It was there that he created
works that celebrate the attractions of the
Mediterranean world. Shortly before his
death – by then the artist who was nearly
80 years old was crippled, in a wheelchair
and had to have his paintbrush tied to his
twisted arthritic fingers – Renoir devoted
himself to a series of compositions with
nude bathers.

His markedly violent method of painting
conflicts with the physical condition of the
artist. The large painting which shows two
voluminous women reclining at leisure in
a lush landscape has the effect of an impro-
visation placed directly onto the canvas.
Over the long years of his career as an artist
Renoir had created an extensive repertoire
of female nudes and poses which he was
able to call upon quite easily, now that he
was painting *The Bathers*. By using thinly
applied colors he endowed his nudes with
a liveliness which turns them into embod-
iments of sheer vitality.

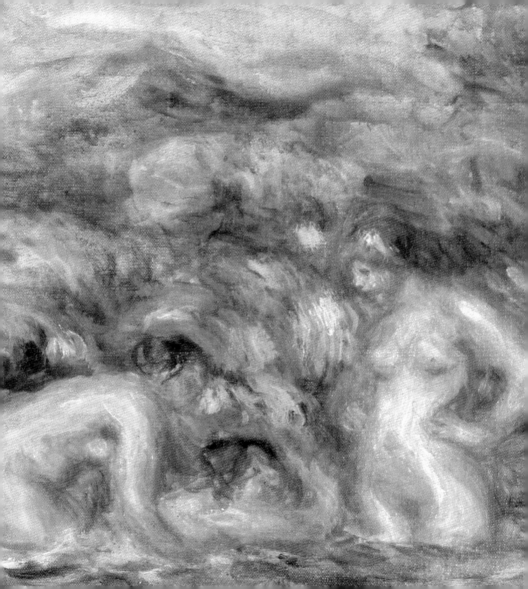

Auguste Renoir,
Gabrielle with a Rose, 1911
Oil on canvas, 55.5 x 47 cm

In this painting the connection between woman and nature is touched upon again in the work of Renoir. The roses are strikingly placed in relationship to Gabrielle's face and to her almost bare breast. "She is like a plant in bloom herself," the art historian Werner Hofmann shrewdly observed of the painting.

Renoir had already stood out as a student. "You paint for pleasure, I presume," his teacher, Charles Gleyre, is supposed to have said. Renoir replied, "Of course, if I didn't enjoy it you can be sure I wouldn't be doing it." The artist continued to enjoy his work even when he was an old man. Renoir's artistic credo was consistent for he also declared, "I love paintings which give me pleasure to walk in them when they depict a landscape, or to stroke a nipple or a back when they portray a female figure." Gabrielle Renard had come to the Renoir household in 1894 as a nanny when she was only fifteen years old. She stayed with the Renoirs until her marriage to an American artist in 1914 and was one of the artist's favorite models for many years while she lived with the family.

Odilon Redon

Odilon Redon (1840–1916),
Closed Eyes, 1890
Oil on canvas, 44 x 36 cm

This small painting is one of the painter's best-known works and is typical of Redon's symbolism. It shows a female face framed by long hair, painted in delicate and thinly applied colors. The woman's eyes are closed, her gaze directed inwards. The unreal blue of the background distances the face in the same way as the horizon. The head, absorbed in itself, is not a portrait. It could just as easily be called "The Dream" or "Meditation" – titles such as these occur again and again in Redon.

Redon's first series of lithographs had appeared in 1879. The artist chose a telling title for them: *Dans le rêve* (In dreams). The magic of the dream, the reality of fantasy, and the realm of imagination characterized the painter's artistic works. He himself admitted that he believed only in what he could not see and in what he felt, in opposition to the visual emphasis of Impressionism. There is an affinity here with Symbolist poetry, whose representatives were some of Redon's earliest admirers. This becomes clear on reading Stéphane Mallarmé's words: "Absorption in things, the image emerging from the dreams which evoke things, that is poetic song. To name something directly means suppressing three quarters of the value of the poem, which consists in the pleasure of gradually moving intuitively into the depths. Intimation, suggestion, therein lies the dream."

Odilon Redon, The Shell, 1912
Pastel, 51 x 57.8 cm

In the center of the painting the irregular outside edge of the shell is clearly outlined in black. A second, smaller shell in the bottom right-hand corner of the picture is similarly given a clear outline in order that it does not become lost in the browny-gold background. While we only see the the simple outside of the small shell, we can look at the inside of the large one. Shades of pink, white, and mother-of-pearl and the colored surfaces of the background merged into each other give the impression of a vision. Even if the background is composed of layers of brush strokes, it remains three-dimensionally uncertain.

Redon is able to lend a new magic to such an apparently insignificant motif as the shell. The gleaming mother-of-pearl surface appears to be the source of light.

Odilon Redon,
The Triumphal Car of Apollo, 1905/1914
Pastel, 91 x 77 cm

The sun-god Apollo, who was nicknamed "the shining one," is not directly visible himself in *The Triumphal Car of Apollo* but is probably understood to be present in the beam of light on the right-hand edge of the picture. The reflection of this light on the horses pulling his chariot conveys its intensity.

In an oil painting of 1905 entitled *The Chariot of Apollo* the artist dealt with the subject in a similar way. He gave the picture the telling subtitle of *The Triumph of Brightness over Darkness*. This victory can also be perceived quite literally. In the Musée d'Orsay drawing a monster killed by Apollo with his arrow can be seen in the dark background.

If the painting *Closed Eyes* signified the hesitant victory of color around 1890, then *The Triumphal Car of Apollo* is one of the highpoints of the decorative period (1907–1910) in Redon's work.

A broad spectrum in shades of turquoise and blue dominates the background, in the foreground brown and black predominate. Apollo's appearance is resolved in yellow, orange, and green tones. The horses' bodies are picked out in white, and the monster is accentuated by a very harsh green and by white points of light so that the picture becomes an amazing fantasy of color.

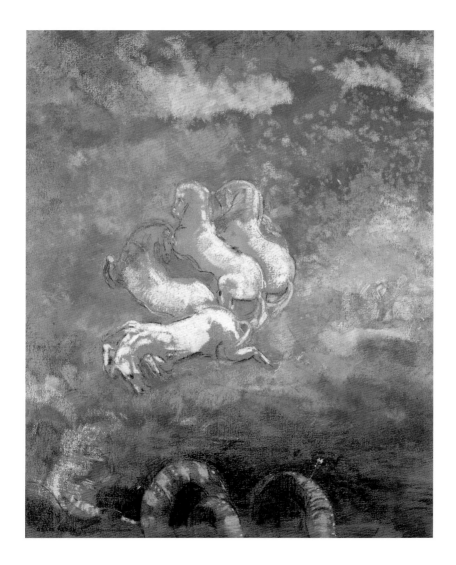

Fin de siècle –
The pleasure in the decline of one's own age

In his drawing Elegant Life, Félicien Rops combined the flowing lines of Art Nouveau with erotic subjects

The 19th century ended in an enormous crisis of confidence. After the Industrial Revolution, the political changes of the post-Napoleonic era, and the reinterpretation of all values through the understanding of science – all amounting to a real tide of modernization since 1800 that had continuously undermined existing social traditions – the feeling remained above all of living in an age of change. Things that had always been regarded as irrefutable by the previous generation no longer seemed to be so. Social barriers, moral dogmas, the individual rhythm of life and everyday order of society – all of these seemingly had to be readjusted and brought into line with a changing world.

This collective crisis of identity became known by the

term "Fin de Siècle," which appeared for the first time in the 1880s as the title of a light comedy and was immediately promoted to an "in-word," indeed as the motto for the forthcoming changes at the turn of the century.

It is found in Oscar Wilde's novel *The Picture of Dorian Gray* (1890), and likewise in the famous verse cycle *Pantasus* (1898–99) by Arno Holz. "Oh, yes, there is bad air in the epoch, this fin de siècle, in which one can hardly move for demolition work… nerves are in shreds, and in addition there's neurosis," Emile Zola writes in his artist's novel *L'Oeuvre*, published in 1886, in which he characterizes feelings that became the commonplace attitudes of the age. A mood of decline, thoughts of death and shattered nerves – enduring the modern age was made the central theme, in fact was almost celebrated.

There arose a fin-de-siècle generation, carried along by privileged intellectuals, artists, and snobs, a thoroughly urbane society which was able to devote itself to the ambivalent feelings of apocalypse or new beginning. Hugo von Hofmannsthal described it as "sensitive, but too tired for violent feelings, lively, but without any strong intention; with a gracious, somewhat precocious irony, the need for kindness and affection and now and then with a certain inner ebb tide."

The concept of "decadence" characterized this class of refined aesthetes whose pleasure in morbidity produced some almost absurd forms. In his novel *A rebours* (Against the Grain) published in 1884, which is regarded as the key work of fin-de-siècle literature, Joris-Karl Huysmans (1848–1907) relates the story of a bizarre

Joris-Karl Huysmans (1848–1907)

funeral meal that a prosperous duke organized on some trivial occasion for his decadent artistic friends: "The dining room was all lined in black. It led out into a completely transformed garden whose paths were strewn with fine coal dust for the occasion; the small pool edged with basalt was filled with black ink, the bushes were spruces and cypresses. The meal was served on a black tablecloth in the middle of which were baskets of flowers filled with violets and scabious. Greenish flames burned in tall candlesticks and wax candles in candelabra lit the room. An invisible orchestra played funeral marches and the guests were served by naked negresses dressed in slippers and little stockings made of silver material covered in small glittering beads…" Thus they celebrated the finis saeculi in style, the end of time which St. Augustine had already expected in antiquity

and which they now — in a secularized form — discerned in the widespread decline in values.

Not only writers but painters too found images which reflected this mood. Two outstanding examples of the Paris scene were the Flemish graphic artist Félicien Rops (1833–1898), whose erotic paintings with their satanic portrayals associated him with morbid pandemonic scenes, and the painter Gustave Moreau (1826–1898), who became the forerunner of antinaturalist surreal painting.

It seems curious and at the same time significant for the inner turmoil of the age that, parallel to the discovery of the pure observation of nature by Impressionism, there arose at first sight a historicist style of painting which turned to anachronistic mythological themes.

Moreau and also the younger Odilon Redon (1840–1916), however, no longer understood the classical subjects as moral and ethical paradigms of action but as perfect examples of the human unconscious and the imaginary. The discovery of the dream and the meaning of dreams led to a new investigation of the human psyche which was to dominate the 20th century. Interestingly enough, Siegmund Freud, the founder of psychoanalysis, was studying in Paris in the 1880s.

Moreau and Redon became celebrated stars of a relatively closed fin-de-siècle scene, which in the midst of the rising tide of the moderns created a refuge for its own recently discovered and all the more sought-after "self". A further extract from Huysman's aforementioned novel illustrates how his own sensitivities became stylized from observation of and empathy for the painting of Moreau.

"For the delight of his mind as for the joy of his eyes he needed paintings which transport him into an unknown world, reveal to him traces of new ideas and shake up his nervous system by frenzied sensations". There was one artist in particular who sent him into raptures: Moreau.

Gustave Moreau, Hesiod and the Muse, 1891
oil on wood, 59 x 34.5 cm, ground floor, room 12

"He owned two of his masterpieces and during the night he used to sit in front of one of them, the painting of 'Salome'... She was not just the dancer who, by the sensuous wiggling of her hips, causes a weak old man to cry out in dissolute desire as she submits to the will of a king by the movements of her body and the trembling of her thighs; she was, so to speak, the symbolic deity of indestructible lust, the goddess of immortal hysteria; that pure sensual animal, immense, unfeeling, insensitive, poisoning everything which approaches her, touches her, sees her...

"Lost in his observations the duke tried to trace the origin of this great artist, this mystical heathen, this illuminatus who was able to isolate himself completely from the world in order to see shining out in the middle of Paris cruel visions, fairy-like apotheoses of bygone ages..."

People felt abandoned and a sense of being in the wrong place at the wrong time. And yet the protagonists of decadence needed modern society as a foil before which they could sense and realize their own alienation and their artificial awareness of life. Parallel to this some very different ideologies for putting the world to rights were developing: The call of "back to nature" with the aid of every imaginable change in lifestyle was part of it, likewise the emerging youth culture and Art Nouveau, which with its tendency toward the total work of art sought to have a formative effect on the whole human environment. The 20th century for a long time drew both artistic and ideological creativity from these fin-de-siècle sources.

MP

This painting by Félicien Rops, Satan Sowing Weeds illustrates the dark side of the fin de siècle mentality.

The Gachet Collection

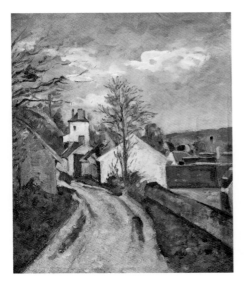

Paul Cézanne (1839–1906),
Dr. Gachet's House in Auvers, ca. 1873
Oil on canvas, 46 x 38 cm

Cézanne himself confirmed that he discovered landscape through the "theory" of the "tireless Pissarro" and learnt to appreciate nature as an authority. Thus it was possible for him to forsake literary mythological topics and to choose so insignificant a motif as this village street.

The sequence of houses arranged in the background along the curve of the road is striking. Constructivism can already be

detected in them. Cézanne's striving for increasing clarity and unity of composition is felt here.

Paul Cézanne, A Modern Olympia, ca. 1874
Oil on canvas, 46 x 55.5 cm

From its colorfulness and flowing painting style this picture is so unique in Paul Cézanne's overall work that it would be difficult to date it with any accuracy were it not for the fact that it is known to have been shown in 1874 at the first joint Impressionist exhibition.

As the title *A Modern Olympia* shows, Cézanne refers to Manet's famous *Olympia* (see p. 117) which caused a storm of protest in the Salon in 1865. Almost all the important motifs in the model are in fact taken up: the nude Olympia, the black servant, the bouquet of flowers. But simply on the basis of the courtesan's admirer, whom Cézanne also includes in the painting and to whom in addition he even gives features similar to his own, one cannot help thinking that Cézanne was trying to poke fun at Manet. The sight of the amply proportioned beauty appears to overpower the admirer, in fact actually pushes him down onto the sofa. To the right of the man stands a huge bouquet of flowers which makes him appear even smaller. On the other hand the strange little dog, who in Manet is awarded to Olympia, sits bolt

upright next to him. The reclining courtesan is uncovered by the servant by a swift movement. Her bed is placed in the background of the picture; consequently she appears to float like a vision behind the table and the flowers.

Perhaps the painting resulted from a conversation between Paul Gachet and Cézanne about Manet's picture. The sketch-like freshness, the improvised quality, should be understood against this background – the small picture is like a painting that has been executed as a spontaneous discussion-piece without prolonged study. What Manet himself said about this bold attack on his role as the most modern painter of the age is unfortunately not known.

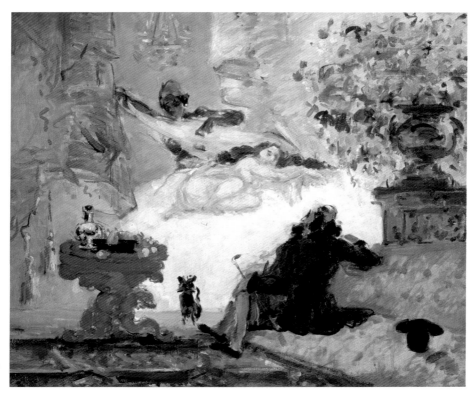

Camille Pissarro,
The Louveciennes Road, 1872
Oil on canvas, 60 x 73.5 cm

Pissarro took the motifs for his landscape paintings from the country areas in which he mainly lived, in Louveciennes, in Pontoise, in Auvers-sur-Oise, or in Eragny-sur-Epte. Since the Impressionists left their studios in order to work in the open air, nature played an important role for these artists and consequently led to an excess of landscape paintings amongst their works.

Pissarro's village scenes often show the road leading into the town. Houses, walls, or hedges line the streets, people walk along, and trees line the sides of the road. For Pissarro these were suitable motifs for examining the interplay between light and shade on a sunny day. In so doing he

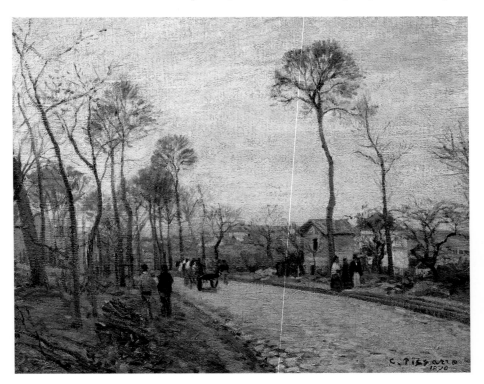

mostly fell back on a quite traditional artistic form where a tapering street leads into the distance. He combined this rather conservative method of composition, however, with a new kind of coloring.

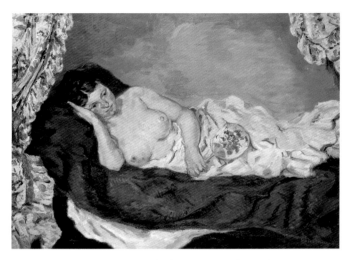

**Armand Guillaumin,
Reclining Nude, ca. 1877**
Oil on canvas, 49 x 65 cm

Although in his own day the paintings of Armand Guillaumin were represented at six of the eight Impressionist group exhibitions and the artist was regarded as a friend of both Pissarro and Cézanne, he has almost sunk into oblivion today. The Reclining Nude, which was shown at the third Impressionist exhibition in Paris in 1877, is one of the few figure paintings by Guillaumin, who was predominantly a landscape painter. The painting shows a young woman with bare breasts reclining full length on a bed on her right side. She supports her head with her right hand. In so doing the melancholy-looking, pensive woman avoids eye-contact with the observer of the picture. Her eyes are cast down somewhat dreamily. Both the model and the plain surroundings, consisting of mainly green and blue tones, evoke a mood of despair. Only the

fan in the left hand of the reclining woman and the curtains on both sides of the picture with their floral pattern create points of light in the otherwise gray sadness of the representation. Armand Guillaumin was certainly influenced by Edouard Manet's *Olympia* in his motif of the reclining nude. In the final analysis, however, the subject refers back to Renaissance painting, to the representations of Venus by Titian, Giorgione and other masters.

CS

Henri Rousseau

Henri Rousseau (1844–1910),
War, 1894
Oil on canvas, 114 x 195 cm

Rousseau, to whom posterity has awarded the nickname of the douanier, since he worked for the customs almost all his life, turned exclusively to art as a self-taught painter late in life.

The artist exhibited the painting *War* in 1894 in the Salon des Indépendants. And although the motif is often found in 19th-century art the painting nevertheless represents a completely independent work.

Henri Rousseau treats the subject of war with a naiveté reminiscent of children's or folk art without concrete references to place and time. The picture evokes however a horribly ghostly and nightmarish atmosphere.

A woman, or rather a little girl, in an innocent white dress is riding through a barren landscape with a torch and saber as the personification of war and revenge. The vegetation is dead, the trees bare. The people lying on the ground are already dead or still writhing about in their last agony. Their light bodies have already

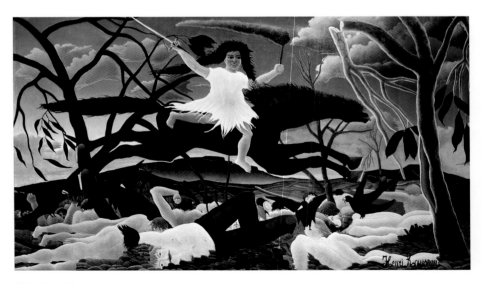

become carcasses for birds of prey. The horizon is bathed in glaring light.

Despite the totally naive form – the figure is sitting on a horse in an impossible pose and the clouds appear pink against a turquoise sky – which reminds us of children's drawings, Rousseau conveys in an impressive and convincing way his personal view of war.

Henri Rousseau,
Portrait of Madame M., ca. 1897
Oil on canvas, 198 x 114 cm

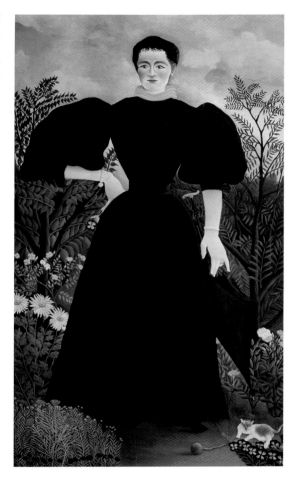

Complex arrangements of vegetation are often used by Rousseau as part of his pictorial language. The sequence of different leaf and flower patterns produces a rhythmical structure. In this portrait, the tall gaunt woman in a black dress with remarkably wide puff sleeves stands out directly in front of a background of flowers, above which only her head protrudes. The proportions are inconsistent, her hands almost larger than her head. Even more unrealistic is the scale of the head of this nameless woman and the little cat in the foreground on the right. On the basis of these characteristics the painter succeeds in creating an impressive representation of the human figure.

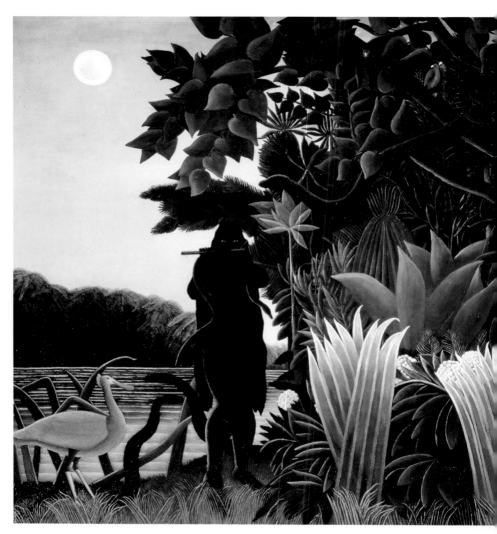

Henri Rousseau, The Snake Charmer (with detail), 1907
Oil on canvas, 169 x 189.5 cm

After working for almost 20 years, Rousseau sold his first pictures at the beginning of the 20th century. He received his first commission at the same time. Rousseau painted *The Snake Charmer* in 1907 for the mother of the artist Robert Delaunay, who was an enthusiastic admirer of his art. The work, which belongs to his series of exotic pictures that he started in 1904, for the first time found great approval in the autumn Salon in which it was shown in the year of its creation. Thus, at long last, the much delayed recognition and material success was under way.

All the motifs in this painting are precise and clearly outlined, with the figure, animal, and plants depicted using the same care, and all are awarded equal value. With the enigmatic figure of the snake charmer Rousseau discovered a motif which, like other creatures of his pictorial world, seems to anticipate the magic of Surrealist art. The black figure playing the flute, whose eyes shine like stars in the night, is bewitching nature. Large dark snakes stretch out toward him. Birds flock together in the foliage and on the bank of the lake. Everything, even the fertile vegetation which takes up the whole of the right-hand side of the painting, seems to have abandoned itself to a heavenly stillness and peace.

With *The Snake Charmer* Rousseau created a clear contrast to his *War* painting of 1894 only a few years earlier. It typically evokes an exotic world of magic.

The Pont-Aven School

Emile Bernard (1868–1941),
The Harvest (Breton Landscape), 1888
Oil on canvas, 56.5 x 45 cm

In the years after 1886 a group of painters who turned away from Impressionism congregated around Paul Gauguin and Emile Bernard in the Breton town of Pont-Aven. In the great simplicity and two-dimensionality of their compositions they were influenced by folk art and Japanese woodcuts. Thus in a work like *The Harvest* to a large extent Bernard also abandoned the modeling of figures. He made them as flat as the neutral background from which they stand out so clearly. In addition he depicted the figures in some basic attitudes which are emphasized even more by rhythmic repetition. Light and shadow hardly have any role to play in this painting. The fundamental outlines to which the artist reduces all the shapes are drawn clearly. Every object is distinctly defined. This emphasis of outline which is reminiscent of the clear metal frame in enamel work or the cames in stained-glass windows led to this style of painting being given the name *cloisonné* (from French *cloison*: partition (wall)). Bernard claimed to have been its originator, though Gauguin refused to acknowledge this.

Paul Sérusier (1864–1927),
Breton Wrestling Match, 1894
Oil on canvas, 92 x 73 cm

Paul Sérusier regularly visited Brittany from 1888; he finally settled there in 1914. In the painting *Breton Wrestling Match* he portrays the gouren, which still played an important role in traditional festivals in Brittany even during the late 19th century. Only a few positions were allowed in this extremely ritualized system of fighting, for instance the position called in Breton the *klikedou*, shown here. The men were required to fight barefoot and wear simple white linen shirts. The fact that these wrestling matches were very popular with the locals is shown by the large number of women dressed in the native costume of Pont-Aven, who are crowded together behind the policeman in the upper half of the picture.

Sérusier spent the summer months of 1891 to 1893 in the small Breton town of Huelgoat. In a letter from that time he writes that he has decorated the walls of his room with Japanese woodcuts. These could have inspired the artist in his choice of wrestling scene and in his use of the bright yellow in the foreground. This same yellow tone appears again in the upper left-hand corner and makes a considerable contribution to the two-dimensional effect of the painting, which betrays the clear influence of Gauguin.

CS

**Paul Gauguin (1848–1903),
Haymaking in Brittany, 1888**
Oil on canvas, 73 x 92 cm

The search for originality drove Gauguin restlessly to the remotest corners of civilization. In July 1886, he felt compelled to go to Pont-Aven in Brittany for the first time. Between the years of 1888 and 1890 he also spent time in this small town sur-rounded by steep hills out of which narrow paths led to fertile high ground with farms, chapels, and small areas of woodland. This picture, which was painted on a cloudy summer's day in 1888, shows the hay harvest in the so-called Derout-Lollichon field. While the farmers, observed at their daily work, and the dog seen romping about in the foreground, are still portrayed in the Impressionist style, the bright intense

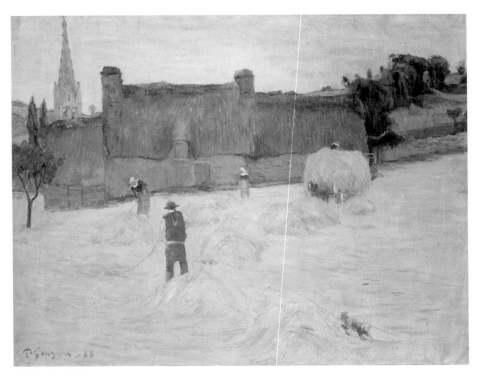

yellow and green tones of the field, the steeply rising church steeple and the protective, earthbound farmhouse appear to reflect the feelings of the artist, which reach beyond a simple portrayal of nature.

CS

Paul Gauguin,
The Alyscamps at Arles, 1888
Oil on canvas, 91.5 x 72.5 cm

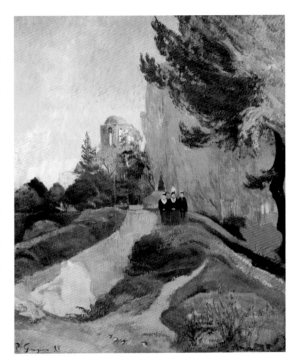

Gauguin spent the autumn of 1888 in Provence in order to work with van Gogh in Arles. A motif to which both painters turned is the famous landscape at Alyscamps, which Gauguin in his painting portrayed around the tiny chapel of St Honoratus, shown in the background. Gauguin divided up the landscape distinctly into various color zones marked off by decorative arabesque-like lines. The impression of nature – the autumn coloring – is his reason for painting, but Gauguin's efforts are not directed at transferring observations of nature onto the canvas but at shaping the surface of the painting. He wanted to invent a new landscape. This intention also explains the arbitrariness of color, the blue tree trunk for example or the bright red bush at the right-hand side of the picture.

Van Gogh's painting of Alyscamps is not only more vivid in color but is also less violent in his brush strokes. In contrast, Gauguin worked using a more subtle technique and far less temperamentally. His search for a synthesis is also revealed in this work, the attempt to combine isolated shapes and independent color in such a way that they produce both a decorative and a meaningful effect.

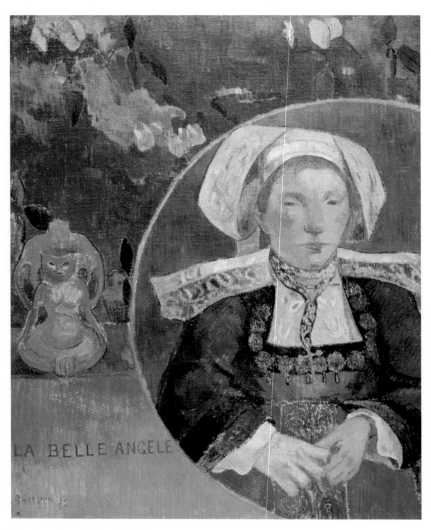

LA BELLE ANGÈLE

Paul Gauguin,
La Belle Angèle
(with detail), 1889
Oil on canvas, 92 x 73 cm

Angèle Satre, the wife of the mayor of Le Pouldu, is portrayed here in the typical native Breton costume. In order to break all ties between the "model and damned nature," as Gauguin wrote to Bernard, he set the portrait into a tondo cut into on two sides and in this way separated the portrait itself very distinctly from the surrounding background. Gauguin was not much concerned with realistic representation; his preference was to combine simplified forms with bold exaggerated colors. Understandably, Angèle Satre did not much like this portrait of her.

In the background is one of Gauguin's ceramics, so that the artist was, as it were, signing his picture twice. The title within the picture is a novelty which seems like a foretaste of many late works from Tahiti.

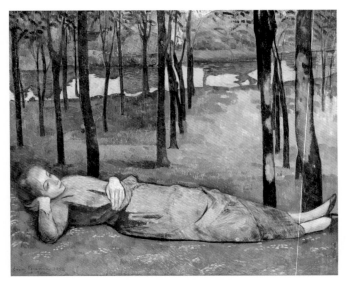

may be discerned. At the same time the powerful blue outline removes the figure from realistic nature and, together with the strikingly large hand below the breast, which is so graphically presented to the observer, makes one think of something else; a youthful expectation seems to be reflected in the pose and expression of Madeleine. Bernard blends hints of Eros and sexuality with the grave and death.

Emile Bernard,
Madeleine in the Forest of Love, 1888
Oil on canvas, 137 x 164 cm

Emile Bernard,
Breton Women with Parasols, 1892
Oil on canvas, 81 x 105 cm

As early as the summer of 1888, Bernard painted a portrait of his sister. The early work shows Madeleine with open eyes dreaming in the Forest of Love, a little copse in which the artists frequently painted. Stretched out full length she is lying under the trees. Her pose is reminiscent of medieval grave sculptures, while the lost dreamy expression recalls the paintings of Puvis de Chavannes. In the tectonic arrangement of the background, an echo of Paul Cézanne's style of painting

This portrayal of Breton Women with Parasols is one of the last paintings that Emile Bernard painted in Brittany. After his rift with Paul Gauguin the artist left France and traveled to Egypt, where he lived until 1904.

The quarrel between Bernard and Gauguin had come about because of Bernard's assertion that he had invented *cloisonné* and his friend had merely taken the idea over from him and capitalized on it. Gauguin rejected the accusation and made the

counter-assertion that Bernard was ascribing to his own work more historical significance than the latter really deserved.

The controversial debate found expression in attacks on Bernard by various critics and was also fought out in the pictures and letters of both artists. Emile Bernard was trying with his great work *Breton Women with Parasols,* as well as with other pictures, to continue consciously the controversial *cloisonné* style; thus in typical manner he simplified the formal structuring of the figures and the landscape elements. The interior areas of the drawings are reduced to a minimum, the outlines acquire a strong emphasis. A carefully considered multitude of colors is employed.

CS

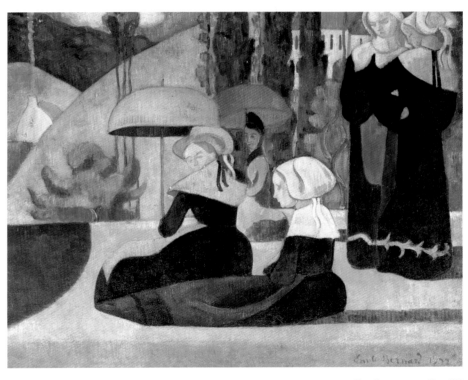

Gauguin in the Tropics

Paul Gauguin (1848–1903), Arearea, 1892
Oil on canvas, 75 x 94 cm

The pictures from Gauguin's first longer stay on Tahiti, which lasted from 1891 to 1893, reflect his dream of a better world. The title Arearea, meaning something like "pleasures," sounds like a promise. It shows two Maohi women who, completely trapped in their physical and sensual existence, seem to be a natural part of creation like the dog. They are leading a peaceful existence beyond all the hectic rush of civilization or the necessities of life.

The two-dimensional, arabesque forms determine the decorative picture. The non-

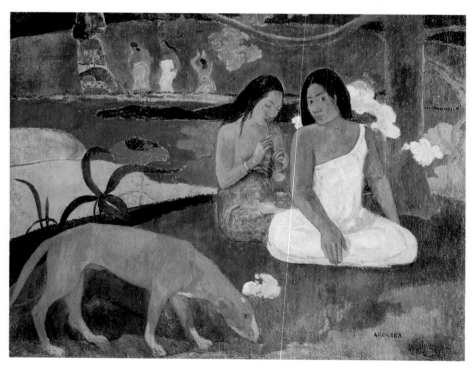

realistic coloring has a bright shine but Gauguin avoided crass contrasts. Red and blue or purple and yellow encounter each other without severity, so that a harmonious overall impression is achieved. Without doubt the South Sea paradise gave Gauguin the chance of becoming a painter of color. Here he found the strong and independent individual style of his later work.

Paul Gauguin,
Idol with Shell, 1892/1893
Toa (ironwood), mother-of-pearl, bone, 34.4 x 14.8 x 18.5 cm

This small sculpture was created at the turn of the year 1892/93. It is only 27cm tall and combines different materials. As well as wood Gauguin made use of mother-of-pearl for the nimbus and pieces of bone for the teeth. Not without self-deprecating irony did the artist speak of wild "knick-knacks" or of decorative figures, with reference to works such as these. Nevertheless the small figure seems like a younger brother of that idol which is being worshipped in the left background of the painting *Arearea*.

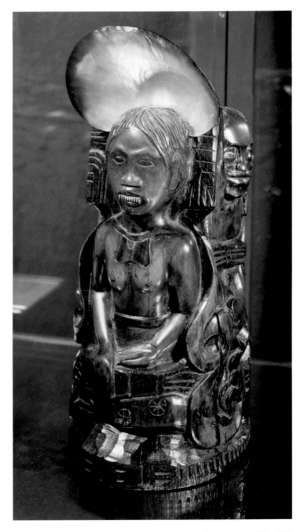

Paul Gauguin, House of Joy (with detail), 1901
painted polychromed wood,
lintel: 40 x 244 x 2.3 cm

In September 1901 Gauguin departed for "a simpler land … with new, more primitive elements," as he called it. He moved to one of the Marquesas Islands, Atuona-Hiva-Oa, where he was to die in 1903. Gauguin acquired a small piece of land there, on which he built himself a hut of wood, palm branches, and bamboo.

The doorposts and the lintel of his new home, which he called "House of Joy,"

were adorned by him with carvings. Since art and life were one for Gauguin, he was quite unconcerned about genre boundaries. It was not in his nature to give lesser respect to applied art than to his painting.

The wood carvings reached France via the navy doctor Victor Ségalen, who acquired this important ensemble after Gauguin's death.

Paul Gauguin, Be Mysterious, 1890
painted polychromed lime-wood,
73 x 95 x 5 cm

From 1877 Gauguin turned to sculpture alongside painting. As a sculptor he always preferred to use the medium of wood. In the 19th century this medium had been forced into the anonymity of folk art and crafts; with Gauguin there began a rehabilitation of this material which was then finally completed in the 20th century by artists like Brancusi, Barlach, and the German Expressionists. Gauguin valued the relief because, in being limited to a few spatial levels, it corresponded to his concept of painting as organization of colored surfaces. The title *Be Mysterious*

is to be understood literally. The relief was created while the artist was hoping to be able to depart for the tropics in search of a simpler lifestyle. It reveals his longing for a primitive and original art which he sought to achieve during the time he spent in the South Seas.

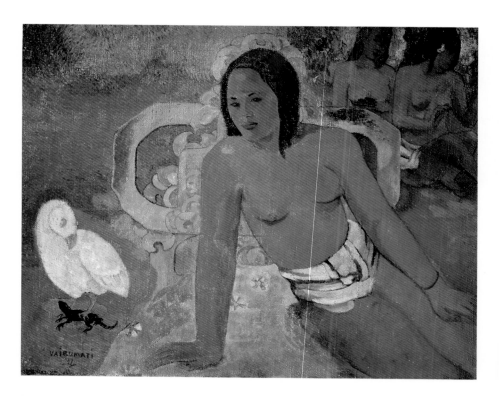

Paul Gauguin, Vairumati, 1897
Oil on canvas, 73 x 94 cm

Gauguin repeatedly gave his paintings Tahitian titles, without having actually mastered this language. This picture entitled "Vairumati" shows a young Maohi woman sitting on a bed in a seductive pose; her head and upper body are framed by the gold decoration of the bedstead, as if by a halo. Gauguin depicted the young woman, as it says in the title, as the Tahitian goddess Vairumati. The latter is the original mother of the island, the mythical Eve from whom the Maohi people were descended. A part of the mythical imagination of Tahiti is also the white bird with the lizard in its claws, a symbol of the ever-recurring cycle of life.

Gauguin interested himself in the gods and demons of the Maohi, which he had

learned about by reading Jacques-Antoine Moerenhout's 1837 book *Voyage aux Iles du Grand Océan* (Voyage to the Islands of the Pacific). The Belgian Moerenhout had been consul general on Tahiti for a long time. He described a culture which Gauguin at the end of the 19th century was already not encountering in its natural and untouched form, but which he revived again in many pictures painted on Tahiti.

CS

Paul Gauguin,
The White Horse, 1898
Oil on canvas,
140 x 91.5 cm

The White Horse, one of the most successful paintings done on Tahiti, was painted in 1898. The animal stands at the front in water amidst mysterious vegetation. In the center and background are two almost hidden horsemen emerging from the branches of the trees.

In the Polynesian imagination the white horse is a sacred animal. Gauguin was able to express this artistically by borrowing the stance of the horse from the frieze on the Parthenon in Athens, of which he possessed old photographs. But this alone does not constitute the magic of the painting. The delicate distrib-

ution of color and the formal language make the highly decorative work appear like a beautifully worked, valuable carpet. It is typical of Gaugin's late style.

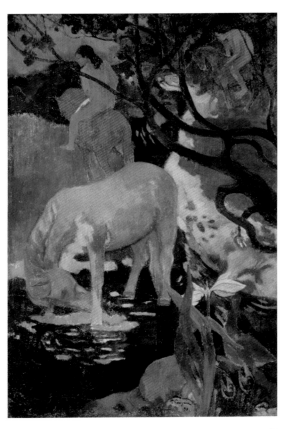

Timelessness and mythical experience of the world – Gauguin's South Sea paintings

Maurice Denis (1870–1943), the theoretical head of the Symbolist group of artists called the Nabis (prophets), in a text published in 1909, wrote with reference to Gauguin:

"We owe it to the barbarians, the primitives of 1890, that they have brought to light again some significant truths. Not to reproduce nature and life by a vague approximation or an improvised trompe l'oeil, but on the contrary to reproduce our feelings and dreams by representing them with harmonious forms and colors, was, I still believe, a new way – at least new for our time – of tackling the problem of art, and this idea has remained fruitful until today."

Paul Gauguin really did define painting formally in a completely new way: No longer is it a slice of reality seen in an illusionist or impressionist way, it is not a window on to the world in the sense of a concrete area based on experience, and neither is it an aesthetic sphere for the structuring of form and color, but it seeks to take up into itself experiences of existence and to represent them. Gauguin's South Sea pictures are to be understood in this spirit; they tell us little about the actual life

of the colonialized island-dwellers but rather depict an archaic world containing symbols and independent of time. The carpet-like, two-dimensional landscapes, the immobile, anatomically drawn female bodies, the changes of perspective within the interior, the direct juxtaposition of foreground and background – all those things are evidence of Gauguin's radically achieved renunciation of the Western painting tradition. He himself many times described this process of turning to the natural, "primitive" roots: "I have gone a long way back, further than to the horses of the Parthenon, back to the hobby-horses of my childhood."

With the emphasis on simplicity, originality, and expression as artistic categories, claims about representational character, about the similarity of image and nature were renounced. Painting – like music and poetry – is thereby recognized as an autonomous and "abstract" system of symbols. Only in this way could

Paul Gauguin, Female Nude and Small Dog, 1901, wood panel from his "House of Joy," 200 x 39.8 cm, upper level, room 44

that which is actually not representable – dream, emotion, myth – become a picture. Gauguin himself spoke in this connection of his "visions" that he was interpreting "by means of an appropriate decor."

A logical consequence of this is also his attempt to break up the traditional frame of the easel painting and to work as a (self-taught) sculptor and potter. As early as during his first stay in Brittany (1886) he was venturing to carry out experiments in clay, then in the South Seas he created amongst other things wood sculptures, inspired by the models of folk art that he found there.

Finally he created his hut built in 1901, the "Maison du Jouir" (House of Joy), with doorposts and panels carved by himself. Here one can comprehend his attempt to create his own artistic cosmos, to create in his work and life a "total work of art," an idea that was to inspire, indeed virtually dominate, the 20th century.

MP

Taken from Paul Gauguin's Noa-Noa-Album, 1893/94, Musée du Louvre, Paris

Paul Gauguin,
Women of Tahiti (On the Beach),
1891
Oil on canvas, 69 x 91.5 cm

The painting known by the title *Women of Tahiti* is one of the main works that Gauguin painted during his first stay on Tahiti (1891–1893). It reached France with the French legionary Charles Armand. Gauguin had sold it to him in order to finance his return journey from the Polynesian islands to Europe.

From a raised standpoint the observer looks at two Maohi women who take up the picture space almost completely. Characteristic is the monumental effect of the figures as well as the clear structure of the composition and the richly contrasting, vivid coloring.

With the depiction of the two women, Gauguin is documenting in an impressive way the cultural change that had taken place on the South Sea island in the course of the 19th century; whereas the woman on the left is wearing the traditional wrap, the "pareu," around her hips, the one on the right has put on a long, high-necked European dress. Even the pareus were already being produced from European cotton that had been printed with special, so-called South Sea patterns. From the middle of the 19th century they were only worn at work and in private. In public, women wore the long dresses that had come to Tahiti with the missionaries and colonial masters. In the damp climate of the island these dresses never completely dried out, wearing them brought tuberculosis and other life-threatening diseases. This and the unaccustomed enjoyment of alcohol which was developing at the time led to a dramatic reduction in the numbers of the original population. So Gauguin, who was well aware of this bad state of affairs, perhaps for that reason never painted laughing and carefree women but always only painted women who seemed to be full of melancholy and sunk in their own thoughts.

CS

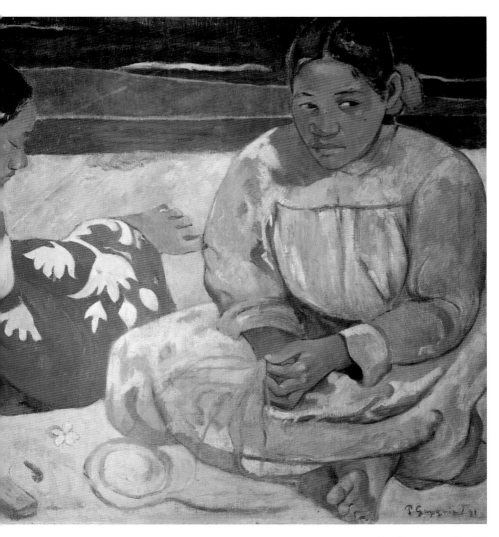

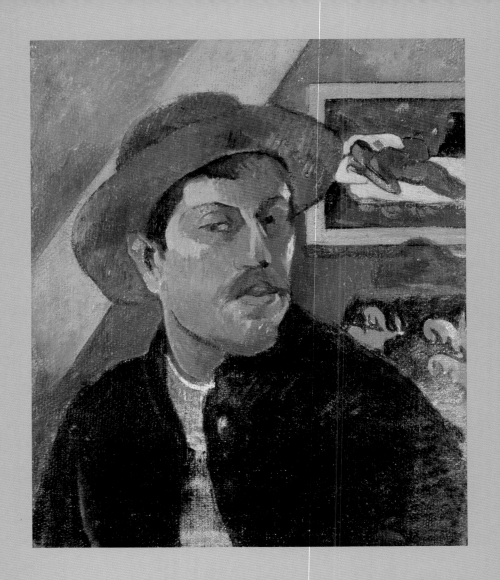

Stocktaking – two self-portraits

Gauguin tackled the topic of the self-portrait during all phases of his artistic career. In the portrait painted in the winter of 1893/94 he shows himself in front of the bright yellow and green walls of his Paris apartment, which he had decorated with souvenirs of his first Tahiti journey, the blue-green material lower right and the paintings he did in the South Seas. In the top right, in mirror image, the painting Manao Tupapau (*The Spirit of the Dead Keeps Watch*) can be seen. Whereas in the earlier self-portrait the artist looks at the observer with an assured, arrogant gaze, in the painting done in 1896 the shaded eyes are cast down and the head is turned to the side in earnest contemplation. When the latter painting was executed, Gauguin, who had left France for ever on July 3, 1895, was living on Tahiti again. He was ill, turning to morphine and talking of suicide. Full of frustration he wrote to Danile de Monfreid on April 7, 1896, "No one has ever made me their protégé because they thought I was strong and that I was too proud. Now I have hit rock bottom. I'm weak, half-exhausted by the pitiless battle that I've been fighting, I'm falling to my knees, and setting aside all my pride. I'm nothing but a failure."

Only one and a half years later Gauguin painted one of his masterpieces, the triptych *Where are we coming from? Who are we?*

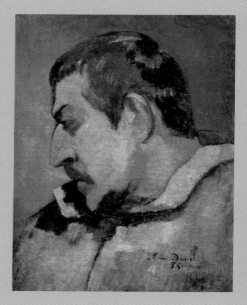

Paul Gauguin, Self-Portrait, 1896,
oil on canvas, 40.5 x 32 cm, top floor, room 44

Where are we going? as his legacy and actually attempted suicide. But he took too little arsenic, and after his recovery he acquired new strength, and he finally died a lonely man in 1903.

CS

Paul Gauguin, Self-Portrait, ca. 1893/94,
oil on canvas, 46 x 38 cm, top floor, room 44

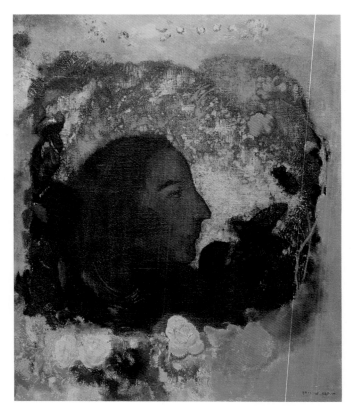

Odilon Redon (1840–1916),
Paul Gauguin, ca. 1903/1905
Oil on canvas, 66 x 54.5 cm

(Odilon Redon and Paul Gauguin had been acquainted with each other since the middle of the 1880s), but completely from memory.

Comparable to a costly medieval manuscript in which the portrayal of an evangelist is worked into a decorated initial, the younger Gauguin is depicted here detached from all material relationships in a world that belongs completely to painting and fantasy, to dream and vision. As if the canvas were indicating an opening, the head comes out of the indefinite darkness further forward than the shoulder. A veil worked in gold picks up the striking profile of Gauguin, whose gaze is not directed at us but out of the picture, toward the right. Blue, yellow, and red flowers surround the portrait section. We encounter them rather frequently in Redon's work, mostly as heralds of the still untouched, dreaming inner life of the figure represented.

The picture, which shows so little likeness to Gauguin, was painted after the latter's death in 1903, in other words not after any direct encounter between the two men

Neo-Impressionism

**Georges Seurat (1859–1891), Boys Bathing
(Study for A Bathing Place in Asnières), 1883**
oil on wood, 15.5 x 25 cm

The small study in oil executed freely in the Impressionist style with quick brush strokes in a natural setting is a preparatory work for one of Seurat's main works, *A Bathing Place in Asnières* (1883/84). It shows a happy scene on the banks of the Seine in bright summer light. The horizontal line of the water surface and the angle of the bank falling from left to right determine the landscape section. The two boys and the man sitting relaxed on the bank in his white clothes remain motionless, apparently without reference to each other. This figure of the man is taken over by Seurat in his later work, as are the dog and the discarded clothing to which he had already devoted a separate study. In *A Bathing Place in Asnières*, however, the figures are much larger in relation to the landscape than in other pieces.

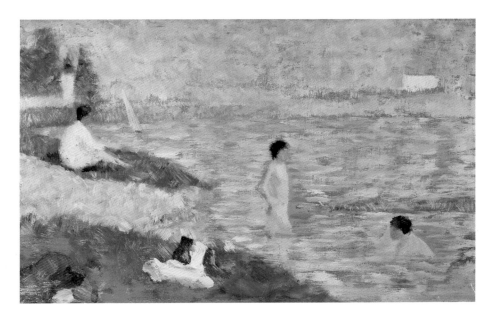

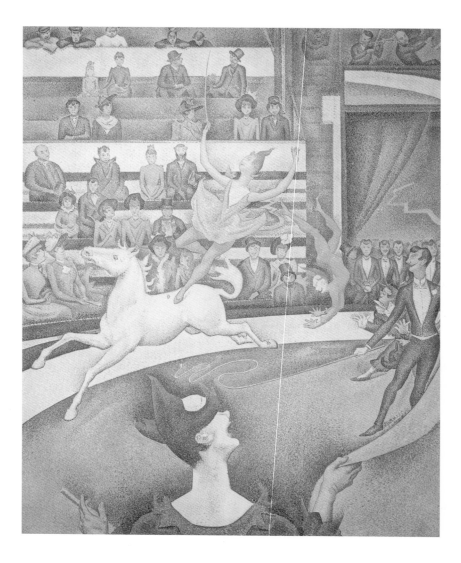

Georges Seurat, The Circus, 1891
Oil on canvas, 185.5 x 152.2 cm

Although the ambitious painting was still not completed at his early death (1891), Seurat had already exhibited it that year in the Salon des Indépendents. It was intended to bring home clearly the principles of his art that he had developed in the previous ten years and at the same time to emphasize his leading role in modern painting. But critics complained about the coldness of the style, while sympathizers reacted euphorically and Paul Signac remarked: "*The Circus* is the purest and freshest of his works."

Through the arrangement of surfaces in Seurat's painting, the action, the contrast between the movement in the ring and the stillness in the spectators' seats is all but frozen. The circus was that of the Cirque Medrano, not far from Seurat's studio, which typically had a wide range of prices. It offered expensive ringside seats as well as cheap rows. To clarify his depiction Seurat left most of the seats empty behind the artiste riding into the arena. Over and above that he indicates a sense of three-dimensionality by the decreasing size of the spectators as one looks deeper into the picture. But it is not a study in spatial perspective because the eye seems to glide over the surface of the picture. There is no real vanishing-point. The work has something of the quality of a poster.

In the ring we can see the woman rider and her horse, the leaping clown, and a trainer, behind whom another clown is coming into view. The clown at the front was added in as a repoussoir figure. Seurat grouped these figures together in a circle. Through the movements of the people and the horse and through the slanting angle of the dancing artiste, which illustrates the speed of her ride, and through the attitude of the trainer, the diagonal is introduced into the picture. It creates a contrast to the orthogonal line structure in the spectator area, which turns into the flat curve of the edge of the ring (though this is not echoed in the tiered seats behind).

Alongside that there are zigzag lines that have no objective significance: the yellow ribbon behind the dancer and the similarly colored strips in the entrance to the ring. They seem like mere paraphrases for the dancing whip.

The coloring of the picture is determined by a bright yellow. These bright colors are often heightened with white. In contrast to the yellow, orange, and red tones applied in the smallest dabs is the blue of the contours and the shadow tones. Originally the picture had a colored frame painted by Seurat, which must have had a bluish or purple effect.

Because of the famous objectivity of his method of representation, no spark of emotion is transmitted from Seurat's painting to the observer. The figures in the seats are types and the performers seem like automata. The living world of the circus appears to be frozen into a scene of complete artificiality.

Georges Seurat, Model in Profile, ca. 1887
oil on wood, 25 x 16 cm

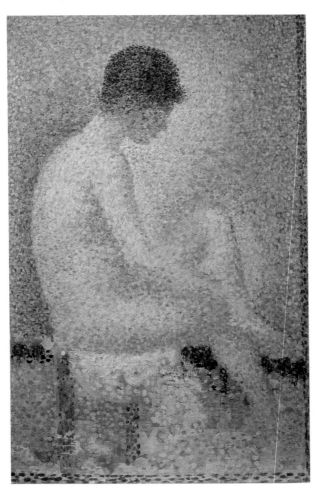

The small work is part of three pictures which preceded Seurat's great work *Models in the Studio* (1888). The model is sitting in profile in front of a light, lilac-colored background that is composed, as in the large version, of red and bluish-purple dabs which are "decolored" by yellowy white and orange into a shimmering gray. The lower legs of the girl, who has put her left foot onto her right leg, form a falling diagonal. Her arms lie parallel behind each other.

The three nudes of the large painting form a compositional triangle completed on the right by this figure. Remarkably, Seurat later "straightens" the softly flowing contour of the thigh on the seat; the natural body shape is geometrically strengthened in a manner typical of him. Thus, despite the dissolving effect of the color, the form is given firmness.

Paul Signac (1863–1935), The Red Buoy, 1895
Oil on canvas, 81 x 65 cm

Signac preferred to paint seascapes and views of harbors. St. Tropez, where the artist regularly stayed in summer, was discovered by him in 1891 for his art. *The Red Buoy* exhibits a common Impressionist theme: boats and houses are reflected on the surface of the water beneath a blue sky. In contrast to Monet and his friends Signac made efforts not to let the motifs become blurred, but in reproducing them sought to organize them systematically on the canvas. Like Seurat, Signac also employed only pure colors of the spectrum mixed with white, dabbing them onto the canvas. The dabs are placed close together, with the result that from a slight distance the observer sees them as mixed. Thereby – with all the intensity of color which distinguishes the work – he deliberately avoids the spontaneous effect which typifies most Impressionist paintings. Paul Signac recorded his memories and thoughts on painting in the book *D'Eugène Delacroix au néo-impressionisme* (From Delacroix to Neo-Impressionism) (1899) including a definition of neo-Impressionism.

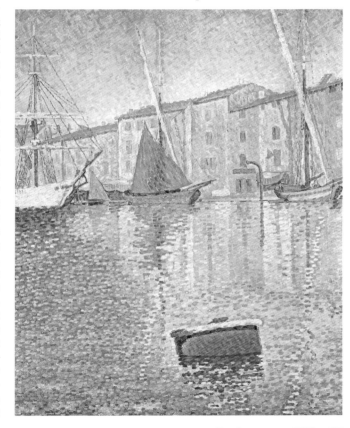

Purity of the color spectrum as the aim of painting – Seurat, Signac, and neo-Impressionism

When in 1886 Camille Pissarro organized the eighth and last group exhibition of the Impressionists, a quarrel arose about the participation of two young artist colleagues; the paintings of the 23-year-old Paul Signac and the 27-year-old Georges Seurat caused a sensation. There was an especially controversial discussion about the approximately two by three meters large program picture *A Sunday Afternoon* on the Island of Grande Jatte by Seurat, which already broke the bounds of Impressionist painting because of its size. Alongside this work, which dominated the space, could be seen paintings by Signac and also by Pissarro himself, the color scale and characteristic style of which seemed to the public and also to most art critics almost identical; in place of the loose and spontaneous brushwork of the Impressionists had appeared a systematically organized application of color, composed of equally large dots which covered the canvases uniformly. On standing closer it could be seen that the artists' palette comprised just the three primary colors – blue, red, and yellow, together with their complementary respective colors – orange, green, and violet. These colors were lightened and varied with white, but not mixed together. The novelty of this experiment in painting was quickly recognized; the critic Félix Fénéon, in his discussion of the exhibition of 1886, already coined the term "neo-Impressionism" in order to characterize the dissolving of the object portrayed into colored dots (pointillism) that only seem to become merged

Georges Seurat, Port-en-Bessin, The Outer Harbor, High Tide (with detail) 1888, oil on canvas, 67 x 82 cm. Top floor, room 45

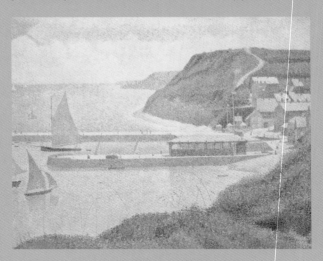

together again though the optical processes of the observer. The systematization of painting through a really scientific analytical experiment in color perception was above all the achievement of Georges Seurat, who studied intensively the writings of the physicist Charles Blanc, and later also the works of Antoine Chevreul. The result of his studies was, in sum, the recognition that a visual union of separate tones can achieve an essentially greater brightness than is possible with mixed colors. "Since I have been holding a brush in my hands I have been looking for a formula for optical painting," Seurat wrote in retrospect.

Thus art came to be newly defined by the pointillists as an almost scientific discipline with fixed rules. Connected with that was a slow process in the studio instead of the usual quick open-air paintin only dependant on the weather. Thus emerged the typically neo-Impressionist peaceful pictorial worlds which do not capture the changing moment but are structured as calculated compositions.

**Theo van Rysselberghe
(1862–1926),
The Man at the Helm, 1892**
Oil on canvas, 60.2 x 80.3 cm

The Belgian painter Theo van Rysselberghe met Seurat and Signac in 1886 and adopted the pointillist style of painting developed by them. His painting shows a helmsman who is under way with his ship in high seas. By the division of the picture space the painter stresses the dramatic nature of this voyage. The sail takes up the upper left-hand corner, the man at the helm the lower right. Taut ropes cross the crest of a high wave and in this way bring in an additional dynamic element. On top of that there are the color contrasts characteristic of pointillism: Thus the red of the hands and face contrasts with the green of the sea, also the orange with the blue of the waterproof clothing. For the pointillists art meant finding harmony in contrasts.

**Henri-Edmond Cross
(1856–1910), The Iles d'Or, 1892**
Oil on canvas, 59 x 54 cm
(following page)

The golden islands, as in the title, are the Iles du Levant, Port-Cros and Porquerolles in the Bay of Hyères. From the shingle beach in the foreground the gaze of the observer glides over the sea to the chain of islands, whose silhouette towers above the horizon in a reddish color. The overwhelming, gleaming bright light of the Mediterranean world is expressed in the coloring; the harmonies of the picture show a strikingly high proportion of white. The parallel areas of color which succeed each other in the almost square picture consist of mosaic-like dots whose size decreases from bottom to top. This is a last indication of the illusion of depth, for Cross's composition is characterized by a soberness touching on abstraction. Thus both aspects, independence from the portrayal of nature and the work of art, are emphasized as an autonomous element.

Henri Edmond Cross,
Afternoon in Pardigon, 1907
Oil on canvas, 81 x 65 cm

This landscape painting has a very much more representational and colorful quality than *The Iles d'Or*. For Cross it is an important picture because he created a companion piece for it, showing approximately the same section but extended by one figure and with its theme as the evening sun instead of the midday light. There is a distinct three-dimesional gradation leading from the pine on the hill to the group of trees situated further back and over the sea to the chain of hills. The dissolving of a southern landscape into intensive dabs of color reveals here the close relationship between neo-Impressionism and Fauvism, in whose emergence this painting played an important part. The Musée d'Orsay offers the possibility of comparing Cross's picture with the picture painted three years earlier, Matisse's Luxe, *Calme et Volupté* (Luxury, Calm, and Sensual Delight), which in a sense forms a link between both movements and which has filled the silent landscape with a group of nude women bathing. Both are modern pastoral images.

Henri de Toulouse-Lautrec

Henri de Toulouse-Lautrec (1864-1901)
The Female Clown Cha-U-Kao, 1895
Oil on cardboard, 64 x 49 cm

The picture shows the female clown, Cha-U-Kao, who was frequently depicted by Toulouse-Lautrec and whose name goes back to the dance chahut-chaos. She had made a name for herself as a dancer and acrobat in both the Moulin Rouge and the Nouveau Cirque. With her sweeping contours the painter places the amply proportioned clown eye-catchingly in the picture. Her back half turned toward the observer, she is portrayed in a room at the theater before a turqoise-colored background on a red divan. The star is seen arranging her costume in readiness for her act. Cha-U-Kao is dressed in a strapless lilac-colored costume with a widely flouncing frill of yellow tulle. Her white hair is held together at the front by a bright yellow bow. An observer has slipped into the intimate scene, apparently unobserved by the clown. On the wall the face of a man can be seen in the mirror. The popular clown of Montmartre is not alone, she has a male visitor.

**Henri de Toulouse-Lautrec,
Jane Avril Dancing, ca. 1892**
oil on cardboard, 86.5 x 45 cm

The dancer Jane Avril also came from the world of Montmartre into which Toulouse-Lautrec had penetrated in 1884 and which determined his art for years. He always had to concentrate on a favorite model in order to feel a real desire for creativity. 1891 was the year of La Goulue, the following one became the year of the solo dancer Jane Avril with the nickname La Mélinite (the explosive one). The most striking things about her dance were the movements of her legs and the circling of her hips. The press spoke of an "orchid in delirium."

The surroundings only interested the artist in so far as they were related to the person being depicted. Only by means of the man in the box – he is the Englishman at the Moulin Rouge, as a lithograph of 1892 is entitled – is it indicated where Jane Avril is appearing. The sketch-like execution is in keeping with the reduction of all accessories. The discrepancy between the fully painted sections and the unpainted cardboard background is characteristic of Toulouse-Lautrec at this time.

A place for art (history) –
Montmartre between social misery and new
beginnings in art

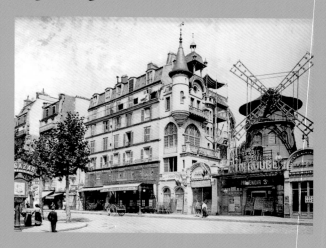

The Moulin Rouge on the Boulevard de Clichy around 1880

At the time Baron Haussmann was driving his ambitious boulevards like monstrous corridors into the urban organism of Paris, Montmartre, as a northern suburb and only recently incorporated into the city, remained as good as untouched by all this. Even today narrow lanes and little streets still climb up the hill and when Vincent van Gogh painted the Butte in 1886 he was portraying a landscape that the writer Gérard de Nerval (1808–1855) had described shortly before his death as follows: "There are windmills, summer houses, country schools, quiet lanes, bordered by thatched cottages, barns, dense gardens, and green open spaces ..., in some parts reminiscent of a Roman landscape."

In this idyllic landscape, which because of its situation on a hill also promised better air and in the summer a refreshing breeze, the affluent Parisians had already in the 18th century erected their summer houses, the so-called Folies, between the windmills and vineyards. In parallel to that there arose for the entertainment of the aristocrats and upper bourgeoisie the first cabarets and cafés with the dancing for which Montmartre was to become famous; around 1876, Auguste Renoir painted a typical Sunday dance at the "Moulin de la Galette" (see p. 242). At the beginning of the 19th century, as a result of the general expansion of Paris, but above all through the drastic rent increases in the renovated areas of the city, the population increased enormously in the suburb where building was restricted because of the hill. Whereas at the beginning of the century only 650 inhabitants had lived in Montmartre, by 1832 5,200 people had moved there. At its incorporation into Paris in 1860, the quarter, which was added to the

18th arrondissement, already numbered 57,000 inhabitants. It was primarily the unsophisticated people who settled here, in order to find cheap accommodation in the hurriedly built apartments or to find work in the Montmartre quarries. The Goutte d'Or (drop of gold) quarter, named after the wine still produced there in the 18th century, in particular became a focal point for those who no longer had a place in the "new Paris" and found shelter in poor housing. Emile Zola's novel *L'Assommoir* (1877), in which the social downside of the Haussmann era is forcefully described through the example of the washerwoman Gervaise, is for good reasons set in this district.

Montmartre, whose Latin name mons martyrium (mountain of the martyrs) goes back to the execution of three local saints at this spot in the Middle Ages, was, however, not only a poverty-stricken area but also at the same time the most important nightclub district for the Parisian bourgeoisie. Particularly around the place de Clichy a whole series of cabarets and places of entertainment opened in the 1880s and 1890s, of which the Moulin Rouge is certainly the most famous today. One of the regular visitors there, the graphic artist Henri de Toulouse-Lautrec, was given the commission in 1891 of drawing a poster for the new season at the Moulin Rouge. In the following years he was to become an outstanding chronicler of the Montmartre demimonde scene. He portrayed the whole array of its denizens — eccentric dancers, the dubious impresarios, and scurrilous types. His posters advertising the various cabaret ensembles, were soon to be seen all

All levels of society met at balls in the Moulin Rouge

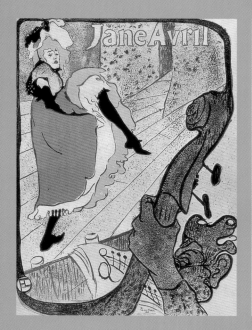

Jane Avril on a poster by Henri de Toulouse-Lautrec, 1893

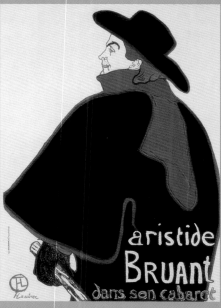

Henri de Toulouse-Lautrec, a poster for Aristide Bruant's cabaret in Paris, 1893

over the Paris streets and showed an innovative pictorial language which the art critic Felix Fénéon tellingly characterized as follows: "My goodness, isn't he outrageous, this Lautrec; he doesn't stop at anything, either in his drawing or in his colors. White, black, red in large blobs and simple shapes, that's his style. There's never been anyone as good as him at portraying the horrid faces of the seedy capitalists sitting at tables in the company of whores who are licking their gobs to turn them on."

It was not only Toulouse-Lautrec who worked and lived in Montmartre – a whole series of artists moved into this area in the 1880s looking for inexpensive accommodation, temporary studios, interesting subjects, and cheap models. Edgar Degas lived there, as did the two van Gogh brothers, the neo-Impressionist Georges Seurat, the artist Suzanne Valadon, and her son Maurice Utrillo. In 1890 the famous art-dealer Ambroise Vollard opened his gallery in Montmartre and went around the district looking for

talent. The little paint merchant Père Tanguy had his shop quite near to van Gogh's apartment and, to the concern of his wife, was always swapping canvases and paint for the unsalable pictures of the Dutchman. Picasso also had his first Paris home at rue Gabrielle 49 in Montmartre before a few years later moving into a house-cum-studio in a former piano factory nearby, in the present-day place des Abbesses. In this building, the so-called Bateau-Lavoir, he painted the world-famous picture *Les Demoiselles d'Avignon*. Apart from Picasso, Georges Braque, Juan Gris, Kees van Dongen, Henri Matisse, and Amadeo Modigliani also worked here, among others. Thus the development of Cubism is also closely linked with this district, which was only abandoned by artists in the 1920s and exchanged with Montparnasse as their cultural center.

In many old pictures, drawings, and prints the great age of Montmartre has, however, retained its presence and everyone today who climbs the hill to the Sacré-Coeur, past the portrait painters who lie in wait for a willing customer, tries to recapture that atmosphere which around 1900 was equally fascinating to both the newly arrived and the old artists..

MP

Montmartre with view of the Sacré Coeur

Henri de Toulouse-Lautrec, The Bed, ca. 1892
oil on cardboard, 54 x 70.5 cm

From 1892, Toulouse-Lautrec was more frequently to be found in the inner city than in Montmartre. A new world opened up for the artist in the *maisons closes*, the houses of ill-repute in the area around the Opéra. In this world the crippled aristocrat could feel himself to be a human being. Toulouse-Lautrec in return gave back human qualities to the women, who, as Zola said, "lose their decency along with their clothes." This can be seen in *The Bed* – one of the four paintings which were done from 1892 onwards and dedicated to the shared moments of two ladies of easy virtue – above all to human closeness and a commonly shared warmth.

The two heads are drawn in bold perspective, partly hidden by the bedclothes, and partly buried in the pillows. The faces are turned toward each other. The artist – and with him the observer – appears not to

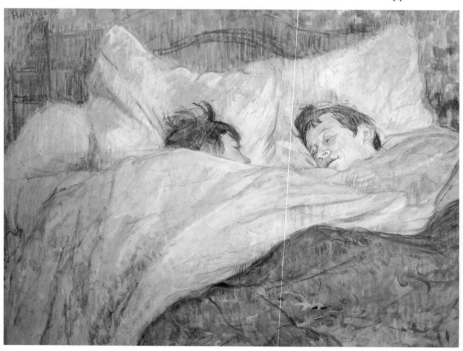

be present; neither of the two women takes any notice of him. The pair have withdrawn from the outside world. And Toulouse-Lautrec respected the withdrawal of these people into the consolation of togetherness, in fact even emphasized it by this treasure of a painting. The place is bathed in warm colors; orange and red tones predominate, partly applied on top of each other and mixed with blue. For all of its intimacy Toulouse-Lautrec's style never slips into the indiscreet or offensive.

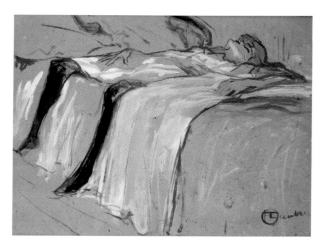

Toulouse-Lautrec was not the first artist to discover the world of the brothel for his art. Félicien Rops and Constantin Guys as well as Edgar Degas in his time had already used this milieu as their subject.

Henri de Toulouse-Lautrec, Alone, 1896

oil on cardboard, 31 x 40 cm

This sketch in oils shows a prostitute with orange hair wearing only an underskirt and black stockings who has collapsed exhausted onto a bed. This woman has nothing of the self-assured *grandes cocottes* about her as, for example, Edouard Manet had portrayed them in his *Olympia* painting of 1863 (see p. 117). Rather she is a simple prostitute from one of the *maisons closes* situated near the Opéra in which Toulouse-Lautrec often spent several weeks between 1892 and 1895. The artist became familiar with the women's daily routine there and in numerous drawings, prints, and paintings recorded their morning toilette, breakfast, waiting for custom, or simply their exhaustion after their clients' visits.

The worm's eye view motif had also been used by Toulouse-Lautrec in a similar form for a lithograph in the ten-part series "Elle" likewise done in 1896. This series too indicates a discreet and respectful portrayal by the painter.

CS

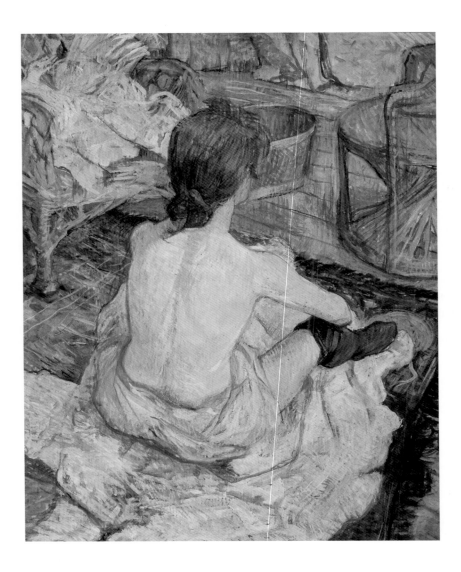

Henri de Toulouse-Lautrec,
La Toilette, 1896
oil on cardboard, 67 x 54 cm

La Toilette is one of the few works in which Henri de Toulouse-Lautrec turned away from the human face. A woman's back sitting on an article of clothing on the floor takes up the center of the composition. Everything to be seen in the space around her is subordinated to the view of her. The two wicker chairs to the left and right of the bed are chopped off by the edge of the picture, the woman portrayed is herself partly covering the bath tub between the two chairs.

As he did so often Toulouse-Lautrec also worked here with oil paints thinned down with large amounts of turpentine and applied to the cardboard as a painting ground. The wealth of variation used by the artist is impressive. Alongside places in which layers are set on top of each other with quick brush strokes – for example on the light part of the back – are those where the color hardly covers the painting ground, as is the case with the representation of floorboards.

Henri de Toulouse-Lautrec,
Portrait of Paul Leclercq, 1897
oil on cardboard, 54 x 67 cm

It is certainly worth noting that Toulouse-Lautrec's creative power decreased noticeably towards the end of the 1890s, yet we hear from Paul Leclercq about the ease with which he was still painting, "As soon as I went in he asked me to adopt the agreed pose in a wide wicker armchair, and, wearing the small felt hat that he always wore in his studio, he stood in front of the easel. Now he directed his pince-nez at me, screwed up his eyes, took the paintbrush and, after taking a close look, made a few light strokes with very thinned down paint. He did not speak a word as he painted but seemed to be consuming something very tasty behind his moist lips. Then he began to sing the Chanson du Forgeron, put the brush down, and declared decisively, 'That's enough work! Weather's too nice!' Thereupon we took a walk around the area."

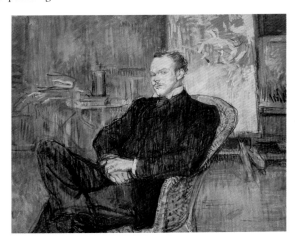

Small-format paintings

Edouard Vuillard (1868–1940),
Félix Vallotton, 1900
Oil on cardboard, 63 x 49.5 cm

Félix Vallotton, who came from Switzerland, lived mainly in Paris where he formed strong links with the Nabis group. Edouard Vuillard's portrait shows the painter and graphic artist sitting in the corner of a room. His arms are folded, his legs crossed, and his head is slightly iclined to the side – a sign of contemplation.

The portrait is painted in subdued colors. Highlights are given to the paintings on the walls and Vallotton's clothes: The voluminous blue-gray suit, which ends in curved lines and contains only a minimum of drawing in the shadowy parts, but above all the red socks and shoes. They complete an ornament which seems to match the meander pattern to be seen in the wall decoration.

Paul Sérusier (1864–1927), The Bois d'Amour by Pont-Aven (The Talisman), 1888
oil on wood, 27 x 21.5 cm

In the summer of 1880 Paul Sérusier joined Paul Gauguin and Emile Bernard in Pont-Aven. In the Bois d'Amour there was a painting lesson during which Sérusier painted this small wooden panel before Gauguin's eyes. Large regular dots of color are combined into a minimum of naturalistic elements. The pale blue tree trunks crowned by yellow and blue surfaces, a blue dot which stands for a piece of the sky, and the reflection of all this in the water produce a landscape painting which can hardly be recognized as such any more.

Back in Paris, Sérusier showed the painting to Pierre Bonnard and Maurice Denis. The artists of the Nabis (a Hebrew word meaning "prophets") declared it their talisman; Denis received it as a gift. Sérusier had often told them of the painting lesson and thus made it clear what Gauguin's message to the young painters was: "'How do you perceive this tree?', Gauguin had asked on seeing the scenery in the Bois d'Amour. 'Is it green? Then take the green, the most beautiful green on your palette; and these shadows – could they be blue? Then don't be afraid to paint them as blue as possible.'" The color palette was to be developed into the highest possible purity. With the frankness of youthful enthusiasm Sérusier had gone even further than Gauguin. His approach to landscape painting touches on abstraction and for that very reason his friends learnt of the "creative concept of the 'flat surface, which is covered in a definite arrangement of colors'," as Maurice Denis describes it. The painting was of crucial significance in the development of Symbolism.

Hunger for pictures – from panorama to photography

The first French panorama, that is a huge frameless round picture which was exhibited in a specially made rotunda and could be viewed by visitors from a central platform, was opened in Paris in July 1799 in the Jardin des Capucines. It shows a view of the city from the Tuileries and, after payment of the entrance fee, could be visited by everyone. From this time on until the invention of the photograph by Louis-Jacques-Mandé Daguerre (1787–1851) in 1839, a revolution in means of communication took place which even today influences our dealings with the media. Alongside art, and above all painting, there now emerged a financially planned entertainment industry addressing a wide audience, prompting and encouraging it to purchase pictures. A visit to a panorama replaced a trip to a foreign land, made historical events come to life, played with the visual perception and imagination in ways that were previously unknown. "After five minutes you don't see any 'painting' any more; nature itself appears before your eyes," a visitor remarked about a panorama of Rome which could be viewed in Paris in the summer of 1804: "I have no doubt that panoramas have overcome the boundaries of painting with the increase in the power of illusion."

Between 1800 and 1805, three further panorama rotundas were built in Paris alone. To produce the views – mostly panoramas of exotic landscapes and famous cities but also impressive representations of historic battles – large groups of painters were working, partly under piecework conditions, according to precise sketches on individual parts of the picture on a canvas of up to 2000 square meters in size. A studio supervisor checked the paintings from where the observer would eventually stand and most important of all saw to the foreshortening which was vital for creating the

desired illusion. In order to increase further the optical illusion or to conceal the weak spot of the panoramas, the transition from reality (the observation platform) to fiction (the canvas), they introduced in 1830 the so-called faux terrain. This transition area, decorated with three-dimensional staffage objects, improved the spatial illusion. Nevertheless, the panorama lacked the dimension of movement and the category of time, in other words crucial moments of perception that are supposedly able to eradicate fully the difference between picture and reality.

In 1822, the theater artist Daguerre was successful with a further development, the so-called diorama. Through different lighting effects it could simulate the course of a day, varying weather conditions, and, through reflections, even flowing water. Unlike the panorama, the diorama did not offer a circular view, but instead observers in a semicircular room with seats looked through a dark viewing tube at a transparent image, which was painted on both sides and fitted with countless drop scenes, blinds, and filters. After some time the observation room could be rotated and focused on one or several other pictures. In order to increase the illusion of real activity, Daguerre worked with sounds as well as with realistic set pieces in the faux terrain. Thus in one Alpine diorama, the Chamonix Valley for instance, he not only had alpenhorns sounding and singers from Switzerland appearing, but also a goat wandering through the picture chewing and bleating. The spectators commented ironically at their own amazement, "Their fronts are real but their backs painted."

If the panorama and diorama were new mass media, which might be regarded as early forms of the present-day cinema, in photography a medium was being developed which could be used by the individual. As early as the 1790s Joseph Nicephore Niépce (1765–1833) in France and Thomas Wedgewood (1771–1805) in England had worked on a procedure for recording by a chemical process the familiar pictures pro-

One of the first daguerrotypes shows Paris with a view of the Seine and the Louvre, 1839

Louis-Jacques-Mandé Daguerre (1787-1851) is regarded as the inventor of photography

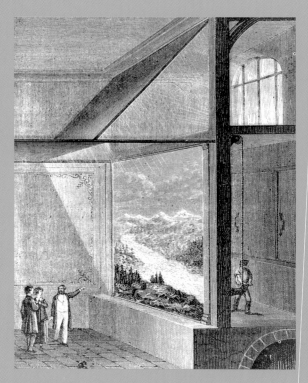

Daguerre's diorama with the mechanism for lighting up the image

"pick up" an image. This initially very complex process, with which only a single copy could be produced, was soon refined and developed further. Through increasingly shorter exposure times, above all through the possibility of an almost limitless number of copies there emerged a new, fascinating world of pictures which attained a portrayal of reality as it had never been achieved before. Many painting tasks became almost obsolete as a result of photography, and so the photograph increasingly replaced portrait painters in the 19th century and enabled many levels of society to possess their own portraits. The documenting of personal history, but also of great historical events, was now no longer a problem and the private, as well as the public, contact with the picture was democratized with lasting effect. In the course of this enormous boom in photography the great Parisian photographic studios of the 1850s and 1860s were born. Mainly situated on the major arterial roads, the boulevards, in close proximity to the theaters, restaurants, and music halls, they became a further social meeting point of the wealthy bourgeoisie. Félix Nadar (1820–1910) opened perhaps the most famous studio known today on the boulevard des Capucines. It was one of the most elegant establishments in the city. As part of the sumptuous interior furnishings in the

duced by the camera obscura. Their primary motive was simplification of the production or duplication of pictures. Daguerre also turned his attention to this problem, and in August 1839 introduced a process which today marks the birth of photography. The so-called "daguerrotype" used light-sensitive iodized silver plates that could

reception rooms there was even an artificial channel of water which cascaded down over some rocks. Nadar planned a photographic pantheon of French society and in fact managed to take portraits of almost all the intellectual and creative élite such as the Goncourt brothers, Charles Baudelaire, Gustave Doré, and Gustave Courbet, as well as stars of the theater, Sarah Bernhardt for instance, and the rich and distinguished members of Parisian society. Nadar moreover probably became the most famous portraitist of his native Paris. He photographed the Nouveau Paris as well as the old areas being demolished, he climbed down into the catacombs and the sewers and undertook his famous flights in a hot-air balloon in order to be able to capture the panorama of the city from a number of different perspectives.

Félix Nadar, an aerial view of Paris taken from a balloon, 1868

The development and spread of photography as a mass medium was not without consequences for art. Did it lose its traditional task of the reproducing and interpreting of history, nature, and the individual, or was it relieved of having to carry out each and every second-rate imitative commission? Did photography become a competitive art form or did it remain an unimaginative mechanistic process? Was the artist to concern himself with photography as an aid or even as a new possibility of expression, or ignore it if possible as being a cheap consumer item? These questions determined the beginnings of the coexistence of photography and art and had a different effect on both media according to the state of current debate. Photography today is regarded equally as an everyday consumer item and as a means of artistic expression with its own principles. Whilst the cinema completely replaced panorama and diorama – the dinosaurs of mass media – painting was challenged by photography and provoked artistically into emancipation from the representational. This development opened up to artists new avenues which could be discovered and visualized pictorially.

MP

Félix Nadar, portrait of Sarah Bernhardt, ca. 1860

Félix Nadar, self-portrait in a series of 12 photographs, ca. 1865

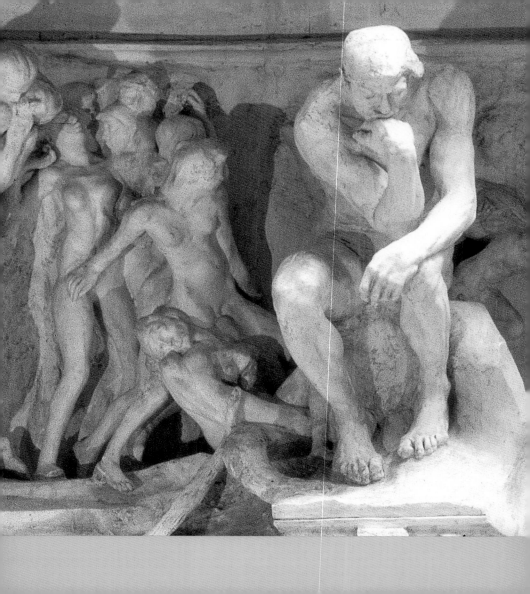

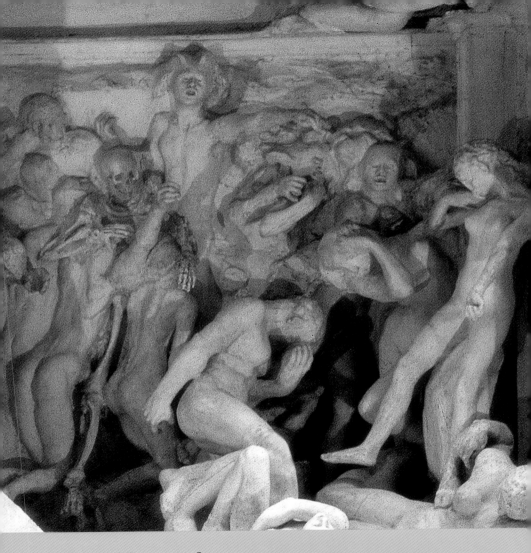

Mezzanine

Mezzanine 1

Constantin Meunier,
Puddlers, p. 420

Edvard Munch,
*Summer night in
Aasgaardstrand*, p. 434

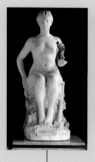

Jean Léon Gérôme,
Tanagra, p. 400

Festival Hall,
p. 402

Other works:

1 Léon Bonnet, *Jules Grévy*,
 room 52, p. 398

2 Edouard Vuillard, *In the Park*,
 room 70, p. 492

3 Félix Vallotton, *The Ball*, room
 71, p. 494

*Previous double page: Auguste Renoir, The Gates of Hell
(detail), Mezzanine, Rodin Terrace*

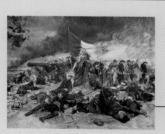

Ernest Meissonier,
The Occupation of Paris, p. 410

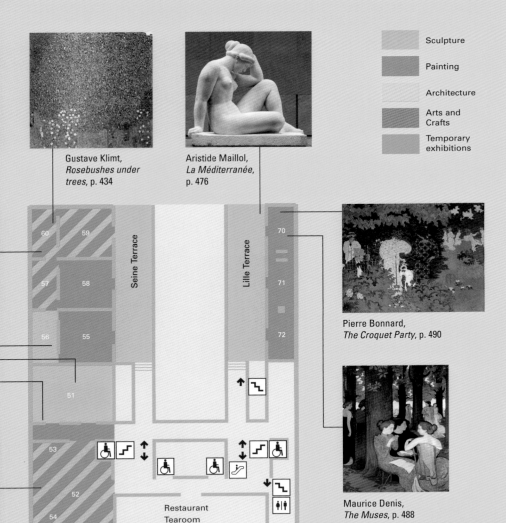

Gustave Klimt,
*Rosebushes under
trees*, p. 434

Aristide Maillol,
La Méditerranée,
p. 476

Sculpture

Painting

Architecture

Arts and
Crafts

Temporary
exhibitions

Seine Terrace

Lille Terrace

60
59
57
58
56
55
51
53
52
54

70
71
72

Restaurant
Tearoom

Pierre Bonnard,
The Croquet Party, p. 490

Maurice Denis,
The Muses, p. 488

Mezzanine 2

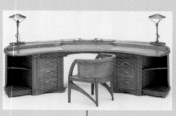

Henry van de Velde,
Writing desk,
p. 460

Camille Claudel,
The Age of Maturity, p. 465

Emile Gallé, *Hand,*
Surrounded by
Algae and Shells,
p. 455

Other works:

1 Réne Lalique, Pendant and
chair, p. 442

2 Auguste Rodin, *The Age of*
Bronze, Seine Terrace, p. 462

Hector Guimard, Balcony railing, p. 452

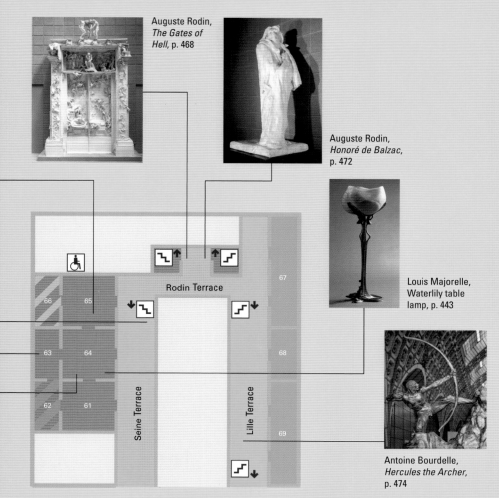

Auguste Rodin, *The Gates of Hell*, p. 468

Auguste Rodin, *Honoré de Balzac*, p. 472

Louis Majorelle, Waterlily table lamp, p. 443

Antoine Bourdelle, *Hercules the Archer*, p. 474

Rodin Terrace

67

66 | 65

63 | 64

62 | 61

68

69

Seine Terrace

Lille Terrace

Examples of academic paintings and sculptures

Léon Bonnat (1833–1922),
Jules Grévy, 1880
Oil on canvas, 152 x 116 cm

Léon Bonnat made a name for himself in the 1860s as a historical painter and portrait artist. This painting of Jules Grévy, who was voted president of France in 1879 at the advanced age of 72, is the epitome of an official state portrait in the Third Republic.

Bonnat aimed to incorporate the politician's personality, just as much as his external appearance, and to show him as an individual wielding power and authority. Thus Jules Grévy's strong, upright stance directly facing the viewer, with his left arm hanging loosely down by his side and his right hand resting lightly on books on the table, combines an almost photographic reproduction with an expression of honorable seriousness and presidential dignity.

Léon Bonnat left absolutely nothing to chance. He chose the official black as the main color for his work, and a strict symmetry for the composition. He also chose a style that shows each minute detail: the politician's thinning hair is reproduced with the same amount of care as his slightly reddened cheeks and the lines around his eyes and on his hands. The detail shown in the reproduction of the president's severe clothing matches that of the item of furniture on his right.

William Bouguereau (1825–1905),
The Birth of Venus, 1879
Oil on canvas, 300 x 218 cm

William Bouguereau presented his painting *The Birth of Venus* at the Paris Salon of 1879, and later that year it was bought for an amazing FF. 15,000 by the French State. The great enthusiasm shown for the painting by the public at the time is hardly surprising, since the subject and the traditional academic execution were in complete accord with the prevailing ideal of official tastes in art in the Third Republic.

The mythological subject enables the artist to tackle nude painting, a division that at the time was not even classed as a category in its own right. The naked body of the goddess of love is reproduced naturalistically. Bouguereau styled his painting of it on works of the Italian Renaissance, cf. Raphael's *Triumph of Galatea*, as well as on works by Ingres, whose nude in his celebrated painting *The Spring* (1820–1856; see p. 22) reveals the same gentle lines and sensual angling of the hips, so characteristic of Ingres' works, that is also such a typical feature of Bouguereau's *Venus*. It was paintings such as this that made Bouguereau the most revered academic painter of his day.

CS

**Jean Léon Gérôme (1824–1904),
Tanagra (with Detail), 1890**
Marble, 154.7 x 56 x 57.3 cm
Figurine: 23.3 x 10.5 x 9 cm

Gérôme, originally a painter, turned to sculpting late in life. Once he had, he consistently combined sculpture and painting in all his works. The painting *The Marble Work* (1895), for example, shows the artist and his model at work on *Tanagra*, the first colored sculpture in Gérôme's oeuvre, which was a huge success at the Salon of 1890.

In the 1860s, French archaeologists digging in the ancient Greek city of Tanagra to the east of Thebes unearthed a number of painted terracotta figures that soon became famous for their charm and subtle delicate colors. Gérôme's female form is of Tyche, a deity who represented the personification of the Greek city. She is seated on an excavation mound with an excavation implement leaning against it. In her open hand she is holding an imitation of a

Tanagra figurine, a tiny undulating dancer. Originally the whole group was painted, and not just this little sculpture. In line with classical tradition, Gérôme covered his sculpture with wax in order to preserve the colors and make them more transparent. However, years of storage in the Louvre – it was still in the basement there in the 1970s – caused serious damage to the work. As is the case with so many old painted sculptures, this one – which was created just 100 years ago – is now monochrome.

Inspired above everything else by archaeological findings, the arrival of the colored sculpture in England and France coincided noticeably with the period of the triumphal march of color in painting.

The Festival Hall of the Hôtel d'Orsay

The palatial facades of the Gare d'Orsay on the Rue de Bellechasse and the Rue de Lille used to conceal a luxurious hotel with 370 rooms, the Festival Hall and restaurant of which are now on display in the Musée d'Orsay. The Festival Hall faces the Seine and boasts good views of the Tuileries Gardens and the Louvre. The magnificent interior design of Victor Laloux (1850–1937), who also designed the railway station, is in the feudal style of the French Baroque and Rococo, Louis XIV to Louis XVI. Pairs of marbled columns are placed against the walls, which are lavishly decorated in gilded plaster. The light from the crystal chandeliers and light garlands is reflected in large mirrors with gilded plaster frames. Laloux commissioned Adrien Moreau-Néret to paint the supraporta, and Pierre Fritel (1853–1942) to paint the center ceiling panel of a sun chariot. Both artists were popular in the official Salons.

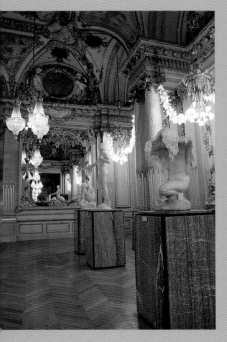

The Festival Hall is decorated in a very lavish style, which was totally in line with the fin-de-siècle passion for pompous, historical designs. In fact, it is almost impossible to imagine a more marked contrast with the technical-industrial iron architecture which was adopted at the turn of the 20th century. The Hall contains examples of official paintings and sculptures from the Third Republic that, not unlike the architecture of the day, are far removed from contemporary reality.

BS

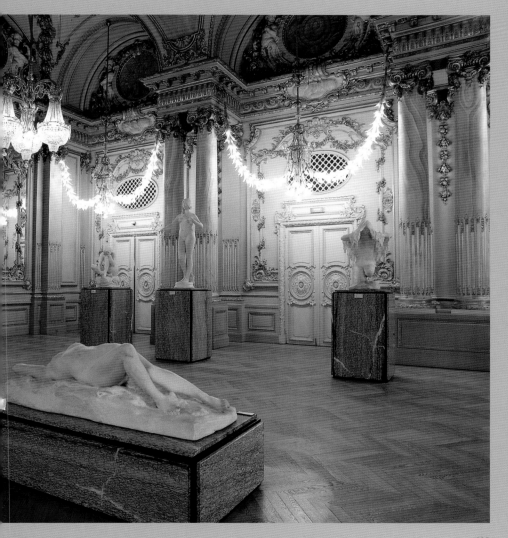

Louis-Ernest Barrias (1841–1905), Nature Exposing Herself to Science, 1899
Marble and onyx, 200 x 55 cm

Barrias' allegory is a so-called polylithic sculpture, which means that it consists of various natural-colored stones. The incarnadine is white marble, the hair yellow Sienese stone, the slip is lively, marbled onyx, and the cloak, ochre-colored onyx (these are both from the French colony of Algeria), and the plinth is gray granite. The girdle, which is secured by a large, gold-plated malachite scarab, is made from blue lapis lazuli. The stone was much used for ornaments and jewelry in antiquity.

This allegory is the only life-size polychromatic figure Barrias created, and he presented it for the first time in the Salon in 1899. This upward sweeping, all-embracing figure, with its confident use of the materials, as well as contemporary styling of the female form, and the warm, muted colors, became the best-known of his works.

Denys Puech (1854–1942),
Aurora, 1900
Marble, 116 x 80 x 59 cm

Aurora, the Roman goddess of the dawn, who, together with other gods of light, is regarded as the messenger of the day and the conqueror of the night, is kneeling on a cloud, using her hands to part her long, thick locks. According to legend, the goddess, who is identified with the Greek goddess Eos, rose up from the depths of the sea on her horses every morning in order to accompany Helios on his daily journey across the sky.

Since classical antiquity, Aurora has usually been depicted with wings. By contrast, Denys Puech, who is little known outside France, shows her in the academic style as a nude of tender years. His work was first shown in the Salon of the Artistes Français in 1901, and was acquired for the French State collection in 1910. Sèvres, the porcelain manufacturer, produces reproductions of this marble sculpture in biscuit ware (bisque). CS

**Emmanuel Fremiet (1824–1910),
St. Michael, after 1897**
Copper, 617 x 260 x 120 cm

Even more than Gustave Deloye's *Mark the Evangelist*, Fremiet's *St. Michael* is a classic example of the monumental sculptures of the Third Republic. The sculptor first exhibited the plaster model of this sculpture of the Archangel in the Salon in 1896. The sword, held in the figure's raised right hand, appears to be aimed at Satan, who is depicted in the form of the dragon kneeling at the saint's feet.

This version in the Musée d'Orsay is over six meters high, and is a copy of the original which has topped the famous spire of the church on Mont Saint-Michel in Normandy since 1897. Beaten copper was then the material of choice, and this method enabled the artist to produce a faithful reproduction of the figure. Thus, despite the mighty wing and the halo of a circle of rays, the Archangel is depicted as a noble fighter.

**Gustave Deloye (1838–1899),
Mark the Evangelist, 1878**
Plaster, 205 x 145 x 154 cm

Gustave Deloye first presented this oversized figure, which is half standing, half seated on an animal, at the Salon in 1878. One of the feet of the winged lion, which identifies the rider as Mark the Evangelist, is resting on a scroll. Although Mark is holding his writing utensils in his hand, Deloye does not show him to be writing. The head, under its eye-catching hood, is raised, the face angled to the side.

The saint's expression is contemplative and brooding; by contrast, the massive head of the lion is looking straight ahead. The tension created between these two principles of life – the contemplation of man on the one hand, and the animal, active strength of the lion on the other– adds a special charm to the sculpture.

The Franco-Prussian War

**Alphonse de Neuville (1835–1885), The
Cemetery at Saint-Privat (August 18, 1870),1881**
Oil on canvas, 235.5 x 341 cm

Throughout his career Alphonse de
Neuville produced scenes of war and battle.
He executed countless paintings of his

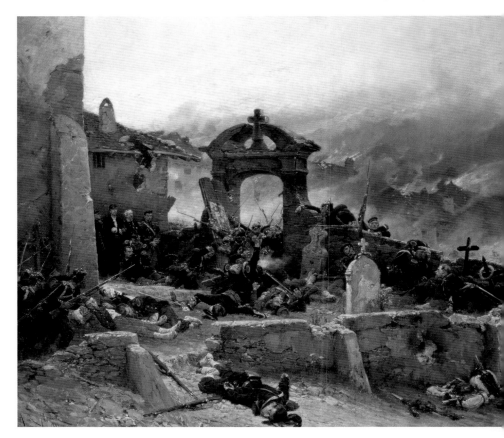

experiences as a lieutenant in the engineering corps in the Franco-Prussian War of 1870–71. In this huge painting, which was first exhibited at the Salon of 1881, de Neuville shows the merciless battle of August 18, 1870 in Saint-Privat in the Lorraine, waged against the dramatic background of burning houses, and even a walled cemetery. The appalling confusion ended in defeat for the French troops, after which Lorraine and the Alsace region became part of Prussia.

CS

Ernest Meissonier (1815–1891), Travelling into the Wind, 1878/1890

Wax, leather, and textile, 47.8 x 39.5 cm

This statuette should not be seen as an independent sculpture. It is in total contrast to Degas' *Little 14-year-old Dancer* (p. 220), which appears to point towards Meissonier's *Travelling into the Wind*, and this is why the artist never exhibited it during his lifetime; the wax statuette was in fact used as a model for many of his paintings that include galloping horses.

The ochre-painted wax composition of a horse and rider, apparently battling against a strong wind, is an example of how real materials were increasingly being used in sculptures around the 1880s. The horse has a leather harness and a saddle of yellow

leather; the rider's cloak is made of green fabric.

Meissonier consistently sought artistic precision and showed the keenest attention to detail in his works. He devoted himself, with scientific meticulousness, to painting galloping horses, a subject that was for a long time extremely difficult to achieve with any amount of success. He was one of the first artists to make use of the works of Eadweard Muybridge, the Englishman who produced series of photographs that show the precise sequence of movements of a galloping horse in the finest detail.

**Ernest Meissonier,
The Occupation of Paris, 1870**
Oil on canvas, 53.5 x 70.5 cm

The Franco-Prussian War broke out in July 1870. After a period of heavy fighting in Alsace-Lorraine, German troops were soon besieging the French capital, and the city was finally surrendered when France capitulated in 1871. This was followed by the turbulent period of the so-called Paris Commune, an elected municipal government that was set up in order to establish a socialist republic. During fierce fighting in May 1871, the Commune was at the mercy of the government's troops, and Paris became a scene of despair and horror.

It was not long before France's artists began to portray these historical events in their works. Ernest Meissonier, one of the leading Salon painters, chose the Franco-Prussian War as the subject of his patriotic painting *The Occupation of Paris*. This relatively small, beautifully detailed work combines the representation of the battle with an allegory of war. In the foreground are dead and dying soldiers and a fallen horse. The Prussian eagle and the personification of hunger are shown at the top left of the picture. The centre is occupied by an oversized female figure, representing the city of Paris. On her head is a helmet with a lion's head, the symbol of strength and willingness to do battle. Directly behind her, its shreds blowing in the wind, is the battle-damaged tricolor. In the background on the left are soldiers, fighting the occupiers with cannon; a number of injured soldiers are on the right. The sky is full of black smoke.

Meissonier's picture was painted in 1870 during bloody battles in and around Paris. The artist had often produced works depicting motifs from the Napoleonic wars and the Revolution of 1848 (p. 66). He used these images to awaken feelings of patriotism by idealizing war and, by glorifying the idea of the hero's death on the battlefield, made it a much-celebrated part of French history.

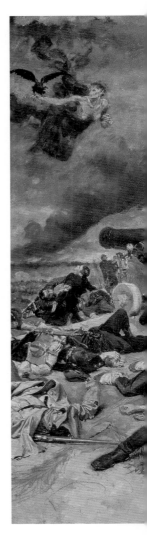

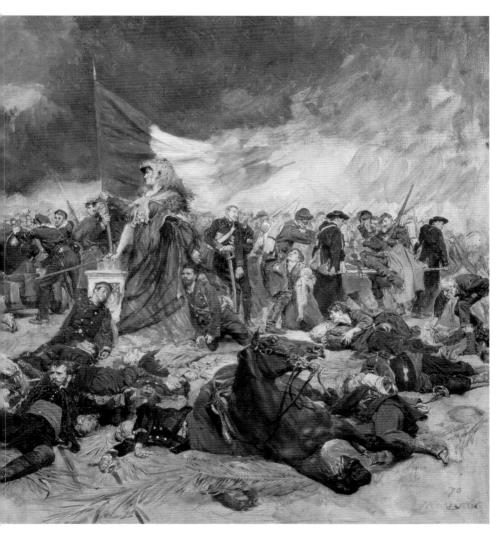

"Nouveau Paris – the capital of Europe"

The Paris we know today was "designed" in the 19th century. What was then a medieval town was transformed into a metropolis that appealed to the functional and aesthetic requirements of a modern capital city. This transformation of Paris, which was a significant structural intervention in the town planning of the time, was the work of Emperor Napoléon III

Gustave Caillebotte, Paris Street in the Rain, 1877. Oil on canvas, 212 x 276 cm
The Art Institute of Chicago

and his congenial prefect, the Baron Georges-Eugène Haussmann (1809–1891).

Haussmann, who was in fact a military engineer, planned and realized a fundamental renovation of the city that was intended to improve standards of hygiene, accommodate the requirements of increasing volumes of traffic, optimize living space, and create a new and representative image for the city. To this end, a complicated system of wide boulevards and avenues was constructed in the cramped districts, which opened up and connected the city in all four directions. Between 1853 and 1872, 25,000 buildings were demolished as part of this scheme and 40,000 new ones built in the suburbs. Ninety thousand kilometres of new roads were constructed.

The legal prerequisite for such extensive renovations and relocations was provided by an ancient expropriation law forbidding political resistance, which enabled the city fathers to overrule private ownership. "His Majesty the Emperor was in haste to show me a map of Paris on which he had drawn, in his own hand and using blue, red, green, or yellow to identify the level of importance, the new roads he wanted to build," reported Haussmann, who was knighted for his efforts in 1853. From then onward, every possible technical means available in the industrial age was employed, com-

Baron Georges-Eugène Haussmann (1809–1891), designer of Nouveau Paris

bined with the entire state authority of the regime, to realize the plans for the new look of the city.

The need for such a fundamental reorganization was made patently obvious by the miserable living conditions found in the narrow, overcrowded alleys, which had lacked any form of basic facilities or provision for hygiene in the 18th century. In 1846, Honoré de Balzac wrote in

his novel *La Cousine Bette* of one such den of misery located close to the Louvre:

"One rarely sees another human being on the streets … darkness, silence, stony air, and the cellar-like depth of the soil, make these houses more like tombs, turning them into graves for living human beings. It's enough to turn the stomach of anybody who travels through this horrendous quarter by carriage, and they could not be blamed for avoiding the area if at all possible – especially at night, when all the lowlife of Paris makes its way here to rendezvous, and no

The place de la Bastille, c.1830, with the column commemorating the victims of the Revolution of 1830

end of trouble is to be expected." The Emperor was well aware that social conditions such as the ones in these areas could lead to revolutionary unrest. It is highly likely that it was generally felt that wide boulevards would make it difficult to construct barricades while at the same time providing ample accommodation for marching troops, and this probably played a major strategic role in the events of the time. In fact, there never were any public demonstrations such as those of 1830 and 1848 during his reign.

27. PARIS — Place de la Bastille 1903

Cinq étages du monde parisien.

*The satirical magazine published by Edmund Texier in 1852
shows the social levels typical in a Parisian apartment block.*

The capital was reorganized and overhauled to create a new one that would still enable rich and poor, every social layer, to coexist. The internal structure of the (predominantly) five-storied Parisian apartment blocks that were built along the boulevards was typical of the time. The second floor, known as the bel-étage, and the third floor provided comfortable town accommodation for prosperous upper-middle-class families. The upper floors contained less elaborate accommodation for the middle classes, and the roof housed domestic staff, students and young artists. The first floor was for the landlady, the celebrated concièrge, who, with greater or less discretion, oversaw the events in the whole house. There were also shops, cafés, and bistros.

The boulevard itself became a showcase for the city's mixed and therefore lively society. It also contained the theatres, variétés, and restaurants that were so popular with the monde parisien, a hotchpotch of prosperous nobility, bourgeoisie, bankers, speculators, and industrialists.

Around them was the demi-monde, the half-world of parvenus, freeloaders, coquettes, and – last, but by no means least – artists and the literati. The new top layer of society led a life of endless costly balls, banquets, and receptions, usually held either in the park or on the racecourse.

The construction of Charles Garnier's new Opera House, an ornate building of overwhelming magnificence with a massive staircase and extensive foyers designed specifically for the performance of "seeing-and-being-seen", became a symbol of the times, with various members of society regarding themselves as characters in some racy operetta. The laconic wealthy chose to disport themselves on the avenues and streets, strolling along at a leisurely pace with no particular goal in mind. The passages were covered, consisting of new-style glass and iron constructions and gas lighting, so not even the weather or time of day could impede the "performance". The city, together with the goods it had on display, could now be consumed at any time. It was no longer necessary to be of noble birth to sample the delights on offer; all that was needed was money – and a willingness to spend it freely.

Emile Zola captured perfectly the spirit of the Second Empire in his novel *Nana* (1879/80), characterizing it tellingly in the form of his protagonist, a young woman who, thanks to the generosity of various sponsors, becomes powerful and untouchable.

The Impressionists, led by Edouard Manet, soon turned to city life as an exciting new subject for their works, working endlessly to find the appropriate artistic expression. MP

The amazing Large Staircase of the Opera House (1862–1875) by Charles Garnier provides an impressive background for the "performances" by Parisian society.

Edouard Detaille (1848–1912),
The Dream, 1888
Oil on canvas, 300 x 390 cm

The Dream, an impressive work and a prime example of military painting, demonstrates a patriotism that developed consistently in France during the 19th century, especially after the Prussian victory of 1870/71.

The myth and reality of war confront each other. Soldiers have prepared themselves a place to rest for the night on the ground; a small white dog is in the foreground. The soldiers' rifles have been placed upright to make a neat line that stretches as far as the horizon.

An unworldly scene unfurls against the red sky. French military triumph is represented by the patriotic colours of red, white, and blue, a symbol of the results of war and peace that rises, gloriously, above the brutal everyday reality of war.

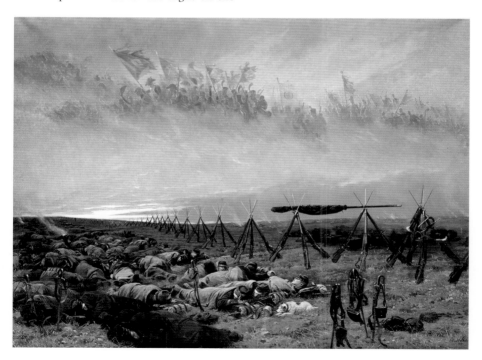

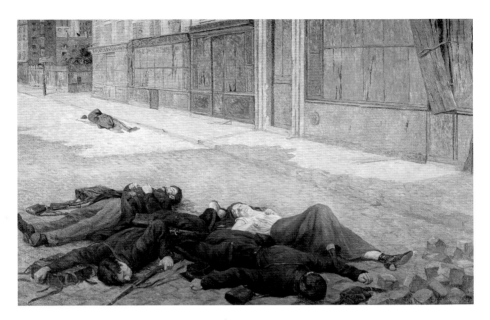

Maximilien Luce (1858–1914),
A Street in Paris in May 1871, 1903/05
Oil on canvas, 151 x 225 cm

Maximilian Luce was only 13 at the time of the Paris Commune, and yet the memories of the terror of the time must have been so overwhelming that, more than 30 years later, the neo-Impressionist chose terrible street fighting as a subject, painting this large picture of a scene from May 1871. Warm sunshine is falling on a deserted road and lighting up a line of houses. The windows of the shops and houses are boarded up. There are several bodies, including that of a woman, in the foreground, lying on the road as they fell when death found them. The road surface is broken: Bits of it have been used as ammunition. The body of a member of the National Guard is in the background.

Maximilian Luce's neo-Impressionist style of painting, generally more evocative of a beach or other place of pleasure, here reveals the stark reality of civil war.

Naturalism

Aimé-Jules Dalou (1838–1902),
Blacksmith, 1879/1889
Plaster, 67.8 x 37 x 62 cm

This plaster version of the *Blacksmith* belongs to one of Dalou's most ambitious and successful groups of sculptures, the *Triumph of the Republic,* and he worked on the project for more than nine years. A globe, on which a carriage is balanced, is carrying the personification of the Republic. It is drawn by two lions representing the strength of the population. The Genius of Freedom is steering the carriage, with Abundance and Wealth following. Labor and Justice are pushing the carriage along at the sides. Labor is embodied by the "blacksmith," a muscular figure with a naked torso, carrying the hammer across his shoulder and clad in a work apron and tough heavy shoes.

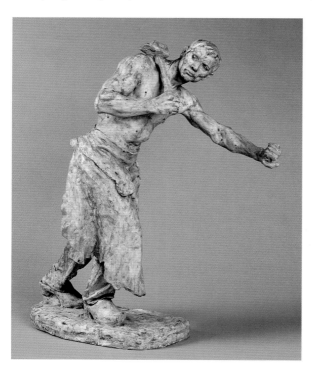

Although Dalou's work was created for a competition to design a memorial to the Republic, it was made and then erected on the place de la Nation.

Constantin Meunier (1831–1905),
Puddlers, 1893
Bronze, 50 x 49 x 13 cm

Belgian artist Meunier found his true métier in about 1880: "man at work". From 1885, he also turned to this particular subject in his sculpting.

Only a small area of the blast furnace, the actual place of work, is shown on the

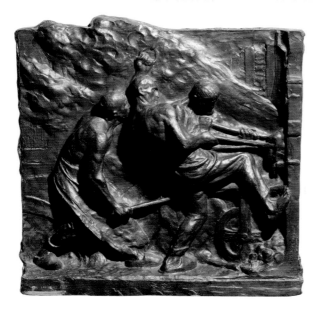

Like Dalou, Meunier planned a memorial to labor and, like Dalou, was unable to realize the project. Thus every one of his countless reliefs that deal with the man-labor-machine relationship are fragments of a planned monumental work.

Bernhard Hoetger (1874-1949), Machine Man, 1902
Bronze, 44 x 37 x 18 cm
(following page)

It is often difficult to tell what was the greater inspiration for the artists who, late in the 19th century, turned to the working world for inspiration: The machine or the men who worked it. Consequently, what occurred was a fusion of the two – one excellent example of which is Hoetger's powerful bronze relief, *Machine Man*. The subject is probably a miner underground, which the artist has reproduced with a particularly keen eye. The torso of the muscular figure is bent forward and appears to be foreshortened; the head is inclined so that it is almost impossible to make out the facial features. The person is characterized solely by the impression of physical power.

right-hand edge of this relief *Puddlers* (the title is a reference to the puddling and Krupp burning process used in iron-making). The middle one of the three laborers, seen in the center of the painting, is one of the most impressive to be seen in any of Meunier's works. His right foot is pressed against the furnace, his torso is stretching backwards. Every muscle, every sinew is tensed, from the tip of his foot to the crown of his head as he works the iron with all his strength.

Meunier's laborers are types rather than individual people and are idealized. The artist heroized labor in his approach to the working world in what was the age of industrialization.

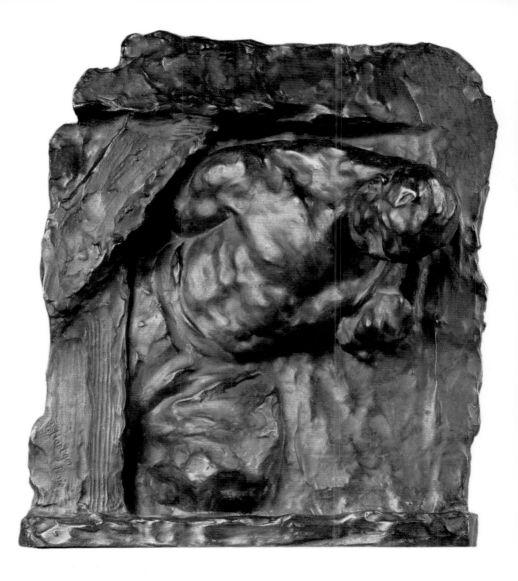

**Jules Bastien-Lepage (1848–1884),
Haymaking, 1877**
Oil on canvas, 180 x 195 cm

His realistic, sometimes sentimental scenes made Bastien-Lapage – a pupil of Cabanel – one of the most popular Salon painters of his day. By the same token, however, his *Haymaking* has little in common with Mellet's paintings of country life of 20 years before (see pp. 76 and 84). Exhausted by their day's labors, a man is stretched out on the grass, his hands still tightly balled into fists. The back of the woman sitting at the front of the painting is rounded, as she gazes questioningly into emptiness, her arms resting lightly on her thighs. Her hands – the palm of one is turned upward, the other down – show traces of hard physical work. The same is true of the robust clothing and solid footwear.

The startlingly parallel arrangement of the two people's limbs robs them of their individuality, turning them into working puppets. This impression is broken by the woman's up-right position, which adds a new direction that is followed by the man's forearms. If we now also take her facial expression and his fists into consideration, we cannot help but understand that they are beginning to question – if not revolt against – their lot, something that would not have occurred to Millet's farming couples, resigned as they were to the way in which they lived.

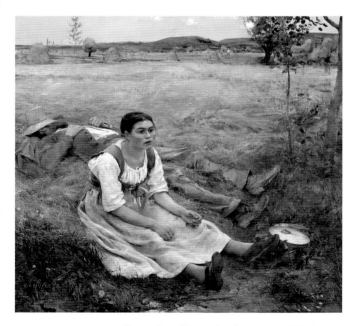

Fernand Cormon (1845–1924), Cain, 1880
Oil on canvas, 380 x 700 cm

This huge canvas shows a horde of primitive men, women, and children traveling through a barren landscape. The people in question are Cain's family, who, after he murdered his brother Abel, was sentenced by God to spend the rest of his days moving from place to place. Unlike older works of

F. Cormon 80.

art which show Cain's fate as a single-figure scene, Cormon's painting includes Cain's wife, son, and other descendants. This wild group of people, clad only in leather loincloths, is followed mercilessly

and pushed onwards by God's unforgiving rays of light.

When this unusual painting was first displayed in the Paris Salon of 1880, the public was attracted and repelled in equal measure by its brute force. Although the scene is that of the fratricide committed in the first book of Moses (Genesis 4, 1–16), Cormon also quoted three lines in the Salon brochure from Victor Hugo's "Legends of the centuries" from his poem *The Conscience*, "When Cain and his children, clad in animal skins and with wild hair, fled from Jehovah, pale in the eye of the storm, as it became evening, the dark man appeared on a large plain at the foot of a mountain...." This dramatic passage obviously appealed more to Cormon than the comparatively sober words that are to be found in the Bible.

Cormon's Cain appeared at a time that was dominated by Charles Darwin (1809–1882) and his theory of evolution; a time of research expeditions to the farthest corners of the world, of world exhibitions, and the openings of the first ethnology museums. The search for the origins of man and for untouched civilization was a social event in the late 19th century and also featured widely as the subject of many contemporary paintings.

CS

Panorama of the age – the world exhibitions

It goes without saying that Louis-Napoléon, who was passionately interested in progress, was delighted by the project and saw to it that the second world exhibition, the Exposition Universelle, was held in Paris in 1855. The event set more than a few records: The exhibition area measured 18,000 m² and had substantially more than five million visitors; there were amazing examples of technical innovation and inventions, of exotic attractions from the colonies, and first-rate art products. Locomotives and luxurious railway carriages; gaslights, electric

The Palais de l'Industrie, Paris, copperplate engraving, 1855

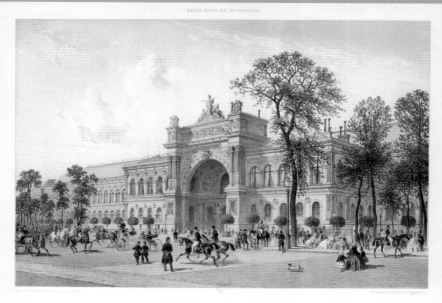

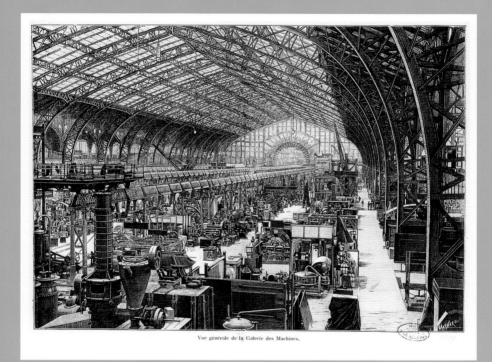

Overall view of the Galerie des Machines in the Exposition Universelle of 1889 in Paris

batteries, and the first light bulbs were on display. An American named John Goodyear showed a number of items made of vulcanized rubber, an incredibly inexpensive and virtually indestructible material that was highly malleable and therefore ideal for a wide range of uses. The first sewing machine was presented, as was a coffee machine that amazed visitors by producing 2000 cups of filtered coffee every

hour. A notice announcing that, "Nothing will be done by hand in the coming age" became the motto of the event. The machine appeared to possess undreamed-of powers and opportunities, and it looked as if human beings were – finally – going to be released from hard physical work. One journalist, overwhelmed by what he had seen, wrote: "Nothing that has been written about the Hanging Gardens of Babylon…can

Sculptures in the Grand Palais during the Exposition Universelle of 1900 in Paris

Werner Ross. The Exposition Universelle of 1900 became a touchable, livable panorama of the 19th century; it was a botanical garden and a zoo, circus and museum, trade fair and chamber of miracles, all in one. It made it possible to experience an amazing range of shapes and sizes that in turn led to a highly varied coexistence of different styles. The adoption of historical styles from other eras and the adaptation of Oriental, Far Eastern and even primitive designs and traditions became the fashion, albeit revealing at the same time that the era was still seeking its own particular "look." Thus began a time of experimentation with different style patterns. Form, decor, and ornament should, on the one hand, add to the aesthetic appeal of utilitarian and luxury objects whilst at the same time enabling us to forget that the particular item was no longer handmade and unique, but a machine-made mass product. By today's standards, much of what was available at the time was "kitsch," and at the turn of the 20th century international Art Nouveau artists and designers decided to influence what they

compare with the wonderful presentation that is the world exhibition. Human beings have dethroned the fairy godmothers by filling the amazing palace with realities that had in the past been carried out by fairy godmothers…."

The inventions of the Europeans and Americans combined the cultural variety of the nations with the blinding wealth of the colonies. "The Turks had an abundance of falchions and hookahs; the USA had Indians coming out of wigwams; and there was a full-size replica of a Pompeiian house," to use the words of novelist

regarded as a peculiar lack of taste and inject some style into it.

The turn came with the fourth Exposition Universelle in Paris, which took place in 1889, for which engineer Gustave Eiffel (1832–1923) planned and constructed a gigantic tower that was intended to demonstrate the ability and excellence of the French steel industry and its engineers. Unlike the exhibition hall, which was also made of steel and glass but then fitted with neo-Baroque façades, the tower consisted solely of a steel "skeleton" and was constructed along aerodynamic lines. It therefore revealed itself in stark technical "nudity," its outsize proportions clearly stating its intent to become the symbol of the city. A storm of protest that involved prominent artists and the literati broke when Eiffel's plans became known. Charles Garnier, the designer of the Opéra, Guy de Maupassant, Emile Zola, and others signed a petition against the "ridiculous tower that would only induce dizziness…raging over Paris like some grimy factory chimney," so that "all our monuments would be humiliated, all our buildings reduced in size." This "attack" on the city's appearance was seen as an injury to the fundamental aesthetic rules of play and as a drain on architectural and historical meaning. Those in favor of the proposal, however, saw it as a monument to the nation's willingness to embrace contemporary progress.

The Eiffel Tower announced that Paris belonged to the 19th century, and it remains the embodiment and expression of technical ability, progress, and an inquiring spirit that was so typical of this era – and was to be shaken to the core in the 20th century. Still, it was to be several more decades before the structure, dispensing as it does with any kind of historical embellishment and serving no particular function, would be widely accepted aesthetically.

The 1900 Exposition Universelle of Paris, looking towards the Pont-Alexandre III and the Grand Palais

The people of the time, and not just the conservatives were, as is revealed by Zola's attitude, simply unable to integrate technology and industry in art and culture in such a radical fashion. Nowadays, visitors to Paris think nothing of seeing the Eiffel Tower – a historical monument in its own right – as part of the cityscape and representing the optimistic mood of the period in which it was created.

MP

A view of the city from the gardens of the Trocadéro during the Paris Exposition Universelle of 1900

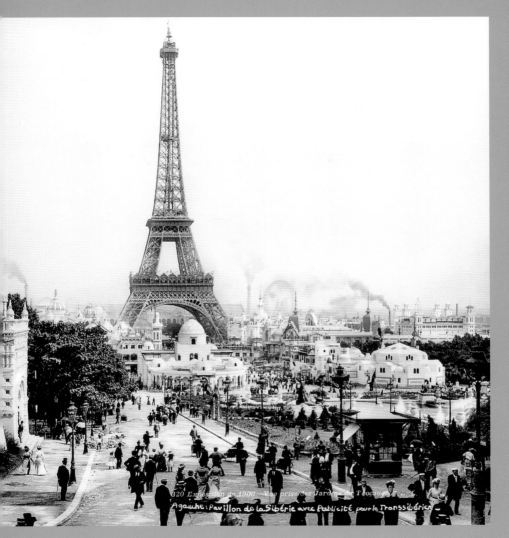

820 Exposition de 1900 - Vue prise des Jardins du Trocadéro L. L.

A gauche: Pavillon de la Sibérie avec Publicité pour le Transsibérien.

431

Europe around 1900

Giovanni Boldini (1842–1931),
Madame Charles Max, 1896
Oil on canvas, 205 x 100 cm

Giovanni Boldini painted his portrait of Madame Charles Max in Paris in 1896, a time in which his reputation as the leading painter of portraits for the world of the theatre and the aristocracy was being consolidated. The upper-class ladies in particular appreciated his work because they knew that the well-traveled artist – who had seen the works of the old Italian, Dutch, English, and Spanish masters with his own eyes – could be relied upon to produce their likenesses with elegance and to their advantage.

Madame Max is wearing a light, silver-colored evening dress, its floor-length skirt bunched in her right hand. The gracious position of her arms and legs emphasizes the contours of her slim body, with which Boldini was familiar as the result of a nude study he had created beforehand. The artist executed the work with quick, light brush strokes, thereby adapting his style to the desired unencumbered nature of the picture. Its extravagant, fleeting lightness is typical of the spirit of the fin de siècle.

CS

**Paul Petrovitch Troubetzkoy (1866–1938),
Robert de Montesquiou, 1907**
Bronze, 56 x 62 x 56.5 cm

The Russian sculptor Count Paul Petrovitch Troubetzkoy moved to Paris in 1906, where he quickly rose in reputation to become one of the city's most esteemed portrait sculptors.

Famous personalities at the turn of the twentieth century included Count Robert de Montesquiou, writer, man of the world, and a declared aesthete, among other things. Troubetzkoy's small bronze statuette shows him seated, an elegantly attired figure; his head raised confidently, his outstretched right hand is resting on a delicate walking stick, and he is holding a hat in his left. A Russian greyhound is lying at his feet.

This small sculpture reveals a freshness of conception; a sketched, temperamental treatment of the form is expressed, for example, by the cloth covering the plinth on which Montesquiou's chair has been placed.

the front of the picture, the other toward the back – is particularly inviting. The center of the picture, a huge, dark green tree, is threatening in appearance. The wall covers the full width of the picture, excluding the viewer, keeping him on this side and refusing admission to the unknown world beyond.

The penetration of the experience of existence and painting heralded the arrival of Expressionism; Munch's work is quite rightly regarded as the stage that directly preceded it.

Edvard Munch (1863–1944),
Summer Night in Aasgaardstrand, 1904
Oil on canvas, 99 x 103.5 cm

Gustav Klimt (1862–1918),
Rosebushes under Trees, 1905
Oil on canvas, 110 x 110 cm

Munch's Nordic landscape was created in Aasgaardstrand. Between 1900 and 1907, when he was resident mainly in Germany, he usually spent at least the summer months here.

Munch's ambition was neither to represent a natural impression nor to create a decorative stylization of the same. To him, nature was the landscape of the soul, the expression of the self's own state. Thus neither of the two paths – one leading across

Klimt, a leading exponents of Viennese Art Nouveau, chose square shapes for his landscapes. As he himself said, they enabled him to "dip the subject in the atmosphere of peace." The landscape contains no form of storytelling: There are no people. It lacks any indication of a horizon; there is no hint of a depth of space into the background. The surface is almost entirely covered by trees and rosebushes. Klimt often used a telescope or opera glasses to observe nature

and see distant objects in greater detail. Thus he was able to break trees and roses into a mosaic as he painted them, transforming the landscape into a decorative ornament.

Eugène Carrière (1849–1906),
The Sick Child, 1885
Oil on canvas, 200 x 246 cm

This large painting of a domestic genre scene is characteristic of Carrière's art. Bordering on both Realism and Impressionism, this friend of Gauguin usually painted his portraits and family groups in monochrome shades of gray and brown, and allowed the shapes to blend in a mysterious light. His aim was not to restrict himself to reproducing what was visible, but to seek a deeper expression of moods and emotions in his paintings.

Full of concern for her sick child, who is sitting on her lap, the mother leans toward it with particular care and affection. The child's two siblings share their parent's concern. One is bending down to retrieve

something that has fallen on the floor; the elder sister is standing close to them with a cup in her hand. Even the family dog seems depressed.

The dark colors that surround the room, the objects and the people add a particular poignancy to the still, sad scene.

Thomas Eakins (1844–1916), Clara, ca. 1900
Oil on canvas, 61 x 51 cm

After his return to the USA in 1872, Eakins, who had moved to the art metropolis as a young man in 1866 and attended the art classes of Gérôme, became one of his country's leading Realist artists. The subject of this particular work is Clara Janney Mather, one of his pupils. Two sketches showing her standing and wearing a black dress were to serve as preparatory studies for a full portrait that was in fact never painted. Eakins painted this portrait instead. Light and shadow fall on the face, to which the artist has given a solid, plastic form, lending it a rich expression. With its darkly illuminated colorfulness and being slightly off-center, it is what catches the eye; this is emphasized by the tilt of the head, the even features, the full mouth and the light eyes, cast sideways. Eakins gave dreamy Clara a highly contemporary expression.

Winslow Homer (1836–1910),
Summer night, 1890
Oil on canvas, 76.7 x 102 cm

The coast of the American state of Maine is what inspired Winslow Homer to create this painting. It shows two women against the backdrop of the moving ocean, dancing closely together by the light of the moon. The figures to the right of the painting, shown only as dark silhouettes, are looking out over the ocean, apparently lost in thought. Using just a few colors and a simply constructed composition, Homer managed to convey the feelings and longings of the people as they regarded the mighty forces of nature. He thus created an atmospheric picture that was evocative of Symbolism. *Summer Night* received a gold medal at the 1900 World Exhibition in Paris, and was acquired by the French State that same year.

CS

Angelo Morbelli (1853-1919),
High Day in the Trivulzio Hospice in Milan, 1892
Oil on canvas, 78 x 122 cm

High Day in the Trivulzio Hospice in Milan is characteristic of the work of the relatively unknown Italian artist Angelo Morbelli. Looking out from low down in the room, it gives an unobstructed view of the cheerless communal room in a home for old men. Only a few have stayed behind on this day to spend their time in prayer and dozing. The figures of the men yield to the symmetrical rhythm of the long tables and benches that continue beyond the edges of the picture, as indicated by the hands folded in prayer that are to be seen at the bottom left. Only a few splashes of light on the rear wall and at the right window break through the sadness. Christian symbols of hope and salvation, they are what give the room a sacred dignity.

Morbelli's painting, one of a series of dramatic representations of the neglect of the elderly, was presented at the 1900 World Exhibition of Paris, and acquired by the French State. It is in the naturalist style which started in France, which spread internationally over the last 40 years of the 19th century, and which – particularly towards the end of the century – often dealt with socially critical subjects. CS

Art Nouveau in France and Belgium

Gustave Serrurier-Bovy (1858–1910), Bed, ca. 1898/99

Mahogany, copper fittings, embroidered and painted silk, 279 x 211 x 240 cm

Another leading Belgian artist of the Art Nouveau – apart from van de Velde – who is represented in the Musée d'Orsay is Gustave Serrurier-Bovy, who sold furniture and interior design accessories in his home town of Liège. With this bed as part of a complete bedroom, the surface, bedside tables, and silk-covered wall decorations have become a single organic unit. The generous flow of lines hints at Serrurier-Bovy's understanding of construction and geometric order. The metal fittings on the mahogany and delicate squares of flowers in the embroidery provide the understated decorative highlights.

Despite the fact that the language of his lines is developed from organic shapes, this work is more factual than the majority of Belgian Art Nouveau, which often borders on kitsch.

BS

Jean Carriès (1855–1894),
Flower pot, 1891/92
Glazed stoneware, 16 x 17 x 17 cm

Initially a sculptor, Jean Carriès turned to artistic stoneware in the late 1880s after his confrontation with Japanese stoneware and the ceramics of Ernest Chaplet and Paul Gauguin. His ceramics were largely plain and understated, their particular charm lying in the nuances of the color and the random course of the glazes. Carriès' new ways in ceramics were well received during his lifetime.

BS

Ernest Chaplet (1835–1909), Vase, 1900
Porcelain, 45 x 20 x 20 cm

Ernest Chaplet, one of the most successful French ceramists of his time, gained extensive experience in ceramic techniques in a number of works. For a brief time in 1886 he worked with Gauguin. Chaplet specialized in porcelain with highly burned glazes, including the East Asian copper-red glaze, the so-called "ox blood" glaze that was so popular at the time.

Shortly before his death, Chaplet destroyed his porcelain recipes in a final burning. His works, all styled in the simple shapes of East Asia and folk art, are regarded as early masterpieces of modern European ceramics.

BS

Thus Lalique opened up jewelry design to a wealth of new design ideas. His highly imaginative creations with symbolic motifs, delicately broken shades, and delightful material combinations, are a sign of technical perfection, and are included in the supreme works of Art Nouveau in Paris.

BS

Eugène Feuillâtre (1870–1916), Bonbonniere, 1904
Crystal, silver, and enamel with metal inlays, 8.3 x 14.5 cm

The French goldsmith and enamelist Eugène Feuillâtre, who worked for René Lalique in the 1890s, created a number of small decorative and utility articles – such as this crystal and enamel bonbonnière – as

René Lalique (1860–1945), Pendant and chain, ca. 1903/05
Gold, enamel, diamonds, and aquamarines, 6.9 x 5.7 x 0.8 cm

The celebrated jewelry creations by René Lalique were a reaction to the rigid jewelry art practiced during the Empire, and were based primarily on historical designs. Lalique, by contrast, was inspired by nature and preferred stylized plant and insect motifs and female shapes. He also used less costly materials, such as semiprecious stones and base metals, horn, and glass, and techniques such as enameling instead of costly designs involving precious gems.

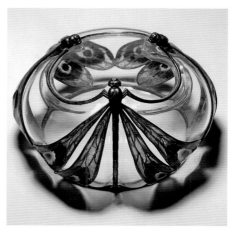

well as jewelry. The long wings of three insect-like creatures, in iridescent shades of green and blue and with contours of narrow silver bars, are spread open, in pairs, across the entire surface of the container. The bizarre stylization of fragile natural motifs and the interplay between transparent glass and the different shades of the enamel are in total harmony with the refined aesthetics of the Fin de Siècle. Delights such as these are the reserve of only a very small, select group of buyers.

BS

Louis Majorelle (1859–1926),
design for Daum Frères,
Waterlily table lamp,
ca. 1903/1905
Blown glass, design etched and engraved, gold-plated bronze, 82 x 40 cm

The Daum brothers in Nancy were one leading manufacturer of glass art; Emile Gallé's facility being the other. They produced a large number of lampshades, and made highly creative use of the transparency and colorfulness of glass in their electric light creations. Designs and motifs were in accord with the floral diversity of Nancy. The base of this lamp (from a design by Louis Majorelle) rises up like the stem of a plant. The glass lampshade is shaped like a stylized waterlily, a symbol both of light and of the creative change represented by Art Nouveau.

BS

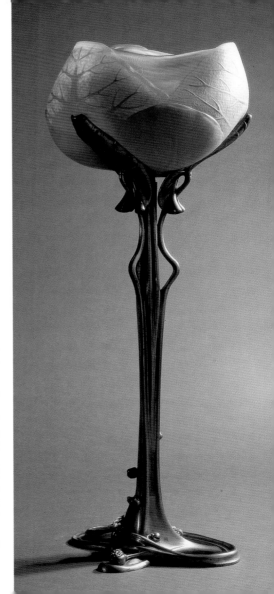

Commercial art and architecture

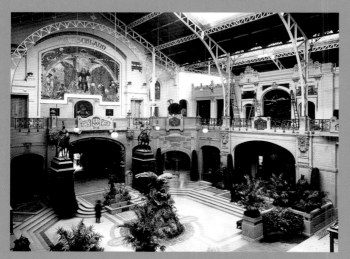

The architecture of the German pavilion at the World Exhibition of 1900 is a combination of various historical styles.

From 1851, the World Exhibitions, which were held at short, regular intervals, were of great importance to the commercial arts. Artisans, manufacturers, and factories displayed their wares to the general public in the international competitions for highly coveted design awards. For Napoléon III and his ambitious spouse Eugénie, the Paris exhibitions that took place in 1855 and 1867 provided a suitably impressive backdrop against which, with the development of the courtly splendor of the Second Empire, they could proudly demonstrate the brilliant feats of French artisans – the same delights that can be seen in the Musée d'Orsay today.

Whether furniture manufacturer or silversmith, porcelain or glass manufacturer, textiles manufacturer or architect – after the middle of the 19th century it became common practice to adapt the style to history, whether from antiquity, or Oriental, Gothic or Renaissance, Baroque, Rococo, or Empire. At that time, which was known as the period of historicism, the ultimate aim was not to produce copies but creative reproductions that could hold their own against the much-admired historical originals.

Ornate furniture in the styles of various major epochs of French furniture art, ranging from Louis Quinze (around 1710–1770) to Empire (around 1800–1830), diamond-encrusted jewelry treasures, ceramics, and glass with delightful touches of the Orient and East Asia, high-quality enamel, and decorative faience in the style of

the Renaissance all testify to the lavish touches so beloved in the eclectic 19th century. In applied art, pompous designs and material value were far more important than practical use and function. As in other countries, art in France was a way of demonstrating the good character and wealth of its middle classes: The elegant apartment had a Renaissance library or study and a delicate salon or boudoir in the neo-Rococo or possibly Japanese style. Louis Quatorze or Louis Seize (ca. 1760–1790) were the preferred styles for the bedroom. The conservatory was exotic with cane furniture; the smoking room was Turkish. And although technological change and industrial progress provided the means for inexpensive serial production of furniture, carpets, utensils, pots and pans, it inevitably meant a fall in the value of the item. This was also the time in which the major cities of Paris, London, and Vienna were given their modern appearance. Private and public buildings were constructed in the style of past epochs – churches were neo-Gothic, parliamentary buildings classical, town halls neo-Renaissance. Neo-Baroque architectural elements on houses and public buildings such as theaters and operas –

e.g. the Paris Opéra by Charles Garnier – allowed courtly splendor and feudal magnificence to shine in a bourgeois ambience. Even the "naked" iron and glass constructions of the new functional buildings of the industrial age, such as railroad stations, factories, and exhibition halls, were clothed in historicizing architecture.

In the second half of the 19th century, architects and theorists such as Gottfried Semper and Eugène-Emmanuel Viollet-le-Duc, followed a short time later by the artists of the English Arts and Crafts Movement and William Morris, committed themselves to creating new designs and improving the quality and functionality of commercial art and architecture.

Henri Toussaint, project for the Eiffel Tower, World Exhibition 1900, gouache, 90 x 114 cm

In the 1890s, these efforts at reformation resulted in a completely new style that was known in France as Art Nouveau after the gallery of Siegfried Bing, in England and America as Modern Style, in Italy as Stile Liberty, in Vienna as Secessionist, and in Germany as Jugendstil (after the art publication *Die Jugend*). It celebrated its resounding success at the Paris World Exhibition of 1900.

The objective of Art Nouveau was to break free from rigid style conventions. Art, industry, and craft should combine in a single unit.

The boundaries between free and applied art, so-called "high" and "low" art, were to be broken, and all the arts combined in a single, life-penetrating total art. Many specialist painters and sculptors became versatile architects and designers for commercial art and industry, and they valued originality and innovation. Their motto – "Art for all" – concealed criticism of elitist academicism. High-quality products – both in manufacture and aesthetic appeal – for a wide public were preferred to poor quality mass-produced goods. Most were produced as single items or in small series in discerning workshops, less frequently in industrial manufacturing facilities, and still remained the preserve of the more affluent buyer.

The artistic interpretation of nature became a leitmotif for Art Nouveau. Japanese works, whether colored woodcuts or made of ceramic, lacquer, wood, ivory, or bronze, were a revelation. Pared-down, subtle plant and animal motifs and the calligraphic lines of Japanese art were as fascinating as the clear lines and clever techniques of East Asian ceramics. The artists strove for harmony between decoration and construction. Suitability for use and the appropriate materials were as much required as the emotive, symbolic expression of line, color, and form.

In Paris, Nancy, and Brussels, the style of choice was inspired by the basic organic/plant

Pavilion of art dealer Siegfried Bing at the World Exhibition of 1900 with furniture by Edouard Collona

shapes. The buildings created by Belgian architect Victor Horta, which were constructed with the "modern" materials glass and iron, blended transparent surfaces and rhythmic lines in a harmonious complete work of architecture and interior design. The floral abstract railings in the Paris metro by Hector Guimard were plastic ornaments with a utility value, a cross between architecture and commercial art, sculpture and decoration, their energetic lines a harmonious combination of form and function. Furniture and interior designs by Louis Majorelle, Eugène Gaillard, Alexandre Charpentier, and Eugène Vallin were designed in line with the idea of plant growth.

The artistically cut crystal and opal glasses of Emile Gallé and the Daum brothers, and their

Ludwig Zumbusch, cover of Jugend magazine, II, issue 40, 1897, color lithography, 29 x 22.5 cm

new blending and application techniques, were revolutionary. Like the poetically fantastic jewelry creations of René Lalique with their opals, pearls, floral-set moonstones, orchids, and poppies, they were impressive in their originality, technical skill, and symbolic expression.

Victor Horta's iron beams, glass windows and floor mosaics blend together in the Hôtel Tassel's entrance hall in Brussels (1893).

erally bathed in flowers, the ornamental lines of Belgian Henry van de Velde were inextricably bound to a desire for unreserved functionality. His work is easy to identify: The strong desire for ornamentation is constantly suppressed by the purpose; he combines himself with it. For van de Velde, function and decoration formed an absolute unit. Stylization and reduction to geometric and tectonic shapes reigned in Glasgow, Vienna, and Chicago. Clear, right-angled order and elegantly straight lines characterize the architectural, interior design, and utility items of Charles Rennie Mackintosh, Frank Lloyd Wright, and Josef Hoffmann. The horizontal and the vertical dominated the overall picture that included decorative highlights. Everything was representative of spatial art that paid homage to the laws of the perfect ornament. Thus

Delicately metallic, iridescent color effects and luster designs were achieved on glass by American Louis Comfort Tiffany, and on ceramics by Frenchman Clément Massier. Ernest Chaplet, Jean Carriès, and Auguste Delaherche employed new shapes and glazing technologies to create individual design possibilities in a modern spirit. While the French Art Nouveau lit-

the geometric stylization of the Viennese furniture, glass, and metalwork by Otto Wagner, Josef Hoffmann, and Koloman Moser aimed more for aesthetic appeal than practical use. However, it was the very objectivity of this geographic direction of Art Nouveau that pointed the way to the future: It was a major precursor and trailblazer of the strict functionalism and

pure utilitarianism of design and architecture in the 20th century, as represented by the Bauhaus in the Weimar period, and even more so in the Dessau period.

BS

Hector Guimard, Place du Palais-Royale metro station, Paris, 1899/1900

Hector Guimard (1867–1942),
Chair with armrests, 1903
Pear wood, original leather upholstery
with carvings, 106 x 76 x 56 cm

Solidly shaped, restrained in emotion and
plasticity, this armchair is based on
Guimard. Legs, seat, arms, and backrest
form an organic structural unit. The essential flow of the lines begins at the legs, continues in the gently splayed arms with the
sculpted arm supports and backrest. The
leather cover is incorporated in the overall
structure, as the carvings on the leather
back follow the same lines of movement.
Functionality and rhythmic movement
form a single unit in this item of furniture.

BS

Hector Guimard,
Bench for a smoking salon, 1897
Jarrah, engraved metal, modern cover,
260 x 262 x 66 cm

As one of the leading exponents of the Art
Nouveau of Paris and an architect and
designer who created a number of residences and items for interior design, Hector Guimard became famous for the
entrances to the metro, among other
things. His original designs are noted for
their abstract vegetable shapes that develop
in the same sense as plant growth.

This bench merges with the wall and
with the architecture of the room. An
asymmetrical, ornamental wooden construction, not unlike a liana, rises upwards
from the bench. Continuing on from the
left armrest is a wall cupboard with a glass
door, over that a shelf. This extravagant
item of furniture differs from the functional designs of Henry van de Velde and
from the decorative-floral style of the
school of Nancy in the sheer playfulness of
its nature.

BS

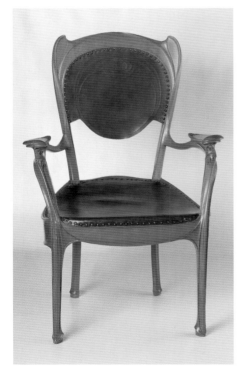

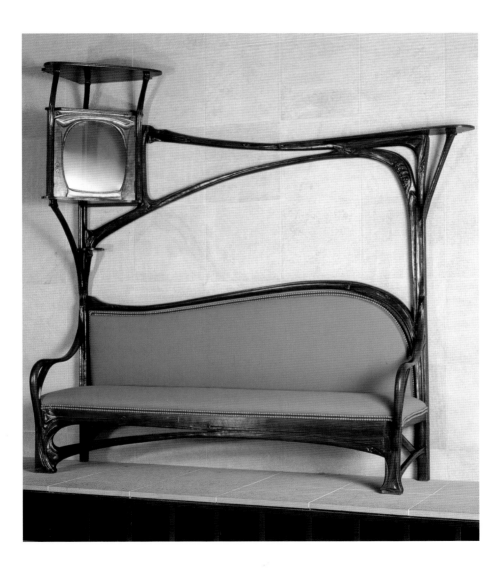

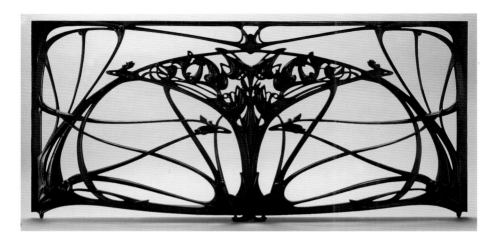

Hector Guimard,
Balcony railing, sample design 1905–1907
Cast iron, 81 x 173 cm

In 1907 the foundry of St.-Dizier issued a catalog with iron artwork based on designs by Guimard, the designer of some of Paris's best-known metro stations. It contained a selection of balcony railings, decorative elements for stairways, fenders, door handles, garden containers, and similar items. An impressive array of castings is on display in the Musée d'Orsay. Through rhythmic lines very similar to those of the famous metro railings, Guimard created the impression of growing plant organisms without referring to specific plant varieties – as is often the case with the school of Nancy. Plant vitality is interpreted in abstract-linear terms. This imparts a mean-

ing and expressiveness to these cast iron architectural elements that transgresses a purely decorative function. With their sweeping linearity, they are the means of expressing individual artistic energy.

BS

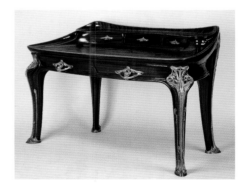

Louis Majorelle (1859–1926),
Orchid bureau bookcase, ca. 1905–1909
Mahogany, marquetry in a variety of woods,
gold-plated bronze, embossed leather
Writing desk: 95 x 170 x 70 cm
Bookcase: 205 x 250 cm

The son of a carpenter whose preferred style was Rococo, Louis Majorelle took over his father's business in Nancy. He helped found the Nancy School in 1901. In the late 1880s he based his designs on furniture by Gallé, but soon developed his own style. Thanks to extensive workshop production, by the end of the century he had become France's leading furniture manufacturer. Plant-based motifs and elegant, clear lines with touches of the Rococo are characteristic of Majorelle's furniture. Gold-plated bronze fittings based on highly symbolic plants – such as this Orchid ensemble – are in clear contrast to the elegant mahogany. As decorative elements, they highlight the organic structure of the furniture.

BS

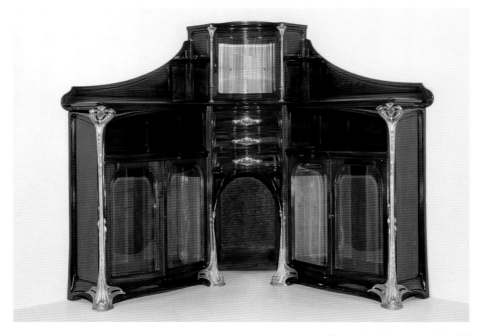

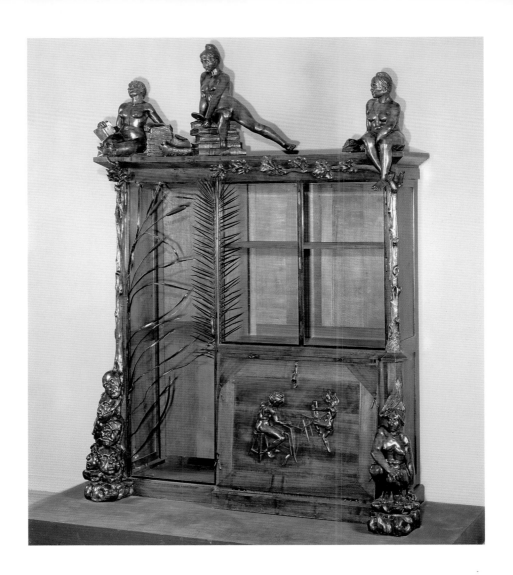

**François-Rupert Carabin (1862–1932),
Bookcase, 1890**
Nut wood, wrought iron, glass
290 x 215 x 83 cm

Wood sculptor and furniture artist
François-Rupert Carabin was commis-
sioned by an art lover to design this highly
unusual item of furniture. The ornate
plastic decorations indicate its function as a
bookcase. United at the base are Stupidity,
Ignorance, and Vanity, the enemies of
common sense, while three naked female
forms at the top symbolize Truth and
Recognition.
With its emphasis on functionality and
construction, this bookcase differs from Art
Nouveau furniture in its storytelling
elements and in its symbolism. However,
Caradin did not forget the practicalities,
and there is plenty of space for books
behind the glass. At the bottom right is a
drawer for graphics, on the door of which
are female forms with a graphics portfolio
and a printing press. BS

**Emile Gallé (1846–1904),
Hand, Surrounded by Algae and Shells, 1904**
Cut crystal glass, coated, inlaid work,
33.4 x 13.4 cm

Emile Gallé is one of the most distin-
guished artistic personalities of Art Nou-
veau. He was the leading French
glassblower of his time, and founder of the
school of Nancy, a leading center for Art

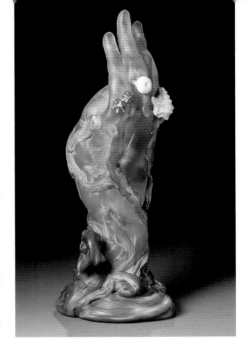

Nouveau in the provinces. Often the work
of this multitalented man was inspired by
literature and music, and contained sym-
bolic features – such as this glass sculpture
of a hand surrounded by algae and shells.
The *Hand* was created shortly before Emile
Gallé's death, and its organic ornamenta-
tion is typical. In the differentiating inter-
play between opaque and transparent
glass, the hand becomes a symbol of
mankind itself, which, although in har-
mony with nature, is in danger of being
taken over by its elemental power.

BS

**Philippe-Joseph Brocard
(ca. 1830– pre-1898), Bowl, 1871**
Glass, enamel, and gold
decoration, ebony base,
height 20 x 39 cm

The enthusiasm for the Orient that was inspired in the first half of the 19th century by travel diaries and exotic souvenirs and objects soon spread to cover every artistic realm, including the field of commercial art. While restoring old Oriental Mosque lamps, Philippe-Joseph Brocard analyzed the Syrian enamel painting on glasses of the 12th to 14th centuries and experimented with the same. At the Paris World Exhibition of 1867, Brocard presented decorated glasses, based on Islamic designs, that soon found recognition. The brilliant enamel colors and beautiful gold painting of delicate floral and geometric designs on clear, brown glass earned him his well-deserved reputation as one of the leading glass artists in this highly specialized field. Brocard's work also influenced Emile Gallé, among others, who held him in extremely high regard.

BS

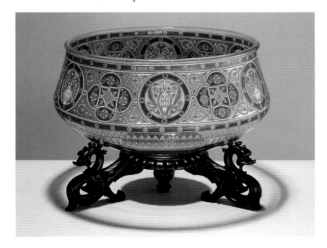

Emile Gallé, Vase, 1895
Crystal glass, several coatings, engraved, gold
particles, 47 x 13 cm

The magnificent glasses by Emile Gallé of
Nancy, with stylized decorative motifs that
are derived from the plant and animal
worlds and a fascinating interplay of shim-
mering light and shade, soon became
famous. Often, Gallé emphasized the lyri-
cal emotion and symbolism of these tech-
nically demanding glass creations with
engraved inscriptions. This vase, for exam-
ple, contains verses by his friend, the aes-
thete and man of letters Count Robert de
Montesquiou. BS

**Henry van de Velde (1863–1957),
Tray, ca. 1899/1900**
Silver-plated metal, 71 x 42 cm

Van de Velde created an item of furniture
with the same passion as a dinner set or a
letter opener. An example of the close
combination of decorative purpose and
function that he sought is to be found in
this elegant silver tray. The surface is sur-
rounded by a linear frame ornament con-
sisting of sweeping lines that become
thicker in the middle of each side and cre-
ate an exciting dynamic. The tray handles
become part of the decoration by taking up
and continuing the moving line play. BS

Glass windows by Tiffany

New York-born Louis Comfort Tiffany, originally a painter, established an interior design company in 1878. He became world famous for his hand-made iridescent glass creations, which strongly influenced Europe's Art Nouveau glass production. In 1894, in cooperation with the eminent Parisian art dealer Siegfried Bing, Tiffany planned the production of glass windows based on designs created by French artists including Bonnard, Denis, Vallotton, and Toulouse-Lautrec. Just a year later the windows were presented at the Paris Salon on the Champ de Mars and at the opening of Bing's gallery L'Art Nouveau. Only a few are still in existence today, for example this composition based on the work of Toulouse-Lautrec. Created in the flat poster style of the famous painter and lithographer, it shows an excerpt from a circus scene. Toulouse-Lautrec emphasized contours and silhouettes, whereas the glass artist Tiffany emphasized extensive differentiation between iridescent color surfaces.

BS

Henri de Toulouse-Lautrec, design for the glass window Au nouveau cirque, ca. 1892, watercolors and oil on paper, 59.5 x 40.5 cm, McIllhenny Trust, Philadelphia Museum of Art

Louis Comfort Tiffany, Au nouveau cirque, Papa Chrysanthème, 1894/95, Favrile glass, leaded, 120 x 85, Depot

Henry van de Velde,
Writing desk, design 1898/99
Oak, gold-plated bronze fittings, copper lights,
writing pad with leather, 128 x 268 x 122 cm

The architect and designer Henry van de Velde hailed from Belgium, and was one of the trailblazers of Art Nouveau and modern functional designs. His aim was to combine decorative beauty with pure functionality. In this desk, which is one of his masterpieces, he achieved an overwhelming combination of decoration and construction. The bowed shape and surrounding dynamic line impart a flowing elegance to this item of oak furniture, and cast a spell on the viewer. The writing desk was intended to provide everything the user needed for concentration by surrounding him. The drawer handles are designed in contrast to the overall movement, and, like the metal runners and lights on the sides, contribute to the harmony. The drawers on the sides are useful for storing papers, and save the item from appearing too solid and enclosed. The desk, which embodies van de Velde's concept of the "speaking line", was prominently displayed in the Paris shop La Maison Moderne.

BS

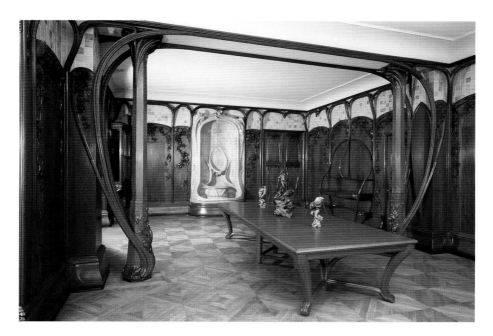

**Alexandre Charpentier (1856–1909),
Dining room, 1900/01**
Mahogany, oak, poplar, gold-plated bronze,
stoneware, 3.46 x 10.55 x 6.21 m

The idea of a complete work of art, a union
of art, architecture, and interior design,
was well mastered by the artists of Art
Nouveau. Alexandre Charpentier was pri-
vately commissioned to carry out complete
rooms as a harmonious ensemble – such as
this dining room for the villa belonging to
banker Adrien Bénard in Champrosay.
Architecture, furnishings, and decoration

form a complete unit. The whole room is
paneled in mahogany with carved motifs of
plants and tendrils. Two dressers and cup-
boards are combined with the wall panel-
ing. There is a surrounding frieze of tiles
beneath the ceiling, and a niche with a
large stoneware flower container, both
being the work of ceramist Alexandre Bigot
(1862–1927) and both incorporated in the
wall decoration. The arrangement was
completed by the table and originally 24
chairs, none of which have survived, as
well as wall lights and chandeliers.

BS

Auguste Rodin and Camille Claudel

Auguste Rodin (1840–1917),
The Age of Bronze, 1877
Bronze, 178 x 59 x 61 cm

This work by Rodin – probably the most famous sculptor of his time – was his first freestanding bronze. The naked youth is posed as if leaning on a spear held in his left hand. By removing this detail, Rodin opened up the work for new interpretation. It is no longer an image of a warrior, but "Spring awakening" or "Man of spring."

When Rodin first presented the sculpture to the public in 1877, accusations were made that his work was in fact a mold of a live model. As destructive as this criticism was intended to be, at the same time it also touched on something fundamental: Rodin's superlative modeling skills and the lifelike structure of the surface.

Auguste Rodin,
The Walking Man, 1877/1880
Bronze, 213 x 161 x 72 cm

This torso contains two features of Rodin's plastic designs – fragmentation and assemblage, i.e. the connection of existing items. The torso of the *Walking Man*, which was modeled on an older design, is combined with legs modeled on a real person. Because Rodin wanted to create an expression of movement – as opposed to the traditional understanding of plastic – he had to break with the convention of a complete human picture and dispense with head and arms; their individuality and personal expression would have distracted the viewer from the actual subject. By concentrating on the torso, the act of walking becomes the dominant motif.

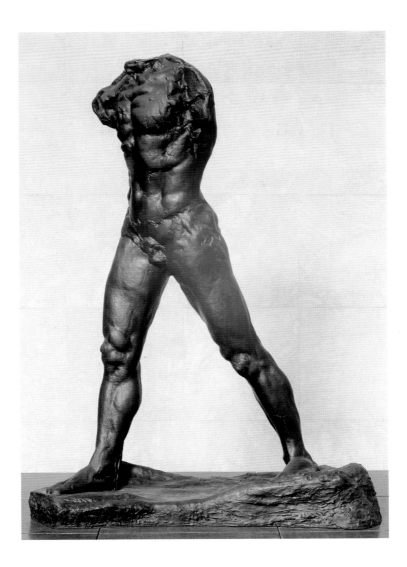

Auguste Rodin,
The Thought, 1886/1889
Marble, 74.2 x 43.5 x 46.1 cm

The Thought is the third statue created by Rodin of Camille Claudel, 20 years his junior and his protégée, lover, co-worker, and muse. Although complete in every detail, her head appears to be growing out of the solid block of white marble. She is wearing a cap, marking a formal completion of the top of the head. In contrast to the face, the artist has put less detail into the cap and the closed block of the "plinth," which results in a deliberate contrast between apparently unformed and plastically detailed elements. This contrast may on the one hand be a homage to the young woman – like Rodin a sculptor who worked with stone – but on the other it brings to mind the Non finito piece by Michelangelo, whose work greatly impressed Rodin on a visit to Italy in 1875.

In Michelangelo's work, the conflict between the idea of a work of art and its realization which was inevitably bound to the material, was manifested in the incompleteness. By contrast, Rodin's unfinished work is the symbol of a deliberate act of design; to Rodin, artistically the unfinished figure is a finished work. Rodin's fearless approach is targeted against academic tradition and the demand for completion.

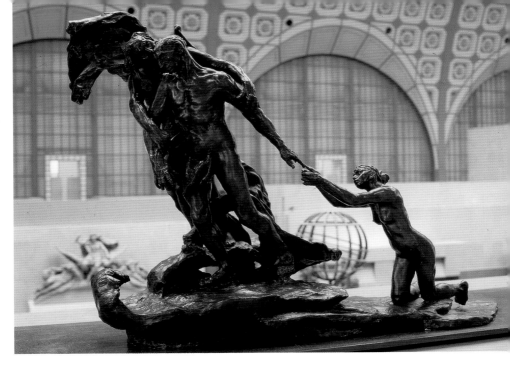

Camille Claudel (1864–1943),
The Age of Maturity, 1898
Bronze, 114 x 163 x 72 cm

This sculpture is one of Claudel's major works. She started it after separating from Rodin in 1893. *The Age of Maturity* shows a man between two women, one younger and one older. The composition develops as a triangle on two surfaces of different heights, one of which is pushed inside the other. The man is not actually standing between the women: The decision has already been made. The older one is leading him away with her, with no visible resistance from him. The younger one stays behind, her hands stretched out toward him beseechingly. Although this work is not a portrait, it does bear a number of unmistakably autobiographical features. It is a symbolic representation of the triangular relationship between Rose Beuret, Rodin, and Camille Claudel herself. Older than Claudel, Rose Beuret was Rodin's life-long partner: He first met her in 1864 but did not marry her until 1917.

Auguste Rodin,
Fugit Amor, 1881
Bronze, 38.8 x 46 x 33.5 cm

This small bronze group, which is also known as "The race into the abyss," is dedicated to the one particular subject that featured time and again in Rodin's work: man's constant desire for love, and the transience of the same.

The fleeing love, shown here in the form of a woman, escapes the embrace of the man stretching behind her by writhing away from him like a snake; he is using every shred of his strength to hold her back. The man cannot bear to accept that the woman has finally turned away from him, proving that her love was not permanent, but instead that it has shattered and passed.

This sculpture was often reproduced, and appeared in different sizes and materials throughout Rodin's career.

Camille Claudel,
Torso of Clotho, ca. 1893
Plaster, 44.5 x 25 x 14 cm

In 1893 Camille Claudel created one of her most unusual figures, *Clotho*. According to the Greek myth, Clotho weaves the threads of life, one of the Three Fates who determines man's fate.

The artist produced the body and head of the figure in a separate study, *Torso of Clotho*, which is half the size of this work. This goddess of fate, who decides over life and death, is depicted as a haggard old woman, well marked by physical decay: Her body is skin and bones. Her head leans far over to one side, clearly revealing the sinews in her neck. The lines on her face and sunken eye sockets are what mark the naked head.

Camille Claudel was less than 29 years old when she created this highly impressive plaster figure.

August Rodin,
The Gates of Hell (with detail), 1880–1917
Plaster, 520 x 400 x 94 cm

In 1880, when the French State purchased the *Age of Bronze* – one of Rodin's first works – he was also commissioned to design a bronze portal for the planned Musée des Arts Décoratifs. He chose Dante's *Divine Comedy* as his subject, a text that had gripped him since his trip to Italy in 1875.

The fact that the project for the new building was canceled in 1887 was not without consequence for Rodin. The original function, a door with two wings, need no longer be considered. *The Gates of Hell* could now be realized as an autonomous work of art.

Like many artists before him, Rodin was greatly inspired by Dante's portrayal of Hell. Only a few preparatory drawings seem to refer to scenes of Purgatory and Paradise, the two other parts of the poetic work. The door wings are the last stop before the descent into Hell.

The impression of falling, of fighting one's fate, and the unavoidable descent into the grave dominate the scene, the most impressive example of this being the "Falling" on the left door wing.

The four lower reliefs on the center field symbolize the "Empire of the Mothers." The life that they bestow becomes part of the circle. Limbo is depicted on the pilasters, and although there is a way up from there, it is only to start the descent anew – as is revealed by the scenes that are depicted on the tympanum.

The crown on the "Gate to Hell" is a picture of hopelessness. The three different aspects of one of the figures in the "Three Shades" group appear to embody a sentence that could be the motto to the "Courtroom" of the tympanum: "Abandon all hope, ye who enter here."

Rodin was dealing with a problem that was central to humanity. Simply by existing, by his weakness and guilt, man is condemned to suffer. In Ugolini's case, it is naked lust (cf. p. 41). In the relationship between Paolo Malatesta and Francesca da Rimini – the second major theme for which Rodin is indebted to Dante – the libido transgresses moral laws. While stealing their first kiss, the couple are caught by Francesca's husband, Paolo's elder brother, whom he then murders. (Both scenes are depicted in the lower part of the left-hand door.)

One of Rodin's statements refers to what is mysterious in life, and this is what he attempts to depict in this monumental relief: "What use are the laws that chain creatures to being, only to see them suffer? What use the eternal lure that lets them love life so dearly despite all its pain? This is and remains a tortuous problem."

The Gates of Hell occupied Rodin until the end of his life. He removed individual figures and groups from the universe of figures and scenes and turned them into independent works. *The Gates of Hell* is widely regarded as his main work; to the

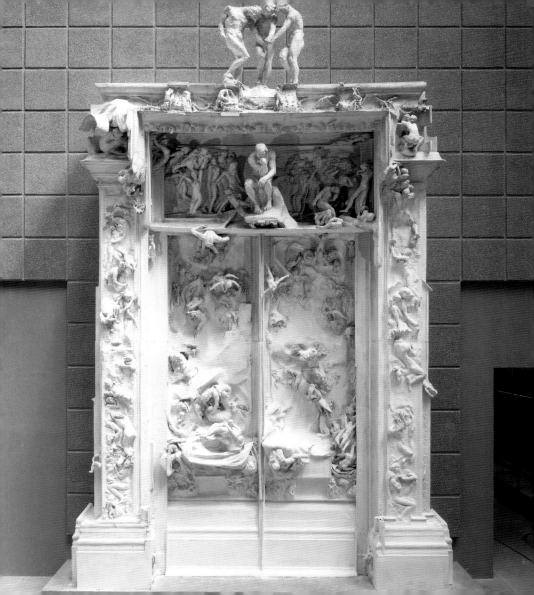

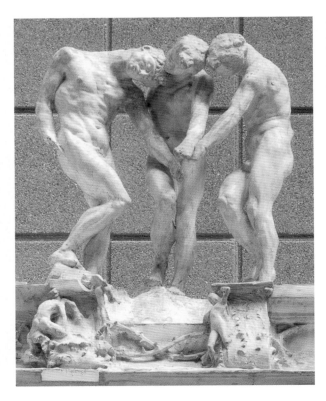

common with a judge, however. It is powerless in the face of the cycle of life. Deep thinking – it is actually more like brooding, because the chin is supported on the right hand with the top lip protruding over it – casts no light on the riddles of earthly life.

Today – ironically – the plaster frame of the *The Gates of Hell* is close to the place where the original should have been erected. The project was canceled at the time in favor of a new railway station – the Gare d'Orsay – where the Musée d'Orsay is now to be found.

Auguste Rodin, "Three Shades"
(detail from the Gates of Hell)

sculptor it was also a constant source of inspiration. Rodin developed the figure of the *Thinker*, for example, from the court-room scene surrounding Minos, the Judge of the Underworld, who allocated punishment to sinners. Rodin's figure has little in

Auguste Rodin, The Gates of Hell (detail of "The Thinker"), 1880–1917, bronze, 635 x 400 x 85 cm, Musée Rodin, Paris

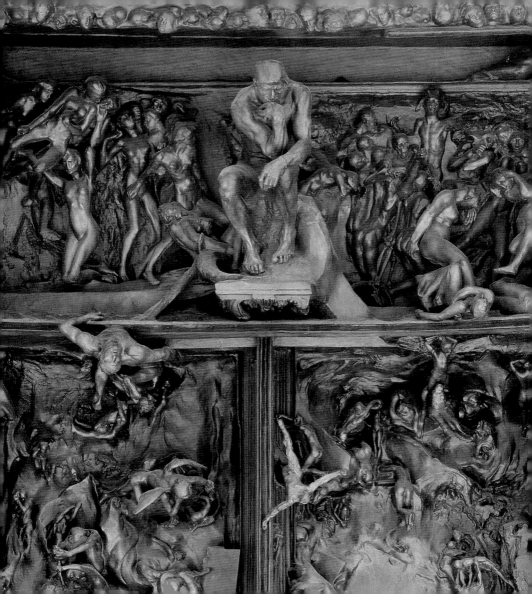

Auguste Rodin,
Honoré de Balzac
1891–1897
Plaster, 275 x 121 x 132 cm

In 1891, Auguste Rodin was commissioned by the Paris-based Société des Gens de Lettres, the French society of authors, to erect a memorial in honor of its first president, Honoré de Balzac (1799–1850). Rodin prepared for the task with extreme care. He studied the literary works of the great poet and performed extensive research to establish what he had looked like and what kind of character he was. He even managed to trace Balzac's tailor to find out more about the poet's build.

During the long period of development – it lasted almost eight years – he created some 50 sculpted designs of the figure, head, and garments. Between 1892 and 1895 Rodin worked on a number of life studies of the poet. In 1896 he then set the final position of the sculpture, with its right foot slightly in front of the left and with the hands crossed in front of the body. Rodin was carrying out significant changes to the striking head up to 1898, finally wrapping the figure in a monk's habit – Balzac's preferred form of working clothing. The sculptor gave the poet the appearance of a powerful, immovable figure that rises up before the viewer like a rock. When the figure, which is almost three meters high, was first presented to the Société Nationale at the Salon in 1898, it created such a scandal that Rodin finally withdrew it. The indig-

nant members of the society of authors then commissioned Alexandre Falguière to create a new monument. Rodin's sculpture was considered too superficial and inadequate, and its execution too free.

The first bronze casting of Rodin's *Balzac* was made in 1930, 13 years after the

Auguste Rodin, Balzac (detail), 1897, bronze, Musée Rodin, Paris

artist's death. One example of the controversial memorial, which is one of Rodin's main works, was subsequently erected in 1939 at the junction of the boulevards Montparnasse and Raspail in the heart of Paris.

CS

Antoine Bourdelle

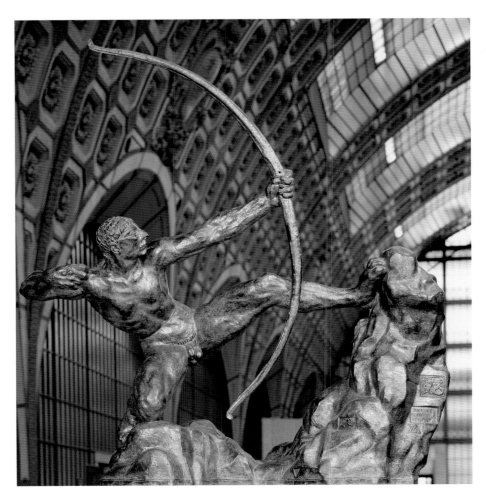

Antoine Bourdelle (1861–1929),
Hercules the Archer, 1909
Bronze, 248 x 247 x 123 cm

Bourdelle's oversize *Hercules the Archer* was a tremendous success in the Salon of 1910. There are two versions of the hero's fight with the Stymphalian birds, the fifth of the twelve labors which Hercules had to perform. The Musée d'Orsay contains a cast of the second version, which shows the archer not executed as a torso and includes the cliff formation on which Hercules knelt and that provided him with support.

The sculpture is designed to be viewed from the side, which is how the strength that the archer is intended to express is seen to the greatest effect. Bourdelle used an athlete as model for this figure.

Antoine Bourdelle, Ludwig van Beethoven,
1902/03
Bronze, 68 x 34 x 35 cm (with plinth)

Between 1887 and 1929, Bourdelle created 45 sculptures and innumerable drawings and watercolors of Ludwig van Beethoven (1770–1827). Whereas the earlier works, produced in the late 1880s, were quite traditional in appearance, those created after 1901 are rougher and more disturbing. Bourdelle tried to find a sculptural analogy to the moving inner life and the tragic fate of the composer, to whom he was very close. This sculptural approach looked right into the very heart of the person it depicts, and provided considerable inspiration for

other sculptors during the early part of the 20th century.

The bronze in the Musée d'Orsay was presented to the Paris Salon of 1903. It shows Beethoven with a serious, introverted expression. His closed eyes and lips give the impression that he is totally absorbed by the sounds of his music. The wild hair surrounding his head is the first indication of the extreme, rugged forms of the following variations.

CS

Aristide Maillol

**Aristide Maillol (1861–1944),
La Méditerranée, 1905/1927**
Marble, 110 x 175 x 68 cm

In drawings and the plastic study of a kneeling woman, Aristide Maillol developed the seated naked figure of a woman, the plaster model of which was exhibited at the Autumn Salon of 1905 under the title *Femme* (woman). It was not until the early 1920s that Maillol decided on the title *La Méditerranée*. The artist produced the marble version in the Musée d'Orsay between 1923 and 1927, having been commissioned to do this work by the French State.

Clear proportions determine the sculpture, which presents a combination of supporting and load-giving parts. Simple volumina are brought together in close harmony with smooth surfaces. The voluptuous female form appears to be inside an imaginary cube. Maillol created the sculpture in the same way that an architect would build a house, and although it is only just over one meter high, it appears monumental; the very quintessence of balance.

In *La Méditerranée* Maillol created the type of woman that is generally regarded as typical of his work. One of the seven existing bronze casts is to be found on his grave in Banyuls-sur-Mer.

**Aristide Maillol, Spring
(Torso), 1910–1912**
Bronze, 148 x 41 x 26 cm

In 1910 the Russian collector Ivan Morozov commissioned Maillol to produce three sculptures for him. By 1912 he had created a group of three slim upright women, producing several versions of each one. The client's version is now in the Pushkin Museum in Moscow.

CS

Nature and idea –
Maillol's sculptural conceptions

Aristide Maillol (1861–1944) is quite rightly regarded as the main exponent of modern sculpture in France. Whereas Auguste Rodin's singular, even genial vision remained rooted in the 19th century, Maillol introduced new principles in sculpting that were stylistically instructive. His sculptural concept is summed up by terms such as simplification, integration, clarity, and plasticity.

Maillol, who left his home in the South of France in 1882 and took his dreams of becoming a painter to Paris, studied initially at the Ecole des Beaux-Arts under Alexandre Cabanel, a well-known Salon painter. He gained admission to the avant-garde circle of artists through his contact with the Nabis, and in particular through his close friendship with Maurice Denis. In 1895, Maillol began his first woodcarvings, mostly small reliefs such as the ornamental *Dancer*; he also continued to paint and designed tapestries. At his first solo exhibition in Ambroise Vollard's gallery in 1902, he also displayed his first statues in plaster, wood, and bronze as well as his commercial artwork, which Vollard produced – and sold – in large quantities over the following years.

Maillol then concentrated on sculpting. The breakthrough came in 1904, after 20 years of poverty, when he was finally invited to exhibit his sculptures in the newly established Autumn Salon, and the German art critic Julius Meier-Graefe dedicated an entire article to him in his influen-

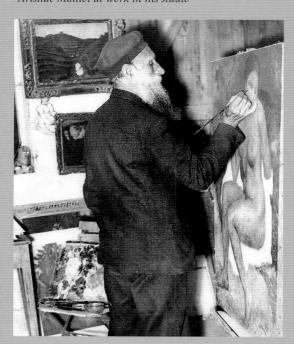

Aristide Maillol at work in his studio

tial publication *Die Entwicklungsgeschichte der modernen Kunst* (the history of the development of modern art). From now on, Maillol had important international connections to collectors, dealers, and sponsors, and received increasingly lucrative commissions. This was when he developed his ideas of sculptural form and themes which were to dominate his entire working life. The main feature was the female nude, which he modeled in three basic positions: standing, sitting, and lying down. Examples of these in the Musée d'Orsay are the works *Ile-de-France*, *La Méditerranée*, and *Memorial to Cézanne*. His sculptures are characterized by severe, superior construction, the stance of the figure, and the monumentality of the overall piece. This includes Maillol's specific relationship to the model, which he described thus: "It is not enough to have a model to copy. Although nature is undoubtedly the basis of all work…art does not exist in copying nature."

In the quest for a closed composition, Maillol included all the anatomical details in a harmonious silhouette, softening individual features in favor of the perfect artistic form.

To Maillol, the synthetic relationship between nature and artistic idea was so important that he totally banned any references to content or storytelling from his work. The titles of his works, which usually resulted retrospectively from the function of the sculpture, perhaps as a memorial or as an allegory, were sometimes thought up long before the actual work was produced, and therefore had no influence on the final form. The sculptures know no other content than that of supertemporal beauty – and it is because of this aspect that their modernity has lasted until today and paved the way to abstraction for the next generation of sculptors.

MP

Aristide Maillol, Ile-de-France, 1907–1933 Stone, 152 x 49 x 57.5 cm, mezzanine, Lille terrace

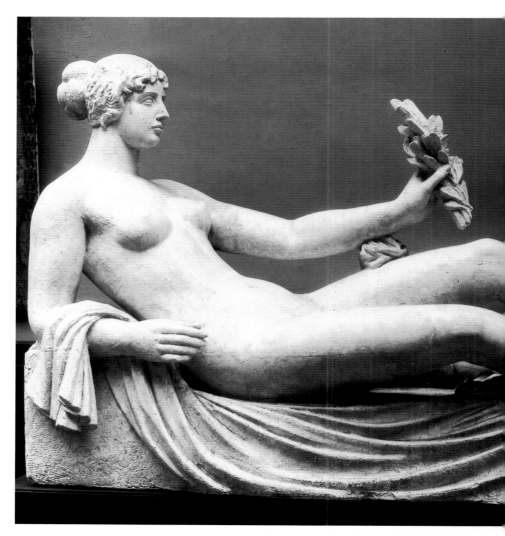

Aristide Maillol,
Memorial to Cézanne, 1925
Marble, 140 x 227 x 77 cm

From 1907 onwards, Aristide Maillol worked on designs for a sculpture in honor of Paul Cézanne. Around 1912 he was commissioned by the Comité du Monument Cézanne to erect a memorial in the painter's hometown of Aix-en-Provence. Maillol prepared the work in numerous forms including sketches, lithographs, and terracotta bozzetti, a few of which were also cast in bronze.

The large plaster model was basically complete before the First World War, but the stone figure in rose marble was not finished until 1925. Because the city fathers refused to allow the monument to be erected in Aix-en-Provence, it was put in the Tuileries Gardens in 1927. In 1963, it was replaced by one of the six surviving lead castings.

Maillol was a great admirer of Paul Cézanne (1839–1906), and did in fact meet him. Like his friend Maurice Denis, Maillol saw in Cézanne the father of a new "classicism" and felt himself confirmed by the other artist's work that fulfilled his longing for calm, solidly set compositions, and basic geometric shapes. So it is hardly surprising that Maillol chose for the monument the relaxed, reclining female nude with a laurel in her hand, a picture that is highly reminiscent of the tympanums of ancient temples.

CS

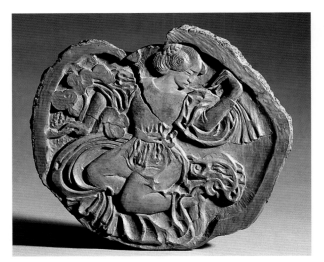

**Aristide Maillol,
The Desire, 1907**
Lead, 120 x 115 x 25 cm

Maillol prepared *The Desire* with numerous designs, initially by concentrating on the individual figures and then on the way they worked together.

The two figures fit closely inside the borders of the relief. The horizontal and vertical lines of the frame around the work determine the construction of the two bodies. The thighs of both bodies form the border at the bottom of the picture. The pair's thighs perform an almost symmetrical movement to the lateral edges. These vertical boundaries follow the man's back and the woman's upper arm. Her right arm and his shoulder are in line with the upper horizontal edge of the relief. The woman's right thigh and the two figures' lower arms form another horizontal in the middle of the plate.

The strict geometry which Maillol constructs from human bodies provides meaningful support for the message contained in the relief: being trapped in desire, the man's urging and the woman's resistance.

Aristide Maillol, The Dancer, 1895
Wood, 22 x 24.5 x 5 cm

Aristide Maillol first wanted to be a painter, and it was not until 1895 that he began to create sculptural works. At the turn of the 20th century he turned solely to sculpting.

The first works to be exhibited by the artist were wooden sculptures such as *The Dancer*. This early round picture follows a design principle that is typical of Maillol: the figure keeps within the boundaries set by the material. At the same time, the curved lines (against which the clothes are stylized) reveal the association with the art of Gauguin and Bernard and proximity to Art Nouveau.

Joseph Bernard and Medardo Rosso

Joseph Bernard (1866–1931),
Turning to Nature, 1906/07
Stone, 32 x 29 x 31.5 cm

The solid, almost blunt head of a young woman with almond-shaped eyes, the lips closed and gently smiling, the cheeks full, is typical of Joseph Bernard's oeuvre. What was unusual and new about the bust was that the individual elements were formed simply as the morphological properties of the stone allowed them to be: The ears are flat, the forehead even, the neck enlarged. Instead of academic smoothness, the surface of the sculpture is noteworthy for its relative roughness. It reveals the stages in the working process. Form and material together create a natural union.

CS

**Medardo Rosso
(1858–1928), Ecce Puer
(impression of a child),
1906**
Bronze, 44 x 37 x 27 cm

Italian-born sculptor Medardo Rosso's works were often based on a range of unpretentious subjects from everyday life; his paintings depicting city scenes are reminiscent of the Impressionists. This bust, a "portrait" of six-year-old Alfred Mond, is a fleeting model that captures the fluidity of the child's head and dispenses with showing any detailed work on the face.

Rosso's preferred material was soft wax, which was more suitable for his particular artistic designs than any other material. The subsequent bronze casting limits the meaningfulness of

Rosso's small sculpture somewhat. The 20th century was slow to appreciate this artist; in his day, Rosso's works were seen more as bozzetti, as three-dimensional designs, rather than as works of art. Appollinaire, however, described him as the greatest sculptor alive", and he was much admired by Rodin, among others.

The Nabis

Maurice Denis (1870–1943),
Homage to Cézanne (with detail), 1900
Oil on canvas, 180 x 240 cm

In March 1898 the painter made a note "to create a picture in Vollard's gallery, surrounded by Vuillard, Bonnard, etc." The painting thus described not only shows the members of that group of Symbolist painters that gathered in 1889 under the programmatic name of Nabis (prophets); it also reveals the tenets in which they believed.

The structure of Denis' group picture tells a strong story. To the left of Paul Cézanne's still life on the easel is Odilon Redon. He was the artist to whom the Nabis had dedicated the previous year's

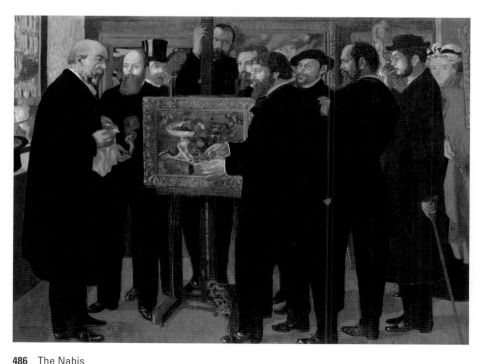

exhibition *Hommage à Redon*, which was held on Duran-Ruel's premises. Redon is listening to what the person opposite has to say about Paul Sérusier; he was an important intermediary between the Nabis and the members of the school of Pont-Aven. To Denis, who is slightly hidden from view by Sérusier, and his friends his painting *The Bois d'Amour Seen from Pont-Aven*, which was cre-

ated under the watchful eye of Gauguin in the tiny village in Brittany (see p. 385), was something of a talisman. Marthe Denis, the painter's wife, is standing near the right-hand edge; as her husband's muse, she was the only woman included in the group. Next to her is Pierre Bonnard, who is holding a cane in his hand. Edouard Vuillard is beside Redon, obviously waiting in eager anticipation for what Sérusier is about to say. The room in which the people are standing is Ambroise Vollard's gallery; the art dealer is standing behind the easel, with one hand resting on it. In 1895, he staged an exhibition of Cézanne's works on his premises, which had a lasting impression on the Nabis.

To the Nabis, Redon was something of a teacher of Symbolism, the art movement that revealed realities other than those of nature. Cézanne valued the Nabis because he wanted to "make something solid,

something permanent of Impressionism," as Denis, the group's theorist, had done. Gauguin and the school of Pont-Aven were exciting because of their figurative language, which chose the two-dimensional and decorative. Hanging on the wall in the background to the left can be seen a work by Gauguin.

The fact that Denis even dared to paint a *Homage to Cézanne* reveals an important difference from its celebrated precursor, Fantin-Latour's *Homage to Delacroix* of 1864 (see p. 186). When Fantin-Latour showed his respect – posthumously, it should be noted – Delacroix was considered a great artist. In Paul Cézanne's case, though, the situation was slightly different, and he received less public acclaim. It arrived slowly throughout the 1890s, but never transgressed a small circle of admirers. It was only later that he became internationally famous.

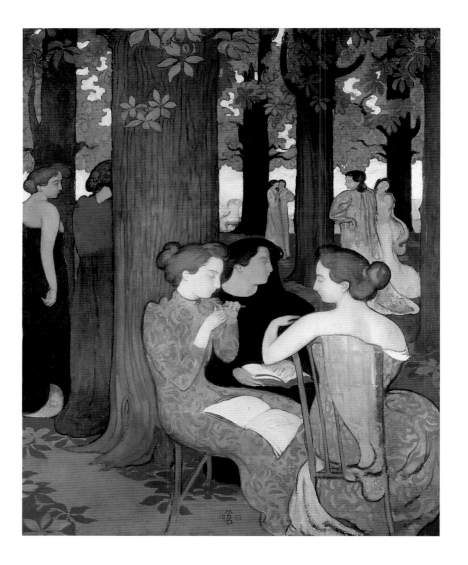

Maurice Denis,
The Muses, 1893
Oil on canvas, 171.5 x 137.4 cm

"A picture – before being a war-horse, a nude woman, or some sort of anecdote – is essentially a flat surface that is covered with colors arranged into a certain order." In line with his realization of 1890, Denis and his friends painted their pictures in a deliberately flat style.

The nine Muses, the Greek goddesses of the arts and sciences, are gathered in a forest grove. Three of them are at the front of the picture; the others are wandering about in pairs. The palette is subdued. Denis plays cleverly with stylized, arabesque-like leaf shapes that recur on the ground, in the clothing, on the trees, and on the horizon. There is something of an ideal attached to Denis' young figures. The quality of the female forms in his work earned him the sobriquet "Nabi of the beautiful icons."

Pierre Bonnard (1867–1947),
Child Playing in the Sand,
1894/95
Oil on canvas, 167 x 50 cm

The works of the Nabis were not just intended to prettify everyday life. The artists also wanted to put their art "into life," and so they committed themselves to applied art. In 1894, Bonnard created his first decorative ensemble using a wind or fire screen. *Child Playing in the Sand* is one of the four parts of this work. A small piece of a door and two steps in the top left corner of the picture indicate that the place is probably the front or back of a house. The lively inner drawing of a small tree in a square pot to the right of the steps contrasts with the child's checked clothing, and the rounded shape of the crouching child echoes the circular shape of the tree. In this subtle way Bonnard created a connection between the picture of the child in the foreground and the background scene.

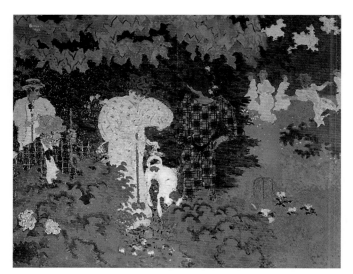

women and two men are passing the time by playing croquet. The people on the left at the front are known to be Bonnard's father, his sister Andrée, and his brother-in-law, the musician Claude Terrasse, accompanied by a friend. Five young women clad in long, white dresses are dancing in the background on the right. The subject of this painting, an Arcadian landscape of uncomplicated, harmonious pleasure in the summer freshness of the countryside, is still in the style of Impressionism. The subjective reproduction of this section of the landscape, which is as flat and ornamental as the figures in their patterned clothing, reveals *The Croquet Party* as typical of the Nabis. In 1937, Pierre Bonnard himself looked back on the early years of his output: "… we attempted to defeat the Impressionists with their naturalistic impressions of color. After all, art isn't nature!"

CS

Pierre Bonnard,
The Croquet Party, 1892
Oil on canvas, 130 x 162 cm

The Croquet Party is one of Pierre Bonnard's early works; the artist was one of the founder members of the Nabis group in 1888. His early success as a lithographer led him to resign as a lawyer in 1891 in order to concentrate on his career as an artist. He then appeared regularly at the Salon des Indépendants, where *The Croquet Party* was first exhibited in 1892, albeit under the title of *Twilight*.

The painting shows the garden of the Bonnard family's country home in Le Grand-Lemps au Clos in the Isère département. Two

Edouard Vuillard (1868–1940),
In Bed, 1891
Oil on canvas, 73 x 92,5 cm

In Bed is an intimate painting. Because the Nabis artists had a penchant for subjects such as this, their style was also known as "Intimism." Vuillard places his painting under the primacy of two-dimensionality, far more so than his role model Bernard or fellow combatant Bonnard. The bed, figure, and wall are transformed to create an interplay between the surfaces. Vuillard restricts the color palette to gray, ochre, and brown in order to maximize the decorative effect. The simplification Vuillard is able to derive from the subject reveals why, at the beginning of his career, he was the leading Nabi.

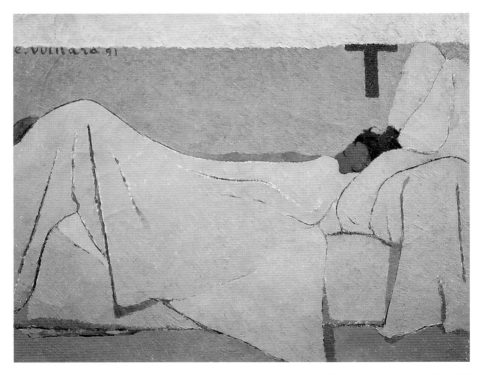

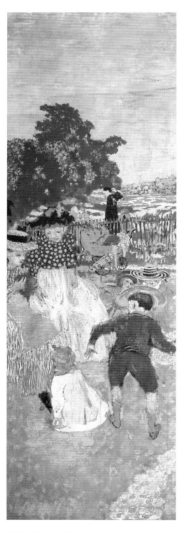
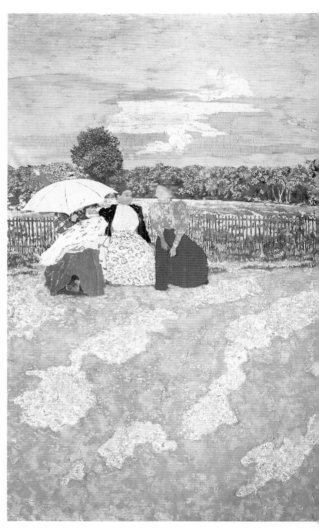

Edouard Vuillard,
In the Park, 1894/1936
Oil on canvas,
213.5 x 73 cm (The Nurses)
213 x 154 cm (The Conversation)
214 x 81 cm (The Red Parasol)

Vuillard's panels belonged to what were originally nine wall pictures produced for the dining room belonging to Alexandre Natanson (1873–1932), the publisher of *Revue Blanche*. The magazine, which first appeared in 1891, became the voice of the Nabis. It contained drawings and graphics by the artists, and they also designed covers and posters for it. The circle around *Revue Blanche* included artists such as Henri de Toulouse-Lautrec, then later Edvard Munch and Henry van de Velde. It provided a forum for less well-known writers such as Marcel Proust, André Gide (formerly the owner of Denis' *Hommage à Cézanne*, 1900), Paul Claudel (brother of the sculptress Camille), and Jarry, as well as for the famous poets of Symbolism.

Vuillard's panels *Girls Playing*, *The Inquisition*, *The Conversation*, *The Nurses* and *The Red Parasol* (the last three are shown here) should be viewed from a distance. The asymmetrical picture rhythm is striking. The large picture surfaces appear to have been distributed randomly. Vuillard also reproduced his figures – such as those in *The Inquisition* – much shorter than they really were, which enhanced the decorative effect of the works.

Félix Vallotton (1865–1925),
The Ball (Child Playing with a Ball),
(with detail), 1899
Oil on card, 48 x 61 cm

The painting is noteworthy for its highly imaginative distribution. In full keeping with the style of the Nabis, Vallotton chooses large areas of color – almost so large that the viewer is at risk of losing sight of the child, were it not for the fact that she is highlighted in color, dressed in white, and wearing a large yellow sun hat. We see the little girl from an unusual angle: She is positioned between two balls. One, which she has her back to, is large and plainly col-ored; the other, which she is running toward, is small and red. In the background, proba-bly in the child's sight, are two figures, one dressed in white, the other in blue. In the overall context of the picture they are no less striking in color than the little girl.

Because of the surprising view from above, the nature in the picture appears to be ani-mated in an unusual way. This applies to the foliage and deep black shadows at the top right and to the mysterious shadows on the left, which seem almost to reach out to the child. All of this adds a fairy-tale enchant-ment to the picture.

The artists and their makers – famous art dealers in Paris

Not only were there new art terms and a new type of artist during the second half of the 19th century, but there was also a transformation of art procurement and the art market . Now the artist worked less on commissions from the Church or the Court – traditionally the major employers of the past –and worked instead for an unknown potential buyer or collector. The latter had to become interested in the artist, be delighted by him, and then be convinced that the asking price for a painting, drawing, or graphic was fair remuneration for the hours of work involved in its creation. From the start, selling art meant procuring it. This was the task

Paul Durand-Ruel (1831–1922) in his gallery, ca. 1910

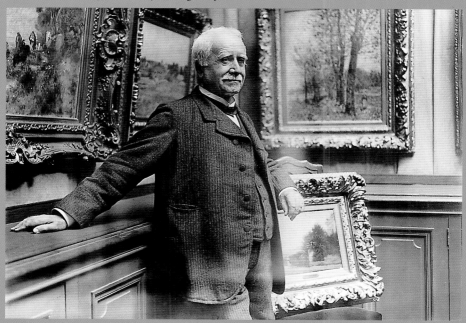

of the gallery-owners, who became increasingly specialized during the course of the 19th century. The dealers of "mixed" forms of art from every epoch and style opted to become either antiquarian dealers who dealt mainly in the sale of old – and therefore financially solid – works of art, or dealers in modern art. The latter were prepared to put contemporary and therefore as yet unsanctioned art on the market. The gallery-owners were and remained institutional, but were also the very people on whom the young unknowns pinned their hopes. It is easy to appreciate the situation in Paris in the second half of the 19th century: There were only a few (but very important) art dealers who were interested in modern painters – first the group from Barbizon around Corot, then the Impressionists and neo-Impressionists, then finally the Fauves – and they worked hard on their behalf.

Apart from the more conservative gallery of Bernheim-Jeune and the very cautious but increasingly capable Georges Petit, Paul Durand-Ruel (1831–1922) was one of

Durand-Ruel's and Vollard's galleries were on the Rue Lafitte.

the few gallery-owners who actively promoted and marketed his artists, often providing them with financial aid as well.

Durand-Ruel was self-taught. He acquired his marketing skills while working for his father, a stationer who also sold painting and drawing materials and later opened a small gallery. Young Paul was a frequent visitor to the Louvre, and soon developed a particular interest in contemporary art. Finally, he opened his new gallery on the rue Lafitte, developing a hanging and lighting concept that set the standards for displaying art. Instead of the so-called "Petersburg method," where the pictures were hung closely together from the floor to the ceiling, Durand-Ruel displayed only a few works, hanging them side by side and lighting them as they were. This gave each individual work more gravitas and added value. Each picture needed to be seen and perceived as an individual artistic achievement.

Financial success eluded him for a long time, and Durand-Ruel struggled with various problems during his career as a gallery-owner. At first, art critics and the public mocked and sneered at his protégés. Nonetheless, he offered virtually penniless artists such as Monet and Pissarro a modest but regular income by taking the risk of purchasing their works on his own account. After his failed attempt to establish himself in London during the war and the Commune of 1870/71, he ventured a new start in Paris. However, sales of Impressionist art did not start to improve – and then only slowly – until after the second Impressionist group exhibition (1876). Once prices had stabilized and the first potential buyers appeared, Durand-Ruel

found himself with a serious competitor in Georges Petit, who managed at the beginning of the 1880s to contract the increasingly successful Claude Monet to his establishment. 1884 saw Durand-Ruel heavily in debt and facing bankruptcy. However, through his contacts with Mary Cassatt and the USA he found himself dealing with wealthy American collectors, and this was what saved him from ruin. He opened a second main branch in New York in 1888, regarding it as security for his business. There were also highly successful sales throughout Europe, and in particular in Germany. Durand-Ruel's situation stabilized in the 1890s, but he still had to come to terms with losing artists to other galleries despite his willingness to take risks and become personally involved. For example, the young Theo van Gogh, who was employed by Boussard & Valadon until his early death, also tried to stage exhibitions of Impressionist works, buying paintings by Degas, Gauguin, Pissarro, Monet, etc. for the gallery.

In 1893, as Durand-Ruel was expanding internationally and finally able to reap the rewards of his artistic activities, a young colleague opened another gallery close by. This was Ambroise Vollard (1865–1939), one of the most glittering figures on the art dealing scene of 1900. Also self-taught and very much a self-made man, he tried to learn from Durand-Ruel's experiences and signed a number of artists on exclusive contracts from the outset, thereby binding them and their oeuvres to the Vollard gallery. Vollard

Paul Cézanne, Portrait of Ambroise Vollard, 1899, Oil on canvas, 100 x 80 cm, Musée du Petit Palais, Paris

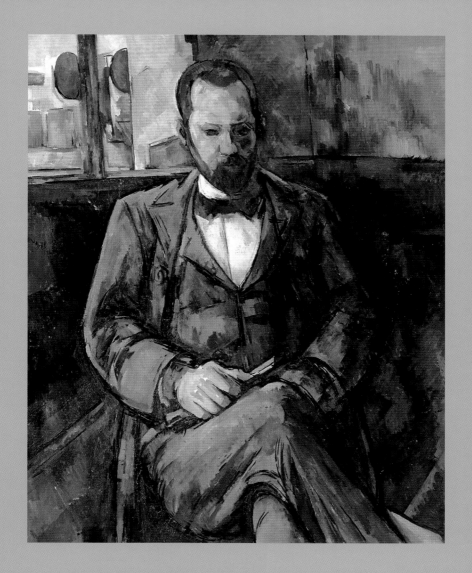

A quick pen-and-ink sketch by Pierre Bonnard showing gallery-owner Ambroise Vollard surrounded by his pictures

proved to have an unusual talent in choosing "his" artists, which he ascribed to his *bon œil* (good eye) and *bonne oreille* (good ear) – in his opinion the most important requirements for a successful art dealer. In Paris in 1895 he staged a major exhibition of Cézanne's works after a 20-year absence. One year later he signed an exclusive contract with Gauguin, who was living in Tahiti, and became the only gallery-owner in Paris to offer the artist's South Sea paintings for sale. In 1901 Vollard staged the first exhibi-tion of the works of 20-year-old Pablo Picasso, and just three years later the Fauvist paintings of Henri Matisse were displayed in a solo exhibition in the Vollard Gallery. Ambroise Vollard's program was an important contribution to the international success of the avant-garde – his strong personality made a lasting impression on anyone who ever met him.

Vollard's unpredictable, gruff, and yet sensual appearance in the overall picture of this bohemia of modern artists was completely dif-

ferent from that of the conservative and bourgeois Durand-Ruel. Gertrude Stein, a leading American collector who moved to Paris at the beginning of the 20th century, spoke thus of her visits to the Vollard Gallery: "It was the most incredible place. It didn't look a bit like an art gallery. There were a few pictures facing the wall; in one corner there was a small pile of large and small pictures, all stacked together any old how, and in the middle of the room was this large, dark man who stared down broodingly. That was Vollard – in a good mood. When he was feeling less cheerful, he'd plant his huge body outside the glass door to the street, raise his arms above his head with his hands in the top corners of the door, and scowl. No one would dare to enter."

Despite his apparent scratchiness, invitations to Vollard's celebrated dinners, which were held in the basement of his premises on the Rue Lafitte, were in great demand by artists and collectors. Anyone who was allowed to enter the fusty arches felt they had been accepted by a hand-selected circle of the Parisian avantgarde.

MP

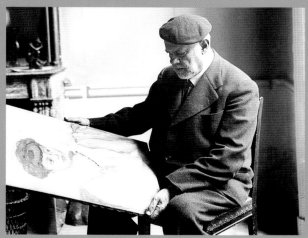

Ambroise Vollard (1865–1939), art dealer, publisher and writer

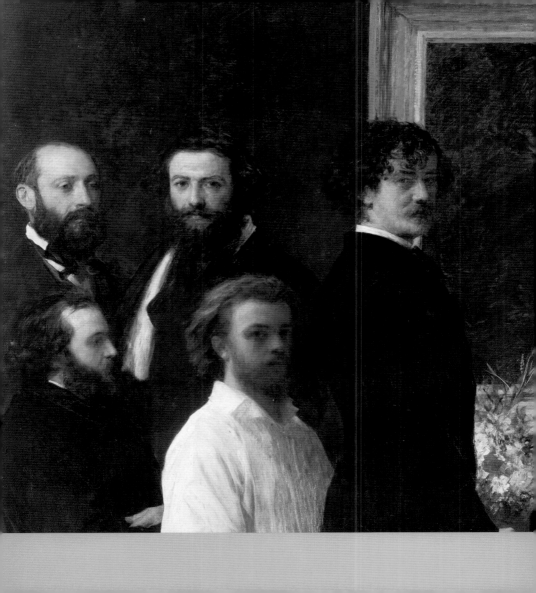

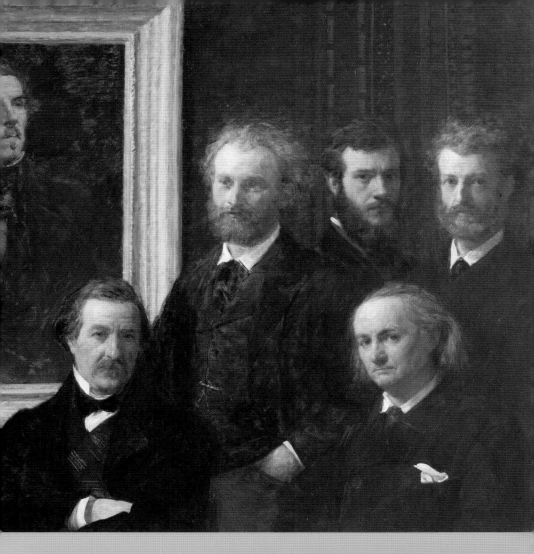

Appendix

Biographies of the artists

Antigna, Alexandre (1817 Orléans – 1878 Paris) Joined the Ecole des Beaux-Arts in 1837; also studied under Paul Delaroche in Paris. He sent a number of genre-rich representations of social themes, especially paintings of poor children, to the Salon of 1847. In pictures of catastrophes, such as *The Fire* (1850), he painted a historical picture of something that was not important to the prevailing outlook of the time, namely the fate of poor people. After a trip to Spain in 1863, the darkness of the Realist's palette became noticeably lighter, and his preferred subject matter changed to countryside idylls and genre scenes.

Baltard, Victor (1805 Paris–1874 Paris) Studied under his father, the architect Louis-Pierre Baltard, in Paris from 1823. In 1833 his design for an Ecole Militaire won him the Rome prize. On his return from Italy, his design of the grave for Napoleon (1839) brought him early artistic success. His main works, the market halls constructed in glass and iron between 1852 and 1859 (demolished between 1971 and 1973) and the church of St. Augustine (1860–1868), a cupola-roofed central construction with an ambitious iron structure on the inside, are bold examples of historical architecture in 19th-century Paris.

Barrias, Louis-Ernest (1841 Paris – 1905 Paris) Studied sculpture under Léon Cogniet, and with Cavelier from 1854, and François Jouffroy from 1857. On his return from Italy in 1870, his mythological figures, memorials, and busts soon won him the highest recognition. In 1894 he took over Cavelier's master studio in sculpting at the Ecole des Beaux-Arts. His usually polychromatic works, and in particular his highly regarded sculpture *Nature Exposing Herself to Science* (1899), combined Baroque and Neoclassical influences.

Previous double page: Henri Fantin-Latour, Homage to Delacroix (detail), top floor, room 29

Bastien-Lepage, Jules (1848 Damvillers, Meuse – 1884 Paris) was the son of a wealthy farmer from the Lorraine. Studied under Alexandre Cabanel in Paris from 1868. This leading exponent of Naturalism achieved his first major success at the Salon of 1874 with his sentimentally transfigured countryside motifs, realistic portraits and lifesize representations of farmers. His historical scene depicting the awakening of *Joan of Arc* (1880) is a superb example of religious art in the late 19th century.

Bazille, Frédéric (1841 Montpellier – 1870 Beaune-la-Rolande) From 1862, studied under Charles Gleyre at the Ecole des Beaux-Arts in Paris, while also studying medicine, although he eventually abandoned the latter. He became friends with Monet, Renoir, and Sisley from 1863, and the group made several painting trips

Frédéric Bazille at his easel (Detail),
Portrait by Auguste Renoir 1867, Musée d'Orsay, Paris

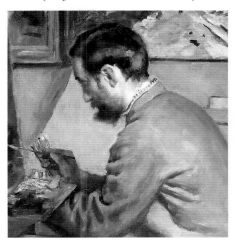

to Fontainebleau and Honfleur and set up an artists' commune in his studio between 1865 and 1870. His light, brightly colored landscapes and compositions of figures in the open air – trailblazing for the Impressionists – which the artist often imbued with a melancholy seriousness, were strongly influenced by Monet. Bazille was killed in the Franco-Prussian War at the early age of twenty nine.

Benouville, Léon (1821 Paris – 1859 Paris) Studied under Léon Cogniet in Paris. In 1855 he broke away from his classical style of painting and turned to Ary Scheffer, Paul Delaroche, and Ingres for inspiration. In Rome from 1846 to 1850, Raphael kindled his interest in Italian painting. In his religious and mythological pictures, his deep concentration on the essential led to severity and sobriety in the representation. The Salon painter was important in his day for his work on the restoration of religious painting in the second half of the 19th century, but has now largely been forgotten.

Bernard, Emile (1868 Lille – 1941 Paris) Joined the Pont-Aven group in 1886 after completing his studies under Fernand Cormon in Paris in 1886. Formed a close friendship with Paul Gauguin, with whom he developed Synthetism. Bernard adopted Gauguin's increased color expression and simplified shapes, but the practice of surrounding colored areas with dark contours – known as *cloisonné* – was invented by Bernard. As well as his (partly religious) screen pictures, his works included book illustrations, woodcuts, and sculptures. His meetings with Cézanne in 1904, whom Bernard referred to as his teacher, and with van Gogh led to intense spiritual exchanges on the nature of modern art.

Bernard, Joseph (1866 Vienna/Isère – 1931 Boulogne-Billancourt) Along with Bourdelle and Maillol, he was one of the main exponents of the sculpture generation after Rodin. Trained as a stonemason in his father's workshop. From 1887 to 1891 he studied under Cavelier in Paris. From 1892 his work was regularly displayed in the Salon des Artistes Français, and from 1910 in the Salon d'Automne.

Giovanni Boldini, Self-portrait, 1892, Uffizi Gallery, Florence

Bernard's oeuvre included sculptures in marble, stone, and bronze, predominantly female nudes and portraits, as well as graphics. His artistic working method, which deliberately leaves traces of the work process that add a tactile, incomplete character to his sculptures, had a marked effect on several successive artists.

Boldini, Giovanni (1842 Ferrara – 1931 Paris) Studied in the studio of his father, the historical and portrait painter Antonio Boldini. Became a student at the Art Academy in Florence in 1862, joined the Macchiaioli, a Tuscan group of artists committed to realistic open-air painting. In exile in London in 1871/72, Boldini specialized in portraits of the aristocracy. Back in Paris

in 1872, he was again in great demand as a portraitist for high society. His works were often of Parisian street scenes in pastel shades. He also produced pastels, drawings, and watercolors.

Bonnard, Pierre (1867 Fontenay-aux-Roses – 1947 Le Cannet) Studied law, then went to the Ecole des Beaux-Arts from 1885 and the Académie Julian in Paris in 1887. Met Denis, Sérusier, and Vuillard; joined the Nabis in 1889. In 1891, he formed a studio group with Denis and Vuillard. Bonnard and Vuillard were the two main exponents of Intimism. Bonnard's was a surface style of painting with highly emphasized lines in unbroken colors and independent compositions. He took his unassuming subjects from everyday Parisian life. Bonnard produced his extensive graphic work around the turn of the 20th century, in particular lithographs and illustrations. From 1926 his landscapes were produced in increasing seclusion, but became more generous, the brush strokes freer and the palette more intense.

Bonnat, Léon (1833 Bayonne – 1922 Monchy-Saint-Eloi, Oise) Was strongly influenced by Spanish art as a child while living in Madrid from 1847 to 1853. He studied Velázquez, Murillo, Ribera, and Goya at the Prado. From 1854, Bonnat studied under Léon Cogniet in Paris, and soon after 1867 he was numbered among the main exponents of official art. In additional to historical works, he painted numerous portraits of famous personalities, frescoes in the Palais de Justice (1872), in the Panthéon (1886), and in various churches in Paris. As a chronicler of the Third Republic, he became one of the late 19th century's most important – albeit always conservative – creators of bourgeois social portraits. His studio fostered artists such as Caillebotte, Munch, and Toulouse-Lautrec.

Boudin, Eugène (1824 Honfleur – 1898 Deauville) Was counted – with Camille Corot – as one of the trailblazers of Impressionism. On the advice of Millet and Troyon, he based his early works on nature; studied at the Ecole des Beaux-Arts in Paris from 1851 to

Léon Bonnat, Self-portrait, 1855, Musée d'Orsay, Paris

1853. Boudin's famous paintings of landscapes in Normandy and Brittany, lively street scenes, and seascapes, reflect the influence of 17th-century Dutch paintings. With their subtle nuances, his works are Impressionist in their reproduction of light – although Boudin participated only once in their exhibitions, in 1874.

Bouguereau, William (1825 La Rochelle – 1905 La Rochelle) Studied from 1846 in the studio of François-Edouard Picot and at the Ecole des Beaux-Arts in Paris. In Rome from 1851 to 1854, he styled his work on Giotto and Raphael. His smooth, academic style and classically oriented historical paintings found the highest recognition, and imperial commissions followed in the Second Empire. His highly idealized genre paintings were reproduced in large quantities

as photographs and postcards, and made Bouguereau one of the highest-paid artists of his time in France.

Bourdelle, Antoine (1861 Montauban, Tarn-et-Garonne – 1929 Le Vésinet/Yvelines) Worked from 1893 to 1905 in the studio of Auguste Rodin, who had a marked influence on Bourdelle's art. His major works include 21 busts of Ludwig van Beethoven (1888–1929). As the result of his baroque theatrical works, Bourdelle was appointed the official memorial artist of the Third Republic. In addition to his monumental sculptures and portraits, his oeuvre included watercolors, frescoes, and book illustrations, all of which bear testimony to the versatility of this French artist of the fin de siècle who was second only in importance to Rodin.

Cabanel, Alexandre (1823 Montpellier – 1889 Paris) Representative of French academic classicism, together with Gérôme and Bouguereau. Trained at the Ecole des Beaux-Arts from 1840. Studied the works of Raphael and Michelangelo in Rome from 1846 to 1851, which he later utilized eclectically. His technical brilliance at drawing and coloration and the smoothness of his artistic approach – combined with a certain amount of eroticism – are generally regarded as the quintessence of good taste. The large number of students he taught, plus his official awards and offices held are all testimony to the regard in which this popular artist was held.

Caillebotte, Gustave (1848 Paris – 1894 Gennevilliers) Went to study under Léon Bonnat in 1872. Met Degas, Monet, and Renoir early in his career; appeared at the Impressionist exhibitions between 1876 and 1882. From a wealthy home, Caillebotte was a collector and munificent sponsor of the Impressionists – his somewhat controversial gift of modern paintings to the French State in 1894 formed the rootstock of the Impressionist collection at the Musée d'Orsay. The highly original thematic, unusual compositions and clever perspective of Caillebotte's own work were an important contribution to Impressionist painting.

Carolus-Duran, Charles (1838 Lille – 1917 Paris) Real name Charles-Emile-Auguste Duran(d) or Durant. Studied at the Académie Suisse in Paris from 1859 to 1861. Made copies in the Louvre and on his travels through Italy, Spain, and England, especially of Diego Velázquez, Thomas Gainsborough, Joshua Reynolds, and Thomas Lawrence. Also influenced by Courbet, his specialty – realistic bourgeois society portraits – were tremendously successful. He opened his own studio in 1872; John Singer Sargent was one of his pupils. Became the director of the French Academy in Rome in 1904.

Carpeaux, Jean-Baptiste (1827 Valenciennes – 1875 Château Bécon in Courbevoie, Seine) Studied sculpting under François Rude from 1844. Winning the Rome prize in 1854 enabled him to spend from 1856 to

Gustave Caillebotte, Self-portrait, ca. 1892, Musée d'Orsay, Paris

1863 in the Eternal City, where he familiarized himself with the works of Michelangelo and Bernini, both of whom were important to his work. The unveiling of his work *The Dance* (1869) at the Paris Opéra caused a scandal, and he was accused of realism and inappropriate modernity. Carpeaux produced in his artistic development of surface and the effects of light a combination of an innovative language of shape with traditional elements. He was one of the leading sculptors of the second part of the 19th century.

Carrière, Eugène (1849 Gournay-sur-Marne – 1906 Paris) Was one of the main representatives of Symbolism in France. Studied advertising lithography in Strasbourg from 1864, and also at the studio of Alexandre Cabanet. In order to survive, he worked both at his regular profession and as a decorative painter. Fame and commercial success came to him in the 1880s. The motifs of his landscapes, religious histories, portraits, and figures were in reduced colors and a mysterious semi-darkness with blurred contours, as if seen through a veil.

Cassatt, Mary (1845 Allegheny City, Pittsburgh, Pennsylvania – 1926 Château de Beaufresne au Mesnil-Théribus) The daughter of a wealthy Pittsburgh banker, she attended the Pennsylvania Academy of the Fine Arts from 1861 to 1865. From 1873 in Paris she was considered one of the established artists in the circle of Impressionists. She met Degas in 1877, who encouraged her to take part in their exhibitions. In 1879, Mary Cassatt took Impressionism as a style to America in her works. She and Berthe Morisot were considered the two most important female exponents of Impressionism; her work included paintings, watercolors, etchings, and drawings, predominantly of female figures and portraits. With her art, she made an important and lasting contribution to Japonisme in France.

Cavalier, Pierre-Jules (1814 Paris – 1894 Paris) Studied under the sculptor Pierre-Jean David d'Angers and under Paul Delaroche at the Ecole des Beaux-Arts in Paris from 1831 to 1836. On the advice of his teacher David d'Angers, he adopted a classic style of portraiture, strongly based on the ideal of antiquity, producing busts and medallions, allegorical sculptures, and statues of historical and contemporary figures. In 1864, Cavalier took over the master class in sculpture at the Ecole des Beaux-Arts in Paris.

Cézanne, Paul (1839 Aix-en-Provence – 1906 Aix-en-Provence) No other Impressonist artist went without official recognition for as long as Cézanne did. After studying law (having been turned down by the Ecole des Beaux-Arts in Paris), the son of a wealthy banker went to the private Académie Suisse in 1863, where he met Camille Pissarro and Auguste Renoir. His early work was inspired by Delacroix and the painters of the Renaissance, Venetian Mannerism, and the Baroque, which he copied in the Louvre. His collaboration with Pissarro in Pontoise and Auvers-sur-Oise from 1872 led to plein-air painting, light colors, and greater coloristic differentiation. This was when he started to paint landscapes in the style of Impressionism. However, the works he displayed at the exhibitions of 1874 and 1877 were greeted with scorn and ridicule. He became financially independent on the death of his father in 1886. Toward the end of the century his work started to receive the recognition it deserved, although he experienced only the early stages of this changing situation. His still lifes, landscapes, portraits, and figure compositions stayed traditional in style but provided plenty of inspiration for modern art. More than any other artist, his understanding of art, his rejection of imitation, and development toward the autonomy of painting continued to have a fundamental effect not only on his contemporaries, but also on various other directions of art until well into the 20th century.

Chassériau, Théodore (1819 El Limón near S. Bárbara de Samana, Dominican Republic – 1856 Paris) Studied at the studio of Jean-Auguste-Dominique Ingres from 1830 to 1834, who was at the time (along with Jacques-Louis David) the main representative of academic art. Changed direction completely in 1850,

to a Romantic colorism based on Eugène Delacroix. Paintings in the stairways of the audit office (destroyed 1844–1848, 1871) and in various churches bear witness to his importance as a leading creator of monumental wall paintings in Paris.

Claudel, Camille (1864 Fêre-en-Tardenois, Aisne – 1943 Montdevergues, Vaucluse) As a sculptress, the elder sister of writer Paul Claudel remained in the shadow of Auguste Rodin for a long time. She met him while studying at the Académie Colarossi in 1883, and became his colleague and mistress. Expansive Expressionism and shape-dissolving surface designs characterized her portrait busts and allegorical studies, which she exhibited regularly at the Salon between 1887 and 1905. After separating from Rodin in the mid-1890s, creative difficulties and crippling loneliness increasingly hampered her work, and she was committed to a psychiatric institution in 1913, where she remained until her death.

Cordier, Charles (1827 Cambrai – 1905 Algiers) Studied under a jeweler in Cambrai and under François Rude at the Ecole des Beaux-Arts in 1846/47. His busts of various races, created by the commission of the Musée d'Histoire Naturelle, whose exotic effects were increased by the variety and colors of the materials used, were an important contribution to polychromatic sculpture in the second half of the 19th century.

Cormon, Fernand (1845 Paris – 1924 Paris) Real name

Paul Cézanne, Self-portrait (detail), 1877–1880, Musée d'Orsay, Paris

Fernand-Anne Piestre. Studied under Jan Frans Portaels in Brussels, and under Alexandre Cabanel and Eugène Fromentin from 1863 to 1866. Cormon discovered the early history of the human race as a subject for his painting and produced biblical themes in a controversial naturalism (*Cain*, 1880). He created large decorative cycles of paintings, including several for the Musée d'Histoire Naturelle (1896–1898),

the Hôtel de Ville (1902), and the Petit Palais (1911). His studio fostered Vincent van Gogh, Paul Gauguin, and Henri de Toulouse-Lautrec.

Corot, Camille (1796 Paris – 1875 Paris) After an apprenticeship as a draper, he went on to study classic landscape art under Victor Bertin and others. Trained in Poussin's style, he copied works by Vernet and the 17th-century Dutch Masters as well as working from nature. His work was noticeably influenced by a number of extended stays in Rome. Corot's landscapes are noteworthy for their strict, clear composition, adherence to detail, and the freshness of the light and mood. At the end of the 1840s, inspired by artists of the Barbizon School, he developed a diffuse, blurred style of representation that submitted to the expression of atmosphere. His atmospheric landscapes had a strong influence on the Impressionists.

Camille Corot, Self-portrait at the Easel, 1825(?), Musée du Louvre, Paris

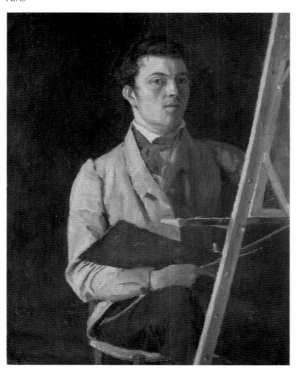

Courbet, Gustave (1819 Ornans near Besançon – 1877 La-Tour-de-Peilz near Vevey, Switzerland). Self-taught from 1840; copied works by Velázquez, Hals, and Rembrandt; also painted from nature. Influenced by his socialist friend Pierre-Joseph Proudhon, Courbet strove for a realistic form of representation that reflected the spirit of the times. He painted factually and without sentiment, choosing subjects from the everyday lives of farmers and laborers. He rejected the Academy and "official" historical painting, and was a cofounder of Realism. Despite criticism, he had his first success ca. 1850, especially in Germany, which he visited several times. In 1871, he joined the Paris Commune. Was arrested after it was defeated, and fled to Switzerland in 1873, and later died there.

Couture, Thomas (1815 Senlis – 1879 Villiers-le-Bel) Studied under Baron Antoine-Jean Gros, and from 1835 under Paul Delaroche. His monumental painting, *The Romans of the Decadence*, which was exhibited at the Salon in 1847, is one of the most discussed and reproduced paintings of the 19th century. Portrait and state commissions, the maintenance of his own studios and writing on the theory

of art were all key features in the productivity of this highly influential teacher and important exponent of monumental historical art, who was later unable to continue his success and disappeared into obscurity.

Cross, Henri-Edmond (1856 Douai – 1910 St-Clair) Real name Henri-Edmond-Joseph Delacroix. Went to Paris in 1878 to study under François Bonvin. Changed his name to Cross in 1883 to avoid confusion with Eugène Delacroix. His early works tended to be dark and realistic, but influenced by Seurat and Signac – with whom he set up the Société des Artistes Indépendants in 1884 – he turned to neo-Impressionism. The Pointillist, who was of great importance to the Fauves, produced Mediterranean landscapes based on the principles of color separation and lyrical, mythologically populated visions of nature.

Dalou, Aimé-Jules (1838 Paris – 1902 Paris) Was discovered as a sculptor and sponsored by his friend and teacher Carpeaux. Undertook numerous official commissions in London, where he spent from 1872 to 1879 in political exile, and in Paris, including *Charity* (1878) and his famous memorial, *Triumph of the Republic* (1889). As one of the key representatives of official art at the turn of the 20th century, Dalou created an extensive oeuvre of public monumental works, architectural, portrait and forms of sculpture, and became one of the main exponents of neo-Baroque and neo-Rococo.

Daumier, Honoré (1808 Marseilles – 1879 Valmondois, Val-d'Oise) Became famous for his political caricatures, which appeared between 1832 and 1835 in *La Caricature* magazine and in *Le Charivari* between 1833 and 1860. They also brought him a six-month prison sentence. Daumier worked for Zépherin the publisher in the new medium of lithography, and became the most important artist in France in this field. He combined a number of contradictory characteristics: The satirically biting chronicler of Parisian daily life was a realist, but was admired as a Romantic for his spirit of invention and his commitment to allegorical and religious themes. Balzac and

Gustave Courbet, Self-portrait (detail), 1863, Mesdag Museum, The Hague

Daubigny compared him with Michelangelo, others with Tintoretto and Goya. His famous busts of the *Deputies* (from 1831) bear witness to Daumier's mercilessly satirical language of form, which was also strongly evident in his sculptural works.

Decamps, Alexandre-Gabriel (1803 Paris – 1860 Fontainebleau) Was one of the first artists to discover the Orient as a theme for Romantic painting, doing so on a voyage through Asia Minor in 1827. Trained under architectural artist Etienne Bouhot from ca. 1816, and from 1817 in the studio of Abel de Pujol, a former pupil of David. Around the middle of the 19th century, Decamps' Eastern paintings, biblical and historical scenes, landscapes, drawings, book illustrations, and lithographs made him one of the most celebrated Salon painters and Orientalists.

Degas, Edgar (1834 Paris – 1917 Paris) Born Hilaire-Germain-Edgar de Gas into a wealthy banking family. Studied in Paris from 1853 to 1855 under Ingres' successors Louis Lamothe and Hippolyte Flandrin, who passed on their valuable expertise on the works of Ingres. Degas maintained friendships with Renoir and Monet and participated in Impressionist exhibitions. His main interest, however, was the human – and in particular the female – form; to him, its poses and movements were synonymous with perfection and harmony. The way he treated space and light in his works depicting jockeys, dancers, and washerwomen (which from the late 1870s he produced primarily in watercolors) was what differentiated his output from classic images and identified his proximity to neo-Impressionism. From 1865 he created a

Edgar Degas, Degas and Evariste de Valernes (detail), ca. 1865, Musée d'Orsay, Paris

number of wax figures, mostly of dancers. These were not intended for public display, and were in fact not cast in bronze until after his death.

Delacroix, Eugène (1798 St.-Maurice-Charenton near Paris – 1863 Paris) The defining artist of the 19th century. From 1815 he attended the studio of Pierre Guérin and the Ecole des Beaux-Arts in Paris. He was greatly inspired by the works of Goya, Rubens, and Veronese; later he admired the light, fresh color-work of Constable, which persuaded him to visit London in 1825. A second decisive journey in 1832 took him to North Africa and southern Spain. Delacroix, who joined the Academy in 1857, was the leader of Romantic painting in France. His designs, which developed solely from brilliant colors, rejected "official" classicism. His belief that color should reproduce light (amongst other things) and that shadow is its colored reflection proved to be of utmost importance to the generation of the Impressionists.

Delaroche, Paul (1797 Paris – 1856 Paris) Real name Hippolyte Delaroche. Studied under Antoine-Jean Gros, and became the leading exponent of the historical genre, a trend that dealt with historical themes. Already successful in the Salon of 1822, Delaroche's theatrically inspired, precisely researched representations suited the tastes of the juste milieu, the public at the time of Louis-Philippe. His main work was the semicircular painting *Apotheosis of the Visual Arts* (1837–1841) in the Ecole des Beaux-Arts. Between 1835 and 1840, Delaroche was one of the most popular teachers in France; Couture, Gérôme, and Millet were just a few of the renowned artists who worked in his studio.

Deloye, Gustave (1838 Sedan – 1899 Paris) Studied at the Ecole des Beaux-Arts in Paris from 1857. The large number of allegorical/mythical, partly polychromatic statues, statuettes and groups of sculptures, busts, and medallions bear witness to his extraordinary productivity. He worked for clients in Russia and Italy, relocating to Vienna in 1873, where he was sponsored by Prince Johann von Liechtenstein.

Eugène Delacroix, Self-portrait, ca. 1840, Uffizi gallery, Florence

provided the themes for this conservative artist: Representations of actual war events and historical scenes from the time of Napoleon Bonaparte, paintings and two panoramas with monumental battle scenes, one of which was exhibited in Paris in 1882 and the other in Vienna in 1883.

Dupré, Jules (1811 Nantes – 1889 L'Isle-Adam, Val-d'Oise) Along with Daubigny, Diaz de la Peña, Millet, and his friend Théodore Rousseau, Dupré was from the Barbizon School. He first worked in his father's porcelain works in Parmain, then studied under landscape artist Jean-Michel Diébolt. From 1840 in Barbizon, the Mecca of plein-air painting, and other villages in the Ile-de-France, such as L'Isle Adam and L'Isle-Saint-Denis, Dupré cultivated the new *paysage intime* in small, elegiac landscapes. From 1868 he produced seascapes in Cayeux-sur-Mer.

Eakins, Thomas (1844 Philadelphia – 1916 Philadelphia) Studied under Jean-Léon Gérôme in Paris from 1866, then moved to Philadelphia to live and teach. Eakins made his name with his exceptional portraits and genre scenes. In his representations of modern American heroes, e.g. his *Portrait of Professor Rand* (1874) and *The Gross Clinic* (1875), which were in the style of Rembrandt and Velázquez, he combined an Old Master picture scheme with contemporary subjects; he became one of the most significant American Realists.

Falguière, Alexandre (1831 Toulouse – 1900 Paris) Was a student of François Jouffroy in Paris. Spent the years 1860 to 1867 in Rome. Alexandre Falguière was regarded as the successor to Jean-Baptiste Carpeaux, and the first Realist of 19th-century French sculpture. His restrained classical, and in most cases, female mythological figures – the Dianas, nymphs, and bacchantes – made him extremely popular. He also created busts and monuments. From the early 1870s he added historical and landscape painting to his body of work.

Denis, Maurice (1870 Granville, Manche – 1943 Paris) Together with Bonnard, Dérusier, and Vuillard, he was one of the founders of the Nabis in 1889. In 1888 he went to the Académie Julian and the Ecole des Beaux-Arts in Paris. In 1891 he worked in a community with Bonnard and Vuillard, exhibiting at the Salon des Indépendants. Developing the beliefs of the Nabis in his theories of art, he strove to imbue art with ideas of Christianity, and in 1919 he established the Ateliers d'Art Sacré, the workshops for Christian art.

Detaille, Edouard (1848 Paris – 1912 Paris) Trained in the studio of Ernest Meissonier. From 1867 until his death he exhibited regularly and successfully at the Paris Salon. The example of his teacher and his involvement in the Franco-Prussian War (1870/71)

Fantin-Latour, Henri (1836 Grenoble – 1904 Buré, Orne) In the circle of Impressionists he found a Romantic style of painting that was somewhere between Realism and Symbolism. Studied under his father, the artist Jean-Théodore Fantin-Latour, and later under Courbet. Like Manet, this admirer of Richard Wagner belonged to the artistic circle of the Café Guerbois, to whom he paid tribute in his programmatic pictures in the style of the Dutch group portraits of the 17th century, such as *Homage to Delacroix* (1864) and *The Studio in Batignolles* (1870). His highly impressive still lifes of flowers were inspired by Courbet.

Fremiet, Emmanuel (1824 Paris – 1910 Paris) Gained his first artistic experiences as a modeler of anatomical wax preparations for the Ecole de Médicine in Paris. Studied in the studio of his uncle François Rude from 1840. Specialized in animal sculptures but also produced sculptures of horses and riders, statues and statuettes, medallions, and commercial art. He also produced large amounts of important anatomical and natural history sketches in his role, from 1875, as professor of drawing at the Musée d'Histoire Naturelle. He was an important exponent of Scientific Realism.

Fromentin, Eugène (1820 La Rochelle – 1876 Saint-Maurice near La Rochelle) From 1843 he studied under landscape artist Louis Cabet and Oriental artist Prosper Marilhat. Produced primarily atmospheric Oriental landscapes, which were the fruits of three trips to North Africa between 1846 and 1853. As well as his novel *Dominique* (1862), Fromentin also wrote a collection of essays on the Dutch Masters of the 15th and 17th centuries, *Les maîtres d'autrefois* (1876), at the time highly influential pieces of artistic literature that had considerable influence on later generations of artists.

Froment-Meurice, François-Désiré (1802 Paris – 1855 Paris) The son of a goldsmith, he learned his father's profession under his stepfather Pierre Meurice. Received strong encouragement from the silversmith

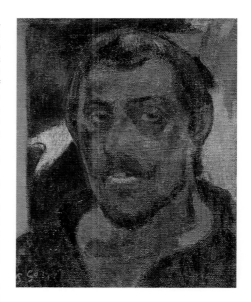

Paul Gauguin, Self-portrait, ca. 1888, Pushkin Museum, Moscow

and engraver Charles Wagner. Appointed Argentier de la ville de Paris (silversmith of the city of Paris), Froment-Meurice ran a flourishing workshop and supplied goods to clients of the highest social standing all over the world, including the shah of Persia and popes Gregory XVI and Pius IX. Froment-Meurice was hailed as a new Benvenuto Cellini (1500–1571), and is considered the major goldsmith of the Romantic movement.

Gallé, Emile (1846 Nancy – 1904 Nancy) One of the most imaginative glass and furniture artists of the Art Nouveau style. He trained in an industrial glassworks in 1866/67, then entered his father's faience works in Saint-Clément. The works was moved to Nancy in 1874, and a furniture-manufacturing workshop was

added in the 1880s. Gallé became the artistic director and took the company to several world exhibitions with his incomparable glass artwork – produced using the latest technology – as well as furniture, making the company world famous at the same time. In 1901 he established the School of Nancy, which became the second leading regional center for Art Nouveau after Paris.

Gauguin, Paul (1848 Paris – 1903 Hiva-Oa, Marquesas Islands) Joined the merchant navy, and traveled the world's seas from 1865 to 1871. Turned to art in 1882; met Manet, Degas, Renoir, and Pissarro, and took part in a number of Impressionist exhibitions. His wanderlust took him to Pont-Aven, where a number of other artists gathered around him in a loose group. Went to Arles to be with van Gogh in 1888, and finally to the South Seas in 1895, where he developed his style of large, exotic expanses of color with strong light and which strongly influenced the Nabis, the Fauves, and the Expressionists.

Gérôme, Jean-Léon (1824 Vesoul, Haute Saône – 1904 Paris) Visited Rome with his teacher Paul Delaroche in 1844 and studied in the studio of Charles Gleyre. His *Cockfight* was a huge success in the Salon of 1847. Just as Delaroche specialized in the historic genre, Gérôme created scenes from modern history, antiquity, and the Orient in colonial colors. His slave markets, women's baths, and harem scenes had an effect on the public resulting from the sensual, licentious character of his usual style. Produced sculptures from 1878 that confirmed the high technical virtuosity of this conservative classicist.

Gleyre, Charles (1806 Chevilly, Waadt – 1874 Paris) Took over Delaroche's frequently visited studio in 1843, and – like Delaroche – proved highly successful as a teacher. His best-known students were Bazille, Gérôme, Monet, Renoir, Sisley, and Whistler. Gleyre studied under Richard Parkes Bonington in Paris from 1825. Went to Rome in 1830, where he was advised by Léopold Robert and the Nazarenes. Returned to Paris after traveling to the Orient from 1834 to 1837. Influenced by the execution of the new ideas of classicism of David's group and students; became a leading exponent of Romantically inspired classicism.

Gogh, Vincent van (1853 Groot-Zundert – 1890 Auvers-sur-Oise) Became a lay preacher in the Belgian coal-mining area of Borinage after studying theology. Studied art from 1880 in Brussels and Antwerp, and in Paris from 1886 to 1888. His early works derived from the Hague School. His landscapes, portraits, and still lifes, produced in Paris under the influence of the Impressionists and Pointillists, and in Arles from 1888 in a feverish frenzy of activity, are testimony to his wholly independent style that used color with an increasing force of expression. A nervous complaint led him to enter the Saint-Rémy institution in 1889, shortly after being released he committed suicide.

Vincent van Gogh, Self-portrait with Bandaged Ear, 1889, private collection, Chicago

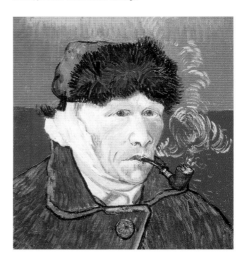

Guillaume, Eugène (1822 Montbard – 1905 Rome) Student of James Pradier in Paris from 1841. Won the Rome prize and spent from 1846 to 1850 in Italy. On his return he carried out commissions for the façades of Paris churches, including decorative statues. Made his name in the Salon of 1853 with his strictly classical group of figures, *The Cenotaph of the Gracchi* (1848/1853). In 1864 he became director of the Ecole des Beaux-Arts. His extensive portrait sculptures, monuments, and tombs revealed a great interest in the art of Antiquity.

Guillaumet, Gustave (1840 Paris – 1887 Paris) Studied under François-Edouard Picot and Abel de Pujol at the Ecole des Beaux-Arts. After 1861 his works were regularly displayed at the Salon. A prolonged stay in Algiers inspired him to produce widely varied desert landscapes and genre representations of African natives, gaining himself an important position in the ranks of Orientalists. His travel memoirs were published in 1888 under the title *Tableaux algériens*.

Guillaumin, Armand (1841 Paris – 1927 Paris) Was initially a "Sunday painter" while employed by the Paris-Orléans rail company, then later by the city of Paris. After winning a lottery in 1892 he was able to devote himself to his art. At the Académie Suisse in Paris in 1864 he met Cézanne and Pissarro; he participated in the Salon des Refusés in 1863. From 1874 he also appeared at the Impressionist exhibitions. In Pontoise, Auvers-sur-Oise and in the area around Paris he produced a number of Impressionist landscapes that are noted for their use of color.

Guimard, Hector (1867 Lyon – 1942 New York) Attended the Ecole des Arts Décoratifs in 1882; studied architecture from 1889–1893 at the Ecole des Beaux-Arts in Paris. Guimard, whose furniture, glass, and ceramics were extremely popular in the field of applied art, received considerable support from the Belgian architect Victor Horta. Guimard's magnum opus was the Paris apartment block Castel Béranger (1894–1898). The exterior was conventional, the interior a cool combination of metal,

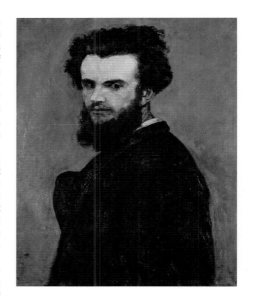

Armand Guillaumin, Self-portrait, ca. 1875, Musée d'Orsay, Paris

faience, and glass. However, he made his name with his entrances to the metro (1899–1904) that still influence the face of the city of Paris to this day.

Hodler, Ferdinand (1853 Bern – 1918 Geneva) Studied in Geneva under landscape artist Barthélémy Menn from 1871. An extended trip to Spain in 1878/79 lightened his palette, and he moved on from his naturalistic-realistic early works to a strict style with clear form. Hodler produced works of large, symbolic figures in rhythmic repetitions, and of historical events. His historical pictures such as *The Return from Marignano* (1896/1900) and the *Departure of the Jena Volunteers in 1813* (1908) were attempts at new monumental designs. His form of composition, which he frequently referred to as "parallelism," also marked

his Symbolist landscapes, which were huge successes with the Viennese Secession.

Hoetger, Bernhard (1874 Hörde near Dortmund – 1949 Beatenberg near Bern) First served an apprenticeship to a stonemason and sculptor, then studied at Düsseldorf Art Academy from 1898 to 1900, and in Paris from 1900 to 1907. Hoetger lived, taught, and worked in the artists' colonies of Darmstadt (Mathildenhöhe) and Worpswede. Of his extensive oeuvre, his early works were influenced by Rodin; his balanced, easily understood forms were also influenced by Maillol and his inclination toward formal simplification. He subsequently adopted a drier Expressionist style. As an architect, Hoetger's designs included the Paula-Becker-Modersohn house in Bremen (1926–1930).

Hoffmann, Josef (1870 Pirnitz, Moravia – 1956 Vienna) Studied under architect Otto Wagner at the Academy of Vienna. Joined the Secession in 1897. Professor of architecture at the Vienna Kunstgewerbeschule, and set up the Wiener Werkstätte with Moser in 1903. Followed Morris's ideas in his principle of the close interconnection between architecture and craft. His works developed from Art Nouveau; their hard, rectangular shapes were obviously influenced by Mackintosh. In his main work, the construction of the elegant town house (1905–1911) for Brussels banker Adolphe Stoclet, he used marble and bronze to achieve a level of elegance and magnificence that had never been seen before.

Homer, Winslow (1836 Boston – 1910 Prout's Neck, Maine) Studied under a Boston lithographer and at the New York National Academy of Design from 1859. Reported for *Harper's Weekly* on the American Civil War; his war scenes and paintings presented a clearly negative picture of the African American race. Produced genre scenes, coastal landscapes, and seascapes, among other things, in Tynemouth on the coast of northern England from 1881/82. His lively watercolors made Homer one of the leading American landscape artists at the end of the 19th century.

Ingres, Jean-Auguste-Dominique (1780 Montauban – 1867 Paris) Studied at the Academy of Toulouse from 1791 to 1796, then under David in Paris. Lived in Florence and Rome between 1806 and 1824, then returned to Paris. In 1853, he was invited to the Academy of Rome, where he taught until 1841. Initially strongly influenced by David, Ingres turned increasingly to early Renaissance art; his particular models were Raphael, Holbein, and Titian. Harmony, dimensions, clever composition, and a delicate surface treatment are key features of his works. As a representative of late classicism, he was the opposite of Delacroix, who was vehemently against "official" art such as his.

Klimt, Gustave (1862 Baumgarten near Vienna – 1918 Vienna) Widely regarded as the leading exponent of Viennese Art Nouveau. Studied at the Staatliche Kunstgewerbeschule from 1876 to 1883; one of the founder members of the Vienna Secession in 1897 and president until 1905, when he left. With his subtle color schemes, abstract ornamental shapes, and rippling decoration, Klimt painted clever pictures of figures, portraits, and landscapes. His unusual combinations of different art styles of the end of the 19th century were in what was known as the "Secession style."

Lalique, René (1860 L'Hay-les-Roses, Val-de-Marne – 1945 Paris) Studied the goldsmith's art at the Ecole des Arts Décoratifs; opened his own studio in 1885, where he worked for the leading Parisian jewelers. His innovative creations displaced the jewelry designs of historicism. Plant and animal motifs in lined, flowing shapes and the use of a wide range of materials – crystal, glass, semiprecious stones, enamel, mother-of-pearl, and ivory – are key features of his style, which fascinated Parisian society at the turn of the 20th century. From 1907 he devoted himself to glass art and Art Déco, and established his own glass manufacturing works in 1914.

Laloux, Victor (1850 Tours – 1937 Paris) Studied under Jules André in Paris from 1869 to 1877. Appointed professor of architecture at the Ecole des Beaux-Arts in 1889, Laloux won the competition to build the

Gare d'Orsay (1898–1900), one of the last examples of academic architecture in Paris and in which stone and stucco were used to conceal the steel construction. Laloux also revealed himself as an historicist architect in other buildings, such as the Basilica Saint-Martin, the town hall, and the railroad station in Tours, the town hall in Roubaix, and the renovation of the palaces of Courtauraux and Saucourt.

Luce, Maximilian (1858 Paris – 1941 Paris) Began his artistic career in 1872 as a woodcarver and lithographer. In 1877, he attended the Académie Suisse and joined the studio of Carolus-Duran. He was advised by Camille Pissarro, Paul Signac, and Georges Seurat, followed the style of neo-Impressionism until ca. 1900, and then concentrated mainly on Impressionist landscapes.

Mackintosh, Charles Rennie (1868 Glasgow – 1928 London) Studied architecture in Glasgow from 1885 to 1889. From 1890 he created architectural designs, interiors, and commercial art. Completed his magnum opus, the Glasgow School of Art, between 1907 and 1909. His clear, rational designs and the combination of sharp-edged shapes with long, flowing lines had a marked effect on developments in other countries, e.g. Art Nouveau in Vienna. Mackintosh left the architectural offices of Honeyman & Keppie in 1913, where he had been a partner since 1904, and devoted himself solely to his art, producing highly unusual and expressive watercolors.

Maillol, Aristide (1861 Banyuls-sur-Mer – 1944 Banyuls-sur-Mer) Studied under Jean-Léon Gérôme and Alexandre Cabanel; under the influence of Gauguin, adopted an artistic style which emphasized line. He formed links with the Nabis from 1893. Produced wall hangings, woodcuts for book illustrations, and small statues in wood and clay. Then worked as a self-taught sculptor. The heavy, closed voluminous figures, strict in form and with an antique-classic simplicity of movement, mark the new style of this sculptor who was such a key figure in modernism at the turn of the 20th century.

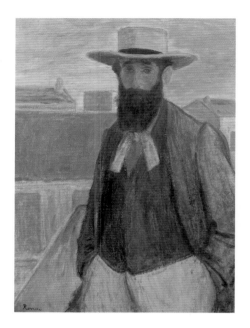

Aristide Maillol, portrait by Joszef Rippl-Ronai, 1899, Musée d'Orsay, Paris

Majorelle, Louis (1859 Toul – 1926 Nancy) Was with Gallé one of the leading carpenters of the Nancy School and French Art Nouveau. After studying painting under Jean-François Millet in Paris, he took over his father's furniture factory in Nancy in 1879. His designs, which bore a floral marquetry after 1894, adapted Art Nouveau shapes for practical, daily requirements, which made his furniture available to more people. After the destruction of his factory in 1916, Majorelle turned to the construction of more Cubist, strict forms and lines, and his work set the course for Art Déco.

Manet, Edouard (1832 Paris – 1883 Paris) Studied at the studio of Thomas Couture from 1850 to 1856. Like Fantin-Latour, he occupied himself closely with the Old Masters in the Louvre, and copied Titian, Tintoretto, Rembrandt, and Velázquez (amongst others) on his travels through Europe. Manet caused a scandal with his works *Le Déjeuner sur l'herbe* (1863) and *Olympia* (1863), and was seen as a Realist who was inspired by Spanish art. In his later oeuvre, which consisted of portraits, landscapes, and still lifes, the emphasis on the picture surface and the reduction in color shading result in a spontaneous and consistent light art that was a determining contribution to Impressionism.

Meissonier, Ernest (1815 Lyon – 1891 Paris) Studied under Léon Cogniet in 1833/34. His extensive success, which started in 1834 with his Salon début, peaked in 1861 when he was made a member of the Académie des Beaux-Arts. His miniaturist, extremely carefully painted genre scenes made him one of the leading Salon painters and he won the highest awards for the technical perfection of his paintings. He produced naturalistic-realistic war pictures and military scenes during the Second Empire, and others inspired by the Franco-Prussian War of 1870/71 and the Commune. Established the Société Nationale des Beaux-Arts with Puvis de Chavannes in 1890.

Mercié, Antonin (1845 Toulouse – 1916 Paris) Studied sculpture under François Jouffroy and Falguière in Paris. Winner of the Prix de Rome, he spent the years 1869 to 1873 at the Académie de France in Rome. Back in Paris, Mercié soon made his name with his *David*, which was inspired by the Italian Renaissance, and became one of France's leading sculptors. He taught at the Académie Julian, and from 1900 at the Ecole des Beaux-Arts. Made president of the Société des Artistes Français in 1913. Tombstones, busts, architectural models, and statues of horses and riders for clients all over the world completed the oeuvre of this painter and sculptor.

Meunier, Constantin (1831 Brussels – 1905 Brussels) Commissioned by the Church to produce religious historical pictures between 1857 and 1875. After 1880 discovered his main theme in industrial regions and coal mines, namely the representation of work in Naturalist paintings. From 1885, as a sculptor he produced monumental realistic figures that lacked the pathos of Rodin. As unmistakable counterparts to Millet's farmers, his modern heroes testified to the French painter's influence on the main exponents of Belgian sculpture.

Millet, Jean-François (1814 Gruchy near Greéville – 1875 Barbizon) Was one of the leading figure painters of the School of Barbizon. The son of Norman farmers, he started drawing at an early age. Studied under Paul Delaroche in Paris from 1837, concentrating on Rococo fashions and gracious shepherd scenes in the style of the 18th century. Fled from the cholera in Paris and arrived in Barbizon in 1849, where Troyon, Rousseau, Diaz de la Peña, and Dupré were already working. Painted landscapes only

Ernest Meissonier, Self-portrait (Detail), 1889, Musée d'Orsay, Paris

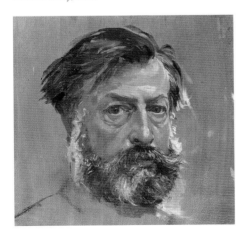

occasionally, preferring his allegorical monumental representations of farming life, the melancholy dignity of which had a marked effect on van Gogh, amongst others.

Monet, Claude (1840 Paris – 1926 Giverny) Introduced to plein-air painting by Boudin in Le Havre. As a pupil of Charles Gleyre, he met Renoir, Sisley, and Bazille, achieved moderate success with paintings of figures, and was influenced by William Turner. His harbor painting, *Impression: Sunrise*, exhibited by Nadar in 1874, inspired the critics to many puns, and gave the group of artists around Monet, the Impressionists, their name. In the intense study of light and atmosphere and endless variations on the picture motif, which was of secondary importance in his

Claude Monet, Self-portrait, 1917, Musée d'Orsay

work, Monet worked consistently to achieve art of the purest visual impression, culminating in the almost nonobjective lyrical abstraction of his waterlilies (from 1899), which he painted in his garden at Giverny. Monet was the main representative of French Impressionism.

Morbelli, Angelo (1853 Alessandria – 1919 Milan) Studied under Giuseppe Bertini at the Accademia di Brera in Milan from 1867 to 1876. Initially a painter of Romantic historical works, this follower of Friedrich Engels and representative of Social Realism produced pictures of his home between Milan and Turin in strict, formal compositions and Divisionist techniques, the theoretical reasons for which are contained in his essay "La Via Crucis del Divisionismo" (1912–1917).

Moreau, Gustave (1826 Paris – 1898 Paris) Trained in the studios of François-Edouard Picot and Théodore Chassériau. Financially independent, Moreau traveled Italy from 1857 to 1859 and exhibited, albeit irregularly, at the Salons between 1852 and 1880. His last exhibition was in 1886 at the Goupil gallery. In mystical, dreamy, fantastic visions of exotic draperies and Oriental décor, he created mythological and religious themes as symbols of the irrational and unfathomable. Influenced by England's Pre-Raphaelites and the Italian Quattrocento, Moreau was regarded as one of the leading exponents of Symbolism. Henri Matisse and Georges Touault were among the artists to train under him.

Morisot, Berthe (1841 Bourges – 1895 Paris) Studied from 1857 under Geoffroy-Alphonse Chocarne, and from 1858 to 1860 under Joseph Guichard in Paris. In 1860 she met Corot, who was her teacher until 1868. She produced her first landscapes in Pontoise and Auvers-sur-Oise in the summer of 1863. Through Manet, for whom she frequently modeled, she gained contact with the Impressionists, and joined in their exhibitions. In 1874 she married Eugène, Manet's younger brother. Her free, and brightly colored, assured works included many pictures of women and

children, and she and Mary Cassatt were the two leading female exponents of Impressionism.

Morris, William (1834 Walthamstow, Essex – 1896 London) The founder of the Arts and Crafts Movement was the trailblazer of modern design. On his travels through England, Belgium, and France and under the influence of Dante Gabriel Rosetti in 1857/58, he received strong impulses from the art of the Middle Ages and the Pre-Raphaelites. In 1861, he established the first modern workshop for commercial art, which operated under the name of Morris & Co. He designed carpets, wallpapers, windows, furniture, glasses, and tiles with usually flat, ornamental, Gothic-based symbols. Established the Kelmscott Press in London in 1891, which played a key role in the development of book design.

Modser, Koloman (1868 Vienna – 1918 Vienna) Artist and designer who was a key figure in the development of Art Nouveau in Austria. In 1897 he cofounded the Vienna Secession. Taught at the Kunstgewerbeschule from 1899, and set up the Wiener Werkstätte with Hoffmann in 1903, where he remained until 1907. Preferred geometric, ornamental shapes in his works. His designs of furniture, jewelry, toys, glasses, and silverware bear witness to the versatility of this highly productive artist. He achieved new forms of expression with his designs for books and posters, as well as the illustrations for *Ver Sacrum* magazine.

Munch, Edvard (1863 Løten, Hedmard – 1944 Ekely) Was a pupil of Naturalist Christian Krog in Christiania (Oslo) and of Léon Bonnat in Paris. After initial attempts at plein-air painting, Munch was strongly influenced by the art of Gauguin, van Gogh, and Toulouse-Lautrec in Paris and was influenced by Art Nouveau and the fin de siècle to produce a symbolic, expressive picture form. Munch's style of areas of color that were dominated by lines, silhouettes, and shapes – he also produced portraits and designed stage sets – involved the subjects of love, fear, and death. His colors and shapes conveyed atmosphere;

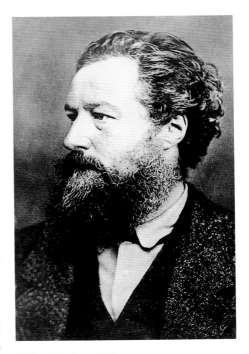

William Morris, ca. 1890

the nature of his landscapes was a world of emotion and pathos. Together with Gauguin and van Gogh, Munch is regarded as one of the great pioneers of Expressionism.

Neuville, Alphonse de (1835 St. Omer – 1885 Paris) Trained under François-Edouard Picot and Delacroix while also studying law. His battle scenes appeared regularly at the Salons from 1859 onward. As a colleague of Edouard Detaille, de Neuville was involved in the execution of the two panoramas with the monumental battle scenes of Rezonville and Champigny, which were displayed in Paris in 1882 and in Vienna

Odilon Redon, Self-portrait, 1867, Musée d'Orsay, Paris

in 1883. De Neuville also produced illustrations for the books by Jules Verne.

Pissarro, Camille (1830 St. Thomas, Antilles – 1903 Paris) Was the oldest of the French Impressionists. Studied at the Académie Suisse in Paris from 1855. His plein-air paintings, peaceful countryside scenes, are reminiscent of Courbet and Corot, and yet also a symbol of an Impressionist art that saw him in Pontoise in 1874 collaborating with Cézanne. From time to time, Pissarro adopted the strict system of the Pointillists, but returned to his original style in 1890. Despite being influenced from various quarters, his oeuvre is generally uniform. Apart from Monet and Sisley, Pissarro was one of the masters of Impressionism, and

the only one to attend all eight of their exhibitions.

Pradier, James (1790 Geneva – 1852 Paris) Real name Jean-Jacques Pradier. Taught by the classicist sculptor Francois-Frédéric Lemot from 1809. Devoted intensive study to antiquity from 1813 to 1819. Success arrived during the time of Louis-Philippe, when there was much demand for public monuments. Pradier was inundated with commissions. As well as marble sculptures, the works of this Neoclassical artist, who was also influenced by Romanticism, included portrait statues, reliefs, and terracotta bozzetti.

Puech, Denys (1854 Gavernac, Aveyron – 1942 Rodez) Studied sculpture under François Jouffroy and Alexandre Falguière from 1872. In 1884 he won the Prix de Rome, after which he spent several years in Italy. He then exhibited at the Salon and at the Société des Artistes Français. He produced his classic works, which included allegorical and some polychromatic figures, monuments, portrait busts, and religious sculptures, in marble or plaster. The allegorical personification of the Seine, produced in 1887 as a relief, was one of his major works. From 1921 to 1933, Puech was the director of the Villa Medici in Rome.

Puvis de Chavannes, Pierre (1824 Lyon – 1898 Paris) A student of Henri Scheffer, Couture, and Delacroix in Paris. Strongly influenced by the works of Chassériaus in the audit office, his monumental compositions of representative buildings, his Christian-mythological themes and allegories in light, transparent colors lie somewhere between Neoclassicism and Symbolism. The major works by this leading French wall painter of the 19th century were his *Scenes from the Life of St. Genoveva* (1874–1877) in the Panthéon in Paris. In 1890, Puvis de Chavannes cofounded the Société Nationale des Beaux-Arts with Meissonier.

Redon, Odilon (1840 Bordeaux – 1916 Paris) Taught by Jean-Léon Gérôme and graphic artist Rodolphe Bresdin, but did not turn to lithography until 1878, doing so on the advice of Fantin-Latour. In 1884, with Bernard, Gauguin, and Seurat established the Salon des Indépendants. The mysterious world of dream

visions and grotesques, inspired by Hieronymus Bosch, Pieter Bruegel, and Francisco de Goya – and leading the way for the Surrealists – later gave way to a more decorative style of flower painting. In his strongly literary works and illustrations for Baudelaire, Poe, and Flaubert, Redon revealed himself as a leading exponent of Symbolism.

Auguste Renoir, Self-portrait (detail), 1879, Musée d'Orsay, Paris

Regnault, Henri (1843 Paris – 1871 Buzenval) Trained from 1860 in the studios of Louis Lamothe and Alexandre Cabanel at the Ecole des Beaux-Arts in Paris. Awarded a scholarship with the Prix de Rome in 1866, which he used primarily for an extended stay in Spain, where he was strongly influenced by the works of Diego Velázquez and Francisco de Goya. His dark-toned portraits, historical pictures and watercolors of the Orient were based closely on the Spanish Masters, the artistic treatment of the Oriental-exotic décor carried out with considerable style and expertise.

Renoir, Auguste (1841 Limoges – 1919 Cagnes-sur-Mer, Nice) Began his career as a painter of porcelain, fans, and curtains. From 1861 he studied with Bazille, Monet, and Sisley in the studio of Charles Gleyre. After figurative works and portraits in the Impressionist style, his palette was strongly influenced by a trip to Algiers and Italy in 1881/82. Under the influence of Ingres, Raphael and the Italian Quattrocento painting, his figures became more classical and gained in monumentality. A relaxed artistic style, softness, and sensuality dominate the (primarily) nudes and figure portraits of his later work.

Rodin, Auguste (1840 Paris – 1917 Meudon) Is regarded as the leading sculptor of the 19th century. Turned down repeatedly by the Ecole des Beaux-Arts, he worked with Albert-Ernest Carrière-Belleuse from 1864 to 1870 and for Sèvres, the porcelain manufacturers. A trip to Rome and Florence in 1875 brought him into contact with the works of Michelangelo and Donatello, and he developed a revolutionary style. With his major work, *The Burghers of Calais* (1884–1886), Rodin produced a new type of memorial in the academic sense that lacked a heroic declaration in the academic style. In his portrait statues, sculpture groups, and sculptures, he achieved a form of expressiveness that had never been seen before, creating psychological expression and emotional stimulation through the dissolution of the surfaces and the increased effects of light and shadow.

Rosso, Medardo (1858 Turin – 1928 Milan) Attended sculpture classes at the Accademia di Brera in Milan in 1882, and then studied with Jules Dalou in Paris from 1884 to 1886, where he became familiar with the sculptures of Rodin and the paintings of the Impressionists. His were everyday themes, and he reproduced visual impressions in three dimensions. Rosso modeled primarily in wax and plaster, and continued the dissolution of form in the Impressionist sense. Sculptors of the early 20th century owe him a debt of gratitude for various impulses to creativity.

Rousseau, Henri (1844 Leval – 1910 Paris) Was called Le Douanier, "the customs officer," which was his true profession, and which he was when he entered the annals of art history. Self-taught, he appeared at the 1885 Salon des Indépendants. Although mocked by the public, he was highly regarded by Gauguin, Redon, Seurat, and Pissarro, and later by Picasso and Delaunay as well. To artists seeking new means of expression, his works came as a revelation. Rousseau's naive art, noted for its variety and simplicity, reveals an exotic dream world in hard, determined forms of magical forcefulness; the fantasy and naive force of their designs had a considerable effect on modern art and the following generation of Surrealists.

Rousseau, Théodore (1812 Paris – 1867 Barbizon) trained at the Ecole des Beaux-Arts in Paris, and copied the works of Claude Lorraine and the Dutch landscape painters of the 17th century in the Louvre. He created highly impressive nature studies on extensive journeys through Normandy, the Auvergne, the Jura, and Switzerland. A friend of Dupré, Rousseau moved to Barbizon in 1847. Moved from Romantic landscapes with powerful expression to *paysage intime*, small-scale landscapes, atmospheric in mood and in glowing colors. Was, with Dupré, one of the leading representatives of the Barbizon School.

Rude, François (1784 Dijon – 1855 Paris) Trained under classical sculptor Pierre Cartellier in Paris from 1805. A follower of Napoleon, he had to leave France after the latter's fall in 1814. Success arrived on his return from exile in Brussels in 1827. Fame came with his relief, completed in 1836, *La Marseillaise*, on the plinth of the Arc de Triomphe. With his independent combination of the commonplace and heroism in his portrait busts, statues, and monuments, his oeuvre is somewhere in between Romanticism and classicism.

Rysselberghe, Theo van (1862 Ghent – 1926 St.-Clair) Studied at the Academies of Ghent and Brussels. In 1884, he was one of the cofounders of the Brussels artists' group Les Vingt. Met Seurat and Signac in 1886; joined the neo-Impressionists. Exhibited at the Salon des Indépendants. His work included figures, landscapes, and portraits. Van Rysselberghe was one of the Belgian neo-Impressionists.

Sérusier, Paul (1864 Paris – 1927 Morlaix, Finistère) An art student of the Académie Julian in Paris in 1888, he went to Pont-Aven and met Paul Gauguin, who had a marked influence on his work. Sérusier later recorded the teachings of Gauguin in his *ABC de la peinture* (1921), and advocated a serious, religious style of art with simple drawing and expressive coloring. Simplified forms and naive plainness are key features of Sérusier's symbolic work.

Seurat, Georges (1859 Paris – 1891 Paris) Studied from 1878 under former pupil of Ingres Henri Lehmann at the Ecole des Beaux-Arts in Paris. Despite an admiration for Impressionism, as a style it was too spontaneous and casual for Seurat's liking. In 1884 he cofounded the Société des Artistes Indépendants. Impressed by scientific discoveries regarding the physical properties of light and color, Seurat developed a complex system of coloring and picture structure: Pointillism or Divisionism. With his work *Sunday Afternoon on the Island of La Grande Jette* (1884/85), in which he executed the technology of color division based on the principles of optical combination and simultaneous contrast on the canvas, he created what became known as the "manifesto" of neo-Impressionism.

Signac, Paul (1863 Paris – 1935 Paris) Like Seurat, a cofounder of the Société des Artistes Indépendants, and became its president in 1898. Initially an Impressionist, he later formed a close friendship with Seurat, under whose influence he developed the theoretical principles of Pointillism and recorded them in *D'Eugène Delacroix au Néo-Impressionisme* (1899). Works by this artist, who was the most important representative of neo-Impressionism after Seurat, include a number of landscape watercolors produced around Saint-Tropez after 1891, and color lithographs.

Sisley, Alfred (1839 Paris – 1899 Moret-sur-Loing) Studied from 1862 in the studio of Charles Gleyre, where he met Renoir, Monet, and Bazille. He turned to plein-air painting and worked, sometimes with Monet, in various regions of the Ile-de-France. The influence of Corot, Courbet, and Manet is evident in his clayey, dark early works. After 1870, Sisley, who belonged to the closest circle of the Impressionists and participated in four of their exhibitions, painted almost exclusively landscapes of a light, delicate charm and harmonious and clever coloring, which are regarded as synonymous with Impressionist art.

Henri de Toulouse-Lautrec, portrait by Edouard Vuillard, ca. 1897/98, Musée Toulouse-Lautrec, Albi

Stevens, Alfred (1823 Brussels – 1906 Paris) A student of Neoclassicist François-Joseph Navez in Brussels, and from 1844 of Jean-Auguste-Dominique Ingres in Paris. Initially Stevens was a representative of Social Realism, and recorded the misery of the lower classes, but his modish representations of society ladies in elegant surroundings made him the most sought-after painter of the Second Empire. The influence of the Impressionists is evident from the open style of his landscapes and seascapes painted from 1880 in Sainte-Adresse.

Toulouse-Lautrec, Henri de (1864 Albi – 1901 Château Malromé, Gironde) A descendant of the counts of Toulouse. A series of childhood accidents left him

crippled. Studied in 1882/83 under Léon Bonnat and Fernand Cormon in Paris, and discovered the demimonde of Montmartre as an art subject in 1885. He produced highly individual portraits of friends, artists, dancers, and prostitutes. With a minimal ornamentation and flowing lines, he revealed what was characteristic in gestures, movements, and physiognomy, innovating modern poster art in doing so. Influenced primarily by the English Art Nouveau painter Aubrey Beardsley, his oeuvre included book illustrations and a number of artistically executed color lithographs.

Troubetzkoy, Paul Petrovitch (1866 Intra, Lago Maggiore – 1938 Suna, Lago Maggiore) Real name Pavel Trubetskoy; an aristocrat and self-taught sculptor. Made a teacher at the Moscow State School of Art in 1897 by the tsar. Achieved fame in Paris, where he lived from 1905, with portraits (inspired by Giuseppe Grandi, Rodin, and Rosso) of his contemporaries, including literati such as George Bernard Shaw and Gabriele d'Annunzio. Pro-

Henry van de Velde, in his old age, picture undated

duced animal and small sculptures in the USA between 1911 and 1921, then returned to divide his time between Paris and Lago Maggiore. His work revealed a sketchlike, Impressionist construction with an excitingly modeled surface structure.

Vallotton, Félix (1865 Lausanne – 1925 Paris) Studied at the Académie Julian in Paris from 1882. The highly talented Swiss produced his first woodcuts in 1890. From 1894 he produced illustrations for art critic Félix Fénéon's art magazine for literary Symbolism and the

Nabis, the *Revue Blanche*, and was also a strong influence on Art Nouveau graphics. Vallotton participated in the first Salon d'Automne in 1903. His landscapes, figures, portraits, and silhouettes are noted for their strong surroundings and clear and decorative colors.

Velde, Henry van de (1863 Antwerp – 1957 Zurich) Studied art in Antwerp, and under Carolus-Duran in Paris in 1884/85. Inspired by the works of William Morris, he dedicated himself to designing furniture, interiors, and commercial art from 1889. In 1902 he

was invited to Weimar to establish the School of Commercial Art (1906), which he ran until 1914. Cofounder of the Werkbund in 1907. Van de Velde's main interests were architecture and interior design, realized in a number of important commissions, e.g. for the Folkwang Museum (1901/02) in Essen and the Werkbund Theater (1914) in Cologne. With their smooth, flowing lines and the blend of ornamentation and construction, his works perfectly epitomize the style of Art Nouveau.

Vuillard, Edouard (1868 Cuiseaux, Saône-et-Loire – 1940 La Baule, Loire-Atlantique) Trained under Jean-Léon Gérôme at the Ecole des Beaux-Arts from 1886 and the Académie Julian from 1888. Joined the Nabis in 1889. Painted in a decorative style, with clear picture sections, carpet-like color patterns, and ornamental surfaces; moved to designing theaters and interiors in 1893, including murals for the Palais Chaillot (1938) in Paris and the League of Nations (1939) in Geneva. Taught at the Académie Ranson in Paris in 1908. Vuillard and Bonnard were the two main representatives of *Intimisme*.

Whistler, James Abbot McNeill (1834 Lowell, Massachusetts – 1903 London) Arrived in Paris in 1855, a fully trained cartographer, and studied under Charles Gleyre. Close links to the second generation of Realists, Fantin-Latour and Alphonse Legros. Lived primarily in London from 1859; displayed his *Little White Girl* (1862) at the Salon des Refusés, and was the most reviled artist after Manet. Finally, in 1892, Whistler's painting, inspired by Japanese colored woodcuts and the Impressionists, his poetic landscapes, and influential portrait art, began to gain recognition. English graphics blossomed again through his extensive cycles of etchings.

Wright, Frank Lloyd (1867 Richland Center, Wisconsin – 1959 Phoenix, Arizona) The leading architect of the first half of the 20th century. Studied in Chicago from 1888 to 1893 in the architectural offices of Adler & Sullivan, and worked closely with his much-admired idol, architect Louis Henry Sullivan. Unaf-

fected by international building methods, Wright constructed a new type of country house: The low, sprawling "prairie houses," built in harmony with nature in a number of Chicago suburbs (pre-1900 to 1909). This style was developed further in his celebrated house "Falling Water" (1935), which was suspended over a waterfall. He designed office blocks, hotels, factories, and private homes in an independent abstraction combined with Primitivism that set the tone for modern European and American architecture. His most famous building is the Guggenheim Museum (1956–1959) in New York, which blends the natural features of the Grand Canyon with the native architecture of the Navajo.

Following double page: The Palais d'Orsay, destroyed by fire during the uprisings of May 1871

Edouard Vuillard, Self-portrait (detail), ca. 1889, Musée d'Orsay, Paris

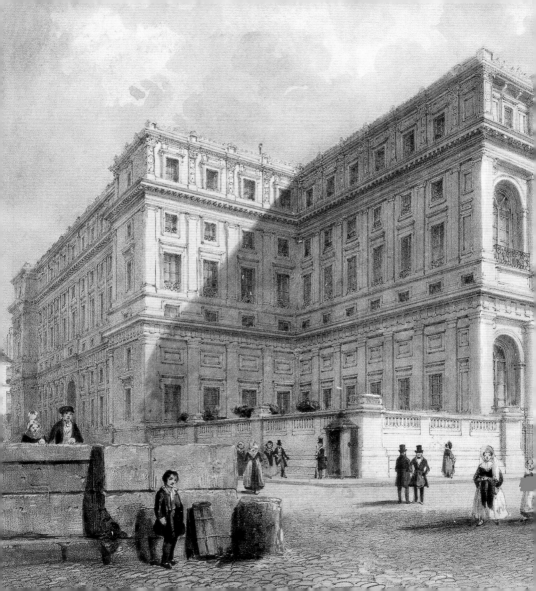

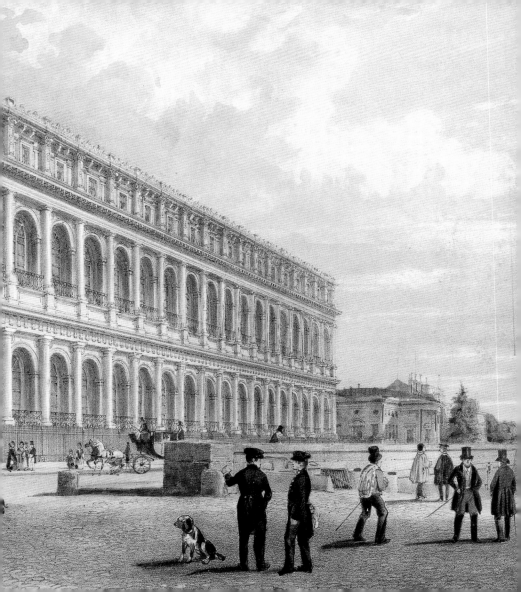

all of Paris (January 28, 1871)

Napoléon III dies in England (1873)

Paris Commune (March–May 1871): The workers' uprising is quashed with bloody fighting

The moderate republican Adolphe Thiers is voted the first state president of the Third Republic (1871)

Constitutional laws for the parliamentary republic passed (1875)

Foundation of the Socialist Party (1880)

1880s – the period of the colonial expansion policy: Tunisia (1881), the colonization of Africa, foundation of the Indo-Chinese Union (1887)

Freedom of the press and right of assembly; schooling becomes compulsory (1881)

1870 1875 1880

Claude Monet's *Impression: unrise* (1872) provides the ame for the new trend in art

Gustave Caillebotte, *Planing the Floor* (1875)

Auguste Renoir, *Dance at the Moulin de la Galette* (1876)

William Bouguereau displays his *Birth of Venus* at the Salon (1879)

Paul Cézanne turns away from Impressionism and develops his own picture language (1879)

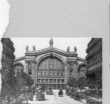

Opening of Charles Garnier's new Opera House (1875)

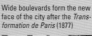
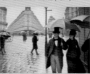
Wide boulevards form the new face of the city after the *Trans-formation de Paris* (1877)

The Palace of the Tuileries is demolished to complete the axis between the place de la Concorde and the place du Carrousel (1882)

Jean-Baptiste Carpeaux, *The Dance* (decoration for the façade of the Opera House, 1869)

Antonin Mercié, *David* (1872)

Auguste Rodin, *The Age of Bronze* (1877)

Auguste Rodin commences work on *The Gates of Hell* (1880)

Edgar Degas commences his sculptural works (1880)

Félix Nadir sets up his luxurious photo studio on the boulevard du Capucines (1863)

First group exhibition by the Impressionists (1874)

Jules Verne, *Around the World in 80 Days* (1874)

Emile Zola: *Nana* (1879/80)

Georges Petit's exhibition of Japanese woodcuts (1883)

Jens-Karl Huysmans, *A rebours* (1884)

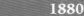

History

February revolution (1848), "Citizen King" Louis-Philippe abdicates and flees; proclamation of the Second Republic

Louis-Napoléon Bonaparte (later Napoléon III) voted president

Coronation of Napoléon III (1852)

Crimean War (1853–56)

Napoléon III held prisoner at Sedan; revolution; proclamation of the Third Republic (1870)

Franco-Prussian War (1870/71)

1850 1860

Painting

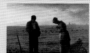

Couture's giant historical painting *The Romans of the Decadence* is a success at the Salon (1847)

Courbet exhibits his works in his own pavilion under the title "Réalisme" (1855)

The Angelus (1857/59) by Jean-François Millet very quickly becomes very popular

Edouard Manet's *Le Déjeuner sur l'Herbe* causes a scandal at the Salon (1863)

Architecture

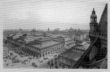
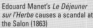

The *Transformation de Paris* by Baron Haussmann (1853–1872)

Construction of Les Halles (1853–1858) by Victor Baltard, France's first major example of iron architecture

Palais d'Industrie for the first *Exposition Universelle* (1855)

Railroad stations complement the grid system of *Nouveau Paris* (1872)

Sculpture

Honoré Daumier commences work on his sculptural portraits of parliamentarians (1831)

François Rude, *Napoleon Awakening to Immortality* (1845/47)

Jean-Baptiste Carpeaux, *Ugolino and his Sons* (1862)

Medal cupboard with sculptural silver decorations in a historical style, well received at the Exposition Universelle in Paris (1857)

Literature and culture

Louis-Jacques-Mandé Daguerre discovers photography (1839)

Alexandre Dumas, *La Dame aux camélias* (1852)

First Exposition Universelle in Paris (1855)

Charles Baudelaire publishes Les Fleurs du mal (1857)

Gustave Flaubert, *Madame Bovary* (1857)

First Salon des Refusés (1863)

Artists' places of work

Edouard Manet,
On the Beach,
p. 224

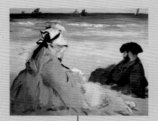

Vincent van Gogh,
The Church at Auvers-sur-Oise,
p. 283

Paul Sérusier,
The Bois d'Amour by Pont-Aven,
p. 385

Gustave Courbet,
The Cliffs of Etretat after the Storm, p. 95

Paul Gauguin,
The Alyscamps at Arles,
p. 345

Alfred Sisley, *Footbridge at Argenteuil*, p. 187

Jean-François Millet,
The Gleaners,
p. 84

Paul Cézanne,
The Bridge at
Maincy, p. 308

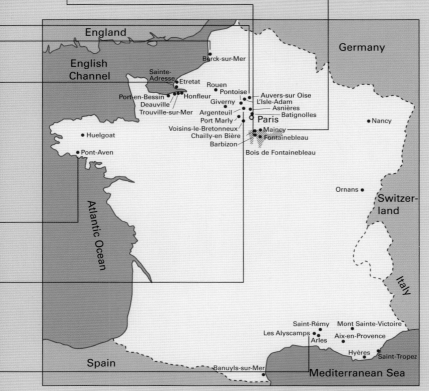

England

English
Channel

Germany

Berck-sur-Mer

Sainte-
Adresse
Etretat
Rouen
Honfleur
Pontoise
Port-en-Bessin
Giverny
Deauville
Trouville-sur-Mer
Argenteuil
Port Marly
Voisins-le-Bretonneux
Chailly-en Bière
Barbizon

Auvers-sur Oise
L'Isle-Adam
Asnières
Batignolles
Paris
Nancy
Maincy
Fontainebleau
Bois de Fontainebleau

Huelgoat

Pont-Aven

Atlantic Ocean

Ornans

Switzer-
land

Italy

Saint-Rémy
Mont Sainte-Victoire
Les Alyscamps
Aix-en-Provence
Arles
Hyères
Saint-Tropez

Spain

Banuyls-sur-Mer

Mediterranean Sea

...sion of Church and ...e (1905)

First Morocco crisis: politico-economic conflict with Germany (1905)

Georges Benjamin Clemenceau, leader of the Radical Left, is voted prime minister (1906)

Dreyfus cleared of the charge of leaking military secrets to Germany (1906)

Socialist Aristide Briand voted prime minister (1909)

Second Morocco crisis: French occupation of Fez (1911), Germany recognizes French predominance

Outbreak of World War I (1914)

1900 **1905** **1910**

Maurice Denis, the leading theoretician of the Nabis, paints his *Homage to Cézanne* (1900)

First recognition for Henri Rousseau's work in the Autumn Salon (1907)

Edvard Munch's paintings point toward the beginning of Expressionism (1904)

Monet's later *Waterlilies* mark the peak — and the end — of Impressionist painting (1916/1919)

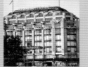

Opening of the glass cupola at the Grand Palais and the Petit Palais (1900)

Opening of the metro (1900); Art Nouveau railings at the entrances designed by Hector Guimard

Completion of the Sacré-Coeur basilica (1904)

Completion of the façade of the Samaritaine department store (1907)

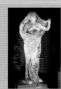

Louis-Ernest Barrias exhibits his allegory, *Nature Exposing Herself to Science* at the Salon (1899)

Aristide Maillol, *La Méditerranée* (1905/1927)

Medardo Rosso, *Ecce Puer* (1906)

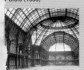

The Galerie Bing exhibits an Art Nouveau work by Colonna at the *Exposition Universelle*

First exhibition by Pablo Picasso at the Galerie Vollard (1901)

Exhibition by the Fauves around Henri Matisse at the Autumn Salon (1905)

Important Cézanne retrospective in the Autumn Salon (1907). His work is warmly received by the Cubists

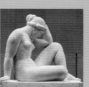

Js – repression of the church;
ulsion of the Jesuits; dissolu-
of the monasteries; national-
on of the schools

The Workers' Congress
declares May 1 a national holi-
day for workers (1889)

The Dreyfus affair causes a major internal politi-
cal crisis. Conflict between the conservative
nationalist opposition and the republicans (1894)

Zola calls for a resumption of the pro-
ceedings against Dreyfus (1898)

End of the Franco-
Prussian crisis (1887)

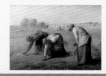

Alliance with Russia (1894)

Declaration of neutrality with Italy in
the event of an attack by Germany
(1902)

385 1890

Henri de Toulouse-Lautrec takes up
residence in Montmartre (1884)

Vincent van Gogh
moves to Arles
and finds his own
style (1888)

Paul Signac publishes his programmatic work *D'Eugène
Delacroix au Néo-Impressionisme* (1899)

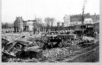

Paul Gauguin visits the
South Seas (1891)

Claude Monet begins his
paintings of the cathe-
dral of Rouen (1892)

pletion of the
l Tower (1889)

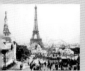

Construction of the iron-framed
Galerie des Machines at the *Expo-
sition Universelle* (1889)

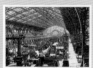

Construction of the first Art
Nouveau apartment block,
Castel Béranger, by Hector
Guimard (1897/98)

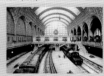

Construction of the Gare d'Orsay
begins (1898)

Completion of Victor Laloux's
Gare d'Orsay (1900)

Gérôme's sculpture
Tanagra well received
at the Paris Salon
(1890)

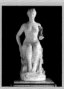

Camille Claudel,
*The Age of
Maturity* (1898)

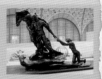

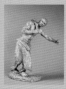

Aime-Jules Dalou
completes Blacksmith
(1889)

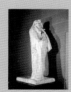

Final version of Auguste
Rodin's *Balzac* (1897)

Émile Zola, *L'Œuvre* (1886)

th of Vic-
Hugo
5)

Eighth and final exhibition by
the Impressionists, in con-
junction with the Pointillists
(1886)

The Lumière broth-
ers discover cine-
matography (1895)

Women admitted to the
Académie des Beaux-Arts
(1897)

Glossary

Absinthe (Greek; apsínthion, "wormwood"). A green, bitter liqueur made of wormwood.

Academic. Derived from the institution of the art academy; designates an aesthetic view oriented to fixed rules of artistic representation, for example in the illustration of anatomy or perspective. The academic doctrine includes, in addition to a regimented education, a precise idea of the artistic "ideal picture," exemplary rules of composition, and picture content with a clearly structured hierarchy of the types of pictures from historical paintings to genre paintings. Since the 19th century this view has been increasingly rejected by art critics as being too rigid and dogmatic.

Academy (Latin; academia; Greek; akadémia). An establishment, institution, or association for the advancement of research and education in the arts and sciences. The first important academies were developed along the lines of the ancient schools during the Renaissance in Milan and Florence. The real history of the artists' academies began in 1599 with the founding of the Accademia di San Luca in Rome. Under the influence of absolutist philosophy the idea of the academy spread throughout Europe. Models included the Académie Française, founded in 1635, and the Académie Royale de Peinture et de Sculpture, established in 1648. The designation was most likely derived from a gymnastics facility

Allegory: Luc Olivier Merson, Truth, 1901, Oil on Canvas, 221 x 372 cm, Musée d'Orsay, Paris

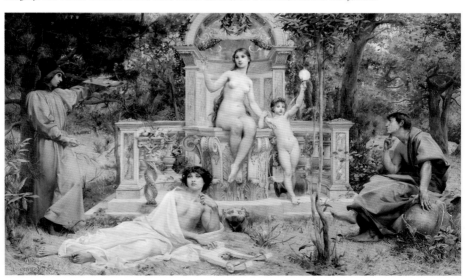

located near Athens, which was dedicated to the Attic hero Akademos. When Plato founded his school of philosophy in 387 B.C., he named it after his favorite place.

Allégorie réelle (French; "realistic allegory"). A concept which originated in the second half of the 19th century that sought to describe a new, contemporary form of the allegory, which no longer served the superelevation of a classical picture theme, but made life itself into the subject of an allegory, e.g. in Edouard Manet's *Déjeuner sur l'Herbe* of 1863.

Allegory (Greek; allegoría, deriv. of allegoreín, "to speak so as to imply something else"). The metaphorical representation, usually based on images from literature, of abstract concepts, ideas, or connections. Representational means include figures (personifications), actions, and symbols. Often used in the 19th century for paintings and sculptures in connection with buildings and monuments, sometimes with political overtones.

Antiquity (French; antique, "ancient;" Latin; antiquus, "old"). Refers to Greco-Roman antiquity. This begins with the early Greek immigration in the 2nd century B.C. and ends in the West in 476 A.D. with the deposition of the Roman emperor Romulus Augustus (around 475 A.D.), and in the East in 529 A.D. with the closing of the Platonic academy by Emperor Justinian (482–565 A.D.). The concept of antiquity was revived in later centuries during the Renaissance, by Classicism and Postmodernism.

Apollo. Greco-Roman god, son of Jupiter and Leto and twin brother of Diana. Over time Apollo assimilated many local gods and their characteristics, so that multitudinous religious ideas are incorporated in his person. Among other things, he is the god of prophecy, of music and art, as well as lord of the muses (Apollo Musagetes), the god of light and of the sun (Phoebus Apollo), and he represented the ancient idea of manly beauty for centuries.

Aquarelle (Italian; acquarella, "watercolor;" from Latin; aqua, "water"). The technique of painting with non-opaque watercolors. The pigments (colored powders) are mixed with a binding agent such as gum arabic (a strong adhesive plant secretion of the African acacia) and water, whereby the colors remain water-soluble after drying. Distinguishing characteristics of aquarelles include the minimal use of drawings and line as well as the inclusion of the ground as an independent component.

Arabesque (French; arabesque; Italian; rebeschi, "climbing plants" and arabesco, "Arabic"). Originally ancient surface ornamentation revived in the Italian Renaissance, consisting of stylized leaf and vine embellishments, often interspersed with heads, masks, or figures. Also the generic term for the stylized plant ornamentation in Islamic art.

Art Déco (French; art décoratif, "decorative art"). Generic term for the artistic tendencies prevailing between 1918 and 1932 in commercial art, interior decoration, and small sculpture, particularly in France. Developed from the French Art Nouveau, Art Déco makes reference to the increasingly technologized environment with its geometric structures, symmetrical forms, sharp edges, straight lines, and brilliant colors. The use of expensive, luxurious materials such as polished stones, high-grade woods, enamel, and chrome often permitted only very limited production. Important representatives of Art Déco include the furniture designer Jacques-Emile Ruhlmann (1869–1933), the jeweler and glassware manufacturer René Lalique (1860–1945), the lacquer artist Jean Dunand (1877–1942), and the silversmith Jean Puiforcat (1897–1945). The term is derived from the name of the 1925 exhibition in Paris: "Exposition Internationale des Arts Décoratifs et Industriels Modernes," but has been in common use only since 1966.

Art Nouveau. An international style movement appearing in the 1890s, known in Germany as "Jugendstil," in England as "Modern Style," and in Austria as "Sezessionsstil." As a defense against the widespread academic and historical tendencies

of the 19th century (Neo-Romanesque, Neo-Gothic, etc.), it sought a link to the dynamics of the times in ornamental, plane, and linear forms with plant forms, such as flowers and leaves. Art Nouveau came to be applied to all areas of life, including architecture, the fine arts, and arts and crafts, the latter being given a position equivalent to art. Forerunners of Art Nouveau in France included the artists Emile Bernard and Paul Gauguin with their flattened figures and accentuated outlines (so-called Cloisonnism). Henri de Toulouse-Lautrec is to a large extent responsible for the popularity of this flattened outline style

Assistant figure (Latin assistere, "to assist"). An ancillary figure, usually in representations with religious content, which is subordinate and not necessarily required by the theme.

Barbizon School. The gathering of several Parisian landscape painters in the village of Barbizon on the edge of the forest at Fontainebleau. Around 1830, Théodore Rousseau, Jean-François Millet, Jules Dupré, and, on the fringe, Camille Corot met regularly in the summer months to paint outdoors. Themes include the simple rural life, the peasants, the landscape. Despite general rejection of the superelevation of the motif practiced by romantic landscape painters, artists such as Millet and Corot often imbue their pictures with a deeper meaning, such as the glorification of the simple life. The artistic style and method of the group had a stimulating influence on Realism in the natural reproduction of the motifs and on Impressionism with regard to the development of plein-air painting.

Batignolles Group. Contemporary designation of the early representatives of Impressionism surrounding Edouard Manet, Auguste Renoir, Claude Monet, and Henri Fantin-Latour; the latter portrayed the group in his renowned painting of the atelier in 1870. The group took its name from the Batignolles quarter in the northwest of Paris, where the famous artists' meeting place Café Guerbois was located.

Bozzetto (Italian; bozzo, "rough stone"). Originally used to designate an incomplete, small-scale model of a sculpture: in a figurative sense the first, still sketchy draft of a work of art that can provide information about the original intentions of a painter or sculptor.

Camera obscura (Latin; "dark chamber"). Originally a box , usually portable, equipped with a hole (aperture) instead of a lens or a mirror, which was used by landscape, architectural, and veduta painters as a drawing aid to construct perspectives. The individual rays of light pass through the small opening, producing a reversed, reduced-size image on the opposite wall of the box.

Caryatids (Greek; karyatides, presumably after the priestesses in the temple of Diana at Karya in Laconia). Female statues in long robes with baskets or cushions as head ornaments, which support the entablature in the place of a column or other tectonic element. Counterpart to the male Hermes.

Cenotaph (Greek; kenos, "empty" and taphos, "grave"). A sepulchral monument known from prehistoric times over an empty grave, erected to commemorate one or more deceased persons.

Centaur (Greek; kentauros, perhaps related to tauros, "bull"). Mythical being of Greek legend with a human upper body and the lower body of a horse.

Chronophotography (Greek; chronos, "time," phos, "light," and graphein, "to write"). Forerunner of cinematography, in which movements are broken down photographically into individual images.

Cloisonnism (French; cloisonner, "partition"). The term is based on a technical process in enameling, in which the liquid enamel is poured into small cells formed by thin metal bands; it describes a painting process in which adjacent paler and darker surfaces are enclosed and separated from each other by strong, dark contour lines. Particularly prevalent in Late Impressionism in the works of Emile Bernard and Paul Gauguin, the representatives of "synthetic" painting.

Clotho. One of the three Greek Fates (in Roman mythology: parcae), either daughter of Night or Jupiter and Themis. Clotho spins the thread of life of each individual person, Lachesis preserves it, and Atropos cuts it off.

Coloration (Italian; colorito, "coloring;" Latin; color, "color"). Color design and effect of a painting.

Complementary contrast. A contrast achieved by using complementary colors (red-green, blue-orange, yellow-violet), which decisively determines the overall color atmosphere of a picture.

Contrapposto (Latin; contrapositus, "placed against," from ponere "to place"). The standing position developed by the sculptor Polyklet (ca 460–415 B.C.) in classical Greek sculpture which

Chronophotography: Eadweard Muybridge, motion study with two men, 1887

became a binding principle in European sculpture: the various force and movement orientations of the human body are thereby brought into harmonious equilibrium. Loading and supporting, resting, and driving forces of a figure are evenly distributed on the standing and free legs to achieve a balance. The contrapposto had a particularly strong revival during the Renaissance (see illustration. p. 542).

Copperplate engraving (Late Latin; cuprum; Latin; aes cyprium "ore from the island of Cyprus"). The oldest artistic photogravure process. Pressure forms the image of the drawing lines scribed or etched into the copper plate. Originally the term was used for all manually produced prints.

Cubism. Since 1911/12 the accepted term for a form of art created primarily by Pablo Picasso (1881–1973) and Georges Braque (1882–1983), and further developed and reshaped by a small group of French, Russian, and Spanish painters and sculptors, which

through abstraction and reduction led to a radical dissolution of all clear visual connections. The hallmark of Analytical Cubism (1910–1912) is the reduction of the object depicted to small, fragmented forms that overlay and penetrate each other, and the representation of these from different standpoints. Synthetic Cubism (after 1912) offers a composition of starkly outlined colored surfaces, whereby new forms and sensory connections arise from the overlays. Painted letters as well as the inclusion of scraps of newspaper, glued-on strips of paper or material created a new connection to reality.

Daguerrotype. Named after its inventor, Louis-Jacques-Mandé Daguerre (1787–1851), this is the oldest form of photography, in which silver-plated copper plates are developed into light-sensitive photo carriers with the addition of iodine or bromine vapor. In 1839, the patent was purchased by the French government and made public.

Dionysus, also Bakchos (Latin; Bacchus). In Greek mythology, the god of wine and universally creative nature, son of Jupiter and Semele, husband of Ariadne. Raised by nymphs in a cave; celebrations in his honor were held in the mountains with torchlight and music.

Divisionism. See Pointillism.

Ductus (Latin; ductus, "drawing off," "leadership", also "handwriting"). The individual style of color application of a painter, in which the point of application and removal of the brush become visible. The ductus reveals something about the painting rhythm, the speed of the color application, the consistency of the surface of the picture.

Earthenware. A ceramic (Greek; keramiké, "pottery") product invented in England around 1720, which belongs to the category of fine stoneware.

The porous white bodies are made of fired raw materials containing clay and kaolin as well as quartz, feldspar, and talc. A transparent glaze is applied upon the first or second firing. Earthenware, which is suitable for everyday use, is distinguished by its light, creamy surface. The most famous example of this category is made by the English firm of Wedgwood (since 1780).

Ecce homo (Latin; "Behold the man!"). According to the Gospel of St. John (19: 4-6), the words with which Pilate presented Christ to his accusers, appealing to the sympathies of the people. In the fine arts, the common term applied to the representation of the flogged and ridiculed Christ wearing a crown of thorns and a loincloth. The scene of the presentation of Christ to his accusers has been a common theme in painting since the Middle Ages. During the Middle Ages it served as an accusation, as a sign of the degradation of human beings.

Eclecticism (Greek; éklegein, "to select"). Often a negative term in art and architecture, it denotes the adoption of existing forms of representation, motifs, and structural forms in imitation of earlier works of art and epochs due to the artist's lack of original creative ability.

Emblematics (Greek; émblema, "something put on, inlay work"). A field of research dealing with the origin and meaning of emblems (symbols with an explanatory motto that appears either above or below them).

Plein-air painting: John Singer Sargent, Claude Monet painting at the edge of a wood, 1887, Oil on Canvas, 20.5 x 25.5 cm, Tate Gallery, London.

Enameling (French; émailler, "to glaze"). Covering of objects with a colored vitreous mass.

Europa. In Greek mythology, the daughter of the Phoenician king Agenor and Telephassa. While playing on the seashore, she was kidnapped by Zeus in the form of a bull and taken to Crete; thus she is always shown with a bull. In the ancient view, the part of the world whose name was first given a meaning through the legend of Europa was bound on the west by the Atlantic, in the east by Phasis, and in the south by the Mediterranean.

Expressionism (French; expression, "expression"). Art movement dating from the beginning of the early 20th century (the Fauves, Die Brücke [The Bridge], Der Blaue Reiter [The Blue Rider]), which was articulated primarily in painting and graphics, less so in sculpture. In a counter-reaction to the visual model of Impressionism, which had already been called into question at the end of the 1880s, and a reaction to Naturalism and Academism, the followers of Expressionism sought to intellectualize and objectivize, thereby eschewing a faithful reproduction of reality. Strong, undiminished colors that cannot be harmonized with natural coloring express a subjective view of reality, the visualization of that which is essential.

Faience (French; after the Italian city of Faenza), also called majolica. Ceramic wares, which are prefired once, then coated with an opaque, usually white tin glaze and painted with fireproof colors.

Fauvism (French; fauves, "wild beasts"). A movement in French painting founded in the first decade of the 20th century by Henri Matisse (1869–1954) and a group of post-Impressionist painters, which dispenses with form and space and is based on the use of pure, brilliant color.

Frontispiece (French; frontispice "front end" [of a building], "title page;" Middle Latin; frontispicium, Latin; frons, "forehead" and specere, "to look"). Triangular gable over the center projection (the center structure jutting from the main alignment at the height of the eaves) of a building, and over the doors and windows as well. Also designates the illustration facing the title page of a book, which makes reference to the contents of the book.

Ganymede. In Greek mythology, the son of Tros; Zeus, who fell in love with the extraordinarily handsome youth, assumed the shape of an eagle and kidnapped him to Mount Olympus, where he made him his cup-bearer and lover. The kidnapping is a particularly frequent theme in the fine arts.

Genre painting (French; genre, "kind, sort"). Painting which has as its subject typical scenes and events of daily life, the circumstances of a particular professional group or social class. The first peak of genre painting occurred in the Dutch art of the 16th and especially the 17th centuries, when the pictorial themes were differentiated into their own particular genres, such as the military genre or conversational pieces. In the 18th century the courtly genre appeared, with shepherd scenes, gallant festival scenes, and frolicking peasants. Satirical and sentimental versions of genre painting also bloomed during this period. The depiction of farmers and factory workers hard at work gave new content and meaning to genre painting in the 19th century.

Glass architecture. A style of architecture with large glazed areas over a "filigree" steel frame. The development of glass architecture was facilitated by two major developments: industrial technological progress, especially the manufacture of malleable iron alloys (steel), and the production of large quantities of sheet glass, as well as the emergence of new areas of application. World fairs, railroad stations, arcades, and department stores required spacious, functional architecture in which the covering of large areas became the central task of the architectural engineer. Already tested in bridge construction, the technical advantages of steel construction were also utilized in greenhouses at the beginning of the 19th century. Thus the famous Crystal Palace was built in London by the greenhouse designer Joseph Paxton for the first world

fair, the Great Exhibition, in 1851. In the second half of the 19th century glass architecture spread rapidly: structures designed with a glass shell covering a steel frame included railway station halls, library halls, covered markets, arcades, department stores, and exhibition pavilions. They were also highly valued in an aesthetic sense due to the dominating role of light, which was similar to that in Impressionist painting (see illustration. p. 543).

Gouache (French; gouache, Italian; guezzo). Painting technique using water-soluble colors. However, in contrast to aquarelles, this technique employs opaque colors. The pigments are mixed with a binding agent (gum arabic or dextrin) and zinc white, thus creating the matt, chalky appearance of the gouache. This method has been used since the 15th

Contrapposto: Symmetrical weight distribution of an archaic sculpture compared to the contrapposto of Greek classical sculpture.

century, particularly in miniature painting, as the colors become lighter after drying and vivid effects can be achieved.

Heliogravure (Greek; helios, "sun," and graphein, "to write"). Generic term for the oldest photomechanical photogravure process. This method, invented by M. Nièpce de Saint-Victor around 1853, uses carbon tissue paper as its basis, which is then copied onto a copper plate after exposure. Especially valued as a high-quality printing process, particularly in an artistic sense, heliogravure was widely used for monochrome book illustrations and, in the art trade, for high-quality reproductions of pen-and-ink drawings and gouaches.

Hercules or Heracles. In Greek mythology, the son of Zeus and Alcmene, who was famous even before his birth as the strongest of all humans and sons of Zeus; the Doric national hero. When the youth killed his teacher in a fit of rage, Zeus exiled him to the mountains, where he vanquished the lion of Cithaeron. At a crossroads, Hercules had to choose between wellbeing and virtue. Struck with madness by Hera, Hercules murdered his children, whereupon he was forced to enter the service of Eurystheus and complete the famous twelve labors (dodekathlos), for instance the slaying of the Stymphalian birds. Versions of the labors vary from region to region. Hercules is usually depicted with a lion skin and a club.

Historical painting (Latin; historia, "learning by inquiry, story"). An academic genre regarded highly since the 17th century that depicts themes from the history of mankind, including mythological tales as well as actual events (such as Napoleon's French campaign). Historical painting was the successor to religious painting. Universal principles to be applied to contemporary times were derived from the depiction of historical events. In the 19th century, the dissolution of the academic tradition resulted in the gradual demise of historical painting as realistic and naturalistic movements emerged. The last great

representatives of historical painting in France were Thomas Couture (1815–1879) and Jean-Léon Gérôme (1824–1904).

Illusionism (Latin; illusio, "irony, ridicule, deception;" French; illusion, "delusion, illusion"). An apparently three-dimensional representation of depth and objects created on a two-dimensional pictorial or relief surface with the aid of design and perspective tricks.

Imperator (Latin; "master, commander, emperor"). First used as a Roman title for commander, which was awarded to Gaius Julius Caesar on a hereditary basis in 45 A.D. upon his victory over the sons of Pompey at Munda. Later the title "Imperator," used by Augustus and his successors, came to designate the emperor.

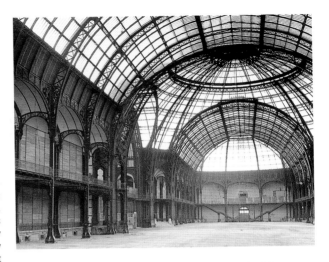

Glass architecture: The 43 m-high glass dome of the Grand Palais (1897–1900), completed for the 1900 Exposition Universelle in Paris.

Impressionism (French; impression, "impression"). A style of painting that became prominent in the last quarter of the 19th century as a reaction to the ossified doctrine of the Academy and the content-oriented atelier, historical, and genre painting. The name is derived from the 1872 painting *Impression, Sunrise* by Claude Monet (Paris, Musée Marmottan), and at first was used by art critics as a mocking description for a group of artists excluded from the official Salon, but who had their own first group exhibition in 1874 at the salon of the Parisian photographer Nadar. Impressionism, as a new type of naturalism, negated classical pictorial methods; based on contemporary theories of physics, it indicated the natural object in a revolutionary fashion – entirely as a manifestation of color. Their supreme principle was "plein-air" or open-air painting, through which the painters tried to capture a direct, spontaneous impression of what they saw.

Incarnadine (French; incarnat, "flesh-colored;" Italian; incarnato; Latin; caro, carnis, "flesh"). The color used in the artistic reproduction of naked human skin, usually a mixture of white and red.

Initial (Latin; initialis, "beginning, first"). The first letter of a section or chapter in handwriting or print which is usually especially illuminated and creatively accentuated.

Interior drawing. Individual lines, structural elements, and shadings within the context of a drawing. Together with the outline drawing it describes the inner structure of an object.

Intimism (French; intime, "intimate, familiar"). An artistic trend in late Impressionism in France. The key representatives of Intimism include Edouard Vuillard and Pierre Bonnard, who have preserved

impressions of the bourgeois world of the late 19th century in their portrayals of convivial domestic interiors, in which men and women often confront each other in intimate groups.

Japonisme. From around 1860 the term used within the context of the disputes surrounding Impressionism, Post-Impressionism, and Art Nouveau for the imitation of picturesque Japanese subjects. Interest in Japanese art, which inspired artists such as Edgar Degas, Félix Vallotton, and Gustav Klimt at various times, grew rapidly after the world fairs in Paris and Vienna, at which Japan was presented on a large scale to the Western world for the first time.

Karst landscape. Mountain landscape composed of pervious, water-soluble stone (lime, gypsum), which is dissolved by surface and ground water.

L'art pour l'art (French; "art for art's sake"). A principle expounded in the mid-19th century by French literati (e.g. Victor Cousin), according to which art should have neither political, social, nor religious connections, but rather should be solely art for its own sake.

Leda. In Greek mythology the mother of the heavenly twins Castor and Pollux, as well as of Helena. Their father was Zeus, who impregnated Leda after he had assumed the shape of a swan.

Les Vingts (French; "The Twenty"), also Les XX. A group that began with 20 Belgian painters and sculptors as well as critics, founded to organize juryless exhibitions following their dissatisfaction with the selection process of the Brussels Academy and the Paris Salon. The group did not represent any one style, but exhibited works of Realism, Impressionism, Symbolism, and Art Nouveau all together. Les Vingts as an artists' group played a significant role in the modernization of art in Belgium by inviting foreign artists as well to the exhibitions, including James Abbott McNeill Whistler (1834–1903), Claude Monet (1840–1926), and Auguste Renoir (1841–1919). The frequent participation of Paul Signac (1863–1935) and Georges Seurat (1859–1891)

led to the development of an independent Belgian Neo-Impressionism with international flair. Important members of Les Vingts included, among others, James Ensor (1860–1949), Fernand Khnopff (1858–1921), Theo van Rysselberghe (1862–1926), Félicien Rops (1833–1898), and Henri van de Velde (1863–1957). The group dissolved itself in 1893 after holding a total of 126 exhibitions.

Lithography (Greek; lithos, "stone," and graphein, "to write"). The oldest planographic printing method, invented by Aloys Senefelder in Munich between 1790 and 1798 and later modified numerous times. In this method the drawing is applied to limestone with lithographic ink or chalk. The acid applied afterwards to the plate causes the printing ink to adhere only to the drawing and only the drawing is transferred to the paper in the subsequent printing process.

Marquetry (French; marqueterie, "inlay work"). Inlay or veneer work consisting of a wooden base with carved-out ornamental or figurative patterns in which different colored woods, or more rarely metals or stones, are inlaid.

Miniaturist (Latin; miniatus, "colored with red lead"). A painter or drafter of illuminations in handwritings and books; in a figurative sense, used for artists who produce very small works of great detail.

Monochromy (Greek; monochromatos). All of one color, in contrast to polychromy (Greek; poly "many"), which means of many colors.

Monotype (Greek; monos, "alone," and typos, "shape, pattern"). Graphic process first used in the 17th century by Giovanni Benedetto Castiglione (1616–1670) which facilitates the production of only one single print. The process is not reproducible: the print is thus comparable to a drawing, and hence remains a unique piece.

Nabis (Hebrew; "prophet, enlightened one"). Group of artists led by Paul Sérusier which met in 1888/89 in Paris and disassociated themselves, beginning with Paul Gauguin (1848–1903), from the Impres-

sionists by promoting expression, concentrated form and color, and strong emotional participation as characteristics of a new artistic truth. In lithography artists such as Pierre Bonnard, Edouard Vuillard, Félix Vallotton, and Henri de Toulouse-Lautrec developed a new style of illustration, which pointed the way to modern book design.

Naiad. In Greek mythology, a river and spring nymph who protected the water and promoted fertility. Naiads are usually depicted as young, pretty maidens, often in the company of river gods.

Naive painting. Artistic activity practiced by laymen in Europe at the beginning of the 18th century outside of the recognized schools of style. It is distinguished by the carefree, naive choice of topics and the imaginative depiction thereof. The painters of naive works often do not follow, due to lack of knowledge, rules of perspective or classical composition patterns, so that the paintings appear flattened and clumsy. Motifs are primarily colorful, detailed, and harmonious depictions of village or city life, landscapes, and fantasy scenes, which express the wish for a happy existence. Among the most important representatives of Naïve painting in France were the cleaning woman Séraphine Louis (1864–1942) and the customs official Henri Rousseau (1844–1910), whose works inspired numerous professional artists such as Paul Gauguin (1848–1903) and Pablo Picasso (1881–1973).

Naturalism (Latin; French; naturalisme). Generic term for scientific positions supported by natural insights. In fine arts and literature between approximately 1870 and 1900, Naturalism tried to reproduce the reality comprehended through sensory experience as realistically as possible, i.e. without idealizing the object, but with scientific precision. In contrast to Realism, which was also based on the accurate description of natural occurrences, Naturalism concerns itself with the sensual dimension of observation, whereby questions of morality and social criticism come to the fore. The spokesman for

Pigment: Oilpaint colors are produced from ground pigments mixed with linseed oil.

literary Naturalism was Emile Zola (1840–1902), who believed that artistic methods provided evidence of human existence.

Neo-Impressionism. An artistic trend that developed toward the end of the 19th century and became a revival movement for Impressionist painting. The Impressionist technique of juxtaposing small amounts of color to create the impression of a total area that first becomes whole in the perception of the viewer was elevated to the supreme principle of painting and refined by Georges Seurat (1859–1891). Seurat wanted to give the spontaneous, impressionistic painting process a scientific foundation. His theories are underpinned by studies in physics, optics, and color theory by Chevreul,

Blanc, and Rood. Unbroken points of color set directly next to each other ("Pointillism," "Divisionism," or "Chromo-Luminarism") reflect not only the color value of the depicted object, but also convey the color of light as a reflection of the object. Seurat demonstrated his "Scientific Impressionism" for the first time in the painting *A Bathing-place in Asnières* (1884, London, National Gallery), which was exhibited to the public in 1884 at the first Salon des Indépendants. Other representatives of Neo-Impressionism include Paul Signac (1863–1935), Camille Pissarro (1830–1903), and Henri-Edmond Cross (1856–1910).

Nereid. In Greek mythology, one of the 50 daughters of Nereus and the ocean nymph Doris. The Nereids are beautiful sea goddesses (sea nymphs) of lower rank who are always well disposed toward humans. The best-known of the nymphs are Amphitrite, Thetis, and Galatea.

Nonfinito (Italian; "unfinished, incomplete"). Designation for an intentionally unfinished sculpture. Originally used in the context of the description of several unfinished works by Michelangelo (1475–1564), including the *Pietà Rondanini* (Milan, Castello Sforzesco). The unfinished quality of the work often increases its expressivity.

Œuvre (French; "work"). The complete body of works created by an artist.

Oil paint. The mixed, light-resistant colors used for artistic purposes, made of drying oils, various additives, and pigments (colored powders) which are not oil-soluble. Binding agents for the pigments are mainly linseed oil, poppyseed oil, and walnut oil.

Orientalism. A particular form of the general exoticism in European art. Oriental tendencies, promoted by travel reports as well as the increasing scientific and touristic opening of the Near East and Egypt, reached a peak in French painting in the 19th century. The thematic spectrum ranged from genre pictures through realistic and imaginary landscapes to scenes of daily life.

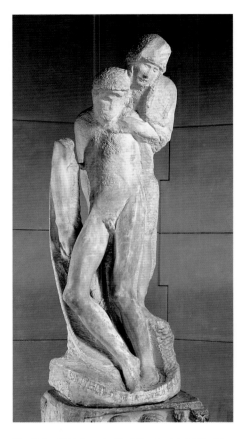

Non finito: Michelangelo, Pietà Rondanini, 1552–64, Marble, height 192 cm, Castello Storzesco, Mailand

Orpheus. In Greek mythology, the son of Oiagros (or Apollo) and the Muse Calliope; a famous singer and musician whose songs could move stones and trees and tame wild animals. Also the inventor of an

alphabet, of healing potions, and magic spells. After the failed attempt to free his wife Eurydice from Hades, Orpheus, who in his bitterness became a misogynist, returned to Thrace, where he was torn apart by mad Bacchantes.

Pandemonium (Greek). The meeting place of all evil spirits together, in opposition to the Pantheon.

Paravent (French; lit. "against the wind"). A fold-away screen against wind or heat.

Pastel (Italian; pasta, "dough"). Painting and drawing technique using monochrome soft crayons made of compressed paint dust. These were used in France even before 1500, and in combination with more solidly adhesive drawing materials such as silver, charcoal, or red ochre, were used at first only for drawings. Soft, tinted natural paper usually served as a background. In the 16th and 17th centuries this technique was used in Italy, the Netherlands, and France. Its peak period in Germany was in the 18th century.

Pastorale (Latin; pastoralis, "shepherd-like," "spiritual"). Type of opera known since the 16th century, based on the "shepherd's play." Found in ancient wall paintings, this was revived in the Renaissance, and idyllic portrayals of the shepherd's life were extremely popular throughout the Baroque and Rococo periods.

Paysage intime (French; "intimate landscape"). A form of landscape painting that appeared in the mid-19th century and cultivated plain views of nature with an intimate, emotional atmosphere instead of invented, heroic, or ideal landscapes. The founders include the group known as the Barbizon school surrounding Théodore Rousseau (1812–1867) and Jean-François Millet (1814–1875).

Pelerine (French; pèlerin, "pilgrim"). Originally a weather-resistant cape worn over the shoulders by pilgrims, it came to mean a waist- or hip-length sleeveless cape.

Personification (Latin; persona, "person," and facere "to do, make"). The representation of concrete but inanimate and impersonal objects or concepts in the form of a person with corresponding attributes; a particular form of allegory.

Pigment (Latin; pigmentum, "coloring"). Colored powder mixed with solvents such as oils, water, or turpentine and binding agents such as glue or resin to form paints. For frescoes (wall paintings on wet plaster), the pigments are bound only with water (see illustration p. 545).

Plein-air painting (French; plein air, "in the open air"). In contrast to painting in an atelier, this painting is done outdoors, under the sky, with the intention of realistically reproducing the natural features of a landscape, its atmosphere, and changes in light. Following the example set by English landscape painters such as John Constable (1776–1837) and Richard Parkes Bonington (1801–1828), French painters, including members of the Barbizon School, began painting their pictures outdoors in the mid-19th century. The Impressionists made plein-air painting a fundamental principle of their painting.

Plinth (Greek; plinthos, "tile"). Square or rectangular socket that serves as the base of a column, a pillar, or a statue.

Pointillism (French; point, "point"). Painting style that appeared in France toward the end of the 19th century. The technique of the Neo-Impressionists of applying pure colors next to each other in order to create the actual color only from a distance through optical mixing in the eye of the beholder was declared to be the supreme principle in painting by Georges Seurat (1859–1891), who rigorously developed it further by applying unbroken colors next to each other in a strict pattern of points or commas. This new technique, called "Divisionism" (French; diviser, "divide, allocate") by Seurat, was exhibited to the public for the first time in 1884 in Paris at an exhibition of the Indépendents.

Polychromy. See monochromy.

Polylith (Greek; poly-, "many," lith- "stone"). An object composed of various stones, e.g. a sculpture.

Pont-Aven, School of. Open association of artists who met regularly beginning in 1888 in the town of Pont-Aven in southern Brittany. The initiator of the group was Paul Gauguin (1848–1903), who rejected the concept of nature as promoted by the Naturalism movement and the Barbizon school. He emphasized the idea of the objects arising in personal impressions and their implementation through independent pictorial means. The so-called Synthetism became the preferred means of representation with which to reproduce the original form of life and the direct impression of nature. The Nabis and the Symbolists originated from the School of Pont-Aven. In addition to Gauguin, the main representatives of this movement include Emile Bernard, Paul Sérusier, and Armand Séguin.

Porcelain (Latin; porcellus; Italian; porcelle, "piglet;" the term actually refers to the glistening white shell of the cowry or porcelain snail). Generic term for a type of ceramic which is fired at extremely high temperatures and is thus very sturdy and heat-resistant. Hard or soft porcelains are developed from the various compositions of pure white kaolin earth, quartz, and feldspar. The hard, white, transparent bodies can be given a colored glaze or decorated using under- or overglaze painting. Porcelain has existed in China since the 7th century and was imported in large quantities to Europe beginning in the 16th century. The invention of the European hard porcelain by Johann Friedrich Böttger (1682–1719) replaced the previously used "fake" porcelain of the white-glazed faience. In 1710 the first German porcelain factory was founded in Meissen; other early factories followed in Vienna and Venice. The first French factory in Vincennes/Sèvres, founded in 1738, was able to produce hard porcelain only from the 1760s.

Portrait (French; Portrait; Latin protrahere, "to bring forth"). The depiction of a particular person through the reproduction of his individual features. Similarity with the person represented should be recognizable, but does not have to match the naturalistic exterior appearance. Thus in an idealized portrait the person is more closely described by name, symbol of office, attributes, symbols, or coat of arms. The main function of the portrait is the representation of the absent person (the deceased), personal commemoration, and homage. For this reason, this genre ranks second only to religious art among the fine arts. Depending on the number of persons depicted, the paintings are known as single, double, and group portraits.

Portrait busts. Creative and interpretative three-dimensional depiction of a person's head and upper body, ending at the shoulder or chest.

Pre-Raphaelites (The Pre-Raphaelite Brotherhood). An artists' group founded in London in 1848, whose members were in opposition to the Royal Academy. They wanted to reform historical painting, which lacked emotion, by reverting to the Italian style of painting of the period before Raphael (1483–1520), the Quattrocento. Their naturalistic works are distinguished by a clear linearity, vibrant colors, and meticulous craftsmanship. They expressed the demand for simplicity and moral seriousness in representation in religious paintings, but also in depictions of the King Arthur legend, plays by William Shakespeare (1564–1616), or the writings of Dante Alighieri (1265–1321). The most important members of the Pre-Raphaelite group were Dante Gabriel Rossetti (1828–1882), William Holman Hunt (1827–1910), and John Everett Millais (1829–1896). Due to irreconcilable theoretical differences among the artists, the members disbanded in 1852, but the groups' ideas remained significant until the end of the century.

Prix de Rome. A grant awarded since 1666 by the Académie in France , which enables French artists to have a period of study in Rome.

Prometheus. A Titan; the wise son of Ispetos and the sea nymph Clymene brought fire from the heavens to the earth, thus promoting the cultural development of mankind. The myth is told in various versions.

Proportion (Latin; proportio, "symmetry, analogy"). Relationship of size. In painting, sculpture, and architecture proportion designates the size relationships of individual parts to each other and of individual parts to the whole. Important proportion rules include the following: 1. the canon (Greek; "standard measure"), whereby for the proportions of the human body the head is the standard measure in a ratio of 1:7 or 1:10 to the body; 2. the golden section (Latin; sectio aurea), in which one distance (A) is divided into a smaller (C) and a larger (B) section, so that A:B is as B:C; 3. quadrature (Middle Italian; quadratura, "squaring;" from Latin; quadrare, "to square"), in which the square is used as the standard measure; 4. triangulature (from Latin; tri-, "three," and angulus, "angle, corner") in which the equidistant triangle is used to determine structurally important points; 5. the harmonic proportion, in which the string lengths and wave ratios of musical intervals are transposed onto the architectural proportions, such as the octave = 1:2, the fifth = 2:3 and the fourth = 3:4.

Putto (Italian; "little boy;" Latin; putus, "boy"). Little naked boy depicted with or without wings, an invention of the early Italian Renaissance in imitation of Gothic child angels according to the model of the ancient Erotics.

Realism (French; réalisme, "reality"). Artistic and literary style which began in the second half of the 19th century. One of the main representatives and spokesmen was the painter Gustav Courbet (1819–1877). In the dispute about ways to represent reality, Realism rebelled against the idealistic and classicist tendencies in painting. In his 1855 article "Le Réalisme," Courbet makes the case for the relevance and timeliness of painting, the task of which is to conceive true representations of the social milieu. Such depictions would facilitate reflection on the political, social, and ideological events of the time, which would be useful both to those represented and to society in general. Courbet's individual exhibitions in 1855 at the world fair and in 1867 became the programmatic peaks of the Realism movement.

Relief or Relievo (French; or It.; from Latin; relevare, "to raise"). An image chiseled or modeled from a surface. According to the degree of depth or height of the motif we refer to high- (haut or alto) relief, half- (mezzo) relief or low- (bas or basso) relief. It also serves as architectural decoration.

Repoussoir (French; repousser, "to push back, frighten off"). Designation for the figures or objects placed in the extreme foreground, e.g. tree stumps or architectural fragments, that are often used to provide the illusion of depth and may draw attention to the main activity in the picture that has been pushed to the back.

Rococo. Style in European art between 1730 and 1780. The most important representative is Antoine Watteau (1684–1721), whose acceptance into the

Plinth, seen in the example of an Ionic column

Capital — Abacus

Volute

Egg-and-dart molding

Shaft — Fluting

Torus

Dado

Base — Plinth

Academy marked the creation of the "fêtes galantes" (French; "elegant parties") genre, artistically refined interpretations of "society at play." Under the auspices of alienation from nature and the longing for more humanitarian conditions, the pastoral theme recurred around 1900 in the nude groups and bathing scenes of Edouard Manet, Auguste Renoir, Paul Cézanne, and Paul Gauguin.

Romanticism (Old French; "exaggerated, wanton, fantastic"). Designation for works of literature, fine arts, and music created between 1790 and 1830. The rejection of classicist and enlightening tendencies was characteristic of this style, while the revival of medieval literature and (folk) art as well as religion was promoted. The method used was the exploration of the rational with the aid of the unconscious and individual emotion. In the fine arts, this style was expressed primarily in painting, but with a close connection to poetry. Common themes were the strong links between humans and nature, traditional lifestyles, and the fairy-tale, as well as religious events; the latter were particularly popular with the Pre-Raphaelites. Important French Romanticists include Théodore Rousseau and Eugène Delacroix.

Salome. A biblical figure, daughter of Herodias. As a reward for a dance, Salome received the head of John the Baptist, whom she hated, from her stepfather, Herod Antipas (Mark 14, 6–11). Common in the Middle Ages, this motif appeared frequently again in the 19th century. Salome became part of the group of seductive women credited with destructive powers, the "femmes fatales."

Salon (French; Italian; salone, originally "large room"). In the French language of the 18th and 19th centuries it designated an actual exhibition space, as well as the academic art exhibitions staged in the Salon d'Apollon of the Louvre since 1667. From 1737, the exhibitions took place biennially and, after the French Revolution, annually in the Salon Carré of the Louvre in Paris. Towards the end of the 19th century, the official Salon jury was dissolved in order to make way for a committee of state-approved artists, i.e. former Salon members, who created the highly influential Société des Artistes Français.

Still-life: Paul Cézanne, Still-life with Soup Tureen ca. 1877
Oil on Canvas, 65 x 81.5 cm, Musée d'Orsay, Paris

Salon des Indépendants (French; "Salon of the Independents"). Founded in Paris in 1884 in opposition to the official Salon, this was an association of "unrecognized and rejected artists" which later became the model for the secessions throughout Europe. In contrast to the Salon des Refusés, this was organized independently of the state.

Salon des Refusés (French; "Salon of the Rejected"). Exhibitions held in 1863/64 and 1873 in opposition to the conservative art policies of the official Paris Salon, where paintings were shown that had been rejected by the latter. The Salon des Refusés was first organized by Napoleon III; participants included, among others, Edouard Manet, Paul Cézanne, Henri Fantin-Latour, Camille Pissarro, and James Abbott McNeill Whistler.

Sappho. Around 600 B.C. the most important Greek poetess, called "the tenth Muse" by Plato. Of the numerous songs and poems she wrote in Mytilene on Lesbos, only two still exist in complete form. She quickly became a legend. Her close relations with young girls and women, probably through cult duties, have subjected her to calumny and ridicule over the centuries.

School of Nancy (French; Ecole de Nancy). Designation of the regional variation of Art Nouveau originating in Nancy, where between 1890 and 1910 arts and crafts objects were produced. The common feature of furniture, glass objects, ceramics, and bookbindings produced by the School of Nancy is the ornamentation with plant motifs. Only in 1901, when an association of arts and crafts producers established the "Ecole de Nancy, Alliance provinciale des industries d'Art" ("Provincial Association of the Art Industry") as a trademark, did the designation become an official style. The products of this association were intended to bring modern forms inspired by nature into harmony with progressive production processes, with the goal of conquering new markets and to distribute more contemporary decorative and useful objects. The founders and most important representatives of the School of Nancy were the designers Emile Gallé (1846–1904) and Louis Majorelle (1859–1926), and the painter Victor Prouvé (1858–1943).

Scumbling (German; Lasurmalerei; Middle Latin; lazur(i)um, "blue stone, blue color;" Arabic lazward; "lapis lazuli, translucent color"). A painting technique that uses thin, transparent colors, so that the underlying layers of color shimmer through and the shade of the newly applied color is slightly changed.

Series (Latin; series, "row, chain, consequence"). Constant repetition of the same theme in painting or in graphics by an individual artist or by different ones. In the 19th century Claude Monet (1840-1926) created some famous series of paintings.

Secession (Latin; secessio, "separation"). The separation of a group of artists from an already existing, traditional association or a demonstrative separation from the academic Salon system, e.g. the Munich Secession of 1892 under Franz von Stuck (1863–1928) or the Vienna Secession of 1897 under Gustav Klimt (1862–1918).

Spectrum, colors of. The unmixed, pure colors resulting from a separation of the spectrum of white light.

Statuette (Latin; statue, "statue"). A small statue as a single figure or as a group of several small figures.

Still-life painting (Dutch; still-leven; still, "motionless," and leven "model"), also known as "nature morte" or "natura morte" (French; or Italian; "dying nature, lifeless creation"). A genre dedicated to the realistic reproduction of "still," motionless objects, which obtained significance primarily in Dutch painting of the 17th century. Depending on the prominence of the objects, works are designated as flower and fruit still lifes, or hunting, kitchen, and market pieces. Ranked in the academic painting of the 18th century as a minor genre, it was rediscovered by the Impressionists. Their interest was not merely the illusion of the object, but rather an exploration of the colored appearance and artistic quality of apparently meaningless objects.

Symbolism. An artistic movement that arose in France toward the end of the 19th century, primarily in literature, in opposition to the reigning schools of Realism and Impressionism. Symbolism demanded a deeper meaning in art and sought to express thoughts and subjective impressions by employing universally understood symbols or suggestive hints. Not the objectively perceived object was to be depicted, but rather the idea or meaning behind it. Subjects therefore included mythical figures as well as fantasy creatures. In addition to Gustav Moreau (1826–1898), whose mysterious "Salome paintings" can be understood as the epitome of Symbolism, the best-known representatives of French Symbolism include Odilon Redon (1840–1916) and Pierre Puvis de Chavannes (1824–1898).

Synthetism (French; synthèse, "summary"). A term that attained significance in the School of Pont-Aven, used primarily by Paul Gauguin (1848–1903) to describe his method of picture development. In this method, the pictorial theme is stored in the mind of the artist in a process of thought synthesis and then applied to the canvas from memory. The result is not necessarily natural colors, but imaginary forms and decorative surface arrangements on the painting. A subject existing in reality thus becomes superfluous. In 1889 the Groupe Synthétiste held an exhibition in which Paul Gauguin, Emile Bernard, Charles Laval, and Louis Anquetin took part.

Tête d'expression: Franz Xaver Messerschmidt, "A lascivious fool", Marble, height 45 cm, Österreichische Galerie, Vienna.

Tempera (Latin; temperare, "to mix correctly, to moderate"). A painting technique in which the pigments (colored powders) are mixed with a binding agent made of egg, glue, or casein (an important protein component in milk). Compared to oil paints, the colors dry faster, so that wet-on-wet painting is not possible, and fine shadings and transitions are achieved with many layers of strokes applied in parallel. Color differences between wet and dry tempera make it difficult to achieve an identical shade in the case of overpainting. Tempera was increasingly replaced by oil paint from the 15th century, but was revived toward the end of the 19th century.

Tepidarium (Latin; tepere, "to be warm, tepid"). The warm air room in a Roman public bath, in which a Turkish bath was finished in milder temperatures.

Terracotta (Italian; terracotta; Latin; terra, "earth," and Italian; cotta, "burned"). Unglazed clay fired at low temperatures, which was already used in ancient times for architectural components, e.g. as a gable crown or as filling for a frieze. Also used for reliefs, utensils, and small statues (e.g. the Tenagra figures from the 3rd century B.C.). In the 19th century it was popular among sculptors as a material for portrait busts, e.g. by Auguste Rodin.

Tête d'expression (French; "expressionist head"). Term in French art theory of the 17th century related to the psychologized representation of the human visage. The term became standard in the teaching of the European art academies of the 18th and 19th

centuries through use in the illustrated textbook "Méthode pour apprendre à dessiner les passions…" ("Method of learning to depict emotions") (Paris, 1667) by the French painter Charles Le Brun (1619–1690).

Tondo (Latin; rotundus, "round;" Italian; "disk, circle"). A picture form that has been popular since the 15th/16th centuries: a painting or relief (sculptured representation on a flat surface) executed in a circular form.

Torso (Italian; "trunk"). Originally an unfinished or incompletely preserved ancient statue. Since the 16th century the torso has been considered a sculptural design in which the execution of the arms or head is consciously omitted.

Triptych (Greek; triptychos, "three-layered, three-fold," from tri-, "three," and ptyche, ptyx, "fold, layer, folded object"). Originally a term used for a medieval winged altar with a fixed center panel and two movable side leaves; the term has come to denote a three-part painting with related content in all three parts.

Tyche. Particularly since the Hellenistic age, the goddess of chance and unpredictable fortune. Usually depicted with a cornucopia, a rudder, and a wheel, or on a rolling ball. Equivalent to the Roman goddess Fortuna.

Venus. Goddess of gardening and flourishing nature, later equivalent to the Greek Aphrodite and thus also the goddess of (sexual) love, who emerged victorious from a beauty contest with Hera and Athena (the so-called Judgment of Paris). Generally revered as the epitome of female beauty, she was the most frequently portrayed female mythological figure from ancient times until the 19th century.

World Fair. A universal exhibition of the type first held in London (the Great Exhibition), which has taken place at intervals of one to eight years in various cities, in which countries from the entire world compete with each other in the fields of technology, science, and culture. The different exhibition buildings and pavilions demonstrate the respective technological state of architecture, e.g. Gustav Eiffel's Tower at the Paris Exposition Universelle of 1889.

Triptych: Arnold Böcklin, Venus Genitrix, 1895, Oil on Wood, 105 x 150cm, Kunsthaus Zürich

Theory of color

Theoretical discussions about color stretch back to ancient times; even Aristotle had something to say on the subject. Following Isaac Newton's discovery of the color spectrum at the end of the 17th century, the foundations were laid for a systematic modern theory of color in the 19th century (Goethe and Runge were just two of those involved). The "miracle" of color is now being researched under many branches of science. While physicists investigate the natural laws of immaterial, intangible color, chemists examine the molecular composition of material colors – such as those used as pigments in painting. Artistic practices in the use of color draw on a combination of these various approaches, which have also been covered by physiologists and psychologists, symbolists and theologians.

Of equal importance are the results of observing the relationship between colors and their perception by the human eye, and in the brain. In 1839 the chemist Michel Eugène Chevreul published a number of revolutionary findings that would completely change the way color was used in art. In his laws of "Harmony and contrast in color," he described how the optical effects of a particular hue affect the colors immediately next to it. As Ogden Rood deduced in 1897, the mixing of a color always takes place in the eye of the beholder. The neo-Impressionists in particular would make use of this effect by avoiding pigmentary mixes in their artistic calculations.

The use of color became the main feature of many artists' work in the 19th century. Instead of the traditional chiaroscuro painting as taught at the academies, this generation favored the predominant use of a light, colorful palette. With their revolutionary findings with regard to the opportunities of color in the composition of pictures, artists such as Turner, Delacroix, Manet, Cézanne, Monet, Renoir, van Gogh, and Seurat would change the course of the history of Western art forever.

Pigments used to mix paint

The color spectrum – color and light

Color is light. This simple premise sums up the fact that the way we perceive color is the result of electromagnetic oscillations on a particular wavelength that is visible to the human eye (396–760 nanometers). In 1672 Isaac Newton managed for the first time to prove the existence of the so-called color spectrum. Using a three-cornered prism, he was able to show that white sunlight can be divided into rays of different wavelengths, appearing as a "rainbow" (also known as the spectral colors). This phenomenon is based on the fact that every color in the spectrum equates to a particular light wavelength. When natural light is fanned out into individual sectors, we perceive the spectral colors of red, orange, yellow, green, blue, indigo, and violet. If the rays are then bundled back together through a convex lens, they combine back again into white light.

The colour spectrum

The perception of color

We sense color through our eyes. This means that color is one of the so-called facial sensations. The lens in the eye bundles a particular group of the wavelengths into light, and displays it as a reverse image onto the light-sensitive nerve cells of the retina. Optical nerves transport the impulse to the brain, where the information that is absorbed by the eye – in conjunction with our other sensory organs – is processed as a subjective sensation. The color effects of an object depend on its molecular surface structure and its specific ability to reflect or absorb light. If we perceive an object as being green, that is because only light waves on the wavelength of green (490–530 nm) are reflected toward our eye. If a surface reflects all of the colors in the spectrum, this appears as white; if, by contrast, they are all absorbed, it appears as black. Changes in light conditions lead to changes in an object's color effects. This observation was employed by Monet in his Haystacks series, as well as in the celebrated paintings of the cathedral at Rouen.

Diagram of the human eye as an organ of sensation in the facial experience of color

Additive and subtractive mixture

If we superimpose the light colors in the spectrum, we can create every other color, including white. The light rays at the different wavelengths matching the spectral primary colors orange-red, green, and violet-blue produce the intermediate shades of blue-green, blue-red, and yellow. Complete superimposition of light rays results in white in the center. The color effect that is thereby created is based on the addition of the various wavelengths.

The material mixture of pigments used in painting follows a different set of rules.

Because the color of a pigment depends on which wavelengths of the total light spectrum are not absorbed by its surface and thus reflected onto the observer's retina, this is known as a subtractive mixture. The superimposition of the three primary colors blue, yellow, and red on a white background results in almost complete absorption of light, and thus in a hue that is more toward black.

Additive mixture of light colors

Subtractive mixture of primary pigmentary colors

Primary, secondary, and tertiary colors

The color circles reveal a sequence of colors of the first, second, and third order. Blue, yellow, and red are known as the primary colors. Apart from the non-colors black and white, these are the only three basic colors that cannot be created by mixing other colors together, nor can they be broken down themselves. However, every other polychromatic color can be produced from the primary colors. Colors that are produced by combining two pure primary colors are known as secondary colors; these are violet, green, and orange. Mixing primary and secondary colors produces colors of the third order, which are known as tertiary colors, and these complete the color circle.

Primary colors

Primary and secondary colors

Primary, secondary, and tertiary colors

Complementary colors

Colors that have the maximum contrast to each other and are therefore located opposite each other on the color circle are known as complementary colors. In the six-part color circle, these are the three pairs that consist of one primary color and the secondary color that is produced by mixing the other two primary colors.

If we mix two complementary colors together, they reduce to a dark gray. If two complementary colors are placed side by side without mixing, each increases the saturation and radiation force of the other. Vincent van Gogh was one of the artists who used strong complementary contrasts in his art and achieved a vibrant, expressive color effect. According to the law of simultaneous contrast formulated by Michel-Eugène Chevreul in 1839, any given color is superimposed by the complementary color of its background hue. Thus gray, for example, on a red background absorbs a green tone because green is the complementary color of red. The same gray on a green background will appear red. Various opposing colors contrasted with a single hue can make a dramatic difference to the effects of that hue.

The complementary color pairs red-green, blue-orange, yellow-violet

The same gray, seen once on a red and again on a green background

Changes in the effects of the same blue displayed against various opposing colors

Quality, saturation, luminosity – the three-dimensionality of colors

Three main features are used to differentiate between colors. The primary quality is the hue or color tendency, for example blue as opposed to red. The purity and intensity of a shade can be measured by the degree of saturation. This depends on whether a color is used unmixed, that is to say in a greater purity, or achieved by adding another color. We also differentiate between the lightness (or darkness) of a color, which results from the added proportions of black and white. Additionally, every primary or secondary color has a specific luminosity value, in accordance with which yellow is brighter than red.

In 1810, Philipp Otto Runge tried to illustrate this three-dimensionality of colors in his color sphere, after spending many years deliberating the problem. The equatorial level formed a colored circle with differing degrees of intensity of the individual hues. By contrast, various degrees of brilliance are displayed in the direction of the two poles of black and white.

Philipp Otto Runge, The color sphere, 1809, copperplate engraving, watercolor, 22.5 x 18.9 cm, Kupferstichkabinett, Hamburger Kunsthalle

A warm red, displayed against cooler green-blue tones, comes to the foreground

Color scales with increasing/ decreasing temperature

The temperature of color

Our perception of color is largely limited to subjective perception. The effect and emotive content of a color's stimulation depends on a wide range of psychological and aesthetic conditions that do not comply with general laws. As a rule, however, we perceive shades of red and yellow as warm, and associate lively, fiery properties with them. Shades of blue or green have a cooler effect on us. Artists have always known how to make subtle use of such color associations. The fact that warm shades come toward the observer whereas cooler ones seem to disappear into the distance has for centuries been a feature of, for example, landscape painting.

Masters of color in detail

Claude Monet, Poppies (detail, see p. 184), 1873

Auguste Renoir, Study, Female Nude in the Sun (detail, see p. 240), ca. 1876

Claude Monet

Monet applied complementary color contrasts to capture the shimmering, vibrant light of a summer's day and its effects on the local coloring of objects. The red dots of the poppies are a marked contrast to the background of the soft, mute green of the meadows. This careful juxtaposing of warm and cool shades actively vitalizes the painting.

Auguste Renoir

Renoir's treatment of the incarnadine (skin tone), a subject that reminds some contemporaries of "rotting flesh," is now unanimously evaluated as evidence of his complete mastery of color. The way in which fleeting light effects are captured by his application of the paint is that of a complete virtuoso. The reflections of the dark blue, almost black, coloring and subtle shading of the leaves weave a magical effect on the changing tones of the skin.

Paul Cézanne

His painting *The Blue Vase* confirms Paul Cézanne as a superlative colorist. The contours of the objects are evenly balanced by the harmonious use of subtly graded shades of blue. The lightness of the reflection on the front of the vase is echoed in the white of the plate behind it, the surface of which reflects the blue of the vase. The color values, which darken toward the edge of the vase, match the different shades of blue of the background.

Vincent van Gogh

The extreme brilliance of van Gogh's later works are the result of his use of pure, unbroken colors, which he positions side by side, allowing them to contrast with each other. With van Gogh's work, color is an adequate form of expression for the sensory impression and moods experienced; this is what gives them their symbolic expressive force. Short brush strokes, hastily placed close together and moving in different directions, dominate the artistic structure of his compositions.

Paul Cézanne, The Blue Vase
(detail, see p. 299), 1889/90

Vincent van Gogh, The Church at Auvers-
sur-Oise (detail, see page 283), 1890

References

Un ami de Cézanne et van Gogh. Le docteur Gachet. Exh. cat. Paris (Galeries Nationales du Grand Palais), Amsterdam (Van Gogh Museum) 1999

Les années romantiques. La peinture française de 1815 à 1850. Ed. by Anne de Margerie. Exh. cat. Nantes, Paris 1995/96

Art nouveau. Symbolismus und Jugendstil in Frankreich. Ed. by Renate Ulmer. Exh. cat. Darmstadt (Institut Mathildenhöhe) 1999

Badt, Kurt: Die Kunst Cézannes, Munich 1959

Baudelaire, Charles: Der Künstler und das moderne Leben. Essays, Salons, intime Tagebücher, Leipzig 1990

Baumgart, Fritz: Idealismus und Realismus 1830–1880. Die Malerei der bürgerlichen Gesellschaft, Cologne 1975

Bazin, Germain: Die Impressionisten. Schöpfer der modernen Malerei, Gütersloh 1981

Berger, Klaus: Japonismus in der westlichen Malerei 1860–1920, Munich 1980

Bihalji-Mérin, Oto: Die Malerei der Naiven, Cologne 1975

Boime, Albert: The Academy and French Painting in the Nineteenth Century, London 1971

Antoine Bourdelle 1861–1929. Exh. cat. Cologne (Wallraf-Richartz-Museum) 1960

Bühler, Hans-Peter: Die Schule von Barbizon. Französische Landschaftsmalerei im 19. Jahrhundert, Munich 1979

Cachin, Françoise und Carrère, Xavier: Treasures of the Musée d'Orsay, Paris 1995

Clark, Timothy J.: Painting of Modern Life. Paris in the Art of Manet and his Followers, New York 1985

Camille Claudel. Ed. by Nicole Barbier. Exh. cat. Paris (Musée Rodin) 1991

Corot, Courbet und die Maler von Barbizon. Ed. by C. Heilmann and J. Sillevis. Exh. cat. Munich 1996

A day in the country. Impressionism and the French Landscape. Exh. cat. Los Angeles (County Museum of Art) et al. 1984/85

Fahr-Becker, Gabriele: Art Nouveau, Cologne 1997

Feist, Peter: Impressionismus. Die Entdeckung der Freizeit, Leipzig 1990

Garb, Tamar: Women Impressionists, Oxford 1986

Paul Gauguin. Das verlorene Paradies. Exh. cat. Essen (Museum Folkwang) 1998

Vincent van Gogh und die Moderne. Exh. cat. Essen (Museum Folkwang), Amsterdam (Van Gogh Museum) 1990/91

Hale, W.H.: Rodin und seine Zeit 1840–1917, Amsterdam 1972

Hofmann, Werner: Das irdische Paradies. Kunst im 19. Jahrhundert, Munich 1960

Hofstätter, Hans H.: Symbolismus und die Kunst der Jahrhundertwende. Voraussetzungen, Erscheinungsformen, Bedeutungen, Cologne 1975

Impressionismus. Paris – Gesellschaft und Kunst. Ed. by Robert L. Herbert et al., Stuttgart 1989

Impressionnisme. Les Origines 1859–1869. Ed. by Henri Loyrette und Gary Tinterow. Exh. cat. Paris (Galeries Nationales du Grand Palais) 1994

L'Impressionnisme et le paysage français. Edition des Musées Nationaux, Paris 1985

Japan und Europa 1543–1929. Ed. by Doris Croissant. Exh. cat. Berlin (Martin-Gropius-Bau) 1993

Le Japonisme. Ed. by Geneviève Lacambre. Exh. cat. Paris (Galeries Nationales du Grand Palais) 1988

Jaworska, Wladyslava: Gauguin et l'école de Pont-Aven, Neuchâtel, Paris 1971

Jugendstil. Der Weg ins 20. Jahrhundert. Ed. by Helmut Seling, Heidelberg, Munich 1959

Koppelkamm, Stefan: Der imaginäre Orient, Berlin 1987

Lavedan, Pierre: Histoire de l'urbanisme à Paris. Nouvelle histoire de Paris, Paris 1975

Loyer, François: Paris XIXe siècle. L'immeuble et la rue, Paris 1987

Maag, Günter: Kunst und Industrie im Zeitalter der

ersten Weltausstellungen, Munich 1986

Aristide Maillol. Ed. by Ursel Berger and Jörg Zutter. Exh. cat. Berlin (Kolbe-Museum) et al. 1996/97

Malerei des Impressionismus. Ed. by Ingo Walter (2 vols.), Cologne 1996

Manet. Monet. La gare Saint-Lazare. Ed. by Juliet Wilson-Bareau. Exh. cat. Paris (Musée d'Orsay) 1998

Metken, Günter: Gustave Courbet, Der Ursprung der Welt: ein Luststück, Munich, New York 1997

Gustave Moreau 1826–1898. Exh. cat. Paris (Galeries Nationales du Grand Palais) 1998/99

Musée d'Orsay. Catalogue sommaire illustré des sculptures, Paris 1986

Musée d'Orsay. Catalogue sommaire illustré des arts décoratifs, Paris 1988

Musée d'Orsay. Meisterwerke der Impressionisten und Post-Impressionisten, Stuttgart 1988

Musée d'Orsay. Catalogue sommaire illustré des peintures (2 vols.), Paris 1990

The Musée d'Orsay. Ed. by Sylvie Messinger. Paris 1998

Die Nabis. Propheten der Moderne. Ed. by Claire Frèches-Thory and Ursula Perucci-Petri. Exh. cat. Zürich (Kunsthalle), Paris (Galeries Nationales du Grand Palais) et al. 1993

Novotny, Fritz: Painting and Sculpture in Europe 1780–1880 (Pelican History of Art), Harmondsworth 1960

L'Œuvre du Baron Haussmann, préfet de la Seine (1853–1870). Ed. by Louis Réau et al., Paris 1954

Ottermann, Stefan: Das Panorama. Die Geschichte eines Massenmediums, Frankfurt 1980

Perucchi-Petri, Ursula: Die Nabis und Japan. Das Frühwerk von Bonnard, Vuillard und Denis, Munich 1976

Quette, Anne-Marie: Art Nouveau. Le mobilier français, Paris 1995

Rewald, John: Die Geschichte des Impressionismus. Schicksal und Werk der Maler einer große Epoche der Kunst, Cologne 1979

Rewald, John: Von van Gogh bis Gauguin. Die Geschichte des Nachimpressionismus, Cologne 1987

Auguste Rodin. Eros und Kreativität. Exh. cat. Munich 1991

Rodin und die Skulptur im Paris der Jahrhundertwende. Exh. cat. Bremen (Paula Modersohn-Becker Museum) 2000

Rosenblum, Robert and Janson, H.W.: Art of the Nineteenth Century. Painting and Sculpture, New York 1984

Rosenblum, Robert: Die Gemäldesammlung des Musée d'Orsay, Cologne 1989

Rosenthal, Léon: Du Romantisme au Réalisme, Paris 1914

Ross, Werner: Charles Baudelaire und die Moderne, Munich 1993

Schmoll, Josef Adolf, known as Eisenwerth: Rodin-Studien. Persönlichkeit, Werke, Wirkung, Bibliographie, Munich 1983

Schreiber, Hermann: Die Belle Epoque. Paris 1871–1900, Munich 1990

The Second Empire. Art in France under Napoleon III. Exh. cat. Philadelphia (Museum of Modern Art) et al. 1978/79

Sedlmayr, Hans: Verlust der Mitte. Die bildende Kunst des 19. und 20. Jahrhunderts als Symbol der Zeit, Salzburg 1948

Shikes, Ralph E. and Harper, Paula: Pissarro. Der Vater des Impressionismus, Königstein 1981

Spies, Werner: Dressierte Malerei – Entrückte Utopie. Zur französischen Kunst des 19. Jahrhunderts, Stuttgart 1990

Statues de Chair. Sculptures de James Pradier (1790–1852). Ed. by Claude Lapaire et al. Exh. cat. Geneva (Musée d'art et d'histoire) 1985

Sternberger, Dolf: Panorama der Ansichten vom 19. Jahrhundert, Berlin 1974

Sterner, Gabriele: Jugendstil – Kunstformen zwischen Individualismus und Massengesellschaft, Cologne 1975

Traum und Wirklichkeit. Vienna 1870–1930. Exh. cat. Vienna 1984

Trier, Eduard: Moderne Plastik, Berlin 1954

Vollard, Ambroise: Erinnerungen eines Kunsthändlers, Zürich 1996

Willms, Johannes: Paris. Hauptstadt Europas 1789–1914, Munich 1988

Zola, Émile: Schriften zur Kunst. Die Salons von 1866–1896, Frankfurt 1988

Index of works

Picture and map credits

The greater proportion of the picture material was provided by SCALA GROUP S.p.A. of Florence. The publishers would also like to thank the museums, collectors, archives and photographers for approving reproduction and for their friendly support in bringing this project to fruition. The publishers endeavoured, up to the time of publication, to establish the holders of other publication rights. We would ask any persons or institutes whom we were not able to contact and who hold the rights to any pictures reproduced here to contact us.

a = above; b = bottom, m = middle, r = right, l = left

© Agfa-Photo-Historama/RBA, Köln (387); © AKG, Berlin (25, 112, 113, 276, 277, 412, 515, 521, 526, 531 reg. 3, ill. 2; 532 reg. 1, ill. 3; 533 reg. 1, ill. 1; 534 reg. 1, ill. 1, 2, 3; 539); © Archiv Gerstenberg, Wietze (292, 319 r, 378 r, 378 l); © Archives Durand-Ruel (289, 496); © Artothek, Peissenberg (127, 531 reg. 5, ill. 2); © Bastin & Evrard, Brussels (448); © Bibliothèque des arts décoratifs (446); © Bibliothèque Nationale, Paris (54, 55, 57, 110, 111, 133, 135, 330, 333, 389, 390, 414/415, 416, 426, 427, 497); © Bildarchiv Preussischer Kulturbesitz, Berlin, photo Margarete Büsing (151); © The Bridgeman Art Library, photo Larous-Giraudon (189); © British Museum, London (182); © Collection Piguet (288); © Comité Masson, Paris (99); © Mario Gastinger, Munich (447); © Giraudon, Paris (136/137); © Hamburger Kunsthalle, photo Walford (560); © Tandem Verlag GmbH, photo Achim Bednorz (552), photo Lothar Schnepf (554/555), map: Peter Frese, Munich, based on ADAC Verlag, Haupka Verlag, Bad Soden (original), graphics: Rolli Arts, Essen (8, 9, 10, 11, 26, 30, 31, 32, 33, 174, 175, 176, 177, 256, 257, 258, 394, 395, 396, 397, 535 b, 542, 555 top, 556, 557, 558, 559, 561), from Guide Gallimard © Editions Gallimard Jeunesse, Paris (258), from Musée d'Orsay, guide, German edition, revised and updated version, Spadem, Paris 1993, p. 277-279 (8, 9, 10, 11, 30, 31, 32, 33, 174, 175, 176, 177, 394, 395, 396, 397); © Kunsthalle Bremen (278); © Kunsthaus Zurich (291 b, 553); © Kupferstichkabinett, Staatliche Museen zu Berlin – Preussischer Kulturbesitz, photo Jörg P. Anders (212); © 1992 Metropolitan Museum of Art, New York, gift of Mrs. Ralph J. Hines, 1955 (55.193) (213); © Musée d'Orsay, Paris (19); © Musée Rodin, Paris, photo Jessie Lipscomb (200), photo Bruno Jarret (317) photo: de Calan (471, 473); © Museum für Ostasiatische Kunst, Cologne/RBA, Köln (316, 318, Otto Riese Collection (319 l); © Philadelphia Museum of Art (458); © Photothèque des Musées de la Ville de Paris, photo Joffre (149), photo Pierrain (152, 499), photo Ladet (528/529); © RMN, Paris (35, 53, 58/59, 64, 71, 123, 158, 159, 161, 162, 164 top, 164 b, 167, 168, 169, 170 r, 170 l, 171, 188, 229 r, 246, 262, 327, 328, 360, 391, 406, 408, 422, 440, 441 top, 450, 451, 452, 453, 469, 470, 477, 512), photo Arnaudet (56, 421, 463, 485, 507, 536), photo Arnaudet/G.B. (332, 352 b), photo Bellot (153, 443), photo Bellot/Schormanns (222, 466), photo Bernard (24, 67, 126, 127), photo Blot (62/63, 163, 357, 407, 442 top, 459, 467), photo Blot/Jean (420, 462), photo Blot/Schormans (144, 222), photo Berizzi (42, 342, 523), photo El Garby (480), photo Hatala (263, 506, 516), photo Ignatiadis (36 b, 69, 475), photo Jean (367, 409, 445, 486, 519, 522), photo Lewandowski (65, 72, 73, 78/79, 82, 97, 156, 165, 166 r, 219, 221, 228 l, 229 r, 253, 268 r, 282, 323, 337, 348, 361, 363, 402, 403, 423, 455, 456 r, 457, 465, 474, 527, 531 reg. 5, ill. 4) photo Néri (232), photo Ojeda (74, 269, 290, 400, 405, 423, 433, 464), photo Préveral (209), photo Raux (294 top), photo Schmidt (220), photo Schormans (2, 15 r, 34, 38, 39, 147, 157, 160, 166 l, 218, 315, 329, 352 top, 353, 356, 362, 372, 381, 436, 441 b, 442 b, 454, 461, 476, 479, 482, 484, 518), photo Vivien (154); © Viollet, Paris (13, 14, 15 l, 16, 17, 18 top, 132, 134, 148, 190, 191, 198, 199, 201, 215, 254, 255, 259, 291 top, 293, 376, 377, 379, 386, 388, 413, 417, 428, 429, 431, 444, 449, 478, 501, 532 reg. 3, ill. 4, 533 reg. 3, ill. 3, 534 reg. 3 ill. 4, 543), photo Boissons et Taponier-Paris (331); © Sipa Press, Paris, photo Ben Simmons (12); © Sotheby's Picture Library, London (460); © Staatliche Museen zu Berlin – Preussischer Kulturbesitz, art library, photo Dietmar Katz (150); © Tony Stone Images, photo Phil Degginger (545); © Tate Gallery, London (540); © Van Gogh Museum, Amsterdam (294 b); © 2001. VG-Bild-Kunst, Bponn (99, 167, 200, 342, 348, 349, 367, 384, 394, 394 ar, 395 reg. 1, ill. 2; 395 mr, 395 br, 396 mr, 419, 421, 432, 434, 442 l, 448, 465, 467, 476, 477, 479, 480, 482, 483, 486, 487, 488, 489, 491, 492, 493, 505, 518, 527, 533 reg. 2, ill. 3; 533 reg. 4, ill. 4; 534 reg. 2, ill. 1; 534 reg. 2, ill. 2; 534 reg. 4, ill. 2; © Elke Walford, Hamburg (532 reg. 5, ill. 3)

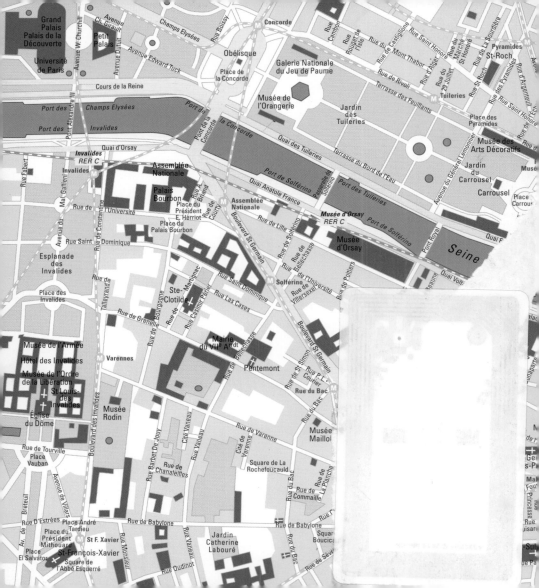